Beholding the
Sacred Mysteries

College Art Association

Monograph on the Fine Arts, LVI

Editor, Debra Pincus

SHARON E. J. GERSTEL

Beholding the Sacred Mysteries
Programs of the Byzantine Sanctuary

Published by

COLLEGE ART ASSOCIATION
in association with
UNIVERSITY OF WASHINGTON PRESS
SEATTLE AND LONDON 1999

In honor of
Mayme and Julius Gerstel

Copyright © 1999 College Art Association, Inc.
ALL RIGHTS RESERVED
Printed in the United States of America

University of Washington Press
PO Box 50096
Seattle, Washington 98145
uwpord@u.washington.edu

Library of Congress Cataloguing-in-Publication Data

Gerstel, Sharon E. J.
 Beholding the sacred mysteries : programs of the Byzantine
sanctuary / Sharon E. J. Gerstel.
 p. cm. — (Monographs on the fine arts : 56)
 Includes bibliographical references and index.
 ISBN 0-295-97800-7 (alk. paper)
 1. Sacred space—Macedonia (Republic). 2. Architecture,
Byzantine—Macedonia (Republic). 3. Christian art and
symbolism—Medieval, 500–1500—Macedonia (Republic).
 I. Title. II. Series : Monographs on the fine arts : 56.
 NA5955.M27G47 1999
 704.9′482′088219—dc21 98-50678
 CIP

The paper used in this book meets the minimum requirements of the
American National Standard for Information Sciences—Permanence of
Paper for Printed Library Materials, ANSI Z39.48-1984.

Contents

LIST OF ILLUSTRATIONS vii

PREFACE I

I The Creation of Sacred Space 5

II Assembling the Company of Bishops 15

III The Sacrificial Offering 37

IV The Sacred Communion 48

V Reviewing the Mandylion 68

VI Conclusion 78

APPENDIX

Catalogue of Decorated Sanctuaries in Macedonia 80

FREQUENTLY CITED SOURCES 112

NOTES 113

GLOSSARY 131

INDEX 133

ILLUSTRATIONS 143

Illustrations

FACING PAGE I
Map of churches in medieval
Macedonia

PAGE 7
St. Euphemia, Constantinople,
Reconstruction of sanctuary
furnishings

COLOR PLATES

I St. Nicholas Orphanos, Thessalonike,
Sanctuary
II St. Nicholas Orphanos, Thessalonike,
Sts. Athanasios and John Chrysostom
III St. George, Kurbinovo, Christ as the
sacrifice
IV St. John the Theologian, Veroia,
Communion of the Apostles
V Christos, Veroia, Sanctuary

FIGURES

1 Panagia ton Chalkeon, Thessalonike,
Sanctuary
2 Panagia ton Chalkeon, Thessalonike,
St. Gregory of Nyssa
3 Panagia ton Chalkeon, Thessalonike,
South wall of sanctuary
4 Hagia Sophia, Ohrid, Sanctuary
5 Hagia Sophia, Ohrid, Communion of
the Apostles
6 Hagia Sophia, Ohrid, St. Basil
Officiating
7 Panagia Eleousa, Veljusa, Drawing of
sanctuary decoration
8 Panagia Eleousa, Veljusa, Drawing of
hetoimasia

9 Panagia Eleousa, Veljusa, St. John
Chrysostom
10 St. Leontios, Vodoča, St. Basil
11 St. Leontios, Vodoča, South wall of
sanctuary
12 Sts. Theodoroi (Old Metropolis),
Serres, St. Andrew
13 St. Panteleimon, Nerezi, Sanctuary
14 St. Panteleimon, Nerezi, Communion
of the Apostles
15 St. Panteleimon, Nerezi, *Hetoimasia*
16 St. Panteleimon, Nerezi, Embracing
apostles
17 St. Michael the Archangel, Prilep, St.
Gregory the Theologian
18 St. Michael the Archangel, Prilep, St.
Andrew
19 Holy Anargyroi, Kastoria, Narthex, St.
Basil
20 Holy Anargyroi, Kastoria, Sanctuary
21 Holy Anargyroi, Kastoria, Gregory the
Theologian and Basil
22 Holy Anargyroi, Kastoria, John
Chrysostom and Nicholas
23 St. Nicholas tou Kasnitze, Kastoria,
Sanctuary and south wall
24 St. Nicholas tou Kasnitze, Kastoria,
Virgin of Annunciation
25 St. George, Kurbinovo, Sanctuary
26 St. George, Kurbinovo, Christ as the
sacrifice
27 Metropolis (St. Demetrios), Servia,
Sanctuary and south wall
28 Metropolis (St. Demetrios), Servia,
South wall
29 Panagia Mavriotissa, Kastoria, Virgin
of Annunciation

30 Old Metropolis, Veroia, Nicholas and Dionysios

31 St. John the Theologian, Veroia, Sanctuary

32 St. John the Theologian, Veroia, Embracing apostles

33 St. Nicholas, Melnik, Consecration of St. James

34 St. Nicholas, Melnik, Consecration of St. James

35 St. Constantine, Svećani, Drawing of the Communion of the Apostles

36 St. Nicholas, Manastir (Moriovo), Sanctuary

37 St. Nicholas, Manastir (Moriovo), Communion of the bread

38 St. Nicholas, Manastir (Moriovo), Communion of the wine

39 St. Nicholas, Manastir (Moriovo), John Chrysostom and Gregory the Theologian

40 St. Nicholas, Manastir (Moriovo), *Melismos*

41 St. John the Theologian (Kaneo), Ohrid, Sanctuary

42 Virgin Peribleptos (church of St. Clement), Ohrid, Sanctuary

43 Protaton, Mount Athos, Sanctuary screen

44 Protaton, Mount Athos, North wall of sanctuary

45 Protaton, Mount Athos, South wall of sanctuary

46 St. Euthymios, Thessalonike, Conch of apse

47 St. Euthymios, Thessalonike, Communion of the bread

48 St. Euthymios, Thessalonike, Communion of the wine

49 Christos, Veroia, Sanctuary

50 Christos, Veroia, North wall of sanctuary

51 St. Blasios, Veroia, Sanctuary

52 St. Nicholas Orphanos, Thessalonike, East wall

53 St. Nicholas Orphanos, Thessalonike, Sanctuary screen

54 St. Nicholas Orphanos, Thessalonike, Communion of the bread

55 St. Nicholas Orphanos, Thessalonike, Communion of the wine

56 St. Nicholas Orphanos, Thessalonike, Sanctuary

57 St. Nicholas Orphanos, Thessalonike, Christ as the sacrifice

58 St. Nicholas Orphanos, Thessalonike, South wall of sanctuary

59 St. Catherine, Thessalonike, Athanasios of Alexandria and John Chrysostom

60 Panagia Protothrone, Naxos, Sanctuary

61 St. Panteleimon, Upper Boularioi, Mani, Sanctuary

62 Hagios Strategos, Upper Boularioi, Mani, Sanctuary

63 Porta Panagia, near Pyli, Trikkala, Gregory the Theologian and Basil

64 Zoodochos Pege, Samari, Messenia, Frontal bishops

65 St. Merkourios, Corfu, Sanctuary

66 St. John Chrysostom, Geraki, Athanasios and John Chrysostom

67 St. John Chrysostom, Geraki, Basil and Gregory the Theologian

68 St. Neophytos, Paphos, Cyprus, Sanctuary

69 Taxiarchs of the Metropolis, Kastoria, Gregory the Theologian and Basil

70 Taxiarchs of the Metropolis, Kastoria, John Chrysostom and Athanasios of Alexandria

71 Hodegetria, Mystra, Leo of Rome

72 Athens, National Library, cod. 2559

73 Patmos, Monastery of St. John the Theologian, cod. 707

74 St. John Chrysostom, Geraki, Christ as the sacrifice

75 Dumbarton Oaks, Washington, D.C., Riha Paten

76 St. Nicholas, Myra, Communion of the Apostles

77 Panagia Phorbiotissa, Asinou, Cyprus, Communion of the Apostles

78 Panagia Phorbiotissa, Asinou, Cyprus, South wall

79 St. John the Theologian, Patmos, Communion of the bread

80 Panagia, Merenta, Attika, Communion of the Apostles

81 Omorphe Ekklesia, Athens, Communion of the bread

82 Iznik Archaeological Museum, Chalice

83 Holy Archangels, Lesnovo, Communion of the wine

84 Zoodochos Pege, Samari, Messenia, Sanctuary screen with Zosimas

85 St. Nicholas, Geraki, Zosimas

86 St. Athanasios, Kastoria, Communion of the Apostles

87 St. Barbara, Khé, Georgia, Mandylion

88 Church of the Savior, Geraki, Sanctuary

89 Thessalonike *epitaphios*

90 Zoodochos Pege, Samari, Messenia, *Epitaphios*

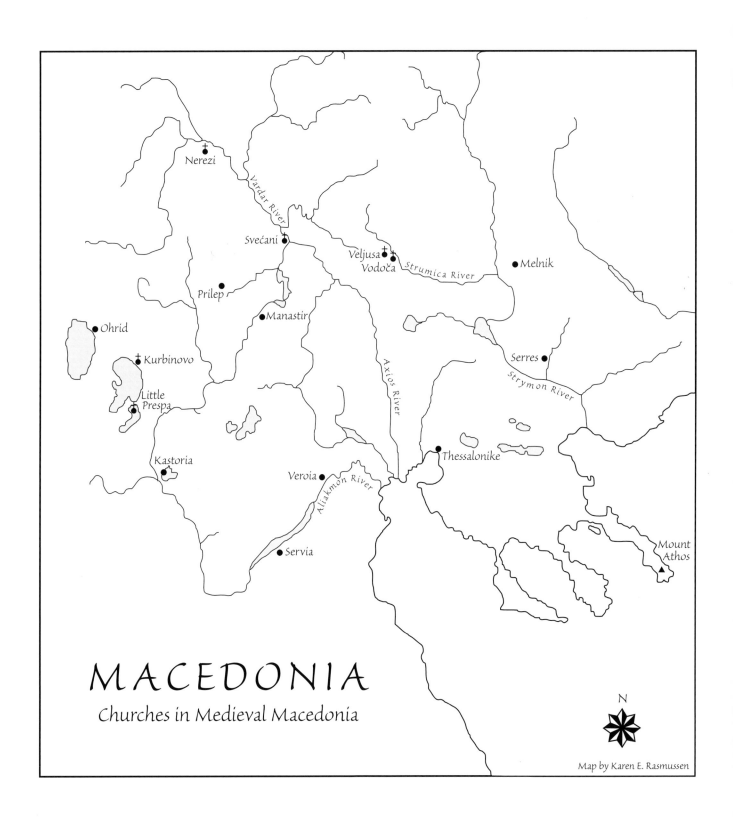

MACEDONIA

Churches in Medieval Macedonia

Nerezi

Vardar River

Svećani

Veljusa
Vodoča
Strumica River

Melnik

Prilep

Manastir

Ohrid

Kurbinovo

Serres

Strymon River

Little
Prespa

Axios River

Kastoria

Veroia
Aliakmon River

Thessalonike

Servia

Mount
Athos

N

Map by Karen E. Rasmussen

Preface

> I still remember what an impression that first night in the church made on my childish imagination. The faint light of the lamps in front of the *iconostasion*, barely able to illumine it and the steps in front of it, rendered the darkness around us even more dubious and frightening than if we had been completely in the dark. Whenever the flame of a candle flickered, it seemed to me that the Saint on the icon facing it had begun to come to life and was stirring, trying to wrench free of the wood and come down onto the pavement, dressed in his broad, red robes, with the halo around his head, and with those staring eyes on his pale and impassive face.
>
> —Georgios Vizyenos, "My Mother's Sin"[1]

In 1883 Georgios Vizyenos drew upon his childhood experience in eastern Thrace to describe how the border between the worlds of the living and the dead was dissolved in the church interior. The sensations evoked in "My Mother's Sin" were created by a program of church decoration and furnishing that was first developed and refined in medieval Byzantium. Of all the parts of the church, the decoration of the sanctuary, hidden behind the screen (the *iconostasion*), most effectively blurs the division between the two worlds. To the faithful, who see the sanctuary decoration from a distance and only fleetingly, the painted bishops of centuries past appear to participate in an ongoing rite that is momentarily interrupted by the entrance of the living celebrant.

In the twelfth and thirteenth century, the sanctuary was gradually divided from the body of the church by a tall screen that delimited a sacred space that could only be entered by men ordained by the Church. Stationed outside this space during the liturgy, the congregants saw the priest and his attendants emerge from the sanctuary to reveal the signs of the Faith. At the First Entrance into the nave, the priest displayed the Gospels. In the second, the Great Entrance, the priest and his retinue left the sanctuary carrying the offered bread and wine. The procession passed among the faithful and re-entered the sanctuary. At other moments of the ceremony, the deacon or priest emerged to pray on behalf of the faithful. The strictly prescribed interactions of priest and parishioner during the course of the liturgy were limited to brief moments.

The withdrawal of the mysteries from the eyes of the faithful and the increasing isolation of the clergy were bound up with the elaboration of the icon screen. Inside this space a new program was developing. In the pages that follow we will approach the Byzantine sanctuary through the rites that were carried out in that space and the texts that were read within it in order to understand how a specific decorative program emerged in the twelfth century. The new program, as we shall see, was intended primarily for the

priest, whether an ordained monk or the spiritual guardian of a local parish. The creation of a program that was aimed at a clerical audience may point to a shift in devotional practices in this period. Within the sanctuary, the new program was directly inspired by texts read by the celebrant. From the twelfth century, the program fully illustrated the words of the liturgy and the instructions that guided the priest and his assistant. The understanding of liturgical texts is thus fundamental to our interpretation of the painted program. We will also use contemporary manuals to reconstruct the movements of the priest within the sacred space. Polemical treatises that defended the Orthodox rite will be invoked to demonstrate how the sanctuary program responded to assaults on Orthodox practice in the twelfth to fourteenth century, and commentaries written by medieval clergymen will be introduced in order to allow the reader to hear the voice of the celebrant and those who surrounded him. Inscriptions and texts have been translated into English; references to the original Greek are provided in the footnotes. Specific components of the sanctuary program—the episcopal portraits, the image of the sacrificed Christ, the apostolic communion, and a cloth relic with eucharistic associations—form the subjects of individual chapters. These components comprise the core program of numerous sanctuaries throughout Byzantium and continue to decorate the sanctuaries in modern Orthodox churches. In discussing each scene, standard and unusual features will be presented.

For their part, the faithful stood outside the sanctuary and were expected to avert their eyes from the sacred rite. "When you enter the church," an eleventh-century official instructed his sons, "do not look over the beauty of women, but facing the sanctuary, keep your eyes downcast."[2] Stationed in the church nave and separated from the mysteries by a barrier, Byzantine men and women focused their devotional fervor on their own intercessors, whose portraits lined the walls of the church, within direct physical and visual access. Only secondarily, and then on a limited basis, was the sanctuary decoration intended for a lay audience. As I will demonstrate in the first chapter, the reconceptualization of the sanctuary decoration forced the creation of an independent program in the church nave that was intended to satisfy the devotional needs of the lay viewer.

The dichotomy between the inner world of the clergy and the outer world of the laity is what first drew me to explore the Byzantine sanctuary. My research on the medieval sanctuary was occasionally hampered by the same rules that prohibited women entrance to this space in the Middle Ages. In more than one church, I was required to pass my camera across the threshold of the sanctuary to a priest waiting on the other side. I depended on his observations, his insights into his own place among the represented saints, and his skill with a camera. The access I had to the sanctuary in a number of churches was prohibited to lay people, both male and female, in medieval Byzantium. This study reveals to the modern reader what was and is manifest to the clergy.

Although the artistic construction of the medieval sanctuary introduced a number of new elements into the church interior, there were portions of the program that expanded upon or modified older formulae.[3] The decoration of the medieval sanctuary, for example, drew upon a long history of displaying authors and martyrs of the church on

the walls surrounding the altar. In monumental decoration in the centuries following the foundation of Christianity, repeated portraits of sainted men and women represented to the faithful the corporate Church and its universality. A frieze of portraits of apostles, evangelists, and martyrs displayed historical figures who were the first converts and teachers of the Faith. Above these portraits, in the conch of the apse, many early churches presented subjects concerned with Christ's Incarnation. The representation of Christ's Transfiguration or Ascension instructed the congregants in dogma central to the faith and taught the significance of witnessing such transformations. In the medieval period, when the Church was well established, the decoration of the sanctuary was slowly transformed to mirror rituals that united the faithful in common practice.[4] The change in the decorative program indicates an alteration of its message and its audience.

In the past, scholars have analyzed developments in sanctuary decoration through isolated scenes and limited monuments.[5] In order to appreciate subtle changes in the program, I will present monuments from a single region that range over a span of three hundred years (1028–1328). This period encompasses the beginnings of the new program, its establishment, and its expansion. In the absence of surviving monuments from the Byzantine capital, this work finds its core evidence in the churches of Macedonia and supporting material, where appropriate, in other parts of the Empire. The sanctuary programs of the twenty-seven churches that form the basis of this study are catalogued at the end of the book (see appendix), and essential references are provided for further study. Macedonia, now divided among Greece, Bulgaria, and the former Yugoslavian Republic that bears its name, contains an unbroken sequence of decorated churches. This study is the first to present the region in its entirety. Although the borders of this region fluctuated in the medieval period, its cities and towns were linked by trade, ecclesiastical connections, and artistic exchange. Inscriptions in the churches are in Greek, and the faithful owed their political allegiance to Byzantium. The superior quality of ecclesiastical decoration in this region defies scholars who might label the churches as "provincial"; their position within the development of monumental painting is demonstrated by the high percentage of patrons from the court, the upper ranks of the clergy, and the local aristocracy. This in-depth examination of a related group of monuments demonstrates the sometimes popular and at other times restricted nature of certain subjects and details of decoration. This study will also indicate how innovative approaches to Christian iconography could be passed between painters and churches.

In writing this book I have benefited from the work, advice, and friendship of a number of scholars, many of whom have generously shared their own research and photographs. Colleagues in Greece created a second home for me and were always prepared to listen to or challenge ideas. I am particularly grateful to Sappho Tambaki for her encouragement and advice. In Greece, my research was facilitated by Tassos Andonaras, Aimilia Bakourou, Paulos Kalogerides, Victoria Kepetzi, Barbara Papadopoulou, Myrtali Acheimastou-Potamianou, Xanthe Savvopoulou, Anastasia Tourta, Eleni Tsafopoulou, Despoina Tsiafaki, and Chryssanthi Mavropoulou-Tsioumi. Soteris Kissas, Doula

Mouriki, and Thanasis Papazotos, who were all instrumental in shaping this study, have not lived to see its completion. I acknowledge the help and inspiration of Thomas F. Mathews, whose work on the relationship of art and liturgy guided my initial study of this subject. Research for my dissertation, completed in 1993, was generously supported by the Gennadeion Library, the Kress Foundation, and Dumbarton Oaks. I thank the Department of Art History and Archaeology of the University of Maryland for assistance in reproducing illustrations in color in this book. For their comments on earlier forms of this work and for their friendship, I warmly thank Annemarie Weyl Carr, Nicholas P. Constas, Anthony Cutler, Stamatina McGrath, Thalia Gouma Peterson, Nancy Ševčenko, and Robert Taft. Above all, I thank Jeffrey C. Anderson, who read and commented on a draft of this book.

I

The Creation
of Sacred Space

BEGINNING IN THE FOURTH CENTURY, a small number of Greek churchmen turned their attention to the interpretation of liturgical celebration.[1] Their intent was to clarify the meaning of the service for a wide audience. In doing so, several found the church building to be a point of reference sufficiently concrete to support complex liturgical and theological interpretation. For the commentators writing about the symbolism of the church, its architectural division corresponded to the parts of the world. In the seventh century, Maximos the Confessor commented that "the sanctuary reminds one of the sky, the dignity of the nave reflects the earth."[2] Altering his metaphor, he compared the church to man: "its soul is the sanctuary; the sacred altar, the mind; and its body the nave."[3] The analogy between the universe and the church was sharpened in the seventh-century liturgical commentary of Sophronios, patriarch of Jerusalem. For him, "the [earthly] sanctuary imitates the heavenly sanctuary; and just as the angels of God performed the liturgy, thus the living priests are present in the holy sanctuary, standing by and adoring the Lord through every means."[4] Much later, in the fifteenth century, Symeon of Thessalonike continued the comparison between the church sanctuary and the Holy of Holies, "which is above the firmament and the heavens. The holy altar represents the throne of God, the Resurrection of Christ, and his venerable tomb. The nave typifies the heavens and paradise, and the far end of the nave and the narthexes represent the creation of the earth for us and all the creatures upon earth."[5] Byzantine congregants, judging from epigraphical evidence, were aware of these architectural divisions and their mystagogical interpretations. An inscription revealed during excavation of the ninth-century chapel of St. Gregory the Theologian in Thebes names the patron and date of construction; the incised words call upon the priests to "honor the church of God as the heavens, the sanctuary as the Holy of Holies."[6]

The reflections of the commentators express, in systematic language, a desire for transcendence that was met by hymns, prayers, and liturgical acts performed on a daily or weekly basis. Hymns such as the Cherubikon invited the congregation to join the angelic choirs and elevated the faithful by their temporary inclusion in the ranks of the holy.[7] In addition to spoken prayers and choreographed actions, a wide range of sensations directed the faithful in their spiritual ascent. Carefully orchestrated lighting and the diffusion of incense demarcated spaces and heightened impressions during the liturgy. According to Symeon of Thessalonike, "By seeing the saints and their beauty and through the light of the

divine lights our sight becomes bright and holy and we shine within."⁸ The painted candles that flank the sanctuary opening at St. Panteleimon at Nerezi and the Virgin Peribleptos at Ohrid refer to the flickering lights that illuminated the gold haloes of the saints (Fig. 42).⁹

As the church became a symbolic space, the actions of the clergy and laity took on new meanings. For monks, passing from the narthex into the church nave symbolized the transition from earth to paradise. At the conclusion of the midnight office, which began in the narthex, "the doors of the nave open like the heavens and we enter as from earth."¹⁰ For the laity, the procession from the western entrance of the church to the threshold of the sanctuary, the site of the eucharistic sacrifice, represented both the symbolic ascent from earth to heaven and the mystical ascent of the soul guided by the words of the liturgy.

Inscriptions interpreted the activities that unfolded within the sanctuary for the faithful. Nearly identical verses in the tenth-century basilica of St. Achilleios in Prespa and the eleventh-century church of Panagia ton Chalkeon in Thessalonike read: "Beholding the sanctuary of the Lord's altar, stand trembling, O man! For within, Christ is sacrificed daily" (Fig. 1).¹¹ Painted around the church sanctuary, these inscriptions sent a powerful message about the divisions between the faithful stationed outside and the ceremony enacted within.

The Threshold of Sanctity

As is well known, the Early Christian laity was separated from the sanctuary by a low barrier.¹² This division between the clergy and laity was stipulated by the sixty-ninth canon of the council in Trullo, which read: "Let it not be permitted to anyone among all the laity to enter the sacred altar, with the exception that the imperial power and authority is in no way or manner excluded therefrom whenever it wishes to offer gifts to the creator, in accordance with a certain most ancient tradition."¹³ Ecclesiastical law was echoed in the mystagogical writings. According to Germanos, the eighth-century patriarch of Constantinople, "The chancel barriers indicate the place of prayer: the outside is for the people, and the inside, the Holy of Holies, is accessible only to the priests."¹⁴

These thoughts were not confined to churchmen of the Byzantine capital but extended throughout the Empire. Words inscribed on an epistyle fragment from an eleventh-century sanctuary screen built into the later belfry of the Panagia Protothrone at Chalke, Naxos, distinguish between those permitted to enter the sanctuary and those who must stand outside. In tone, the inscription recalls the language used in the painted verses at Prespa and Thessalonike:

> Lady Theotokos and Mother of the Lord, protect, guard, and preserve your supplicants who have renovated your glorious church, the most reverend Bishop Leo and the *Protospatharios* and *Tourmarches* of Naxia [Naxos], Niketas, and the Count and *Kamelares,* Stephanos, and those entering in faith and fear, bless them [...] indiction 5, 6560 [= 1052].¹⁵

The words incised on the marble barrier reaffirmed the division between clergy and laity. Lay people were not only prohibited entrance, but were enjoined to guard their eyes against viewing the mysteries.[16]

At some point in the medieval period, the chancel barrier was raised and an effort was made to prevent the laity from viewing the ceremony within the sanctuary. The first step in this process involved the decoration of the screen's epistyle. By the tenth or eleventh century, decorated epistyles were fairly common and often presented intercessory themes or portraits of apostles and saints. Surviving examples and literary sources demonstrate that a wide variety of materials could be employed for the decoration: carved and inlaid stone, painted wood or ceramic, and on rarer occasions, precious metals, ivory, or enamel.[17] By the twelfth century, the thick piers flanking the sanctuary were commonly decorated with monumental portraits of Christ and the Virgin or the titular saint of the church (Figs. 43, 84).[18] These portraits, which scholars call the *proskynetaria* icons, are generally framed by an elaborate painted or sculpted arch. Their name reflects the practice of the faithful, who bow before the icons in reverence and supplication *(proskynesis).* Macedonian examples include the portraits of Panteleimon and Kosmas and Damianos on the south piers of their churches in Nerezi and Kastoria.[19] Most scholars agree that by the middle Byzantine period the sanctuary was divided from the nave by a barrier that was blocked to waist height by decorated panels and was covered by an epistyle that was often inscribed and ornamented. In a number of cases, *proskynetaria* icons were located on the adjacent piers.

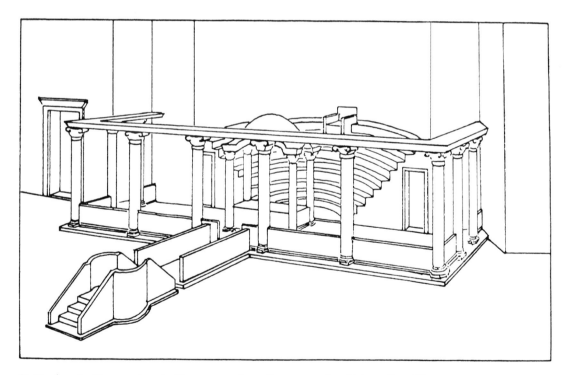

St. Euphemia, Constantinople, Reconstruction of sanctuary furnishings (from Thomas F. Mathews, *The Early Churches of Constantinople: Architecture and Liturgy* [University Park: Pennsylvania State University Press, 1971], fig. 32)

There is, however, wide disagreement concerning when the openings of this barrier were filled in. Suggestions have ranged from the eleventh century through the post-Byzantine period. Several liturgical scholars maintain that the practice originated in Russia and deny a Byzantine origin.[20] This book will suggest that that answer lies in medieval Byzantium and will find its documentation in monumental painting and liturgical practice. By the late thirteenth century, the practice of obscuring the sanctuary was sufficiently widespread that the anti-Latin polemicist Meletios Galesiotes could complain that among the Westerners "the place of the sacrifice is open, accessible to all. Among them, sacred things are not distinct from profane."[21]

The decision to withdraw the mysteries into the closed sanctuary was not sudden. Surviving texts indicate that in the eleventh century, at least in monastic contexts, curtains were being drawn to obscure the sanctuary during critical moments of the liturgy. An eleventh-century letter from Niketas, a Church official in Hagia Sophia, to Niketas Stethatos, abbot of the Stoudios monastery in Constantinople, discusses such a practice:

> In other places I have seen with my own eyes even a curtain hung around the holy bema at the time of the mysteries. It is spread and conceals, so that not even the priests themselves are seen by those outside. This is what Lord Eustathios (1019–1025), most blessed among the patriarchs, did.[22]

In his letter, Stethatos explains the reasons that the mysteries should be concealed from the faithful, and in so doing, divides the church into discrete sections appropriate to certain populations:

> Know that the place of the laity in the assembly of the faithful during the *anaphora* is far from the divine altar. The interior of the sanctuary is reserved to the priests, deacons and sub-deacons, the area outside near the sanctuary to the monks and other ranks of our hierarchy, behind them and the platform, to the laity. . . . How then from such a distance can the laymen, to whom it is not allowed, contemplate the mysteries of God accomplished with trembling by his priests?[23]

Stethatos further advises that the faithful should not look upon the acts performed by the priests in the sanctuary. In the late eleventh century, Nicholas of Andida, discussing the symbolism of church furnishings and ceremony, refers to the closing of curtains after the Creed:

> The shutting of the doors and the drawing of the curtains over them, as is customary in monasteries, and the covering of the gifts with the so-called *aer* signifies, I believe, the night on which the betrayal of the disciple took place. . . . But when the *aer* is removed and the curtain drawn back, and the doors opened, this signifies the dawn when they led him away and handed him over to Pontius Pilate the governor.[24]

Both Niketas Stethatos and Nicholas of Andida refer to monastic practices. The texts indicate that there was a growing movement in this community to obscure the mysteries from those who were not ordained. An inventory of March 1077, drawn up by Michael Attaleiates for the monastery of Christ tou Panoiktirmonos, lists a number of textiles used in liturgical service. These include "two curtains, one for the *templon*" and "a curtain for the *templon,* similar to the altar cloth which also covers the columns of the holy doors, both old."[25] The evidence suggests that in the eleventh century, at least in monastic contexts, the sanctuary was obscured by curtains.

Within a century it appears that icons were inserted into the screen in some regions of the Empire. Guides to ritual celebration provide information about the practices of individual communities in praying before large-scale images flanking the entrance to the sanctuary. Differences in the instructions indicate that monasteries conducted their services in a manner that suited their congregations. Details about the icon screen may be gathered from an analysis of penitential troparia, prayers that were recited by the celebrating priest before he entered the sanctuary. In the eleventh century liturgical instructions have little to say about the manner or location of these prayers. In the twelfth and thirteenth centuries the instructions become more specific. Typical is the thirteenth-century *diataxis* from the monastery of St. John the Theologian on Patmos (cod. 719), where, according to the instructions, the celebrant "comes out to the holy gates and bows three times and kisses the holy icons . . . then he comes into the holy bema and bows three times and kisses the holy Gospels."[26] By the thirteenth century most liturgical instructions direct the priest to bow in front of icons flanking the holy doors of the sanctuary in penance *(metanoia).* By the fourteenth century the priest is provided with more specific instructions for the service of Vespers, and we may take this as evidence that, from the thirteenth century and into the fourteenth, icons were regularly installed within the icon screen on either side of the sanctuary opening. The practice was codified in Philotheos's *diataxis,* a standardized guide to liturgical performance issued by the fourteenth-century patriarch, and is repeated in a number of other sources:

> The priest comes out with the deacon, and bows three times to the icon of
> the Lord Christ while all the brothers are seated. In a similar fashion, he
> bows three times to the icon of the Virgin, then to the center once
> (towards the altar), and to the choirs once, then they enter the sanctuary.[27]

The icons are described as flanking the sanctuary opening, and there is reason to believe, considering the surviving number of large-scale icons dated to this period, that the text refers to images set into a solid icon screen (Fig. 43).

The insertion of icons into the sanctuary screen cannot have happened suddenly and simultaneously throughout the Empire. Churches in some regions may have begun this practice long before others. The writings of Niketas Stethatos refer to a use of curtains that was already established by the eleventh century, and indicate that there was a receptivity, at least in monastic circles, to obscuring the mysteries from the gaze of the unconsecrated.

The best evidence for the adoption of solid icon screens outside of metropolitan and monastic contexts is the large number of masonry barriers with icons represented on plaster in imitation of panel paintings inserted into the intercolumniations of marble screens.[28] The Evangelistria church in Geraki, traditionally dated to the late twelfth or early thirteenth century, contains a built masonry screen decorated with fresco icons of the Virgin and Child and Christ Pantokrator.[29] On the piers to either side of the screen are full-length portraits of Sts. George and Panteleimon. In the same town, the church of St. John Chrysostom, dated circa 1300, also contains a built screen. Inside the sanctuary, the reverse side of the screen is decorated with wavy red and blue lines in imitation of the veins on marble revetment.[30] Painted panels from Cyprus, Mount Sinai, and Mount Athos are decorated with imitation marble veining on their reverse sides, an indication that the celebrant was meant to view a solid marble wall once the icons were installed into the screen.[31] The evidence suggests that the insertion of icons into a tall screen may have begun in some areas of the Empire as early as the end of the twelfth century.

As we will see, the partitioning of the nave from the sanctuary by means of an icon screen was accompanied by changes in the decorative program that surrounded the altar. This program forms the focus of this study. But before proceeding, I would like to offer some thoughts on how the church program, now transformed by spatial divisions, accommodated the lay viewer during the holiest moments of the liturgy.

The Sanctuary and Lay Piety

The increased number of votive images outside of the sanctuary, such as the prominent portrait of the titular saint Nicholas on the south wall of St. Nicholas tou Kasnitze in Kastoria (Fig. 23), suggests that by the late twelfth century the devotional focus of the laity had shifted from the eucharist to holy icons.[32] Changes in the representation of the Virgin in the conch of the apse fit into this pattern of providing intercessory images who spoke directly to the faithful. Increasingly, the Virgin was represented in poses that showed her tender relationship with her son. In Macedonia, from the twelfth century, the Virgin Hodegetria was particularly popular in ecclesiastical decoration. Seated on a throne, the Virgin's maternal role is emphasized as she tries to control the restless motions of the child in her arms (Figs. 20, 25, 46). A shift in the stance of the painted bishops within the sanctuary also took place in the twelfth century, resulting in their withdrawal from the faithful. It would seem that fundamental changes in ritual might have determined both the reconfiguration of church furnishings as well as substantive changes in church decoration.

As early as the seventh century, a set of votive images in the church of St. Demetrios, Thessalonike, acted to define the boundary between the space inhabited by the clergy and that of the laity.[33] Six mosaic panels on the piers flanking the sanctuary include intercessional figures, such as the titular saint and the Virgin Paraklesis. The contemplation of these figures offered an alternative means for the lay worshipper to gain

access to Christ. Even from this period, it is clear that a move was underway to provide the lay audience with images that satisfied personal devotional requirements, ones that did not demand the strict fasting and spiritual catharsis required for the rite of communion. Widespread confusion over the significance of the *antidoron* is yet another indication that the faithful were seeking other devotional outlets.[34] The *antidoron,* the portion of the offered loaf that remained after the bread for consecration was excised, was distributed to the faithful at the conclusion of the service. It was never meant to be a substitute for the eucharistic offering, but by the medieval period a number of lay people chose to receive this gift in place of one whose reception required spiritual introspection and physical abstinence. The establishment of a system of votive panels, placed into the icon screen or painted onto the walls of the church, offered an additional or even alternative focus for lay piety that had centered on the rite of communion in the early Church.

The monumental programs of Holy Anargyroi and St. Nicholas tou Kasnitze in Kastoria offer evidence for the type of painted decoration that accompanied the transition in lay worship. Markings for a high screen that remain on the walls of Holy Anargyroi demonstrate that in this late-twelfth-century church the lay viewer was prevented from seeing the episcopal program in the lower registers of the apse. Directly above this register, placed on either side of the Virgin, are portraits of the titular saints of the church, Kosmas and Damianos (the Anargyroi). Although their hands are extended in an intercessory gesture toward the Virgin, their eyes are directed toward the faithful standing in the nave (Fig. 20). On the south pier adjacent to the sanctuary screen is a second portrait of the titular saints, crowned by Christ. The three figures are represented under a painted molding that imitates a carved *proskynetarion,* the stand that held an icon representing the titular saint or the ecclesiastical feast day.[35] The decorative program of the church focuses the lay viewer's attention on the titular saints as intercessors. The lower registers of the sanctuary interior were obscured and were perhaps irrelevant to the supplicant seeking, as the donor's inscription states, "the recovery of my ailing flesh and the gift of bodily health."[36] The church of St. Nicholas tou Kasnitze, roughly contemporary with the neighboring Holy Anargyroi, also demonstrates the emphasis placed on the portrait of the titular saint as the sanctuary was closed by a high barrier. Traces of the screen's original attachment remain visible on the south wall and reveal that only the Virgin Orant and the Annunciation would have been visible to the viewer standing in the church nave (Fig. 23). On the south wall of the church, adjacent to the mark left by the barrier, is a large portrait of Nicholas, the saint addressed in the metrical inscription painted over the west door.[37] In Macedonia, the practice of providing large-scale icons adjacent to the sanctuary barrier continued into the late Byzantine period in churches such as St. Nicholas Orphanos in Thessalonike, where the Virgin Paraklesis, as in the neighboring church of St. Demetrios, played an intercessory role for those relegated to the nave and side aisles.[38]

The strict prohibition against laymen and women entering the sanctuary was offset by the creation of an elaborate, alternative program aimed at satisfying their devotional needs. Nonetheless, there were ways in which the faithful could enter the sanctu-

ary without trespassing the barrier. Images and inscriptions could serve as surrogates for men and women who sought to approach the main altar.[39]

Although laymen and laywomen were denied entrance to the sanctuary, they could be represented in that most holy space by their name saints or by saints to whom they had a special devotion.[40] The identification of name saints can be traced in church decoration through the comparison of names in inscriptions with the saints represented. In the later medieval period, the votive inscriptions that were often painted directly on portraits of saints provide important clues about devotional practices of the laity, especially those in the Byzantine provinces.[41] For the most part, portraits of name saints are found in the church nave or narthex, where supplicatory prayers could be offered directly to the saint. On rarer occasions, however, these holy surrogates entered the sanctuary, where the proximity of the name saint to the central altar provided powerful intercession on behalf of the living supplicant. In the church of the Virgin Peribleptos in Ohrid, for example, Sts. Michael the Confessor and Eutychios are included among the episcopal saints represented in half-length in a band along the north wall of the sanctuary. These two saints were not regularly included in the decoration of the sanctuary, but their advocacy of the painters Michael Astrapas and Eutychios may explain their insertion into the program.

The introduction of intercessory figures into the Byzantine sanctuary becomes a more freighted issue when it is female saints who cross the sacred barrier. The extraordinary insertion of a monumental image of St. Kalliope into the sanctuary program of the thirteenth-century church of the Transfiguration in Pyrgi, Euboia, can be directly linked to the patronage of Kale Meledone, who is mentioned as the primary donor in an inscription.[42] St. Glykeria's representation in the *diakonikon* of Omorphe Ekklesia in Athens may also have been dictated by a female patron who wished to gain access to the sanctuary through the inclusion of her name saint.[43] These female saints stand in places ordinarily reserved for holy bishops or sainted authors. The presence of painted surrogates within the sanctuary precinct raises important questions regarding how the decorative program of provincial churches was affected by the devotional requirements of Byzantine women.[44] In moments of crisis, of course, women might seek refuge in the sanctuary. The early-ninth-century *Life* of St. Stephen the Younger (d. 764) relates how soldiers sent by the Iconoclast emperor Constantine V entered the nunnery of Trichinarea on Mount Auxentios to seize Anna, Stephen's disciple. The nuns, terrified by the military intrusion during the prayers of the third hour, fled. According to the *Life*, ". . . the hymnody was silenced; one could observe the women of God greatly distressed. And one fled inside the chancel into the sanctuary. Another, lifting up the holy altar cloth hid under the holy altar."[45] Such moments were presumably rare.

In an unusually bold fashion, donors in several churches inserted their own portraits into the sanctuary program and gazed directly at the altar. In the late-thirteenth-century church of Panagia tou Moutoullas on Cyprus (1280), portraits of John Moutoullas and his wife, Eirene, stand on the north wall of the sanctuary. An inscription over the couple's heads reads: "Entreaty of the servant of God John, son of Moutoullas, the founder, and of his wife, Eirene."[46] As the couple extends a model of

the church they had constructed, their supplication is heard by the Virgin, to whom the building is dedicated. This phenomenon is not restricted to Cyprus. In the Maniate church of St. Kyriake at Marathos, dated circa 1300, a man and a woman are represented with their hands raised in entreaty on either side of the Virgin in the conch of the apse. These lay donors clearly assumed that their painted portraits in the sanctuary offered potent and perpetual supplications on their behalf.[47]

In Byzantine churches, especially from the thirteenth century, supplicatory inscriptions were often placed in the sanctuary. The inscriptions regularly included the name of an individual or a family, and their inclusion in the sanctuary guaranteed the recitation or remembrance of their names within that restricted space. The supplicant often placed his name close to that of his name saint or a saint closely associated with his family. In Panagia at Yallou, a small church on Naxos dated 1288/89, the apse contains an image of the Virgin and Child flanked by the archangel Michael and John the Baptist. To the left of the archangel Michael is the inscription: "Entreaty of Michael in the year 6797 [= 1288/89], the second indiction." On either side of the Virgin is inscribed: "Deesis of the servant of God George Pediasemos and his wife, Maria, and their children."[48] Numerous supplicatory inscriptions are painted within the apses of Byzantine churches, an indication that the laity considered the area surrounding the altar to be particularly effective.[49] Several preserved inscriptions directly address the chanters or clergy, asking them to pray for the supplicant. The marble altar table from a church dedicated to Sts. Nicholas and Barbara, now re-used in a post-Byzantine church in the Messenian Mani, is inscribed with the following lines around a central cross: "The altar of St. Nicholas and St. Barbara; chanters, pray for the servant[s] of God Staninas and Pothos, the son of Sirakos."[50] An inscription once painted on the south wall of the sanctuary of the Theotokos church at Apeiranthos, Naxos, speaks to the clergy: "Invocation of the servant of God Demetrios Maurikas and of his wife, Eirene, for salvation of the soul. If a priest celebrates in this church remember us to the Lord. The year 6789 [= 1280/81]."[51]

Word and image provided a means by which the laity could enter the sanctuary without actually crossing the barrier that separated it from the nave. As in the early church, the donation of ecclesiastical books and vessels also allowed the name and gift of the lay donor to be placed on the central altar. Lay donations of liturgical silver have been examined for the Early Christian period.[52] The donation of property to the Athonite monasteries in exchange for spiritual benefits has been studied by Alice-Mary Talbot.[53] Evidence shows that the donations were made by both men and women.

Less well known as a form of donation to the church sanctuary is a type of manuscript that was actually represented in the church program, the liturgical scroll. Hundreds of such manuscripts survive, primarily in collections of large monasteries. Judging from inscriptions placed in the scrolls, often adjacent to the prayers for the living and the dead,[54] these scrolls were occasionally donated to monasteries by lay people, both men and women. Female names are generally found in the margins adjacent to the commemorations of the dead. For example, an inscription in Vatopedi 20, a liturgical scroll containing the Liturgy of Basil and dated to the fourteenth century, reads: "Remember,

Lord, the soul of your servant Nikodemos, the monk, and the soul of your servant, Maria."[55] The headpiece of Patmos 707 depicts the interior of a Byzantine sanctuary. Adjacent to this image, in the left margin of the roll, is a nonscribal inscription naming a woman, Maria (Fig. 73). Such patterns of female donorship are not limited to liturgical scrolls. In 1063 the empress Catherine Komnene donated a luxurious service book to a male monastery on the island of Chalke. The dedicatory inscription, which provides the name of the empress and the date of the gift, asks: "May you all pray for her through the Lord in the Morning Lections and the Divine Liturgy."[56] In the opening of the lectionary, as with the unrolling of the scroll, the name of the donor would have been recalled during the service.

The exclusion of the lay population from the sanctuary demanded new ways in which the Byzantine could enter that space without overstepping the sacred threshold. This transition from an earthly location to a heavenly one could also be reversed. As in earlier periods in the Christian Church, in the Middle Ages lay people could take home items from the church that might serve as touchstones to the activities that unfolded out of their sight. The faithful frequently carried home flasks of the blessed water in order to profit from its curative powers.[57] The commissioning of an icon that resembled a panel or monumental painting within a local or notable church might also be a way for the average worshipper to possess a small part of the church in a more intimate setting.

In the remaining chapters we will turn to the program of the sanctuary as one that evolved to satisfy its principal audience, the clergy. As I will show, parts of the program were intended to be seen by the laity; these are the upper registers visible from the nave over the epistyle of the icon screen. The lower registers, the components of the program that facilitated and mirrored the priestly liturgy, were hidden from the eyes of the faithful throughout much of the service. In order to achieve this division between audiences, patrons and painters devised a number of approaches that created a meaningful dynamic between what was visible and what was invisible.

II

Assembling the Company of Bishops

T HE SANCTUARY of St. Nicholas Orphanos in Thessalonike contains portraits of twenty-nine Church hierarchs (Fig. 58). Yet the faithful, standing in the nave of the church, would have seen only four (Fig. 56). Painted on three walls of the sanctuary, many of the bishops extend their right hand in a gesture of speech and raise closed codices with their left hand. Others hold their books open and gesture as though sermonizing. All look forward, engaging one another and the priest in an ongoing dialogue. In the apse and on the side walls of the sanctuary, full-length bishops holding liturgical scrolls are turned toward the east. They gaze at a small altar painted over the central window of the apse (Color Plate II). A ceremony is underway; a painted paten contains the infant Christ. Covered with an *asterisk* and liturgical veil, his sacrifice is imminent.

In the twelfth century painters and patrons began to conceive of the sanctuary in terms of contemporary liturgical ceremony, its choreography, the costumes worn by celebrants, and the distinctive objects that were used. Perhaps for the first time in the Byzantine Church, the liturgy was celebrated in a painted setting that mirrored the actual ceremony. The twelfth-century program was, to be sure, created from elements that had long been traditional. It will be necessary to acknowledge past approaches to church decoration in order to understand fully the medieval achievement. One striking aspect of this achievement is the degree of flexibility that the program allowed. In the period under examination, a group of patrons, sharing a common set of concerns, exerted a powerful influence on church decoration. But the evidence demonstrates that painters worked with a certain amount of freedom. What emerged were a handful of themes that gave the paintings an apparent unity of appearance. In exploring the range of expression allowed by the themes, I will necessarily cite a large number of sanctuary programs scattered throughout the Byzantine world. But mainly I will concentrate on the region of Macedonia. For a detailed discussion of the churches in this region, see the Catalogue of Decorated Sanctuaries in Macedonia (appendix).

The part of the sanctuary at which we will begin is the lowest with figural decoration. It is situated above the dado, a horizontal band above the pavement that generally was painted to resemble marble revetment or a series of hung curtains; on rare occasions it was actually clad in marble (Fig. 25). The space above the dado was reserved for portraits of bishops and ecclesiastical authors. As the priest moved around the altar, he always had in view his painted concelebrants, whose presence was in some cases nearly

tangible. The illusion that painted figures could step out from the wall surface was not employed first in the sanctuary, but it worked particularly well in this space. As in other sections of the church, painters exploited the curved shape of the wall to enliven two-dimensional portraits.[1] By rendering the bishops in three-quarter stance and by giving them light-colored vestments, gold nimbi, and flowing liturgical scrolls, Byzantine painters were able to create a liturgical environment in which painted celebrants appeared to emerge from the receding blue of the wall surface to surround the celebrant.[2] When illuminated by flickering candles, the painted bishops began to move within a space that was a middle ground between earth and heaven.

The Episcopal Pose

In a number of Early Christian churches and chapels, the lower register of the central apse was decorated with frontal portraits of apostles, martyrs, and local bishops carrying closed codices.[3] In the medieval period, the removal of apostles and martyrs from this space gave rise to an exclusively episcopal program. For the pre-Iconoclastic period, the mosaic decoration of Sant'Apollinare in Classe, which contains portraits of four bishops of Ravenna, is a classic example.[4] Less well known are the sixth- or seventh-century paintings of Panagia Protothrone at Chalke on Naxos (Fig. 60).[5] The sanctuary program presents two groups of apostles who flanked an episcopal throne. Outside of Greece, the chapels of Bawit present evidence for early programs containing portraits of local representatives of the ecclesiastical hierarchy.[6] It is impossible to know, considering the small number of painted churches that survive from the seventh to ninth centuries, to what extent Constantinopolitan churches had similar programs.

Preserved evidence indicates that in the period following Iconoclasm portraits of bishops were included in decorative programs as representatives of Orthodoxy and ecclesiastical authority. As didactic images or intercessory figures, episcopal portraits could be located anywhere in the church, depending on the shape of the building and the needs of the patron or congregation. In Hagia Sophia in Constantinople, for example, portraits of fourteen Church fathers were installed at the base of the north and south tympana. Cyril Mango and Ernest Hawkins, who date the mosaics in the last decades of the ninth century, suggest two reasons for their placement: the sanctuary of the church was revetted in marble and could not afford room for the insertion of episcopal portraits, and the rarity at the time of locating portraits of bishops in the apse and the flanking walls of the sanctuary.[7]

From the limited beginnings that can be traced, the portrayal of episcopal saints, the pillars of Orthodoxy, spread in the tenth and eleventh centuries. In the monastery of Hosios Loukas, far from the capital, half-length portraits of Basil, John Chrysostom, Gregory Thaumatourgos, and Nicholas decorate the four high niches that ring the central nave of the eleventh-century *katholikon*.[8] In Chapel 1 (El Nazar) in Göreme, episcopal portraits are located overhead, in medallions painted in the four pendentives of the

dome.[9] On the Greek island of Kerkyra (Corfu), a portrait of St. Arsenios, dated by Panagiotes Vocotopoulos to the end of the tenth or beginning of the eleventh century, is located on the east wall of the narthex of the church of Sts. Jason and Sosipater.[10] The portrait of this local saint, the tenth-century metropolitan of Kerkyra, must have had special significance for the parishioners, who would have greeted Arsenios upon entering the church.[11] The small church dedicated to the Holy Anargyroi in Kastoria contains full-length representations of Basil and Nicholas on the supporting arches of the narthex vault (Fig. 19). These two episcopal portraits belong to the first layer of painted decoration and have generally been dated to the eleventh century.[12] The portrayal of bishops in different locations within the church demonstrates that episcopal portraits had not yet been linked to a sanctuary program but may have been dictated by the patron or congregation. In the case of Hagia Sophia in Constantinople, the portraits, possibly chosen by the patriarch Photios, illustrated the unity of the Church in the period immediately following the end of Iconoclasm.[13] In the monastic context of Hosios Loukas, the prominent display of bishops who were also authors was intended for a cloistered population engaged in the celebration of hourly prayers and the reading of sacred texts.

In 1959 Manolis Chatzidakis published a study in which he classified the episcopal types found in the Byzantine sanctuary.[14] Chatzidakis proposed three stages of episcopal portraiture in Byzantine monumental decoration. In the first, which ended in the eleventh century, images of bishops could be found throughout the church. In the second, beginning in the eleventh century, bishops, depicted in frontal poses and carrying closed codices, were collected in the sanctuary. The third phase began at the turn of the eleventh to the twelfth century; at this time the pose of the bishops within the sanctuary was transformed from frontal to three-quarter. In his study, Chatzidakis acknowledges that the three stages of development were not strictly sequential and that monumental decoration could evolve at different rates in different regions of the Empire. Nevertheless, the structure imposed by Chatzidakis's typology has affected the manner in which scholars view the subject matter. Frontal bishops executed in the thirteenth century, well past the theoretical transition date, are termed "archaizing" by many scholars, even when there is regional continuity in their representation. With the recent publication of new monumental cycles, it appears that Chatzidakis's chronology needs to be reevaluated. Let us examine separately the two types of episcopal portraits, frontal and three-quarter.

The Iconic Bishop

There is a uniformity in the depiction of frontal bishops that signals the unity and stability of the Church across time and space. In general, the episcopal figures hold the same attribute (a closed codex), raise their right hands in a common benedictional gesture, and are dressed in similar vestments. The manner of depicting frontal bishops in Byzantine wall painting followed a format popular in other artistic media. The frontal bishop carrying a closed codex was widely depicted, for example, in medieval Byzantine manu-

scripts. In the ninth-century Homilies of Gregory of Nazianzos at Paris, Basil, Gregory of Nyssa, and Gregory the Theologian (Nazianzos) are represented in frontal pose, each under a separate arch and holding a Gospel book.[15] The figures wear *omophoria,* the episcopal stole, decorated with crosses. The late-tenth-century Menologion of Basil II contains scores of frontal bishops.[16] Their *omophoria* and the jewel-encrusted Gospel books signify their inclusion in the uppermost ranks of the ecclesiastical hierarchy.

Thorough analysis of preserved ecclesiastical decoration suggests that the concentration of Church hierarchs in the lower register of the apse and the side walls of the sanctuary was an innovation of the late tenth century, though one based on earlier precedents. The double-apsed church of St. Panteleimon in Upper Boularioi is dated by an inscription in the south apse to 991/92 (Fig. 61).[17] Frontal portraits of Nicholas and Chrysostom decorate the southern apse; Basil and Gregory are located in the northern apse. The church's location in the Mani, a fairly isolated region of Greece, suggests that such representations were common by the time the church was decorated.

By the eleventh century, the number of churches containing a sanctuary program that included frontal bishops had increased.[18] Although the presentation of popular bishops clearly symbolized the Church to the faithful, the selection of local episcopal figures appears to fulfill more personal devotional needs.[19] In Panagia ton Chalkeon in Thessalonike, dated 1028, the intermediate register of the church's central apse contains portraits of Sts. Gregory of Armenia, Gregory of Nyssa, Gregory Thaumatourgos, and Gregory of Akragas (Fig. 1). Each bishop is rendered frontally, supports a closed codex on his covered left arm, and extends his right hand in a benedictional gesture.[20] The inclusion of four medallions with medical saints depicted in the lower register of the sanctuary suggests that the program was designed with therapeutic assistance in mind. The sanctuary of St. Eutychios near Rethymnon on the island of Crete, painted in the eleventh century, also displays certain unusual features.[21] In this instance, each frontal bishop is individually framed to create the effect of a double frieze of icons suspended on the east wall of the church. Included among them is the rare depiction of Titos, a local bishop. The selection of bishops proves to be quite varied and often depended on the location of the church or the intentions of its founder.

In addition to honoring figures of regional import, the selection and combination of specific bishops may have met broader religious or political requirements. In the basilica of St. Achilleios, isolated on an island in Lake Prespa, the wide apse of the sanctuary is painted with a series of arches in which are inscribed the names of the fourteen metropolitan seats subject to the archbishop of that region. The painted record of the districts falling under Prespa's ecclesiastical jurisdiction was intended to demonstrate the autocephalous status of the archbishopric.[22] Bishops chosen for the eleventh-century program of Hagia Sophia in Ohrid are grouped by patriarchal seat and thus embody an ecclesiastical hierarchy (Fig. 4). An emphasis on prelates honored in the Constantinopolitan calendar may reflect the patron's desire to connect Ohrid with the imperial strength and patriarchal authority of the distant Byzantine capital.[23]

In his typology, Chatzidakis sees frontal bishops as common in churches of the

eleventh and twelfth centuries. They are then replaced by their counterparts turned in three-quarter pose. The persistence of frontal representations well beyond the twelfth century, however, reveals regional preferences and specific functional considerations lost when they are labeled as archaizing. The term implies, with clear stylistic overtones, an artificial form of representation. Moreover, if a representation were "archaizing," one might expect a break followed by a nostalgic return to an earlier mode of representation. As we shall see, the depiction of frontal bishops in the church sanctuary generally represents a continuity in regional patterns of apsidal decoration.

At some point the representation of frontal bishops provided painters with an alternative to the depiction of bishops in near profile. Painters changed the style of representing the frontal bishops in accordance with the artistic trends, demonstrating that they were not slavishly copying older models. In the eleventh and early twelfth centuries, the frontal bishops and other painted figures often appear thick and stunted in height (Fig. 2). The solidity of the figures results from the use of heavy line for the definition of facial features and details of costume, a stylistic trait of eleventh- and early-twelfth-century painting. In the thirteenth century, the bishops are often rendered in a style different from that of their earlier counterparts. In Porta Panagia in Thessaly, for example, the curve of the sanctuary wall is filled with frontal bishops whose elegantly tall proportions reflect the church's late date (1283–89) (Fig. 63).[24]

The rendering of episcopal figures in a frontal pose on the curved wall of the apse seems to be a regional phenomenon and may reflect traditional workshop practices. As noted, the Maniate church of St. Panteleimon in Upper Boularioi houses some of the earliest representations of frontal bishops (991/92) (Fig. 61). The twelfth-century sanctuary of Hagios Strategos, located in the same village, also displays frontal bishops in the apse (Fig. 62).[25] The use of a common artistic formula demonstrates the influence of the older program on its later medieval neighbor or argues for a continuity in workshop habits that served to give a distinct character to the art of this region. The nearby twelfth-century church of the Episkopi, which shares a number of traits with Hagios Strategos, also presents images of frontal hierarchs in the central apse and flanking chambers.[26] In both churches, John Chrysostom is differentiated from the other bishops by his holding a slender cross in his right hand in addition to his supporting the closed codex in his left arm. The similarity in the depiction of this figure in several churches in Lakonia suggests that painters were looking at local prototypes for the decoration of regional churches.[27] The same is true of the sanctuary of Zoodochos Pege (Samari), a late-twelfth-century church in neighboring Messenia, where four frontal bishops flank the central window of the apse. The bishops are slightly differentiated by the items they hold: closed codices rest on the left arms of the two outermost bishops, Basil grasps the Gospel book in his bare hands, and Chrysostom cradles a Gospel book in his left arm and holds a cross in his right hand (Fig. 64).[28] At Samari, the episcopal types follow a pattern popular in this region; however, the combination of these figures with a unique representation of the *epitaphios* (Fig. 90) in the intermediate register of the apse indicates that the program was inventive rather than "archaizing."

In the south of Greece, frontal bishops are depicted in the central apse well into the thirteenth century.[29] Outside of this region the decision to decorate the central apse with frontal hierarchs seems less common, although the apparent decline may only reflect the small number of preserved churches.[30] By the thirteenth century most churches in the north of Greece already demonstrate a preference for painted bishops in a three-quarter pose. Two exceptions are either located in Epiros or belong to the jurisdiction of the Epirote despotate. In the late-twelfth-century decoration of St. Demetrios tou Katsoure near Arta, Sts. Blasios, Modestos, and Polykarp are rendered in frontal pose.[31] The church of Porta Panagia near Trikkala, built by John Komnenos Doukas, also displays frontal hierarchs in its sanctuary (Fig. 63).

We might understand the frontal portrayal of bishops as a regional preference, as in the south of Greece. Another explanation has been offered for the choice of frontal bishops in the apsidal decoration of two fourteenth-century Constantinopolitan chapels with a funerary function. The parekklesion of the monastery of Chora (Kariye Çamii) is decorated with frontal figures of hierarchs in the lower register of the apse, a selection viewed by Sirarpie Der Nersessian as "an indication that the regular liturgy, including the communion service, was not celebrated in the parekklesion."[32] The parekklesion of St. Mary Pammakaristos, Constantinople, built as a funerary chapel for the *protostrator* Michael Glavas, was also decorated with frontal bishops, although the representations in the lower register of the apse are no longer preserved. In a hypothetical reconstruction of that church's apse, frontal representations of John Chrysostom and Basil were proposed for the two spaces flanking the central window of the apse.[33] Doula Mouriki, who studied the chapel's program, concluded that "the frontal posture of the bishops, as well as the closed Gospel books which they hold, clearly indicates that their presence is not related to the celebration of the Mass, a feature which may be explained by the special function of the chapel."[34] In these two cases, therefore, the selection of the frontal rather than celebrating episcopal type has been attributed to the use of these spaces for functions other than the celebration of the eucharistic liturgy.

To the two churches of the Byzantine capital may be added a Lakonian example dated to the early thirteenth century. The church of St. John the Baptist on the outskirts of Vasilaki contains frontal representations of Sts. Blasios, Basil, Nicholas, and John Chrysostom placed under a representation of the Deesis. Kalliope Diamante, who published the church, notes that the Deesis is often tied to churches serving some funerary function.[35] Indeed, a tomb was discovered in excavations on the north side of the church.[36] Were the frontal hierarchs intentionally placed in the central nave as figures suitable for a burial context? It would seem that images of frontal hierarchs might, like the intercessory scene of the Deesis, have been selected to reflect the commemorative function of certain churches that housed burials.

Scholars have often viewed portraits of frontal bishops as iconic representations of Church hierarchs. As such, they served a devotional function unrelated to the liturgy. If the bishops decorated burial churches, then their pose, prominently displaying the codex, might be linked to funerary rites and the attendance of priests at the vigil over the deceased

placed in their midst. Priests, when they were laid out before burial, had the Gospels placed on their chests. According to Symeon, archbishop of Thessalonike: "Upon the hands (of a cleric) they shall set the Gospel, which should first be read over him as he is dying, if time permits, or after death. This is done because he lived according to the Bible, and also to secure his atonement and blessing by the most holy words."[37] The resemblance between the image of the hierarchs and the preparatory rites before burial is compelling.

Many of the churches with frontal bishops, however, do not have a clear funerary function. As such, another reason for the preference for frontally represented bishops may be proposed. It is possible that their depiction recalled a specific moment of regular liturgical celebration. During the veneration *(aspasmos)* of the Gospels, the priest held the codex to his chest in the manner depicted in the episcopal portraits. As described in the fourteenth-century guide for celebrants *(diataxis)* of Philotheos, patriarch of Constantinople (1353–54/55):

> The priest, having let down his *phelonion* and holding the holy Gospels in
> front of his chest, comes out (of the sanctuary) and stands in the center of
> the naos, and the reader or the church *silentiarios* stands to his right, holding
> a candlestick with a candle set into it and the *aspasmos* of the holy Gospels
> by the brothers takes place as is usual.[38]

The *aspasmos* of the brothers symbolizes their greeting of Christ. An analogous ceremony was performed before the faithful in the church nave. We might link the representation of the frontal bishops to the veneration of the Gospels by the monks and laity. The painted evidence demonstrates that the selection of frontal bishops is not archaizing but, in a number of cases, may reflect certain ceremonial practices.

The Reflection of the Celebrant

During the twelfth century, the episcopal portraits were given a form that was to prevail in Byzantine and post-Byzantine monumental decoration. The bishops stand in a nearly profile position facing the center of the apse and they exchange their closed codices for open scrolls inscribed with the text of the liturgy.[39] By virtue of the curved wall that held their images, they surrounded the main altar in their midst and, within their own space, converged on a painted facsimile placed at the center of the apse. Bishops carrying inscription-bearing scrolls were not new to Byzantine art of the time. Before their appearance in monumental decoration, portraits of bishops with open scrolls were found in manuscripts. As early as the ninth-century edition of the Homilies of Gregory of Nazianzos in Milan, illuminators portrayed figures holding inscribed scrolls.[40] Inscriptions provided the faculty of speech. But the scroll also served to prompt the viewer when reading the homilies. In a similar manner, the opening words of specific prayers spoken by the painted bishops led the viewer to reflect on specific moments, actions, or implications of the liturgy.

In monumental decoration prior to the end of the eleventh century, scrolls were generally associated with Old Testament prophets and patriarchs. The decoration of the double-apsed church of St. Merkourios on Kerkyra illustrates the distinction between the adherents of the Old Law and those of the New (Fig. 65).[41] In the north apse, the prophets Elijah and Elisha are engaged in a conversation from the Second Book of Kings (II Kings 2:9–10). The inscriptions begin on the right scroll, held by Elisha, and continue with Elijah's. The texts serve to foreshadow the ultimate incarnational message of the sanctuary program. The south apse contains two figures: Basil, who extends a closed codex above the central window, and Merkourios, the titular saint of the church. The contrast between the Old Testament prophets and the paradigms of the New Law was thus made clear. The scroll is contrasted with the codex just as the message of the Old Law is contrasted with the liturgy that carries Basil's name.

The apse program in medieval Byzantium created a new meaning for the unfurled roll. Bishops carrying scrolls and converging on the center of the apse first entered Byzantine monumental decoration at the end of the eleventh century with the decoration of Panagia Eleousa at Veljusa (Fig. 7).[42] In this church, dated circa 1080, two frontal bishops and two in three-quarter pose share the central apse. Within twenty years the north church of St. John Chrysostom in Koutsovendis, Cyprus, was decorated with two portraits of bishops in three-quarter manner.[43] The adoption of a three-quarter stance is significant in view of the Byzantine tradition of painting holy figures in a frontal pose. In earlier monumental painting, it was mainly the Virgin (Paraklesis) who, as intercessor, stood in three-quarter pose, holding an inscribed scroll and addressing Christ. The transformation in the bishops' stance resulted in their withdrawal from direct communication with the viewer. By avoiding the contemplative gaze of the faithful, the bishops no longer served as private devotional images for the laity. The painted bishops visually communicate among themselves and with the celebrant, the living priest who is enfolded among their portraits on the curved wall of the sanctuary.

The rendering of the bishops in a three-quarter stance gained in popularity during the twelfth century. In St. Panteleimon at Nerezi, dated 1164, John Chrysostom and Basil are located in the center of the apse (Fig. 13). The placement of these two figures in closest proximity to the altar signifies their importance as authors of the two liturgies most frequently used in the Byzantine Church. Chrysostom and Basil appear on either side of the *hetoimasia* and are framed by representations of large candles, painted imitations of the church furnishings. Gregory the Theologian (north) and Athanasios of Alexandria (south) are depicted on the side walls of the sanctuary.[44] These four bishops—Chrysostom, Basil, Gregory the Theologian, and Athanasios of Alexandria—comprise the core of the concelebrating figures in most later churches. In some instances, Athanasios is replaced by Nicholas, as in, for example, the Holy Anargyroi in Kastoria, decorated at the end of the twelfth century (Fig. 22).

Despite the popularity of bishops in three-quarter stance, a number of programs combined the celebrating bishops with others in frontal pose. In Panagia Eleousa at Veljusa, two frontal bishops join two episcopal concelebrants to create a rare program.[45]

Within the apse, Basil and John Chrysostom are turned toward the central *hetoimasia*, the image of the throne prepared for the Second Coming, while Gregory and Athanasios (?) stand frontally on either side (Fig. 7). Many churches combine the two types by placing bishops in three-quarter pose within the curve of the apse and frontal bishops on the sanctuary's side walls or on the east wall flanking the apsidal opening. This way of using the two distinct types is common in Macedonian churches. In the twelfth century, we find this synthesis in Holy Anargyroi and St. Nicholas tou Kasnitze in Kastoria (Fig. 23), St. Demetrios at Servia (Fig. 27), and St. George at Kurbinovo. At Kurbinovo, for example, eight concelebrating bishops are depicted within the apse (Fig. 25); five others, rendered in frontal pose, wearing episcopal stoles and carrying decorated Gospel books, were placed at the eastern ends of the north and south walls.[46] In the same region, the trend to combine episcopal types continued in churches of the thirteenth and fourteenth centuries.[47] Rendering a bishop in frontal pose by no means signaled his diminished importance. In the Protaton on Mount Athos, James, the brother of the Lord, is depicted on the north wall of the sanctuary holding a Gospel book in both hands (Fig. 44). His vestments, and those of the other frontal bishops, are identical to those worn by the bishops turned in concelebration. In the church of Christ in Veroia, Sts. Cyril, John Eleemon, and Silvester, bishops who often carry scrolls, are depicted in frontal pose on the south and east walls (Fig. 49).[48]

Another means of combining the two types of episcopal portraits was to depict a second register of half-length bishops above the lower register. This formula was extremely popular in Macedonia, especially in churches painted in the late Byzantine period. We see examples of this type of program in churches in Ohrid and Thessalonike (Figs. 41, 42, 46, 58). The stiff frontality of these bishops forms a stark contrast to the movements of their turned counterparts immediately below. A variation on this theme is the individually framed portrait used within an intermediate register of decoration. Scholars have observed that the insertion of such "fictive icons" into the sanctuary program serves to create an ideal liturgical space, complete with panel paintings depicting appropriate saints.[49] Friezes of icons within the sanctuary, either as framed, rectangular portraits or interconnected medallions, were common in late Byzantine churches.[50] In the church of Christ in Veroia, portraits of Clement and Hierotheos flank the conch of the apse; Polykarp and Metrophanes are located on the eastern section of the north and south walls (Fig. 49).[51] In the church of the Taxiarchs, in Kastoria, half-length portraits of bishops are framed and hung by painted hooks that are suspended from the fresco molding that divides the two registers of the sanctuary.[52] Byzantine painters never abandoned the depiction of frontal bishops but, in many cases, used these figures as counterparts to the concelebrating hierarchs.

The Identity of Painted Bishops

The number of bishops within the central apse varies from church to church, depending on its size. Although four seems to have been the most popular number, several church-

es preserve programs that include two, six, eight, or ten bishops converging on a central point. The selection of bishops also varied widely. Basil and Chrysostom were included in all programs to recognize their authorship of the two major liturgies used in the Byzantine Church. Gregory the Theologian, as the reputed author of the Presanctified liturgy, was also commonly represented. From the eleventh century, these three saints shared January 30 as a common feast day.[53] Anthony Cutler has demonstrated that the three saints were already grouped together in certain eleventh-century marginal psalters, soon after the establishment of their commemorative celebration.[54] The fourth place generally alternated between Athanasios of Alexandria and Nicholas. Athanasios's inclusion can be explained by his staunch opposition to Arianism, but Nicholas of Myra was a little-known saint until after Iconoclasm. The immense popularity of his cult in medieval Byzantium explains his presence among the scroll-bearing bishops.[55]

As Christopher Walter has argued, the selection of bishops for the sanctuary decoration may be related to the episcopal figures named during the Prothesis rite.[56] From the eleventh and twelfth centuries this rite included the excision of particles from the bread offered in commemoration of the Virgin, saints, the living, and the dead.[57] Refinements in the ceremony can be traced in Orthodox service books *(euchologia)*. In the twelfth century individual saints are not listed, but a common offering is made in commemoration of categories of saints: the prophets, apostles, hierarchs, martyrs, etc.[58] Thirteenth-century service books prescribe offerings to be made in honor of individually named saints. The commemorated saints varied widely; their selection was determined by the founder of the church, the celebrant, and the congregation. A thirteenth-century service book from the monastery of St. John the Theologian (cod. Patmos 719) stipulates commemorations for Basil, John Chrysostom, Athanasios, Cyril, Nicholas, Spyridon, Amphilochios of Ikonion, Ambrose of Milan, Epiphanios, Averkios, Gregory Thaumatourgos, Gregory the Illuminator, Gregory of Akragas, and Gregory of Nyssa.[59] An early-fourteenth-century service book (cod. 34) from the Esphigmenou monastery on Mount Athos includes the names of John Chrysostom, Basil, Gregory the Theologian, Gregory of Nyssa, Gregory of Dekapolis, Gregory of Akragas, Gregory the Illuminator, Gregory Thaumatourgos, Nicholas, Athanasios, Cyril, John Eleemon, Blasios, Modestos, and Polykarp.[60] The proliferation of variant local usages regarding the consecration of the offerings, especially among the lower clergy, was a cause of some concern.[61] In the mid–fourteenth century, Philotheos Kokkinos, patriarch of Constantinople, attempted to codify the diverse practices through the composition of a standard *diataxis,* a book of liturgical instructions for the celebrant. His *diataxis* names Basil, Gregory the Theologian, John Chrysostom, Nicholas, Athanasios, Cyril, James the Brother of the Lord, Achilleios of Larissa, and Oikoumenios.[62] We might see the selection of bishops in the apse as reflections, in paint, of the wide divergences in the Prothesis rite prior to the mid-fourteenth-century codification of the rite in Philotheos's *diataxis.*

The inclusion of less-familiar hierarchs among the ranks of the concelebrating bishops may be explained by the popular veneration of local saints.[63] The cult of Achilleios, the fourth-century bishop of Larissa, was centered in the church bearing his

name in Lesser Prespa, to which his relics were translated in 985.[64] In Macedonia, St. George at Kurbinovo presents St. Achilleios among the bishops turned in concelebration (Fig. 25).[65] He is also found in the episcopal church at Servia, where he stands among the frontal bishops on the south wall of the sanctuary (Fig. 28). St. Panteleimon at Nerezi and St. Paraskeve in Veroia also number Achilleios among the frontal hierarchs depicted in close proximity to the altar.[66] The depiction of Karpos among the concelebrating bishops on the south wall of St. Blasios in Veroia is explained by the popular (and mistaken) notion that he was the first bishop of Veroia.[67] St. Clement of Ohrid is included among the saints who constitute a narrow frieze of episcopal portraits in the apse of St. John the Theologian (Kaneo) in Ohrid (Fig. 41).[68]

Vesting the Painted Celebrant

The depiction of the painted episcopal costume is precise in its detail and conforms to written descriptions of bishops' vestments in contemporary sources.[69] Prayers for vesting entered the liturgy around the ninth century and thereafter increased in number and complexity.[70] When the priest entered the sanctuary, he dressed in the prescribed vestments, each accompanied by a specific prayer, usually taken from the Old Testament. The liturgical vestments distinguished the celebrant from the faithful. Once vested, the priest became the image of Christ. The painted bishops in the sanctuary may offer valuable information about Byzantine costume that is not readily available from preserved textiles. Prayers outlining the order of vesting list the costume elements that we might expect in episcopal portraiture. A liturgical *diataxis* of the twelfth or thirteenth century in Athens (National Library, cod. 662) orders the bishop to put on his vestments in the following order: *sticharion* (alb), *epitrachelion* (stole), belt, *epimanikia* (cuffs), and *phelonion* (chasuble).[71] This order was ritually symbolic. For Symeon of Thessalonike, writing in the early fifteenth century, the seven components of the vestments signify the seven energies of the Holy Spirit.[72] According to his writings, the archbishop puts on the *sticharion,* the *epitrachelion,* the belt, and the *epigonation.* Following these he takes up the *epimanikia,* the *phelonion,* the *sakkos* (dalmatic) or *polystavrion,* and finally, the *omophorion* (pallium). The celebrating bishops depicted in the thirteenth century and after wear all of the vestments outlined above, except for the *sakkos,* which is reserved for the depiction of Christ as high priest (Figs. 54, 55).[73] For ecclesiastical authors, such as Balsamon and Symeon of Thessalonike, each element of the bishop's costume was symbolically related to the life and Passion of Christ.[74] Episcopal portraits in medieval Macedonia provide pictorial representations of the costume components mentioned by Symeon. I will give only a brief overview.

The *omophorion* was the most distinctive component of the bishop's vestments and was included in episcopal portraiture long before the introduction of the more characteristic *polystavrion.* Wrapped around the neck and often decorated with crosses, the *omophorion* was, according to Germanos, patriarch of Constantinople, "like the stole of Aaron, which the priests of the (Old) Law wore, placing long cloths on their left shoulders."[75] Church

rubrics instructed the celebrant to assume or remove the *omophorion* at specific moments of the liturgy. A twelfth-century guide for the patriarchal service prescribes the *omophorion's* removal prior to the reading of the Gospels and its replacement following communion.[76] According to Symeon of Thessalonike, the bishop removes the *omophorion* before the reading of the Gospel and replaces it before the elevation and fraction.[77]

In monumental decoration, episcopal *omophoria* are generally decorated with crosses that are elongated at the shoulder to emphasize the draping of the stole. The light color of the *omophorion* matches that of the *polystavrion* or *phelonion,* but the crosses usually form a lively contrast to those painted on the episcopal robes. In St. Nicholas Orphanos in Thessalonike and the church of Christ in Veroia, the crosses of the *omophoria* are burgundy or blue in opposition to the cruciform ornamentation of the *polystavrion.* These crosses are occasionally ornamented with figural decoration. In the Virgin Peribleptos in Ohrid, the crosses have jeweled borders; at the center of each cross is a medallion containing a half-length figure (Fig. 42). As costume elements, the *omophoria* either hang straight down or are draped over the bishop's arm. In St. Nicholas Orphanos and a number of other churches in Macedonia, as well as in churches outside the region, such as St. John Chrysostom at Geraki, the *omophorion* is draped over the bishop's arm and forms a cloth cradle below the open scroll or codex (Figs. 56, 66, 67).

The *omophorion* is occasionally decorated with a design that is not strictly cruciform. Often the decoration on Basil's and Chrysostom's *omophoria* distinguishes them from other bishops. In Panagia Eleousa in Veljusa (Fig. 9), St. Leontios in Vodoča (Fig. 10), Holy Anargyroi in Kastoria (Figs. 21, 22), and St. George at Kurbinovo (Fig. 26), John Chrysostom's *omophorion* is adorned with clover leaf crosses and Basil's with "pinwheel" crosses. In St. Nicholas in Melnik, alternating bishops in the scene of the consecration of St. James wear *omophoria* decorated with a clover leaf pattern (Figs. 33, 34). This motif is not restricted to Macedonia: in St. Neophytos near Paphos (Cyprus), the *omophoria* worn by Basil and Epiphanios are decorated with clover leaf crosses (Fig. 68). In discussing episcopal costume in the paintings of Veljusa, Vojislav Djurić suggests that such motifs were found on *omophoria* worn by heretical bishops or by Latin prelates following the end of the twelfth century.[78] His statement is based on representations of bishops in church councils included in the thirteenth-century monastic churches of Mileševa and Arilje in Serbia. Judging from the regular use of these motifs on episcopal *omophoria* in Byzantine churches, it would seem that such decoration, when found in the sanctuary, serves to distinguish rather than condemn specific Orthodox figures.

The term *polystavrion,* denoting a long *phelonion* marked by a distinctive cross pattern, first appeared in the writings of the twelfth-century canonist Theodore Balsamon in his commentary on the seventeenth canon of the council of Chalcedon.[79] In this text, the right to wear the *polystavrion* is given the bishops of Caesarea, Ephesos, Thessalonike, and Corinth. By the early fifteenth century, Symeon of Thessalonike notes that all metropolitans wore *polystavria.*[80] The increased popularity of this vestment in the late Byzantine period is reflected in its increased representation in monumental painting. In thirteenth- and fourteenth-century painting, concelebrants commonly wear *polystavria.*

The transition between the undecorated *phelonia* and one with cruciform decoration may be seen in the two-layered representation of St. Basil in the narthex of Holy Anargyroi in Kastoria (Fig. 19). The tenth-century layer reveals an austere bishop with a plain *phelonion* and an *omophorion* decorated with squares transected by crossing diagonal lines. The second, twelfth-century layer presents Basil in a *polystavrion* with an *omophorion* decorated with clover leaf crosses.

Painters often prepared the vestment for its distinctive cross decoration by scoring a grid into the plaster, as is visible in the fourteenth-century church of St. Catherine in Thessalonike (Fig. 59).[81] By filling different boxes, the painter could achieve several patterns. In many churches, the painted *polystavria* are adorned with squares formed by four angled *gammata,* the Greek letter numerically equivalent to three and suggestive of the Trinity.[82] At its center the square was usually filled with a small cross. This pattern was generally painted alternating between bishops in blue-black or red-burgundy. This form of ornamentation was particularly popular in southern Greece and the Greek islands. In the Lakonian church of St. John Chrysostom in Geraki, the *gammata* decoration no longer decorates the *polystavrion* but is simply a pattern that fills the white space of the vestment (Fig. 67).

The second type of *polystavrion* decoration consists of alternating crosses. It is found often in Macedonian churches. The Protaton on Mount Athos (Fig. 45), the churches of Christ (Fig. 49) and St. Blasios in Veroia (Fig. 51), and the churches of St. Catherine (Fig. 59), St. Panteleimon, and St. Nicholas Orphanos in Thessalonike (Fig. 56) all present alternating crosses on episcopal *polystavria*. As is the case with the *gammata* decoration, painters often alternated the color of the crosses between figures. In the decoration of the bishops' vestments in the churches of Christ and St. Nicholas Orphanos, blue-black crosses alternate with burgundy (Color Plate II).[83]

On rare occasions painters decorated the *polystavrion* with a checkered pattern instead of crosses. In the church of the Taxiarchs in Kastoria, for example, John Chrysostom's *polystavrion* consists of a checkered pattern that bears little resemblance to the usual cross design (Fig. 70). As with the selection of bishops, the decoration of the episcopal vestments reflects regional practices. Although lacking conclusive evidence, we may also see differences in the decoration of *polystavria* as possible references to vestments worn in specific episcopal centers.

The *polystavrion* signaled the episcopal rank of the depicted figure. In the decoration of a number of sanctuaries, the painter distinguished between figures wearing *polystavria* and those who wore undecorated *phelonia*. In general, the difference in costume appears between the bishops in the central apse and those on the side walls of the sanctuary. In the late-twelfth-century decoration of Holy Anargyroi, the bishops in the central apse wear *polystavria,* whereas the frontal bishops on the sanctuary's side walls are dressed in plain *phelonia* (Fig. 20). In churches with wide apses that could accommodate a large number of episcopal portraits, certain bishops among the processing figures might be vested in undecorated *phelonia*. These figures are found usually at the extreme ends of the liturgical procession. At Kurbinovo, for example, Nicholas and Gregory of Nyssa

carry open scrolls but are dressed in undecorated *phelonia* (Fig. 25).[84] In the Old Metropolis in Veroia, the outermost four bishops in the procession of ten—Eleutherios, Gregory Thaumatourgos, Nicholas, and Dionysios—are vested in *phelonia* (Fig. 30).[85] On the south wall of St. Blasios in Veroia, Karpos wears a *phelonion*, whereas Polykarp, adjacent to him but farther from the apse, wears a *polystavrion*.[86] *Phelonia* were often worn by popular figures, such as Karpos, who were venerated as local saints but had not achieved the status of the great Church hierarchs vested in *polystavria*.

Epitrachelia, epimanikia, encheiria, and *epigonatia* were all components that were regularly included in representations of episcopal figures.[87] *Epitrachelia* were thin stoles wrapped around the bishops' necks, which represented, according to Germanos, "the cloth which was put on Christ at the hands of the high priest, and which was on his neck as he was bound and dragged to his Passion."[88] According to Symeon of Thessalonike, the priest was not required to wear this stole during the hourly liturgies. If the celebrant did not possess an *epitrachelion,* he could make do with his belt or a piece of rope.[89] The *epitrachelion* was regularly depicted by the end of the tenth century. In monumental decoration, the *epitrachelion* can be represented by a thin gold band around the collar (Fig. 57) or as a thick scarf bordered by pearls (Fig. 59). Episcopal representations within the church seem to differentiate between the scroll-bearing hierarchs in the central apse, who wear *epitrachelia,* and the frontal bishops on the side walls of the sanctuary, who do not. In the church of Christ in Veroia, Nicholas, represented on the north wall and carrying a scroll, wears an *epitrachelion* (Fig. 50). Opposite him, on the south wall, John Eleemon and Silvester, represented in frontal pose and carrying closed codices, do not. In other words, the vesting and the attributes are used in a way that the Byzantine priest would have instinctively grasped. The presence or absence of the *epitrachelion* may signal the difference between painted bishops in the process of liturgical celebration and those who held closed codices and stood apart from the ceremony.

Epimanikia, cuffs that secured the wide sleeves of the priest's robe, are first mentioned in a mid-eleventh-century source, although they appear earlier in the Panagia ton Chalkeon of 1028 (Fig. 2).[90] The *epimanikia* are often elaborately decorated in episcopal representations. In Holy Anargyroi (Fig. 22) and Nicholas tou Kasnitze, as well as in the Old Metropolis in Veroia (Fig. 30), the *epimanikia* are marked with an elaborate abstract motif, perhaps in imitation of embroidery. In several churches, including the Virgin Peribleptos in Ohrid (Fig. 42) and the Protaton on Mount Athos (Fig. 45), the gold *epimanikia* are bordered with pearls.

The *encheirion,* originally a cloth hung over the bishop's belt, is often represented in gold and decorated with jewels. In episcopal portraits this portion of the vestments is often visible under the *omophorion.* In the Protaton on Mount Athos, St. Blasios in Veroia, and St. Nicholas Orphanos, *encheiria* are doubled over the belt of the bishops' costumes (Fig. 56). The *epigonatia,* a lozenge-shaped cloth panel, depicted in medieval Byzantium are a far cry from the original towel tucked into the bishop's belt that he would use to wipe his hands during the liturgy. In the chapel of St. Euthymios and the church of St. Catherine in Thessalonike, the *epigonatia* are gold and decorated with

abstract or floral designs. The *epigonatia* occasionally carried figural decoration; outside of Macedonia, in the church of the Virgin Hodegetria at Mystra, decorated in the early fourteenth century, the bishops' *epigonatia* are ornamented with representations of angels or cherubim at their centers (Fig. 71). The patron of the church, the abbot Pachomios, may have seen such lavish *epigonatia* when he visited the Byzantine capital. A later inventory of 1396 records the contents of the treasury at Hagia Sophia in Constantinople. Among the lavish vestments is "a gold *epigonation* [with a representation] of the Anastasis."[91] Such vestments would have made an impression on visitors to the city.

The vestments worn by the painted celebrants demonstrate a concern for the careful representation of contemporary ecclesiastical costume and reflect an increasing trend to depict the church ceremony with accuracy. In most cases, the concelebrating bishops of the central apse wear episcopal vestments identical to those described by Symeon of Thessalonike in the fifteenth century. Moreover, the vestments depicted represent those listed in contemporary church inventories. According to monastic records dated May 1375, the community of the Virgin Gavaliotissa at Vodena (Edessa) in Macedonia possessed a number of silk and gold-embroidered vestments.[92] The testament of Maximos for the monastery of the Mother of God of Koteine near Philadelphia in Asia Minor is more specific. This inventory, dated November 1247, records: "Also a white set of vestments. Another purple set. Two *epitrachelia*. Another one embroidered in gold. *Epimanikia* embroidered in gold with [representations of] the Annunciation and the Anastasis. Two other pairs."[93]

Liturgical Readings for Painted Celebrants

The bishops' shift in stance from frontal to three-quarter was accompanied by a change in the form of the texts they held.[94] As with the representation of costume, one should view the rendering of a specific type of liturgical manuscript as a reflection of contemporary liturgical ceremony. Although scrolls had been used since antiquity, our earliest published guide to their use in a liturgical context comes in a twelfth-century text that describes the patriarchal service held in Hagia Sophia.[95] According to this and other sources, liturgical scrolls were unrolled and read by the celebrant at prescribed moments of the service. An examination of the texts and their specific instructions will clarify the explicit connection between the painted liturgy and contemporary liturgical practice.

Monastic inventories suggest that large foundations possessed at least one liturgical scroll for each of the liturgies. The number of actual scrolls in a single monastery varied according to the size of the community and the wealth of the establishment. The inventory taken in September 1200 at the monastery of St. John the Theologian on Patmos listed four scrolls for the Liturgy of St. Basil and four others for the Liturgy of Chrysostom.[96] The inventory of Koteine lists three scrolls containing the Liturgy of Chrysostom and three for that of Basil.[97] In 1396 the treasury of Hagia Sophia in Constantinople contained five scrolls.[98] Large churches or monasteries must have had a collection of scrolls

containing liturgies and prayers appropriate for use at different celebrations and com-memorations. More than one hundred scrolls survive on Mount Athos alone.[99] In most cases the preserved scrolls contain the liturgies of Basil or John Chrysostom as well as briefer instructions for liturgical celebration. In rarer cases the text may also contain or be limited to the Liturgy of James, the Liturgy of the Presanctified, or the communion prayers. These liturgical texts are written on parchment, usually several meters in length and eleven to twenty-six centimeters in width, and are then attached to a wooden roller.

Two decorated liturgical scrolls demonstrate that their illuminators were well aware of the manuscript's place in the Byzantine sanctuary. The headpiece of a liturgical scroll in the National Library in Athens (cod. 2759), attributed to the twelfth century, depicts Basil and John Chrysostom celebrating the liturgy in a setting intended to evoke a church sanctuary (Fig. 72). Dressed in *polystavria,* the liturgical authors stand in the three-quarter pose assumed by bishops in apsidal decoration.[100] The headpiece of the Patmos liturgical roll, cod. 707, dated to the mid–twelfth century, also depicts the central sanctuary of a church (Fig. 73).[101] Basil, the author of the liturgical text contained in the roll, stands behind an altar holding an open scroll between his two hands. The decoration of these scrolls thus refers to their use within the sanctuary, just as the sanctuary decoration makes reference to the celebrant's reading from such manuscripts.

Having seen liturgical scrolls used in the liturgy, Byzantine painters endeavored to bring fresco decoration into closer alignment with ceremonial practice. The manner in which the painted bishops unroll their manuscripts to reveal specific liturgical prayers suggests that the scrolls are more than a mere attribute that denoted the bishops' status as authors. The accurate rendering of the draping of the unwound manuscript and the inclusion of wooden rollers at the ends of the scrolls indicate that monumental painters must have been familiar with their use. The scroll held by St. Basil in the sanctuary program of Holy Anargyroi in Kastoria, for instance, is twisted and sags realistically from the weight of the parchment (Fig. 21). In the sanctuary decoration of St. John Chrysostom at Geraki (circa 1300), thin rollers extend from the ends of the depicted scroll (Figs. 66, 67). The exactitude of such painted reproductions suggests that these manuscripts were sufficiently widespread to have influenced the artistic vocabulary of Byzantine painters.

For painters to have depicted scrolls in so accurate a manner, they must have been familiar with liturgical practice. Preserved guides to ceremonial practices direct the exact moments when the celebrant took up the liturgical roll and read. The twelfth-century guide for the patriarchal liturgy of Hagia Sophia specifies three occasions when the Church dignitary in charge of episcopal vesting extended an open scroll to the celebrant. The first time followed the Trisagion, the second followed the Gospel reading, and the third time came during the inaudible prayer of the Cherubikon.[102]

A narrative scene on the north wall of the early-fourteenth-century chapel of St. Euthymios in Thessalonike corroborates the ecclesiastical source. In a scene of Euthymios officiating, the saint holds an unwound scroll over the altar. His eyes are focused intensely on the text inscribed with the "No one is worthy" prayer, the inaudi-

ble prayer of the Cherubikon mentioned in the twelfth-century guide.[103] Similarly, St. Basil holds an open scroll over the altar in a representation of him officiating in Hagia Sophia, Ohrid (Fig. 6). Three priests stand behind him. The laity is relegated to a subsidiary space sectioned off by columns. Painted evidence for the linking of texts inscribed on scrolls with the use of such manuscripts in the liturgy is also found in the illustrations of an eleventh-century scroll in Jerusalem (Stavrou 109).[104] An anonymous bishop, whom André Grabar identifies as the manuscript's patron, is depicted next to the text of the inaudible prayers of the *Ektene* and the Cherubikon, the prayers for which, according to textual sources, liturgical scrolls would have been unwound.

The three prayers read from a scroll during the patriarchal liturgy are regularly inscribed on the scrolls of the painted bishops in the Byzantine sanctuary. With few exceptions, the "No one is worthy" prayer is held by Basil, its reputed author.[105] The Trisagion may be held by John Chrysostom or Gregory the Theologian. The text of the *Ektene* cannot be associated with a single author. A number of other prayers are commonly found on the painted scrolls, and these may correspond to practices outside the capital. For example, a later service book orders the patriarch to read from a scroll during the three antiphons.[106] As is the case with the prayers described above, the three silent prayers accompanying the antiphons are often inscribed on scrolls held by the painted bishops. For example, in St. George at Kurbinovo, Athanasios displays the first antiphon, Achilleios the second, and Nicholas the third (Fig. 25). Therefore, the same prayers were read from the scrolls by the actual celebrant as by his painted concelebrants all identically dressed and posed.

In rare cases painted bishops hold scrolls inscribed with the words of consecration rather than the silent prayers of the liturgy. Usually scrolls with these inscriptions are only partially unrolled, held in a single hand, and their words inscribed along the roll's main axis rather than perpendicular to it. In the fourteenth-century church of the Taxiarchs in Kastoria, Gregory the Theologian, Basil, John Chrysostom, and Athanasios hold prayers directly tied to the eucharistic sacrifice (Figs. 69, 70).[107] The two outer figures, Gregory and Athanasios, hold scrolls inscribed with the *epiklesis,* the prayer invoking the Holy Spirit, and the prayer following it in the service. Basil and Chrysostom, the two central figures in the composition, extend partially closed scrolls containing the prayers for the consecration of the bread and wine. The consecratory scrolls placed in the hands of the painted bishops correspond to a moment related in the twelfth-century guide to the patriarchal liturgy, which describes the bishop as holding an unrolled scroll in his left hand as he recites the Our Father and declares "Holy things for the Holy."[108] These two prayers fall directly before the *epiklesis* and the distribution of communion. Preserved scrolls containing only the prayers for the communion may be related to such ceremony and representations.[109] Byzantine painters acknowledged these separate scrolls as distinct by representing them partially rolled and by inscribing them in a different manner.

The vast majority of surviving scrolls were produced during the most prolific period of Byzantine monumental painting, that is, the twelfth through fifteenth centuries.

Catalogues for the manuscripts today in monasteries on Mount Athos, Mount Sinai, Meteora, Mega Spelaion, and Patmos list one hundred and forty-one liturgical scrolls, most of them undecorated.[110] Their chronological breakdown (based on the dates given them by the catalogues) is as follows: two scrolls for the tenth century (1 percent), four scrolls for the eleventh century (3 percent), twenty-eight scrolls for the twelfth century (20 percent), thirty-four scrolls for the thirteenth century (24 percent), and seventy-three scrolls for the fourteenth century (52 percent). Considering the existing evidence, it seems clear that the increased production of scrolls for use during the celebration of the liturgy in the period following Iconoclasm corresponds with significant changes in the manner of depicting bishops in the sanctuary. One can thus point to a case where actual liturgical practice inspired a substantive development in church decoration.

In early art, bishops and apostles were given books as an attribute that symbolized apostolic succession and the responsibility of the priest to interpret the Gospels. When these figures were incorporated into the monumental program, they brought this attribute with them. In the eleventh and twelfth centuries, when the sanctuary program was altered to directly reflect liturgical celebration, the attribute in the bishops' hands changed. The Gospel was read outside of the sanctuary screen to the laity, but the silent prayers of the liturgy were read in close proximity to the altar. It was these prayers that were held by the painted bishops, who inspired the priest through active concelebration. The change in attribute must be seen as a mirror of the developing rite and reinforces the idea of interior and exterior space in which the sanctuary barrier figures so prominently.

Reading the Painted Texts

The texts inscribed on the painted liturgical scrolls held by bishops vary from church to church. The scrolls endow the bishops with the faculty of speech and are a means by which they could participate in and comment on the service. The idea that the painted figures actually were capable of speech was familiar to Byzantine rhetoric. The patriarch Photios, in a description of the Nea Ekklesia in Constantinople, envisions the words inscribed on the prophets' scrolls as part of a continuous conversation:

> A choir of apostles and martyrs, yea, of prophets, too, and patriarchs fill and
> beautify the whole church with their images. Of these, one, though silent,
> cries out his sayings of yore, "How amiable are thy tabernacles, O Lord of
> hosts! My soul longeth, yea even fainteth in the courts of the Lord"; anoth-
> er, "How wonderful is this place; this is none other but the house of God."[111]

We should look at the bishops' scrolls in the same manner.

Gordana Babić and Christopher Walter laid the foundation for a study of the prayers inscribed on episcopal scrolls in monumental decoration.[112] In their examination of forty-two churches, the authors identified the opening words of thirty prayers

from the liturgies of Basil and Chrysostom, ranging from the offertory prayer to the concluding prayer of the service. The order of their inscription may be divided into three systems. In the first, each scroll bears the opening line of a different prayer. As one reads from left to right, the order of the prayers does not follow the succession of readings in the liturgy. In the second system, all of the bishops carry lines from a single prayer, which extends from scroll to scroll. The priest reads from left to right as he looks over the altar. In the third system, the two central bishops, Basil and Chrysostom, carry partially rolled scrolls inscribed with the prayers of consecration. This category, as noted above, represents a separate type of apse program.

The most common way of inscribing scrolls in Macedonia, if not throughout Byzantium, is with individual prayers. Basil usually carries the prayer of the Cherubikon, which he reportedly wrote.[113] Chrysostom usually displays the prayer of the Prothesis, but he may also hold the Trisagion, or the third antiphon. We cannot generalize about the prayers held by Gregory the Theologian, since his scroll is inscribed with prayers ranging from the first antiphon to the *epiklesis*. Athanasios and Nicholas often carry scrolls inscribed with one of the antiphons.

In medieval Byzantine churches, the prayers are rarely read from left to right according to liturgical order. In St. George at Kurbinovo and Holy Anargyroi in Kastoria, the inscribed prayers begin with Chrysostom on the right side of the central window and then start again with the bishop on the extreme left of the apse (Figs. 20, 25).[114] In these two churches, the prayers begin on the scroll held by John Chrysostom and end with Basil's. When John Chrysostom is moved to the left side of the apse, a programmatic change in four Macedonian churches, the prayers begin with Chrysostom's scroll and end on the opposite side of the apse.[115]

Few churches contain episcopal programs where a continuous prayer is inscribed on the bishops' scrolls. A rare example is the hermitage of St. Neophytos at Paphos on Cyprus, where the Prothesis prayer continues from one bishop's scroll to another (Fig. 68).[116] In churches belonging to the third category, the scrolls are inscribed with the prayers of consecration. In St. Blasios in Veroia, Basil holds the Cherubikon prayer but Chrysostom holds the prayer for the consecration of the bread (Fig. 51). The lower register of the apse of the church of the Taxiarchs in Kastoria is fully dedicated to the consecration (Figs. 69, 70).[117] The scene of the communion of the apostles is absent from most churches employing this system, a pattern suggesting that the inscription of consecratory prayers obviated the need for the painted communion.

The inscribed passages derive almost exclusively from the silent prayers that precede the entrance of the liturgical offerings into the sanctuary for deposit on the altar; rather, they focus on the spiritual preparedness of the celebrant and his petition to the Lord to accept the sacrifice on behalf of the faithful. By reading the scrolls, the celebrant is led to a more complete state of spiritual preparedness for the role that he must play in the eucharistic sacrifice. In his liturgical writings, the fourteenth-century theologian Nicholas Cabasilas emphasized the need for the priest to approach the divine mysteries in a state of grace:

All these things, which make the souls of both priest and people better and more divine, make them fit for the reception and preservation of the holy mysteries, which is the aim of the liturgy. Especially, they put the priest in a proper frame of mind for the accomplishment of the sacrifice, which is, as has been said, the essential part of the mystagogy. This intention can be seen in many parts of the prayers: the priest prays that he be not judged unworthy to perform so great an act, but that he may devote himself to the sacrifice with pure hands, a pure heart, and a pure tongue. Thus it is that we are aided in the celebration by the very virtue of the words themselves, said or sung.[118]

The inscribed prayers assisted the priest to pray with the Church fathers depicted in front of him. In his text, Cabasilas refers to the Cherubikon, one of the most cathartic prayers in the liturgy, which is held by Basil in nearly every church. Written in the first-person singular, this prayer reminds the priest that "no one is worthy among them that are enslaved by carnal desires and pleasures to approach or come near or minister before Thee, the King of Glory." The prayer is a confession by the celebrant, asking God to "look at me, a sinner . . . and cleanse my soul and heart from any thought of evil." Recited at the beginning of the Liturgy of the Faithful, the prayer asks: "Since I am endowed with the grace of priesthood, make me worthy by the power of the Holy Spirit to stand before this your holy table and to perform the sacrifice of your sacred and immaculate body and precious blood." The secret (silent) prayer following the Trisagion also stresses the spiritual preparedness of the celebrant. In invoking these prayers, the celebrant may have been aware of the writings of John Chrysostom, who was represented directly across the altar. Writing on the sacraments, Chrysostom refers to the purity of the priest:

> When the priest calls upon the Holy Spirit and offers the tremendous sacrifice, tell me in what rank should we place him? What purity shall we require of him, what reverence? Then reflect how those hands should be constituted which perform such services! What should that tongue be which pronounces such words . . . ? At this moment the very angels encompass the priest, and the whole choir of heavenly powers lend their presence and take up the entire space around the altar, to honor him who lies thereon in sacrifice.[119]

It is to the priest that the message of the sanctuary is directed.

Conclusion

From the twelfth century, the sanctuary program represented liturgical ceremony with ever increasing exactitude. Dressed in similar costume and rendered life size, painted bishops were the image of the priest. They, too, converged on an altar holding in their

hands the words of the silent prayers invoked by the celebrant during liturgical celebration. The liturgical verisimilitude of the representations suggests that the composition was directed primarily toward a clerical audience. Physically segregated within the church sanctuary by an increasingly opaque chancel barrier, the bishops inhabited a space that was not only used exclusively by the celebrant and his assistants but was also viewed primarily by them. The laity stood outside the barrier and its members were guided in their personal devotions by a set of holy figures: icons inserted into the sanctuary screen or placed on smaller stands and frescoes of intercessory figures painted on adjacent walls. Within the sanctuary, the episcopal figures became the priest's liturgical concelebrants, and the texts inscribed on the bishops' scrolls demonstrate that the hierarchs were intended to assist the actual celebrant in the difficult process of introspection that preceded the commencement of the eucharistic liturgy. The painted bishops thus served as personal guides for the priest and as accompanying concelebrants who shared in the all-holy ceremony.

Historically, concelebration played an important ceremonial role in the Byzantine liturgy.[120] On feast days and episcopal celebrations that required an increased number of attendants, the movements of the priests were liturgically choreographed and their functions were preassigned. This was especially the case during the patriarchal or episcopal liturgy, when positions within the central sanctuary were strictly assigned according to clerical rank.[121] In medieval Byzantium, however, internal developments in the manner of celebration might have resulted in a decrease in the frequency of these elaborate celebrations. In the thirteenth and fourteenth centuries the liturgy was influenced by the popular rule of St. Sabas, a synthesis of Palestinian monastic practices and Constantinopolitan regulations codified by the Stoudite monks. This "neo-Sabaitic" material was incorporated into mainstream Byzantine practice.[122] The assumption of an essentially monastic pattern of worship into the corporate liturgy may have caused a diminution in the number of priests required for the ceremony. Trends in church building are relevant here. A large number of concelebrants was easily accommodated in the great basilicas of the Early Christian period. Changes in liturgical patterns and the concomitant rise in private devotional practices resulted in the architectural contraction of the church.[123] In small parishes and family churches, where priests would celebrate the liturgy in solitude or with the assistance of a deacon, the proximity of painted bishops of equal size to the priest and dressed in appropriate liturgical vestments must have had a powerful effect. The representation of these figures in churches of the distant provinces, separated from the Byzantine patriarchate or episcopal centers through geographical isolation or through foreign overlordship, visually encouraged the adherence to Orthodoxy through communal celebration of a traditional ritual.

In the repetition of episcopal figures in the church sanctuary, the modern-day viewer sees an inflexible uniformity. The sense of majestic order is surely part of the content of the sanctuary. It should not, however, distract our attention from the diversity of possible choices. The different selections reflect the pietistic requirements of individual communities or the artistic and regional traditions followed by specific painters. Indeed, variations among sanctuary programs demonstrate that Byzantine painters combined

scenes and figures to create new configurations appropriate to particular congregations. In addition to meeting the needs of individual celebrants and congregations, the powerful representation of episcopal portraits may have offered a response to several conditions within the Empire. The inclusion of venerable authors and orators such as John Chrysostom, Basil, and Gregory the Theologian linked the priest and congregation to an ancient tradition of episcopal writing and teaching. These associations may have been essential in a period when the Empire was concerned with internal theological debates and was confronted by religious traditions that challenged accepted notions of orthodoxy.

III

The Sacrificial Offering

THE SANCTUARY of St. George at Kurbinovo contains a startling image at the center of the lower register (Color Plate III). Situated above a masonry throne is a painted altar on which is represented an image of the deceased Christ. His midsection is covered by a liturgical cloth. At his head is a chalice. Above his pelvis is a footed paten containing the eucharistic offering, a circular piece of risen bread. The paten is covered by an *asterisk,* the crossed metal strips that protected the offered bread from its cloth covering. Although stiffened, Christ's right hand makes a benedictional gesture toward the paten. Painted bishops stand to either side; their eyes are directed to the holy sacrifice on the altar, their scrolls are unrolled in prayer.

In the late eleventh and early twelfth centuries, the lowest register of the sanctuary underwent a radical transformation. The frontally depicted authors of the liturgy and bishops of the Orthodox Church turned in a three-quarter pose, unrolled liturgical scrolls, and began to concelebrate mystically with the living priest. The transformation in stance was accompanied by the creation of a central image to which the celebrants turned. Painters were required to balance illusion with reality; the full-length portraits on the concave wall seem to step from the surface and surround the actual altar. By placing a representation at the focal point of the apse, the painted figures were anchored within their two-dimensional space.

The center of the apse usually contained one or more windows, the sole source of natural light for the sanctuary. In the morning, the light that illuminated the liturgy shone in a beam directly over the central image and touched the surface of the altar, thereby heightening the mystery of the ceremony. The painters of the Virgin Peribleptos in Ohrid acknowledged this use of light by inserting the liturgical formula, Φ Χ Φ Π, above the sanctuary window (Fig. 42). The Greek abbreviation for "The Light of Christ Appears to All" is a coded reference to the incoming light.[1] But dramatic lighting came at some cost. Many of the painted representations have been damaged or even destroyed by rain water entering the windows.

Patrons and painters of this period found a variety of subjects suitable for the center of the episcopal zone.[2] In Byzantine Macedonia three subjects stand out.[3] In Panagia Eleousa in Veljusa and St. Panteleimon in Nerezi, two churches associated with members of the Komnenian ruling family, the central element is the *hetoimasia,* the prepared throne. In Kastoria, in the Holy Anargyroi, an altar table is depicted at the center of

the apse wall. In the church of St. George in Kurbinovo, the painter represented Christ as the eucharistic sacrifice, a subject later called the *melismos.* These three images, the *hetoimasia,* the altar, and the *melismos,* and the reasons governing their selection for the center of the lowest register of the sanctuary, form the focus of this discussion.

The Prepared Throne

In his treatise on the liturgy, Germanos, the eighth-century patriarch of Constantinople, interprets the entire sanctuary as the throne that Christ will assume on the day of judgment. The passage may explain the representation of the *hetoimasia,* the throne prepared for the Second Coming of Christ, on the east wall of the sanctuary:

> The bema is a concave place, a throne on which Christ, the king of all, presides with his apostles, as he says to them: "You shall sit on thrones judging the twelve tribes of Israel." It points to the second coming, when he will come sitting on the throne of glory to judge the world, as the prophet says: "Thrones were set for judgment over the house of David."[4]

The *hetoimasia* is represented at the center of the lowest register of the apse in several medieval churches, a position that in many earlier churches had been occupied by the bishop's throne, the symbol of episcopal jurisdiction (Fig. 60).[5] But instead of the customary high-backed episcopal throne, the *hetoimasia* in monumental painting of the medieval period was generally represented as a backless throne, a type of seat found in ancient representations of both deities and emperors. The *hetoimasia* is well known from artistic programs of the Early Christian period when it was used as a sign of the authority the depicted Christ bestowed on his followers and of his promised return.[6] The Byzantine association of the *hetoimasia* and the Second Coming led to its inclusion in representations of the Last Judgment.[7] The prominent inclusion of the dove in the composition suggests that the *hetoimasia* also served as a symbol of the Trinity, a point to which I will return.[8] The image was introduced into the lower register of the sanctuary decoration in the eleventh and twelfth centuries. One of the earliest representations of the *hetoimasia* in a medieval sanctuary is that found in Panagia Eleousa in Veljusa near Stroumitsa, a church established by the monk Manuel around the year 1080. Here the *hetoimasia* was rendered as a backless throne with a broad cushion. Resting on the cushion is a closed Gospel book (Fig. 8). A nimbed dove stands in front of the codex, which, in turn, obscures the lower arm of a cross that supports the crown of thorns. To either side are the instruments of the Passion, the lance and the sponge.[9] A slightly later representation of the *hetoimasia* in Nerezi (1164) is flanked by two half-length angels dressed as deacons, who hold liturgical fans *(rhipidia)* over an ornately decorated throne (Fig. 15). Upon it rest the closed Gospels, a dove, and a double-barred crucifix holding the crown of thorns. The throne is flanked by the lance and the sponge.[10]

In placing the *hetoimasia* at the easternmost point of the apse, Byzantine painters established a link between Christ's sacrifice on the cross and the eucharistic sacrifice on the adjacent altar. The prominent display of the instruments of the Passion at Veljusa and Nerezi makes the liturgical connection manifest.[11] At Nerezi, the eucharistic connections were strengthened by the inclusion of two angels, who extend liturgical fans over the throne like the deacons who "hold [*rhipidia*] in their hands and which move back and forth, as though trembling, over the sacred gifts."[12] Dressed in deacons' ceremonial vestments and flanked by large painted candles, the angels led the viewer to associate the painted image with the ceremony taking place before it. Like the painted bishops, the *hetoimasia* served as a continuing reminder of the eucharistic offering, even when the church was silent.

In addition to its connection with the eucharistic sacrifice generally, the *hetoimasia* also was related to a specific liturgical moment. Once the *hetoimasia* was represented between the painted bishops and behind the altar, the dove with outstretched wings denoted the *epiklesis* of the Holy Spirit, a liturgical prayer invoking divine assistance in the transformation of the eucharistic offerings. The text of the prayer, whose opening line is inscribed on scrolls held by the painted bishops, is as follows:

> Again we offer to thee this reasonable and unbloody worship, and we
> entreat, and pray, and humbly beseech thee, send down thy Holy Spirit
> upon us, and upon these presented gifts. And make this bread the precious
> body of thy Christ. And that which is in this chalice, the precious blood
> of thy Christ. Changing them by thy Holy Spirit. That to those who
> partake thereof they may be unto soberness of soul, unto the remission
> of sins, unto the communion of thy Holy Spirit, unto the fulfilling of the
> kingdom of heaven, unto confidence towards thee; not unto judgment,
> nor unto condemnation.[13]

The *hetoimasia,* by virtue of its placement in the bema, its position in relation to the surrounding bishops, and its conspicuous display of the dove of the Holy Spirit, must be interpreted as a eucharistic image as well as one related to the Second Coming.[14]

The Painted Altar

Approximately twenty years following the decoration of the sanctuary of St. Panteleimon at Nerezi, the apsidal wall of Holy Anargyroi in Kastoria was painted. In this church, an elaborate altar table holding two liturgical vessels is depicted directly behind and slightly higher than the actual altar. The upper section of the wall has been destroyed by water damage, but one can still distinguish a chalice on the left side of the central window and a paten covered by an *asterisk* on the right side.[15] The altar is represented on a marble base and is covered by an ornate altar cloth painted as if woven in a rinceau design and

edged by a black vermiculated pattern on a gold ground. Four bishops flank the altar. Two of them, Basil and Chrysostom, carry liturgical texts that refer to the imminent sacrifice.[16] Gregory and Nicholas, who stand at the outer edges, invoke the mercy of God and pray on behalf of the faithful and the corporate Church.[17] The eyes of the hierarchs are not directed toward the painted altar, but toward the viewer, the priest who joins them in reciting the mystical prayers (Figs. 21, 22).

The representation of an altar on the east wall of the apse is not restricted to Macedonia. Painted altars are depicted, for example, in churches located in Cyprus, Bulgaria, and the Greek islands.[18] They continue to be represented during the thirteenth century, although with less frequency. In the early-thirteenth-century church of Bezirana kilisesi in Cappadocia, the altar is flanked by two small angels holding *rhipidia*.[19] A dove hovers above the altar. Exceptionally, the concelebrating bishops on either side do not hold liturgical scrolls but bend slightly forward, holding one hand to the chest and the other toward the altar in benediction. The words of transubstantiation are inscribed in the intercolumniations between the colonettes that support the altar's ciborium: "And make this bread the precious body of thy Christ, and that which is in this cup, the precious blood of thy Christ."[20] The inscription acknowledges the importance of the physical altar as the site of the offerings' transformation. Like the *hetoimasia,* the painted altar was also tied to the eucharistic sacrifice, specifically, the moment at which the offered gifts were mystically transfigured into Christ's body and blood. Formal connections also link this painted altar with the standing altar as well as with the painted altar found at the center of the communion of the apostles, a topic that we will take up in chapter IV.

The Sacrificed Christ

Although representations of the *hetoimasia* and the painted altar are found with some frequency in the eleventh and twelfth centuries, a new image, the *melismos,* was introduced at the end of the twelfth century. Unlike the *hetoimasia* and the altar, the *melismos* had no artistic antecedents in Byzantium and no parallels in the West. The composition consists of a diminutive figure of Christ, who reclines directly on the painted altar or within a bowl-shaped paten. This image of the sacrificed Christ became widespread in Byzantine sanctuary decoration at the beginning of the thirteenth century and continues to be popular in contemporary church painting.

The church of St. George at Kurbinovo contains the earliest securely dated image of Christ as the eucharistic offering.[21] Viewed from the west end of the church interior, Christ appears to recline directly on the stone altar, although the composition is painted above a masonry throne (Fig. 25). In fact, Christ lies directly on a painted altar whose base descends to the seat of the built throne (Fig. 26). In order to strengthen the link between the recumbent Christ and the eucharistic offering, the painter has depicted liturgical vessels above his body. In the center of the composition, between the two halves of the eastern window, is a footed paten covered by an *asterisk.*[22] The offered bread is

depicted at the center of the paten. A liturgical cloth is draped over Christ's midsection instead of the *asterisk,* presenting an unambiguous analogy between the crucified Christ and the eucharistic sacrifice. The depiction of liturgical furnishings further associates the painted image with actual ritual. At Kurbinovo, three knotted columns are painted around the window. These, in turn, support a shallow ciborium, an imitation of the liturgical canopy that was frequently erected over the altar.

Although Christ is most often represented as an infant in the representation of the *melismos,* the figure at Kurbinovo is clearly an adult. The decoration of several later Byzantine churches depicts Christ in the same manner. In the sanctuary of St. John Chrysostom in Geraki (circa 1300), for example, the stiffened body of the dead Christ is balanced on the rim of a bowl-shaped paten (Fig. 74).[23] Two angels, dressed as deacons, wave *rhipidia* over the recumbent figure. Above the altar is an elaborate ciborium, which covers the offered Christ as well as a chalice and a paten. The paten, which is covered by an *asterisk,* contains a small offering. The century between the painting of Kurbinovo and the church at Geraki may account for an added detail in the later scene. A double stream of blood and water, separated artistically through the use of white and red paint, flows into a chalice from the open wound on Christ's right side. When Christ's side was pierced at the Crucifixion, blood and water poured from the wound (John 19:34). This passage is generally illustrated in Byzantine art through the scene of the Crucifixion, where the blood and water flow freely from Christ's wound. In several twelfth-century churches, an image of Ekklesia collects the blood and water in a chalice,[24] an action that might be seen as visual exegesis of the Orthodox rite of mixing warm water into the eucharistic wine. In the Orthodox Church, the celebrant adds warm water, the "*zeon* of the holy," to the eucharistic wine as a reminder of the life blood that flowed from Christ.[25] In the fourteenth century, Nicholas Cabasilas interpreted the rite as follows: "The blood and water which flowed from his holy side are also recalled by the priest, who symbolizes them by pouring wine and water into the chalice—another commemoration of the Lord—and saying the words: 'And forthwith came there out blood and water.' "[26] The increasing focus on liturgical realism is demonstrated by the Geraki image, for in this church the traditional emphasis on the blood and water in the Crucifixion of the historical Christ has been transferred to the eucharistic Christ. The composition refers simultaneously to the historical basis of the liturgical rite and the living ceremony enacted by the priest.[27]

The most common manner of depicting Christ as the sacrificed offering, however, is as a child placed within a paten. The decision to represent Christ as a child reflects the manner in which mystagogical commentators viewed the preparation of the bread in the prothesis chamber. For Nicholas Cabasilas, writing in the fourteenth century:

> The words and actions performed over the bread which signify the death
> of the Lord are only a description and a symbol. The bread therefore
> remains bread and has received no more than the capacity to be offered to
> God. This is why it typifies the Lord's body in his early years, for, as we

have already pointed out, he himself was an offering from his birth
onwards. This is why the priest relates, and represents over the bread,
the miracles accomplished in him when he was but new-born and still
lying in the manger. Placing what is known as the *asterisk* over it, he
says: "And lo, the star stood over where the child was."[28]

To Cabasilas, the bread offered in the prothesis chamber represented the infant Christ. Germanos of Constantinople, at a much earlier date, interpreted the apse as the cave in Bethlehem where Christ was born.[29] Thus it is entirely appropriate that Christ, who is symbolically carried to the central altar during the Great Entrance, would be represented as a child.

That the Byzantines equated the infant Christ with the eucharistic offering may be confirmed by visual and documentary sources. One is the tenth-century account of the life of Niphon, bishop of Konstantiane in Egypt (died after 328). Based on factors internal to the text, the *Life* was probably composed in Constantinople, and in it we may see some reflection of theological concerns in the Byzantine capital. In this account, the saint reveals a vision of angels sacrificing the Child in place of the blessed bread: "And again the just one saw that one of the angels, taking the knife, slaughtered the Child and drained his blood into the chalice. And dividing (μελίσας) mystically the holy body, offered it instead of the gifts on the holy paten."[30] The composition of the text may echo concerns in the city about the nature of the eucharistic sacrifice. An eleventh-century Constantinopolitan manuscript containing the homilies of Gregory of Nazianzos illustrates the idea set forth in the earlier texts.[31] An initial *rho* is formed by a deacon holding a chalice in his extended right hand. In his raised left hand he holds the legs of the Christ child, who dives into the chalice.

The symbolism of Christ's sacrifice on the altar is set forth by the prayers held by the concelebrating priests. The first lines inscribed on the scrolls remind the celebrant to strive for spiritual purity before approaching the altar. The remaining lines of the inaudible prayers, which do not fit the limited space of the painted scroll, refer to the imminent sacrifice. The Cherubikon, for example, held by St. Basil in nearly every medieval Byzantine church, asks:

> Look down upon me, thy sinful and worthless servant, and cleanse my soul
> and heart from an evil conscience; and by the power of the Holy Spirit
> enable me, embued with the grace of the priesthood, to stand before this
> thy holy table and to consecrate thy holy and most pure body and precious
> blood. . . . For thou dost offer and art offered, and dost receive and art
> received, O Christ our God.[32]

Similarly, the prayer of the Prothesis held by John Chrysostom in the central sanctuary of most late Byzantine churches (even though the prayer is read in the prothesis chamber or at the prothesis niche) addresses the eucharistic sacrifice:

O God, our God, who didst send the heavenly bread, the nourishment of
the whole world, our Lord and God Jesus Christ, our Savior and Redeemer
and Benefactor, blessing and sanctifying us: Thyself bless this oblation, and
accept it on thy most heavenly altar. Remember as a Good One and Lover
of men those who have offered and those for whom they have offered; and
preserve us blameless in the sacerdotal ministry of thy divine mysteries.[33]

The inscriptions held by the flanking hierarchs further clarify the meaning of the central
image and the celebrant's role in the ceremony.

Although the composition appears from the end of the twelfth century in the
south of Greece, in Byzantine Macedonia the earliest instance of the infant Christ as the
melismos is preserved in St. Nicholas in Manastir, dated 1271 (Fig. 40).[34] So far as I know,
the Manastir representation is the first securely dated example in Byzantine painting to
bear the inscription *"melismos."*[35] Here, the infant Christ holds his right hand up in a
gesture of benediction. He is placed in a paten that rests on an elaborate altar cloth. Two
angels, dressed as deacons, extend liturgical fans over the child. This central representation
is immediately flanked by concelebrating hierarchs. The representation is reminiscent of
the instructions for the deacon during the eucharistic liturgy. Medieval *diataxeis* instruct
the deacon to stand to the right of the priest and wave the *rhipidion* over the blessed gifts
in order to protect them from flies.[36] The *melismos* in St. John Kaneo in Ohrid is similar
in its inclusion of two angels flanking the child (Fig. 41). The representation, which has
been displaced by the enlarged central window to a lower position in the apse, is
extremely damaged. The bishops flanking the child hold identical prayers to those at
Manastir, and this similarity, among others, may indicate that the painters of the two
churches were from the same workshop or were using common patterns.

The Macedonian representations display the same characteristics as numerous
examples throughout Byzantium. Changes in the composition may reveal the preferences
of a painter or patron and they often assist in detecting regional trends, as is the case in the
churches in Manastir and Ohrid. As to the name *"melismos,"* there is no universal manner
in which the composition is labeled. Although the word *"melismos"* is inscribed above
the image in Manastir (and has become the common term for the composition in mod-
ern scholarship), other images are labeled simply with the abbreviations for Christ's name.
This is the case, for example, in St. Nicholas Orphanos in Thessalonike, where a diminu-
tive figure of the sacrificed Christ is flanked by Basil and Chrysostom (Fig. 57). In a num-
ber of churches outside of Macedonia, particularly in the Peloponnesos and on the island
of Naxos, the term used to describe the image is *"thyomenos,"* the Sacrificed One.[37]

Because the *melismos* is the only image in the sanctuary that has no antecedents in
Byzantine art, one must question the context of its creation. When painters depicted the
infant Christ in a liturgical paten covered by an *asterisk* and labeled *"melismos"* or *"thy-
omenos,"* they were graphically expressing certain developments in Orthodox dogma and
liturgical practice. Among the many factors that may have guided the development of this
new composition are organic changes in the liturgy that needed to be clarified. From

the tenth century, the Church had made additions to the rite of the preparation of the offerings, and these developments may have contributed to the invention of this image for the sanctuary.[38] An eleventh-century response of the patriarch Nicholas III Grammatikos to a monk indicates that the preparatory rite has been changed by the addition of new ceremonies, such as the cutting of the *amnos* (the lamb), a section of the offered bread.[39] The rite became far more elaborate through the addition of commemorations for specific saints, the living and the dead. The emphasis on the correct and relatively uniform preparation of the eucharistic offering, its proper placement on the paten, and its covering by the *asterisk* and liturgical cloth may have shaped the composition of the *melismos*, which regularly includes many of these elements.

The Depiction of Theological Debate

The introduction, refinement, and proliferation of the *melismos* may have been inspired by theological discussion within Byzantium. As Gordana Babić and others have demonstrated, the creation of the *melismos* and its placement at the center of the apse coincided with a period of intense Christological dispute.[40] At the center of these debates was the question of whether Christ could receive the sacrifice and simultaneously be sacrificed. Numerous church officials and theologians were condemned for their views on this issue and the related subject of Christ's place within the Trinity. John Italos, for example, was censured in 1082 for heresy and paganism.[41] Eustratios of Nicaea, a pupil of Italos, was anathematized in 1117 for claiming that the Son was not equal to the Father. Soterichos Panteugenos, Nikephoros Vassilakes, and Michael Rhetor (Michael of Thessalonike) were condemned by synods, held in 1156 and 1157, for calling into question the last phrase of the Cherubikon, "for thou art the offerer and the offered."[42] In the words of the Byzantine historian John Kinnamos:

> Meanwhile [1156–57] the following events happened in Byzantion. There was one of the Levites [clergy] whom we call deacons, whose name was Basil. As he had been entrusted to unfold the Holy Scriptures to the multitude at religious services anywhere, he desired openly and covertly to abuse in these sermons some of those who had lately quarreled with him, especially Michael [of Thessalonike] and Nikephoros, by surname Vasilakios [Vassilakes]. . . . when Basil was celebrating his usual liturgy at the church of the apostle John the Theologian outside the city, they went to listen, yet with treacherous attention, filled with malice. For as he [Basil] was going through a Gospel passage someplace, I think, he declared the Son of God and the Spirit were one and the same and received the Sacrifice [of the eucharist] along with the Father; they forthwith seized on the expression and going up and down, mocked at it, saying that Basil thereby introduced two hypostases [forms of Christ's being], if one was sacrificed, the other received the sacrifice.[43]

The persistent use of the text of the Cherubikon on the liturgical roll held by Basil served to emphasize within the sanctuary program that the sacrifice of Christ was offered to the Father alone and not to the entire Trinity.[44] The close proximity of the prayer to the altar may have also functioned as a warning against falling into heretical thought.

The introduction of the *hetoimasia* into the sanctuary decoration roughly corresponds to the period in which the theological debates raged inside the Byzantine capital and in related theological centers. The discussions in and outside Church councils continued through the decades in which the sanctuary program was developing and may account for changes and additions to it. The involvement of prominent Constantinopolitan patrons in church construction, decoration, and maintenance may locate the source of iconographic innovations in the capital. The renovation and decoration of St. Panteleimon at Nerezi, for example, was sponsored by Alexios Angelos Komnenos, grandson of the emperor Alexios I Komnenos. Along with a number of his relatives, the younger Alexios attended a Church council held in Constantinople on March 6, 1166.[45] As a witness to the sessions held at the council, he would have followed the discussions over the nature of Christ, which included a review of earlier theological findings. It is possible that the theological disputations that Alexios heard in Constantinople influenced the painting of his church on property in Macedonia.[46] The representation of the *hetoimasia* may provide evidence for such an influence. As a trinitarian symbol, the image of the *hetoimasia* renders in paint certain abstract notions that were discussed at the council, specifically, whether the eucharistic gifts were offered to a single person or to all of the Trinity.[47] The fact that this debate was carried on within intellectual circles that included members of the aristocracy along with members of the clergy may account for the limited dissemination of the *hetoimasia* as a central motif in the sanctuary. Its short-lived and geographically limited representation may reflect an attention given to theological issues that were resolved within this period. In Macedonia, the *hetoimasia* is found in two churches that were built within eighty years of one another. Both were associated with members of the Komnenian family.[48]

The rare inclusion of a painted facsimile of the church altar indicates that this, too, was not a satisfactory image for the center of the apse. Both the *hetoimasia* and the painted altar were quickly supplanted by the image of the sacrificed Christ, a replacement that may be explained by its twelfth-century cultural and religious context.

As with the *hetoimasia,* the *melismos,* the graphic representation of Christ as the eucharistic offering, reflected the need to clarify visually the results of contemporary theological debate. The substance of the eucharistic offering, whether it was the transformed bread (a "type" of Christ) or the actual body of Christ, was an issue widely discussed in theological circles throughout Byzantine history. Confusion over the offering's transformation arose at an early point in Orthodox theology. The fifth- or sixth-century Egyptian *Apophthegmata patrum* relates the story of two men who convinced their companion, a monk who believed that the eucharist was simply a symbol, to pray for enlightenment over the nature of the offering:

God heard both the prayers. At the end of the week they came to the church on Sunday and sat all three on the same mat, the old man in the middle. Then their eyes were opened and when the bread was placed on the holy table, there appeared as it were a little child to these three alone. And when the priest put out his hand to break the bread, behold an angel descended from heaven with a sword and poured the child's blood into the chalice. When the priest cut the bread into small pieces, the angel also cut the child in pieces. When they drew near to receive the sacred elements the old man alone received a morsel of bloody flesh.[49]

A similar miracle is found in a fifth-century text attributed to John Rufus (Beith-Rufin) concerning a eucharistic miracle. Contained in an eleventh-century manuscript, the text describes a man who, during the first week of Lent, came into the church of St. Menas:

When the holy offering of the eucharist had taken place and everyone had received the terrifying mysteries, he, too, came forward, with tears, to partake. And when he opened his hand he saw, instead of bread, flesh soaked in blood, and his entire hand became blood-red. And trembling from the incredible wonder that had taken place, he said, "Woe is me, how is it possible that I have been found receiving meat when everyone else has received bread? How is it possible that I am partaking in flesh when this is a time of fasting?"[50]

Discussions concerning the eucharistic offering continued in the period following the end of Iconoclasm. Their persistence demonstrates the difficulty in finding a resolution to this issue. The writings of John of Damascus, instrumental in the disputes over religious images, were used in the debate over the eucharistic sacrifice.[51] In the eleventh century, the Church attempted to understand the link between the eucharistic offering and the body of Christ by resorting to the relationship between image and prototype. Those who believed that the bread merely symbolized the body of Christ were condemned. The synod of 1082, which sentenced John Italos, also anathematized "those who say that the communion of the body and precious blood of our Lord and Savior Jesus Christ is a communion of ordinary bread and wine."[52] The confusion between symbol (bread) and prototype (body) was widespread. Nicholas of Andida, writing in the late eleventh century, refers to the general bewilderment over the exact nature of the offerings.[53] Even in the early fourteenth century, Nicholas Cabasilas felt compelled to define the question in his liturgical commentary:

Since we are not concerned with a mere figurative sacrifice or symbolic shedding of blood, but with a true holocaust and sacrifice, we must ask ourselves what it is that is sacrificed: is it bread or the Body of Christ? Or, to put it another way, are the offerings sacrificed before consecration or afterwards?[54]

His solution is that the transformation is a double one:

. . . the bread, from being unsacrificed, has become a thing sacrificed, and it has also been changed from simple bread into the Body of Christ. It follows therefore that this immolation, regarded not as that of the bread but as that of the Body of Christ, which is the substance which lies beneath the appearance of bread, is truly the sacrifice not of the bread but of the Lamb of God, and is rightly so called.[55]

The depiction of the *melismos* as the Christ Child responded to the widespread confusion over the transformation of the offered bread into the body of Christ and assisted the viewer to properly understand that the sacrifice is not simply symbolic.

While the introduction of the *melismos* into the sanctuary program may be seen as a response to changes in the text and performance of the liturgy as well as a reflection of internal debates within the Orthodox Church, its prominent placement at the center of the apse may demonstrate a reaction to certain questions that divided the Latin and Orthodox churches. At the same time at which Orthodox Christians questioned the essence of the eucharistic sacrifice, Byzantium was involved in heated discussions with its neighbors over the nature of the offered bread. The Orthodox took communion in the form of leavened or "living" bread, whereas the Latins used *azymes,* unrisen bread. That this debate was raging between the churches is evident in the writings of the patriarch Michael I Keroularios in the mid–eleventh century and in polemical treatises written by numerous others who followed him.[56] The depiction of the *melismos* as a living child is an implicit defense of the Byzantine practice of using a leavened host.

There were many potential catalysts for the insertion of the *melismos* into the program of the medieval Byzantine sanctuary. Changes in the liturgy, such as new developments in the preparation of the offering, focused attention on the manner of preparing the offerings. The absence of standardized rubrics for this portion of the liturgy shows that celebrants were not held to a single manner of ritual performance. Changes in the liturgy in the very period in which the *hetoimasia* and *melismos* entered the painted program sought to bring all celebrants to uniform practice. Aside from liturgical developments, theological debates conducted within intellectual, ecclesiastical, and aristocratic circles centered on the nature of Christ and the eucharistic sacrifice. The substance of these debates must have remained obscure to the lower clergy and common laity and surely would have benefited from the artistic rendering of the essence of the discussion in the form of the *melismos.* Moreover, the addition of an acceptable subject to the sanctuary of numerous Byzantine churches would have helped to shelter Orthodox belief from heresy.

The use of painting to defend Orthodoxy from Latin practice, especially in border areas or in regions inhabited by members of two churches, certainly explains the popularity of an image that is found exclusively in Byzantine painting. It seems unlikely that the Byzantine painter had a single reason for depicting the *hetoimasia,* the altar, or the sacrificed Christ in the center of the apse. As with many subjects represented in the Byzantine church, the invention of these images responded to a wide variety of demands. The images elucidate changes in the liturgy, represent in paint debates over theology and liturgical practice, and refute criticism over performing the eucharistic sacrifice.

IV

The Sacred Communion

DIRECTLY BEHIND THE ALTAR in the church of St. John the Theologian in Veroia, a painted communion is underway (Color Plate IV). Christ, represented twice, stands under a ciborium. On the left side, apostles approach Christ to take bread from his hand. Peter, at the head of his companions, leans over and kisses Christ's right hand as he accepts the offering. Opposite him, on the other side of the apse, Paul leans over to sip from a cup extended by Christ. In the background, painted buildings are located on the extreme ends of the composition. The movement from the outer world to the world of Christ brings the apostles closer to the central altar. An angel, standing behind the group at the right, gazes out at the priest. In front of him, two apostles embrace and momentarily stop the procession.

As patrons and painters turned to the performance of the eucharistic liturgy as a source of inspiration, significant changes in the composition of the Byzantine church program followed, especially in the eleventh and twelfth centuries. Innovations are most apparent in the sanctuary, where the shift from Gospel texts to liturgical sources gave rise to images that mirrored clerical action and guided communal worship. The bishops, apostles, and angels represented in the sanctuary participated in a perpetual eucharistic sacrifice. Occasionally they were joined by the bishop or parish priest, but more often they sanctified the solitude of the empty church. Their permanent supplication on behalf of the Orthodox congregation was a symbolic comfort in a period of unrest. As we have seen, the development and dissemination of scenes such as the *melismos* corresponded to a period of theological activity in the Byzantine Church, a period during which the Empire was immersed in not only heated discussions with her neighbors but also ongoing debates with dissenters within her borders.[1] We might see changes in iconography as a reaction to attacks on the Empire's Orthodoxy. Dissent and disagreement struck at the most basic rite of the Church, communion. The scene that most directly represented this rite, the apostolic communion, was often included in church decoration of the medieval period. The subject's rapid proliferation may be seen as the painted assertion of the antiquity of the service in the face of ecclesiastical and political uncertainty. And, as with other scenes painted in the sanctuary, the Communion of the Apostles is related to liturgical practices of the medieval period.

 The Communion of the Apostles appears as early as two sixth-century manuscripts and two liturgical patens (Fig. 75).[2] In manuscript painting the subject is found

among works, primarily psalters, from the ninth to twelfth centuries.³ The earliest pre-
served representations of the scene in church decoration date to the tenth century and are
found in subsidiary spaces: the side chambers of the sanctuary or secondary apses.⁴ In
the church of the Nativity near Sagri, on the island of Naxos, the communion is located
in the prothesis niche, a small shelf used for the preparation of the eucharistic offerings.⁵
Despite considerable damage, the outlines of the composition are clear: Christ stands at
the center and offers a chalice to the apostles on the left and bread to those on the right.
Later in the tenth century, the north apse of Kılıçlar kilise (Göreme 29) in Cappadocia
was decorated with the Communion of the Apostles.⁶ Even after the subject came to
be associated with the sanctuary and altar, it still might be represented in secondary
spaces. In the thirteenth century, for example, the scene is painted in the vaulted north-
east chamber of St. Nicholas in Myra (Fig. 76).⁷

The appearance of the communion in the central sanctuary, on the side walls, or in
the central register of the apse marks the subject's acceptance as a vital part of the church pro-
gram.⁸ Once placed in the sanctuary, it would remain there, in much the same composi-
tion. Preserved cycles fix the movement of the Communion of the Apostles from the side
chambers to the central sanctuary in the eleventh century. At least six churches attest to the
new location.⁹ By the thirteenth century the number had quadrupled. The sharp increase
illustrates the central place that the Communion of the Apostles had attained within the
sanctuary, where its role was to broaden the meaning of the program. The Communion of
the Apostles emphasized the liturgical manifestation of Christ through the eucharist, just as
his mystical Incarnation was expressed by the Virgin and Child in the conch of the apse
and the Annunciation on the piers guarding the opening to the sanctuary.

The medieval rendering of the apostolic communion follows a formula established
in the Early Christian period. In representations such as that found on the sixth-century
Riha Paten (Fig. 75), Christ, dressed in a mantle and nimbed, is depicted twice. He dis-
tributes the blessed bread and wine to sets of apostles who approach from either side, their
hands extended in reverence. The two sets are usually led to the altar by Peter and Paul.
Peter receives the bread from Christ's hand. Paul generally approaches to drink the wine, but
occasionally he is replaced by John. In painted representations the scene is often inscribed
with the words recited by the priest before the distribution of communion: "Take, eat, this
is my body which is broken for you, for the remission of sins," and "Drink all of it: this is my
blood of the New Testament, which is shed for you and for many for the remission of
sins" (Figs. 37, 38, 55).¹⁰ The use of what are both Christ's words at the Last Supper and
the priestly invocations during the eucharistic service forges a close connection between
word, action, and image. But the labeling of the two halves of the composition as *metadosis*
(the distribution) and *metalepsis* (the partaking) indicates that Byzantine painters conceived
of these scenes as another moment in a sequence of events (Fig. 42).

Although the Communion of the Apostles was repeated from church to church
according to the same basic formula, subtle changes demonstrate differences in liturgical
choreography, hint at theological nuances, and reveal artistic preferences. Whether the mon-
umental representation is fresco or mosaic, as in the metropolitan church at Serres (Fig.

12), the composition reveals similar patterns. The number of the apostles may vary from six to twelve, and the identity of the leading apostle may differ. The shape of the altar, its decoration, and the liturgical vessels utilized assume various forms, sometimes reflecting contemporary realities and at other times following a more historicizing approach to the event's representation. The wine may be distributed from a variety of vessels, from elaborate tablewares to simple stemmed cups. The altar is generally crowned by a canopy supported by columns and is covered by an ornately decorated altar cloth. These small variations correspond to and enrich specific actions and prayers of the liturgy and thus conflate the Communion of the Apostles, the Last Supper, and the actual eucharistic rite.

The Selection of Apostles

In most representations of the communion, the apostles are divided into two groups of six. One apostle leads each procession and directly receives the bread or wine from Christ. In most cases Peter, Paul, or John lead their apostolic colleagues, but in a few, such as in the church of St. Catherine in Thessalonike, Peter is depicted at the head of both groups.[11] When Peter is depicted twice, the apostles are usually divided into groups of twelve rather than six. Yet no matter how the apostles are arranged, Peter always receives the bread. The recipient of the wine may be either Paul or John, although Paul seems to be the more frequent choice in Byzantine ecclesiastical decoration. In Macedonia, however, from the end of the thirteenth century, John is represented as taking the wine in more than six churches attributed to the painters Michael Astrapas and Eutychios or to closely related workshops.[12] John is also featured on the gold-embroidered *epitaphios* that is ascribed to a Thessalonikan atelier (Fig. 89).[13] The substitution of John for Paul in a group of related churches may reflect the working practices of painters in this region. The presence of this unusual detail in churches in Ohrid, Thessalonike, and Mount Athos demonstrates the common training of a group of itinerant painters, or, at the very least, the exchange of patterns between them. The selection of John as the leading apostle was not, however, unique to Macedonia. An emphasis on this apostle within the communion scene was first noted in two twelfth-century churches, both on Cyprus: Holy Apostles at Perachorio and Panagia Phorbiotissa at Asinou (Fig. 77). Arthur H. S. Megaw suggests that John's replacement of Paul reflects a local iconographic tradition.[14] In light of the Macedonian evidence, however, it would seem that John's selection had wider implications. The theological underpinnings of this painted decision need to be clarified.

Several scholars attribute John's prominent role to an artistic choice between a "liturgical" and a "historical" series of apostles.[15] The essence of this division is the replacement of three disciples by three authors of the ecclesiastical texts that formed the basis of the Church service. In the liturgical series, James the Less, Matthias, and Thaddeus are replaced by Paul and the evangelists Mark and Luke. Although most apostolic communions present the liturgical series, those in which John receives the wine represent the historical. The choice of John over Paul seems to follow geographical and chronological patterns

and may derive from an emphasis on John in the representation of the Last Supper in a number of churches. Luke (22:8) writes that John, along with Peter, was sent by Christ to make the Passover ready. He is identified as the "apostle whom Jesus loved," and in John 13:23 he is described as leaning on the breast of Christ, a detail frequently depicted in scenes of the Last Supper.[16] In churches where John is the recipient of the wine, as in the Protaton on Mount Athos, the Last Supper is often represented adjacent to the apostolic communion (Fig. 45). It may be that the visual juxtaposition of the scenes suggested the depiction of John as the apostle who receives the wine from Christ's hand.

Representation and Liturgical Realism

The use of Byzantine sanctuary furnishings in representations of the Communion of the Apostles directly linked the painted scene to liturgical practice and strengthened the connections between the upper and lower registers of decoration. In order to emphasize the parallel between biblical precedent and contemporary ritual, Christ was represented adjacent to or behind an altar. The occasional representation of a chancel barrier around the altar reinforced the topographical immediacy. In Hagia Sophia in Ohrid, the painters included a sanctuary barrier in inverted perspective. It extends from the front of the altar in an attempt to draw the actual sanctuary into the picture (Fig. 5). Two colonettes flank a short gate into the enclosure and support the marble closure slabs. The communion scene in the late-twelfth-century refectory of St. John Theologian on Patmos also includes a chancel screen. Its closure slabs were painted in imitation of inlaid marble plaques decorated with a pattern comprising five interconnected circles centered on a larger and darker roundel (Fig. 79).[17] The painted chancel screens were occasionally interrupted by doors that imitate the gates of actual sanctuary barriers. In some cases, like that of Ohrid, the leaves of the painted doors are divided by a knotted post.[18] This painted post resembles the knotted columns of Hagia Sophia's *templon* screen, which were incorporated into its Turkish minbar.[19] In other cases, the representation carefully reproduced the carved medium of actual sanctuary doors. The chancel doors depicted in the Patmos refectory, for example, are painted to resemble carved wood, a medium frequently used for this purpose (Fig. 79).[20] The thirteenth-century church of the Panagia in Merenta, Attika, offers a clear example of the painted imitation of a chancel barrier and solea (Fig. 80).[21] In the scene of the communion of the wine, Christ and an angel stand behind an enclosure formed by an ornately decorated marble closure slab. The closed doors of the chancel screen are segmented as if carved wood.

In many scenes of the communion, the altar is covered by a ciborium. This feature of the sanctuary was interpreted by mystagogical writers in a number of ways. In the eighth century, Germanos of Constantinople wrote that it represents the place of the Crucifixion and similarly the Ark of the Covenant:

> The ciborium represents here the place where Christ was crucified; for the place where he was buried was nearby and raised on a base. It is placed in

the church in order to represent concisely the crucifixion, burial, and resurrection of Christ. It similarly corresponds to the Ark of the Covenant of the Lord in which, it is written, is his Holy of Holies and his holy place. Next to it God commanded that two wrought Cherubim be placed on either side—for KIB is the ark, and OURIN is the effulgence, or the light, of God.[22]

In the late eleventh century, Nicholas of Andida interpreted the ciborium as representing the center of the earth.[23] In St. Euthymios in Thessalonike (1303), the east wall above the apse is decorated with the Ark of the Covenant, a painted reference to this mystagogical interpretation.[24] The inclusion of the ciborium, like the chancel barrier and gates, places the specific furnishings of the sanctuary into the painted scene.

Ciboria represented in the Communion of the Apostles are divided into two categories: domical and pyramidal. Far more prevalent is the domed roof such as that found in the representations in Ohrid's St. John the Theologian (Fig. 41) and the Virgin Peribleptos (Fig. 42) or in Thessalonike's St. Nicholas Orphanos, where the edges of the ciborium are accentuated by a decorative border in imitation of a carved molding (Fig. 55). The pyramidal ciborium is found in diverse locations: in Kiev's Hagia Sophia, in Hagia Sophia in Ohrid, in St. Demetrios tou Katsoure near Arta, and in Omorphe Ekklesia in Athens, among others (Fig. 81).[25] The upper portion of the ciboria in Omorphe Ekklesia and in St. Demetrios tou Katsoure are both flat with a small pyramid attached at the center. By contrast, the entire upper portion of the ciborium painted in Ohrid is pyramidal (Fig. 5). The shapes chosen were likely influenced by actual furnishings. Several written sources attest to the shape of the ciboria of Hagia Sophia and Holy Apostles in Constantinople. Paul the Silentiary, for example, describes the silver ciborium of Hagia Sophia in the sixth century as having an eight-sided base and terminating in a sharp point.[26] The ciborium of the Constantinopolitan church of Holy Apostles was of a similar shape.[27]

The insertion of these realistic elements suggests that for the Byzantine viewer the Communion of the Apostles was not merely an exegesis of the historical account of the Last Supper, but also, and perhaps more importantly, a pictorial exegesis of the liturgy itself. In other words, the historical event of the Last Supper gave way to the *metadosis* and *metalepsis,* which brought the moment at which Christ distributed the bread and wine to his disciples a visual impact that mirrored medieval ceremonial.

The Chalice and Paten

Liturgical vessels represented in the apostolic communion occasionally copy those used in the medieval service. Patens and chalices included in these paintings are often over-sized and ornately decorated. Chalices assume several forms. Occasionally, they are represented as cups on a long stem with a knop and flaring foot. Chalices like the one painted in St. Panteleimon, Nerezi, resemble the large silver chalices of the Early Christian period (Fig.

14). Other vessels, such as that depicted in St. John the Theologian in Veroia, resemble goblets (Fig. 31). Stemmed ceramic goblets, some from ecclesiastical contexts, have been found in excavations of medieval sites throughout the Byzantine Empire, and we may take their representation in monumental painting to be a reflection of actual church vessels. Two ceramic chalices from the thirteenth century are in the collections of the Archaeological Museum of Iznik (Fig. 82) and the Archaeological Museum of Komotini in Thrace.[28] The Iznik chalice is inscribed with Christ's invocation to his disciples at the Last Supper to "Drink of this," the same phrase that generally accompanies the painted communion in monumental decoration.[29] The inventory of March 1077, composed by Michael Attaleiates for his monastery, lists a silver-gilt chalice with an inscription on the edge that reads "Drink of this," an indication that the painted scene, often labeled with this invocation, the communion vessels, and the rite, were intended to be integrative.[30]

Many of the chalices represented in the communion scene resemble larger storage vessels or tablewares used to hold wine. Two types are common in monumental painting. The first is a small amphora or *stamnos,* usually represented in gold and ornately decorated with jewels.[31] An example of this common type, held aloft by its two handles, is seen in St. Nicholas Orphanos (Fig. 55). The second type, a variation on the first, has a wider body and its rim has a quatrefoil shape. Examples of this fairly common shape are found in the decoration of the Virgin Peribleptos in Ohrid (Fig. 42) and St. Euthymios in Thessalonike (Fig. 48). While such vessels bear little resemblance to the traditional stemmed chalice, the type of container corresponds to pots used in metaphorical descriptions of the human character found in numerous ecclesiastical and secular texts. In an illustrated book of the sermons of Gregory of Nazianzos, dated circa 1080, a poem written in silver letters calls the mind of Gregory the "*stamnos* of dogmas."[32] St. Antony of Kauleas, in his *Life,* is described as serving the "*krater* (mixing bowl) of union especially to the church and placing upon the table the goods of practical dogmas."[33] These descriptions call to mind the type of large vessels pictured in the scene of the Communion of the Apostles, and the metaphorical association of such containers may have encouraged their use in place of more realistic chalices.

Like the chalice, the liturgical paten is depicted at an enlarged scale. The concave bowl is often supported by a raised foot and is unlike patens that survive from Byzantium. It can be argued that Byzantine painters were unable to render a flat paten accurately. In the representation of the celebrating St. Basil in Hagia Sophia, Ohrid, the paten stands on its side in order to expose the stamped eucharistic offering at its center (Fig. 6). The depiction of the liturgical plate as a high-walled bowl also created a visual parallel to the serving plate represented in the scene of the Last Supper, a parallel that may have been intended to assist the viewer in visual comparison. One explanation for the shape of the bowl may derive from actual practice. The bowl-like paten recalls the large vessel that is used today to hold the *antidoron,* the blessed bread that remained after the eucharistic offering had been extracted. It is possible that such a vessel was used in the medieval period to distribute the gift "in place of the gift." The *antidoron* was received by the faithful on the occasions when they did not receive the eucharist. "This bread," according to Symeon of Thessalonike,

is given instead of the great gift of the terrifying communion, since not everyone is worthy of taking the eucharist. The *antidoron* is a present of the grace which God gives to the faithful. This bread is also blessed, pierced by the lance, and has received the holy words in the same way as the bread of Christ. This *antidoron* is only the transmittance of the blessing and the words recited over it in the prothesis chamber.[34]

The faithful received the *antidoron* in their hands, in a manner similar to that represented in the apostolic communion:

> Then the bread which has been offered up, and from which the sacred host was taken, is broken into small pieces and given to the faithful as something which has been hallowed by being dedicated and offered to God. The faithful receive this with all reverence, kissing the hand which has so recently touched the all-holy body of the Savior Christ and which, thus sanctified, can communicate this sanctification to those who touch it.[35]

The representation of a large bowl, often containing several pieces of bread, may have evoked, for the faithful, the more accessible offering, a quasi-communion that did not require a prolonged period of spiritual introspection before its reception.

The Gesture of the Communicant

The liturgical precision with which the communion scene was rendered is no better demonstrated than in the manner in which the hands of the apostles were depicted as they received communion from Christ. As with the liturgical furnishings included in the painted representation, this reflection of contemporary religious practice removed the scene from its roots in the Last Supper and tied it to the actual communion ceremony.

Sources directed the communicants to cup the right hand in the left, a position that is reflected in the communion of the bread. Positioning the hands in this manner is prescribed for the laity in the fourth-century catechesis of Cyril of Jerusalem:

> In approaching, come not with your open hands stretched out or your fingers spread open, but make your left hand a throne for the right which shall receive the king. Then cup your hand and receive the body of Christ, saying the "Amen." When you have carefully sanctified your eyes by touching (them with) the holy body, partake of it. But be careful that no particles fall, for any such loss would be the same as losing some of your own members. Tell me, if anyone gave you gold dust, would you not hold it tightly and carefully, and protect against letting it fall and be lost?

How much more cautious must you be that no particle be lost of that which is more precious than gold and precious stones?

Then, after you have partaken of the body of Christ, approach the chalice of his blood—not stretching out your hands—but bowing. In a spirit of worship and reverence repeat the "Amen" and sanctify yourself by partaking also of the blood of Christ. And while your lips are still full of moisture, touch them with your hands and sanctify your eyes and your brow and the other senses. Then wait for the prayer and give thanks to God who has made you worthy of such great mysteries.[36]

A twelfth-century *diataxis* in the British Library directs the clergy in the proper manner of holding the bread during the communion service:

[The patriarch] descends from the platform and bows three times to the east. . . . With him bows the priest who is supposed to give him communion, and both mount the platform and kiss the holy altar. And first the bishop, having stretched forth his hands, receives. Then holding the bread in the last two fingers, with the other three he takes the other particle and gives it to the one that gave communion to him.[37]

The description of the position of the hands in textual sources is represented with great accuracy in Byzantine monumental decoration, miniature paintings, and the minor arts.

From the time of the Riha Paten, depictions of the apostles in the communion of the bread have shown them with the right hand cupped in the left (Fig. 75). In the Stuma Paten this simple posture is supplemented by the gesture of the leading apostle, who kisses Christ's hand as he receives communion.[38] The additional gesture of kissing is fairly common in representations of the scene in churches of Byzantine Macedonia, as in the church of St. John the Theologian in Veroia, where Peter holds Christ's left hand to his lips as he bends to take the bread (Fig. 31).[39]

The manner of taking the communion of the wine demands a different position of the hands. According to Cyril of Jerusalem, the hands are not raised and the communicant is slightly bent over in a posture of *proskynesis* at the moment of communion.[40] In the church of St. John the Theologian in Veroia, Paul's hands are extended toward the chalice as his lips touch the vessel's rim (Fig. 31). The position of his hands and his bent stance conform to Cyril's instructions regarding the reverential approach that was assumed by the faithful. In the depiction of John in the chapel of St. Euthymios, Thessalonike, however, the apostle's left hand is extended as his right hand crosses in front of his chest; his mouth is open as Christ tips the silver chalice toward him (Fig. 48). A different manner in representing the apostle is seen in the church of the Virgin Peribleptos in Ohrid; John's two hands are covered by his mantle and his open mouth extends toward the rim of the chalice (Fig. 42).

The depiction of the apostles in the precise stance recommended for communi-

cants during the liturgy tied the representation directly to the most sacred proceedings in the life of the faithful. These details, which are not part of the Gospel account of the Last Supper, were added to the scene from an early period as accurate reflections of religious practices.

Reading the Apostolic Communion

As with numerous scenes in the Byzantine church, the apostolic communion was subject to interpretation on a number of levels. The image was rooted in a historical event, that is, the Last Supper.[41] In the reenactment of the Last Supper, the celebrant took on the role of Christ; his concelebrants and congregants imitated the apostles. The parallel becomes inescapable in those churches where the apostolic communion and the Last Supper were placed next to one another.[42] In the Protaton on Mount Athos, the Last Supper was omitted from the narrative sequence in the nave so it could appear behind the icon screen on the south wall of the sanctuary (Fig. 45). Divorced from its historical context and inserted into the sanctuary, the scene also represented a liturgical event, one that was removed from its narrative setting and placed among the ceremonies celebrated in the sanctuary.

When the faithful viewed the scene from the nave of the church, they saw the apostolic communion as a visual prototype for their own communion and that of the clergy. The liturgical vessels, the ciborium, the angels dressed as deacons carrying *rhipidia,* the *sakkos* occasionally worn by Christ, the bent pose and cupped hands of the apostles, and the cloth held by the angel-deacon under the chin of the communicant all reflected contemporary experience. The stately procession of figures who approached Christ at a painted chancel screen mirrored the actions of the faithful, who lined up to receive the offerings at the sanctuary opening from the hand of Christ's surrogate, the officiating priest.

The centrality of the eucharist to the sacramental life was an article of faith to Byzantine authors and theologians.[43] Yet the rise to prominence of the Communion of the Apostles coincided with the period when the laity communicated infrequently. Scholars have suggested that by the medieval period most Byzantines no longer participated in weekly communion.[44] The method of administering the sacrament had also changed. In Early Christian times, the clergy and laity took communion from separate elements. By the eleventh century, as we may infer from accusations leveled by Humbert, the Latin cardinal of Silva Candida, the Orthodox laity received the two elements from a spoon after they had been mixed in the chalice. With great sarcasm, Humbert asked, "Then, how do you defend the fact that you are accustomed to receive the bread of eternal life intincted in the chalice? For the Lord himself did not intinct the bread in the chalice of wine, giving it in that way to the apostles and saying: 'Take and eat *with a spoon,* this is my body.' "[45] By the fifteenth century the difference between lay and clerical communion was sufficiently clear in church ceremony for Symeon, archbishop of Thessalonike, to include a chapter in his liturgical commentary entitled "For what reason do the priests take the mysteries inside the sanctuary with their hands and lips, whereas the laity receive outside the sanctuary with a communion spoon?"[46]

The clergy, unlike the laity, took the eucharistic elements separately; the transformed bread was placed in their hands and they drank directly from the eucharistic chalice. Writing in the late twelfth century, Leo Tuscus described the communion of the clergy in his translation of the Liturgy of Chrysostom, a work intended to make the Eastern liturgy more comprehensible to the Latins. One section describes the manner in which Orthodox concelebrants receive communion in the sanctuary: "Bowing before the holy altar simultaneously, each eats the flesh of the Lord. In like manner they extend the chalice to one another in order to drink the blood of the Lord."[47]

The representation of the apostolic communion appears to reflect, most closely, the experience of the clergy. Considering the location of the scene within the confines of the sanctuary, the link between the apostolic and clerical communion seems fitting. On at least one occasion, however, a painting reflects a certain amount of confusion over the manner of receiving communion. In the fourteenth-century decoration of the church of the Archangels at Lesnovo, Peter is given the wine by means of a liturgical spoon instead of drinking directly from the chalice (Fig. 83).[48] The inclusion of the spoon in the scene of the apostolic communion is rare; the apostles generally receive the elements directly from Christ's hand in the manner of the clergy. The scene at Lesnovo may be an attempt to synthesize the actual experience of both lay and clerical communicant.

Another scene more accurately mirrored lay communion and, significantly, it was most often represented outside the sanctuary. It shows Mary of Egypt receiving the elements from the abbot Zosimas by means of a long spoon.[49] At Panagia Phorbiotissa at Asinou in Cyprus, Mary the Egyptian and Zosimas are depicted below the Annunciation on either side of the apse.[50] The spoon held by Zosimas curves around the wall and visually enters the space of the apse, a physical intrusion that places it directly below and juxtaposes it with the scene of apostolic communion in the central register of the apse (Figs. 77, 78). The two scenes of communion, both placed on the east wall of the church, clearly contrasted the forms of lay and clerical communion. The depiction of the communion of Mary of Egypt near the sanctuary is not unique to Cyprus. In the church of Samari in Messenia, images of Mary and Zosimas are found on the piers flanking the sanctuary below the framed images of Christ and the Virgin (Fig. 84).[51] The images at Asinou and Samari may have been intended for the faithful, who would view the communion scene as they approached the sanctuary to receive the sacrament. A related message was undoubtedly intended by the placement of St. Mary of Egypt and Zosimas *inside* the masonry icon screen at St. Nicholas, Geraki, a small church dated to the late thirteenth century.[52] Separate portraits of the two figures flank the opening of the sanctuary: Mary to the left and Zosimas to the right (Fig. 85). In his left hand Zosimas holds a chalice in which fragments of the eucharistic offering are clearly visible. His right hand, no longer preserved, is extended toward Mary and would have held a liturgical spoon. These images were seen by the priest as he exited the sanctuary to give communion to the laity. The priest was associated with the image of Zosimas just as the faithful were represented by the emaciated saint.

The Communion and Orthodox Politics

In certain regions the selection and representation of the Communion of the Apostles may have expressed the political and theological views of Orthodox churchmen concerning the proper (non-Latin) celebration of the sacrament vis-à-vis Latin practice. The number of churches featuring the Communion of the Apostles rises sharply by the late twelfth century and continues through the fourteenth century. This period begins with the volatile theological discussions of the late Komnenian period and extends through the Latin occupation of the Empire. Representations of the communion increase after the reconquest of Constantinople, a period in which anti-Latin polemical writings also flourished. Following the brief union of the churches affirmed by Michael VIII, Orthodox Christians may have realized that their salvation was in the hands of Christ and his ecclesiastical representatives rather than in those of the weakened emperors. As an image that expressed clerical authority, the Communion of the Apostles responded to the sentiments of the period.

As noted in chapter III, one major point of disagreement between the Latin and Orthodox churches was the issue of *azymes,* the unleavened bread used in the communion rite by the Western Church. This difference in ritual practice should not be underestimated, since bread was a symbol easily apprehended by the general populace. For the Orthodox, the use of *azymes* in the eucharistic celebration was tantamount to heresy. The controversy over *azymes* was heated in the eleventh century. At that time, Leo, archbishop of Ohrid and the patron of Hagia Sophia, wrote that "to observe *azymes* and sabbaths was ordered by Moses. But truly our Passover is Christ."[53] The issue continued to be a sticking point in the negotiations between the Byzantines and the Latins over Church unity, and the dispute dominated exchanges between the two churches, especially in the eleventh and twelfth centuries.[54] John, the twelfth-century patriarch of Antioch, noted that "the chief and primary cause of division between them and us is in the matter of *azymes.*"[55] For Niketas Stethatos, "to employ bread without leaven is to deny that Christ was God as well as man, and thus to fall into the heresy of Apollinaris."[56] The adoption of *azymes* for the eucharist was variously linked with a venerable succession of heretics: Nestorios, Manes, Paul of Samosata, Eutyches, Dioscorus, Severos, Sergios, and Pyrrhos.[57] The controversy over *azymes* did not end in the early twelfth century, but remained an important issue as the Orthodox reacted to the brutal behavior of the Latins, displayed especially in the sack of Thessalonike in 1185 and the conquest of Constantinople in 1204. Shortly after 1204, Constantine Stilbes, the metropolitan of Kyzikos, compiled a list of grievances against the Latins.[58] Among the complaints about the Western manner of taking communion were the following concerning the use of *azymes:* "They do not partake of a specifically sized bread and they do not divide it in order to distribute it in the manner in which the Lord gave it at the Last Supper. They partake of a type of unleavened dough in the form of a coin which the celebrant consumes without breaking it."[59] For Stilbes, the Latin rite was comparable to Jewish, Armenian, and heretical practices.[60] In 1283 the Byzantine patriarch Joseph I Galesiotis sentenced those who had taken com-

munion according to the Latin rite in the period when Byzantium was in Western hands. The patriarchal act recommended "suspending for three months bishops and clerics who have received communion from the Latins, and then inflicting on the laity penalties in accordance with their fault in the same affair."[61] In the fifteenth century, Symeon of Thessalonike also compares the Latins to Jews in their use of unleavened bread for communion, extending the metaphor that had been employed in earlier centuries.[62] The argument over the leavened or unleavened offering was not restricted to the high clergy, and this fact alone suggests that bread could be used as a ready symbol to incite the population. A widely circulated Greek pamphlet of the late thirteenth century features a debate between two characters, an Orthodox bishop named Constantine Panagiotes and a Roman cardinal named Azymites (he of the unleavened bread). In the text a group of twelve cardinals proclaims that it has been sent by the Pope "so that all Christians may partake of the communion of the unleavened bread," after which the pamphlet adds, "which is of course a heresy."[63] The text then lists a number of Orthodox who, to their detriment, took the Latin form of the eucharist. The large number and variety of writings that circulated in the thirteenth century and after prove that the issue of *azymes* was central to theological and popular debate of the period. Although many have argued that the dispute over *azymes* was minor in comparison to the controversy over the *filioque,*[64] the offered bread constituted a symbol both tangible and easily understood.

Scholars have associated one of the earliest monumental representations of the apostolic communion, that located at Hagia Sophia in Ohrid, with the controversy over *azymes* (Fig. 5).[65] The patron of the church was the archbishop Leo, whose inflammatory letter of 1053 helped spark the entire debate.[66] In the scene at Hagia Sophia, Christ holds a large, round, stamped bread in his left hand. This clearly risen bread could in no way be interpreted as an unleavened host. In subsequent scenes of the Communion of the Apostles, the bread contained in the paten is visibly leavened, and the portion handed by Christ to the approaching apostle is clearly risen. The insertion of the *melismos,* most often represented as a living child, below the Communion of the Apostles further strengthened the idea that the offering was indeed living (risen).[67] Finally, the Communion of the Apostles displayed the proper method of communion as established by Christ himself. The representation linked the faithful to the long tradition of Orthodoxy that traced its roots to the very actions and teachings of Christ. At the same time, the subject depicted the practice of the liturgy through the inclusion of recognizable elements, so that each Christian could see the eucharistic incarnation carried out before him in paint and performance.

Apostolic Embraces in Macedonia

One striking variation in the manner of depicting the communion is found in four churches of Byzantine Macedonia. In a rare departure from the standard composition, two apostles interrupt their procession to the altar in order to turn and embrace.[68] This

detail is found in St. Panteleimon at Nerezi, St. John the Theologian in Veroia, St. Constantine in Svećani, and St. Nicholas in Manastir; it does not appear again in Macedonia after the end of the thirteenth century.[69] Its earliest appearance, in St. Panteleimon, occurs in the communion of the bread, where the procession of apostles continues from the central apse onto the north wall of the sanctuary. There the two apostles Luke and Andrew move toward each other, clasp hands, and exchange a kiss (Fig. 16). In St. John the Theologian in Veroia, the apostolic communion is located in the lower register of the sanctuary and immediately surrounds the central altar of the church and the celebrating priest (Fig. 31). The embracing figures, part of the communion of the wine, are located directly behind Paul, the apostle who leads the procession toward Christ. As at Nerezi, the apostles can be identified as Luke (on the basis of his curly reddish-brown hair and tonsure) and Andrew (Fig. 32). In St. Nicholas, Manastir, and at St. Constantine, Svećani, the embracing apostles are the last two figures in the communion of the bread. The frescoes of St. Nicholas have been lightly overpainted, but enough of the original inscription survives to identify the embracing figures as Simon and Bartholomew (Fig. 37). Bartholomew has dark hair and a beard, and Simon is slightly balding with white hair and a beard. The scene in St. Constantine, Svećani, has been published only in a line drawing (Fig. 35). Although it is clear that the last two apostles in the communion of the bread embrace, the poor condition of the frescoes makes their identification impossible. The four churches containing this representation were painted within a century and a half of one another, and all are located within a limited geographic region.

The appearance of the embrace in churches of Byzantine Macedonia is difficult to explain satisfactorily. Petar Miljković-Pepek proposes that as a gesture of peace the embrace was especially suited to Macedonia because so many Christian sects resided in the region.[70] In his analysis, however, he considers only churches located in the former Yugoslavian Republic of Macedonia. The addition of the representation from St. John the Theologian in Veroia suggests that churches containing this scene were found within a unified region that was fully within the borders of Byzantium. The audience for the scene was undoubtedly Orthodox and Byzantine.

The embracing apostles first appear in the communion scene at St. Panteleimon, Nerezi, a church decorated through aristocratic patronage. Its inclusion may suggest an iconographic tie to the Byzantine capital, but where in the capital it might have arisen is difficult to say on the basis of the available clues. The emphasis on Andrew may be related to his status as the apostolic founder of Constantinople's bishopric.[71] Simon and Bartholomew, the embracing apostles in Manastir, are often linked in the West, but rarely in the East. A common element in all of the sets of embracing apostles is the pairing of an elderly apostle with a more youthful follower of Christ. Such juxtapositions were common in Byzantine art and thought.[72] Formal connections between the embracing apostles in monumental painting and scenes representing the meeting of Peter and Paul are strong.[73] Close to the Nerezi figures in terms of style and location is the depiction of Peter and Paul embracing in a fragmentary late-twelfth-century fresco from the Vatopedi monastery on Mount Athos.[74] In miniature painting, the meeting of Peter and Paul is

found in a twelfth-century psalter in Athens.[75] In this book, Peter and Paul embrace in a pose that is nearly identical to the contemporary monumental representation at Nerezi. The borrowing of the formal elements from a scene generally associated with "spiritual brotherhood" and ecumenical peace would have been entirely appropriate for the sanctuary decoration of a monastic church.

Alteration of an important and fixed subject, the Communion of the Apostles, to include the apostolic embrace was an innovation that was more likely grounded in liturgical ceremony than in political or theological movements. Indeed, the embrace visibly mirrored two occasions on which concelebrants exchanged a kiss.[76] The first was the kiss of peace, which preceded the *anaphora*.[77] The exchange of this kiss is documented in a twelfth-century guide for the patriarchal service in Constantinople's Hagia Sophia. In the course of the liturgy, the bishop chants aloud:

> "Peace to all. Let us love one another." And when that is said the bishop bows to the holy altar, and after mounting the platform, kisses it; then, after descending and letting down his *phelonion,* he turns to the right side and stands there. And the priests come up, kiss first the holy altar, then the bishop's hand and right cheek, and one another in turn. And when the kiss is finished, [the bishop] turns again to the east, and when the deacon says, "The doors . . . ," the archdeacon says, "In wisdom, let us be attentive." [78]

In the early Church the reconciliatory and preparatory embrace was exchanged by the entire congregation. By the eleventh century, however, the practice had changed, and the kiss of peace was given only by the clergy.[79]

In the Byzantine Church, a second kiss, the *aspasmos* of the clergy, was specifically associated with the eucharistic sacrifice. According to Byzantine sources contemporary with the wall paintings under examination, the *aspasmos* of the clergy was exchanged when the priest received communion. The rubrics for concelebration in an eleventh-century service book (Grottaferrata, Gb II, f. 20r–v) direct priests as well as deacons to exchange the *aspasmos:*

> And the priest bows three times before the holy altar, and one of the concelebrating priests gives him one piece of the particles. And he in turn gives another piece to the priest. And they receive in like manner from the chalice, giving it to each other, and they kiss each other. And the second communicating priest stands to the right side of the holy altar holding the chalice, and the rest of the priests come up and receive and kiss him. Likewise the deacons, but the subdeacons and the rest of the clergy and the laity receive in the mouth and do not give the kiss. Likewise from the chalice.[80]

The twelfth-century rules for liturgical celebration in Hagia Sophia also link the *aspasmos* with the communion of the priests:

And after having divided enough and wiped and shaken his hands lest per-
chance a pearl [particle of sacred bread] be left on them, he [the bishop]
descends from the platform and bows three times to the east, saying to
himself, *"Your mystical supper. . . ."* With him bows the priest who is sup-
posed to give him communion, and both mount the platform and kiss the
holy altar. And first the bishop, having stretched forth his hands, receives.
Then holding the bread in the last two fingers, with the other three he
takes the other particle and gives it to the one that gave communion to
him, who, after receiving it, kisses his hand and cheek. And both descend
from the platform and after bowing down, consume the divine bread. Then
they wipe the hands clean on the *diskoi*. And the archdeacon gives the
chalice to the priest, and the bishop, after turning to him and bowing,
communicates. Then he turns to the east and wipes the lips clean with the
edge of the *eiliton* [cloth spread under the eucharistic gifts], and makes
three bows in thanksgiving. And after kissing the holy altar, he turns, and
the chalice is taken from the priest, and [the bishop] communicates him.
The priest, after receiving, bows to the bishop and kisses his right hand and
takes the chalice. And thus the bishop goes to the platform and gives com-
munion to those in the sanctuary.[81]

The description resembles the action taking place in monumental decoration, as in the
church of St. John the Theologian, where a procession to receive communion from the
hand of Christ is punctuated by the apostolic embrace.

In the churches surveyed, the celebrant would see his own actions during two
moments of the liturgy reflected on the walls of the sanctuary. This addition to the scene
was undoubtedly intended for a clerical audience. Considering the nature of an embrace,
the kiss of peace and the priestly *aspasmos* both depend on the presence of concelebrants.
A decrease in concelebration, however, caused a shift in the practice of the kiss of peace
that is first documented in the celebratory regulations *(diataxis)* of Philotheos (before
1347). According to this *diataxis,* which was widely disseminated in fourteenth-century
Byzantium but which reflected earlier practices, the practice of kissing the eucharistic
gifts was substituted for the kiss of peace at a liturgy without concelebrants. According to
Robert Taft, "By this time the *pax* was no longer exchanged among the people, and since
the Byzantine custom was to exchange the *pax* among members of the same rank, a
priest celebrating alone had no one with whom to exchange it, so the rite was simply
omitted."[82] In the absence of concelebrants, the painted kiss between apostles thus pre-
served a rite that had fallen out of use and allowed the priest to participate in a priestly
aspasmos, albeit notionally. As we have seen, the painted allusion to concelebration is also
present in the depiction of the celebrating hierarchs in the lower register of the sanctu-
ary, who, by means of their unrolled liturgical scrolls, symbolically join the living priest in
eucharistic performance.[83]

The apostolic embrace illustrated liturgical instructions for the priest. Yet its pres-

ence in Macedonian churches may have also reflected a subtle political agenda. Anti-Latin polemic of the middle Byzantine period includes a striking complaint against the Western Church that is relevant to the interpretation of the painted apostolic embrace. In this genre of ecclesiastical writings, the Western Church was often accused of unorthodox practice. As we have seen, charges were often leveled against the Latin manner of eucharistic celebration, especially against the use of *azymes,* the unleavened host. Michael Keroularios, the eleventh-century patriarch of Constantinople, expanded on this subject in condemning Latin practices: "During holy eucharist, at the time for taking communion, one of the celebrants eats the unleavened bread, and he kisses the others."[84] The charge that a eucharistic kiss substituted for the sacrament took hold of the anti-Latin polemicists. In the late twelfth century, Constantine Stilbes, metropolitan of Kyzikos, states that if the

> [Latin] celebrant should be bishop or priest, he alone takes communion from
> the offered bread, and he gives to the others, clergy or laity, the sacrament of
> communion by a kiss. What has happened in their church to the statement:
> "He who eats my body and drinks my blood will have life eternal?"[85]

A similar accusation was made by Meletios Galesiotes in the late thirteenth century. Among a long list of Latin heresies, Meletios charges that "They say, 'Take, Eat.' But their celebrants present a kiss instead of communion."[86] The Latin custom, as described in this source, runs directly against the Byzantine practice of combining the *aspasmos* with communion and may also reflect confusion over the different place held by the kiss of peace in the Eastern and Western liturgies. These accusations suggest that it is quite possible that the inclusion of the *aspasmos* in the wall paintings of Byzantine Macedonia was an assertion of a correct Orthodox practice in a time of anti-Latin sentiment. In the Macedonian scenes, the embrace is clearly related to the communion rite as described in instructions for liturgical celebration. The creation of iconographic details inspired by anti-Latin polemic was not new to this region. Already in the eleventh-century decoration of Hagia Sophia in Ohrid, the writings of Archbishop Leo had inspired alterations in the communion scene that have been interpreted as reflecting the rabidly anti-Latin stance of that prelate (Fig. 5). The insertion of the apostolic embrace in Macedonian painting may further reflect the artistic response to polemical literature in this region.

Eucharistic Betrayal and the Communion of Judas

The church of St. Athanasios tou Mouzake in Kastoria, painted in 1384/85, contains an unusual feature. Judas, the last apostle to approach and receive the bread, turns away from Christ as if to leave (Fig. 86).[87] This detail in the Communion of the Apostles recalls the treatment of Judas in several other Byzantine churches, where he hides the bread in his robe or secretly eats the offering.[88] In an earlier representation in Panagia Phorbiotissa at

Asinou, Judas, represented in profile, departs from the communion of the wine (Fig. 77).[89] Judas's betrayal of the sacred elements is demonstrated by the way his uplifted knee intrudes into the frame of the scene. His departure from the composition must have been deliberate, since the painter had to elongate and round out the upper leg in order for the knee to penetrate the frame. In this representation of the communion of the wine Judas exits with a piece of the blessed bread between his mouth and hand. He is juxtaposed through his bent pose with the apostle John, at the head of the procession, who leans over to drink from the vessel extended to him by Christ. Christ's eyes are focused on the departing traitor, and the viewer's attention is further directed to Judas by the gesture of the fifth apostle, who points with his right hand toward the escaping betrayer. A similar composition, although considerably damaged, is found in the Holy Apostles at Perachorio, Cyprus.[90] In the Cypriot churches, Judas is included in the communion of the wine, whereas in other regions, the communion of the bread is favored. In the communion of the bread in the sanctuary of Panagia Chrysaphitissa in Lakonia, Judas is represented in the foreground of the scene and painted in a smaller scale. While the remaining apostles turn toward Christ, Judas walks toward the left with the particle in his cupped hands.[91] The departing Judas also appears in several Cretan churches of the late Byzantine period.[92] In Panagia Gouverniotissa, in Potamies, dated by style to the second half of the fourteenth century, Judas, the last of the apostles in the communion of the bread, is depicted on the east wall outside, but adjacent to, the apse. Physically segregated from the apostles depicted within the apse, he turns his back in a pose that further isolates him.[93]

Judas's betrayal of the offered bread is based on John 13:21–30:

> When Jesus had thus said, he was troubled in spirit, and testified and said, Verily, verily I say unto you that one of you shall betray me. Then the disciples looked one on another, doubting of whom he spake. Now there was leaning on Jesus' bosom one of his disciples, whom Jesus loved. Simon Peter therefore beckoned to him, that he should ask who it should be of whom he spake. He then lying on Jesus' breast saith unto him, Lord, who is it? Jesus answered, He it is, to whom I shall give a sop, when I have dripped it. And when he had dipped the sop, he gave it to Judas Iscariot, the son of Simon. And after the sop Satan entered into him. Then said Jesus unto him, That thou doest, do quickly. Now no man at the table knew for what intent he spake thus unto him. For some of them thought, because Judas had the bag, that Jesus had said unto him, Buy those things that we have need of against the feast; or, that he should give some to the poor. He then having received the sop went immediately out: and it was night.

The separation of Judas from the other apostles in the Last Supper dates to a relatively early period in medieval art in the West, that is, well before the twelfth-century examples of the betrayal of the eucharist in the Byzantine communion scene. Ninth-, tenth-, and eleventh-century Western manuscripts represent Judas in the foreground of the Last

Supper, physically separated from the other apostles and distinguished as the sole figure without a nimbus.[94] The added detail finds a place, too, in monumental decoration. The depiction of the Last Supper in the Cathedral church of Monreale illustrates Judas flee-ing from the Communion of the Apostles with the hidden offering.[95] In this late-twelfth-century depiction, Judas stands apart from the remaining apostles as he lunges toward Christ to take the offered bread. A number of Western depictions of the Last Supper represent Judas with a small devil emerging from his mouth. It is possible, then, that the inclusion of the betraying Judas in the scene of the Communion of the Apostles may have been influenced by Western scenes of the Last Supper, as Klaus Wessel has suggest-ed.[96] That Judas appears in communion scenes in areas where interaction with the Latins flourished (Cyprus, Crete, Epiros) may support the transmission of this motif from the West to the East.

Another explanation may be proposed for the artistic emphasis on Judas's betray-al in Byzantine church decoration, both in the communion scene and as part of the nar-rative cycle illustrating the Passion. Judas's actions occupy a central place within the Orthodox readings for Holy Week. In the spiritual climax leading up to the Resurrection, the focus of matins, begun on the evening of Holy Wednesday, is the deception of Judas through his taking of the blessed bread. The sentiment created by the readings and the relationship between the bread and the betrayal are revealed by a prayer intoned at an early point in the morning ceremony: "The traitor takes the bread in his hands, but stretches them out secretly to receive the price of him who fashioned man with his own hands. For Judas, slave and deceiver, still repented not."[97] The prayer that follows stresses the correct way in which to approach the mystical table, the altar: "with pure souls let us receive the Bread." In subsequent prayers, Judas's betrayal of the eucharist is emphasized. The intended contrast between the communion of the faithful and Judas's corruption of that sacrament is glaring:

> O ye faithful, let none who is uninstructed in the mystery draw near to
> the table of the Lord's Supper; let none approach deceitfully as Judas. For
> he received his portion, yet he betrayed the bread. In outward appearance
> he was a disciple, yet in reality he was present as a murderer. He rejoiced
> with the Jews, though he sat at supper with the apostles. He kissed in
> hatred, and with his kiss he sold the God and Savior of our souls, who has
> redeemed us from the curse.[98]

Textual sources for the representation are revealed in a reading from the evening service on Holy Thursday:

> Truly is Judas to be numbered with the generations of vipers, who ate
> manna in the wilderness, yet murmured against Him who fed them;
> and while the food was yet in their mouth, in their ingratitude they spoke
> against God. So Judas in his impiety, still carrying in his mouth

the heavenly bread, went and betrayed the Savior. O ever-greedy heart!
O inhuman rashness![99]

Nicholas of Andida also interprets the verse from the Gospel of John in his mystagogical commentary and relates the Gospel passage to the sacrament and Judas's betrayal. His commentary echoes the passages read during Holy Week. For Nicholas, "whereas all of the apostles received the divine bread in their hands from the hands of Christ our God, and communicated with fear and with faith, only Judas hid (the bread) he had received, showed it to the Jews, and betrayed the mystery (to them)."[100]

The readings for Holy Week may have provided the impetus for the addition of Judas to the communion scene, and this liturgical source, familiar to all who attended services in the week before Easter, forms a plausible alternative to influence from the West. Holy Thursday was and remains one of the most important days for the faithful to partake in communion, and the prayers uttered against Judas were visualized in the fresco decoration of a number of churches.

Like the prayers held by the bishops in the lower register of the apse, the inclusion of the fleeing Judas points to the need for the celebrant to be prepared for the sacrifice. From the fourteenth century, according to Casimir Kucharek, a silent prayer was added to those read by the priests during the liturgy: "Receive me this day as a partaker of your mystical supper; for I will not kiss thee as did Judas, but as the thief I will confess thee: Lord, remember me when thou comest in thy kingdom."[101] It would seem that the inclusion of Judas in the painted communion would have been a potent reminder that the eucharist could be abused when the celebrant was not amply prepared. In many churches the scene of the communion was also visible to the laity above the sanctuary screen, and Judas's betrayal of the eucharist may have been a direct warning to those improperly prepared for the rite. The placement of Judas on the east wall adjacent to the sanctuary opening in Panagia Gouverniotissa made him nearly invisible to the clergy but all too obvious to those standing in the nave.

Conclusion

The Communion of the Apostles has one of the longest histories of any scene in Byzantine art, yet its entrance into the fixed program of the Byzantine church was noticeably delayed from the time of its introduction in the Early Christian period. By the thirteenth century the Communion of the Apostles was widespread in ecclesiastical decoration. In many cases, it was the scene viewed by the faithful immediately above the sanctuary screen, often visible even when the curtains had been drawn to obscure the mysteries of the eucharistic rite (Fig. 53). In representing the Communion of the Apostles in this location, painters explained to the faithful the mysteries that went on inside the sanctuary at the moment of the *epiklesis* and the communion of the clergy.

The apostolic communion formed part of an increasing number of scenes within the sanctuary that represented the actions of the clergy. By adding the apostolic embrace to the communion, painters incorporated regular clerical action into the historical scene. The appeal to the clergy was further demonstrated by the distribution of the apostolic communion in separate elements. Forbidden entrance to the sanctuary, the faithful saw themselves in the image of Mary of Egypt, a despised woman, relegated to the nave and narthex and receiving communion from the priest Zosimas by means of a long spoon. For them, the apostolic communion reflected an ancient type of ceremony that had been superseded by the commingling of bread and wine in a single chalice. When the faithful did take communion, often on Holy Thursday, it followed lengthy prayers relating Judas's betrayal of the eucharist, a betrayal that was incorporated into the representation in a number of Byzantine churches and into the preparatory prayers of the priest. The inscription in front of Panagia ton Chalkeon's apse tells the viewer to tremble, for within the sanctuary, "Christ is sacrificed daily and the powers of the incorporeal angels, celebrating, circle around in fear." Viewed by the faithful standing in the nave, the words of warning were illustrated in the program of the sanctuary, a space that was, in its increasing remoteness, shrouded in mystery.

V

Reviewing the Mandylion

In the church of Christ in Veroia a painted white cloth is suspended over the apse by two golden hooks that take the form of snakes (Color Plate V). In front of the cloth is represented the head of Christ entirely surrounded by a gold nimbus. The image, illusionistically rendered, seems to hang over the opening of the apse. Its placement before the sanctuary in an ancient monument would have been viewed as apotropaic. Indeed, residents of Veroia might have connected such an image with the carved keystone representing the head of a Gorgon that once adorned the entrance gate to their city. Placed at the center of the sanctuary dedicated to Christ, the image labeled as the Mandylion is but one of several Christological images aligned on a vertical axis that begins at the floor and ends at the gable below the roof. The relic, initially known for its healing powers, was associated with Christ's Incarnation. Here, as in many churches in Byzantium, its close proximity to the altar suggests new meanings.

The nature of church decoration is to translate sacred text, practice, and dogma into images. In Byzantium artists and patrons created a powerful decorative scheme that formed a significant core. By augmenting or reshaping this core, those responsible for the decoration of individual churches could create a range of associations. As we have seen in previous chapters, the location of the church, the composition of the congregation, the predilections of patron or painter, and the desire to express theological nuances were all factors that might influence the final form of a decorative program. Even subtle changes could alter long-established meanings and could elicit new readings from the Orthodox viewer. Innovations could include the rearrangement of narrative sequences, the insertion of new motifs into established compositions, and the addition of new saints into the ranks of the venerable. This chapter focuses on the consequences of the relocation of one image, the Mandylion.[1]

As one of Byzantium's most famous relics, the Mandylion was represented frequently in monumental decoration. In domed churches it was often depicted below Christ Pantokrator, between the two eastern pendentives. As a relic that served as tangible evidence for the Incarnation of Christ, the Mandylion contributed to the dome's dogmatic message.[2] But many Byzantine churches were built without domes. They, too, included the Mandylion in their decorative programs. In these churches the relic was represented over the apse. André Grabar, writing on monumental depictions of the holy relic, suggested that it was simply the absence of a dome that led to the image's dis-

placement to the east wall of the church.[3] Although its initial placement over the apse may have resulted from architectural necessity, the continuing presence of the image in that location suggests that it had been assimilated into a new visual complex. Its success there is not surprising. As we have seen, the period in which the Mandylion was placed on the eastern wall witnessed the development and dissemination of a program that elucidated the ritual activities that unfolded around the altar. When the relic was placed directly above the curve of the sanctuary's apse, it was linked visually and compositionally to a set of images collectively imbued with eucharistic significance. Furthermore, its placement within this most holy section of the church associated the painted relic with the rituals performed below, on the central altar. The Mandylion's medieval location within the sanctuary led to a subtle expansion of the relic's initial message of Incarnation. When located on the eastern wall of the church, the image obtained a second, complementary meaning related to the eucharistic sacrifice.

The Incarnation and the Mandylion

The history of the Mandylion has been studied at length.[4] Beginning with Eusebios of Caesarea, sources relate how Abgar of Edessa sought Christ's healing assistance.[5] Instead of appearing before the king, Christ sent him a cloth impressed with his likeness, the Mandylion. The king was cured by the holy cloth, which came to be venerated as an *acheiropoietos,* a miraculous image "not made by human hands." The relic's status was further enhanced and its mystique augmented by its discovery, in 544, within the city gate of Edessa. Found by a local bishop during a time of intense political and religious controversy, the Mandylion was credited with saving Edessa from military threat. Even at that early time reproductions were made of the holy relic. According to the Chronicle of Michael the Syrian, the sixth-century prince Athanasios commissioned an exact copy:

> Then, he came to a very skillful painter and asked him to paint a similar image. This was thus accomplished, and there was another image with a likeness as perfect as possible, since the painter had soiled the colors of the image, in the manner of those ornamented in former times.[6]

The copy made for Athanasios was so faithful that he was temporarily able to exchange the two representations. The miraculous cloth remained in Edessa until 944, when John Kourkouas, a general under Emperor Romanos I Lekapenos, laid siege to the Arab-controlled city. In the settlement made with the emir, the relic was restored to Orthodox possession. With great ceremony the Mandylion was transported to Constantinople, where it arrived on August 15, the feast of the Dormition of the Virgin. The relic was subsequently installed in the Pharos chapel of the Great Palace, and it remained there until it was taken to the West in the aftermath of the Fourth Crusade.[7]

Chapter V

The translation of the Mandylion to Constantinople, in 944, was undoubtedly the cause of its introduction as a subject in various artistic media. Soon after the translation, a reference to the Mandylion appeared in the *Life* of St. Paul of Latros.[8] Written not long after the saint's death in 955, the *Life* describes how Paul requested the emperor Constantine VII Porphyrogennetos to place a cloth over the relic and send it to him. The saint was able to see the transfigured image while all other viewers beheld an unmarked cloth. The establishment of a feast to honor the relic (August 16) and the composition of a treatise on its translation, historically attributed to Constantine VII, led to the proliferation of copies. Two triptych wings, now framed as a single icon in the monastery of St. Catherine on Mount Sinai, present the earliest surviving representation of the relic, dated by Kurt Weitzmann to the tenth century.[9] The upper register of the right-hand panel depicts King Abgar holding the healing cloth. Within a century and a half, the Mandylion was represented in five manuscripts, including a sermon on the translation, which was illustrated in the twelfth century with the head of Christ in front of a fringed, patterned cloth.[10]

In the eleventh century, patrons and painters introduced the relic into the decoration of the Byzantine church. Judging from the surviving evidence, the Mandylion first entered the program of the *diakonikon* chamber or the prothesis niche. Three Cappadocian churches of the eleventh century, Karanlik kilise, Chapel 21, and St. John (Sakli kilise) in Göreme, display the image of the Mandylion in secondary liturgical spaces. As Nicole Thierry has observed, the positioning of the image in the pastophoria is indicative of the early date of the programs.[11] As we have seen, the Communion of the Apostles followed a similar pattern; the scene was first placed in the pastophoria in the eleventh century and was then moved to the walls of the central sanctuary.[12] The painted representations of the relic soon found a new location. Within a century, the relic was relocated to the narrow space between the two eastern pendentives in domed churches or on the eastern wall above the apsidal opening in those without domes.[13] Represented in the upper registers of the decorative program, the Mandylion was visually linked with images that were associated with Christ's Incarnation. At the base of the dome, for example, the relic formed a visual bridge between the Pantokrator above, the evangelists in the flanking eastern pendentives, and the Virgin and Child in the conch of the apse. In this decorative scheme, the Pantokrator represents the incarnate God; the evangelists, the witnesses of the Incarnation; and the Virgin, the vessel through which he became flesh. Depicted on the east wall of the church, directly above the opening into the apse, the relic became associated with a different set of images that also carried an incarnational message. For example, beginning in the twelfth century, painters in several regions of the Empire placed the Mandylion between the two halves of the Annunciation, the event that announced the incarnation of the Logos.[14]

Theological writings confirm the relic's significance as an emblem of the Incarnation within the decorative program of the church. The canon of the Mandylion attributed to the eighth-century patriarch of Constantinople, Germanos, contains numerous allusions to Christ's assuming human form, as does a later canon for the feast of the

70

Mandylion composed around 1100 by Leo of Chalcedon.[15] Such canons suggest that the connection between the Mandylion and the Incarnation would have been understood by the faithful who attended the yearly commemoration of the relic's translation. Sung during church celebration, the hymns of Germanos and Leo of Chalcedon served to fix the meaning of the image within the minds of the Orthodox. But those who were incapable of reading or hearing the canons had only to look at the position of the Mandylion below the Pantokrator or in the midst of the Annunciation to understand the association between the relic and the incarnate Christ.

The Mandylion and the Eucharist

An artistic and liturgical tradition related the Mandylion to the Incarnation, but the location on the east wall created visual associations with a new set of images in a different architectural context. The churches that display a representation of the Mandylion on the east wall are relatively small in size. Many served as family or parish churches. Without the vertical interruption of a dome, the apse was the focus of the decorative program, and the viewer's eye could apprehend in a single glance the decoration of the entire east wall, Mandylion included. Depicted as a real cloth, complete with folds and fringes, and painted in stark white on a deep blue background, the relic seems to billow over the sanctuary opening. The draped form of the painted Mandylion leads the viewer's eye naturally to the conch of the apse and from there to the curve of the sanctuary wall immediately below. As we have seen, by the twelfth century the sanctuary was separated from the laity by a tall screen; the Mandylion was located above, but behind, this partition. Behind the barrier, the sanctuary was decorated with scenes that graphically illustrated eucharistic sacrifice and liturgical performance. Eucharistic links were thus forged by the physical placement of the relic within the precinct of the sanctuary. As we shall see, the Mandylion was more strongly associated with the eucharistic sacrifice when it was placed in the lower registers of the sanctuary decoration, effectively replacing images such as the *melismos*. Moreover, the detailed representation of the cloth relic had the potential to relate, through a complex associative process, to numerous textiles used for the eucharistic sacrifice and liturgical celebration.

The late-twelfth-century church of St. Nicholas tou Kasnitze in Kastoria is one of the earliest churches to incorporate the Mandylion into the sanctuary program (Fig. 23). In this small church, built by Nikephoros Kasnitzes and his wife, Anna, the Mandylion forms a central point dividing the two halves of the Annunciation. The relic is represented as a white, rectangular cloth suspended from its gathered ends.[16] Above the relic is the Deesis, the visualization of the process undertaken by the faithful through their intercessory prayers. Directly below the Mandylion, in the conch of the apse, is the orant Virgin flanked by archangels. On the curved wall encircling the altar table, six bishops extend liturgical scrolls and converge on a painted altar, mirroring the actions of the priest. In his study of the Mandylion, André Grabar cites the fourteenth-century church

of St. Peter at Berende in Bulgaria as the first to include the Mandylion on its eastern wall. It is clear from the representation in Kastoria, however, that the relic appeared in this position at least two centuries earlier.[17] This chronological change is significant, since the relic's appearance in St. Nicholas tou Kasnitze corresponds to the period when the decorative program of the Byzantine sanctuary was developing an explicitly eucharistic and liturgical message.

The early date of this representation affects our understanding of the exchange of certain motifs between Byzantium and the West. The Mandylion depicted in Kastoria, and in a number of other Byzantine churches in Macedonia, takes the form of a suspended cloth onto which the face of Christ has been superimposed. According to Grabar, this manner of depicting the Mandylion was introduced only in the middle of the thirteenth century and probably was imported from the West.[18] The presence of the Mandylion in the church of St. Nicholas tou Kasnitze, already from the end of the twelfth century, suggests that the image was, in fact, of Byzantine origin.[19]

As we have seen, the eleventh and twelfth centuries witnessed substantial changes in the decoration of the sanctuary program. Painters drew upon the performance of the liturgy and liturgical theology, rather than the Gospel text, to create a new, energized program for the space surrounding the altar. This period saw frontal portraits of bishops replaced by figures in an active three-quarter pose. Closed Gospel books were exchanged for open liturgical scrolls inscribed with prayers actually read by the priests. These painted figures, who perpetually celebrated the liturgy, often were joined by the scene of the apostles taking communion from Christ's hand. Such images were appropriate to a space that was accessible only to the clergy, and they mirrored clerical ritual with surprising exactitude. To these scenes was added, in the late twelfth century, the graphic representation of Christ laid on the liturgical paten as the eucharistic offering (the *melismos*). In their entirety, the sanctuary images formed a painted program that simultaneously reflected and illuminated the performance of the eucharistic sacrifice. The images provided liturgical exegesis for the clergy and guided the laity in corporate devotions. As part of this program of liturgical content, the Mandylion became associated directly with the bloodless sacrifice of Christ. A eucharistic reading for the relic is supported by both visual and textual evidence.

The painted program of St. Nicholas Orphanos in Thessalonike demonstrates how the Mandylion could be subsumed into the eucharistic message of the sanctuary. In this early-fourteenth-century church, the Mandylion unites two discrete halves of the apostolic communion. With the curtains of the icon barrier closed, only these three compositions and the Virgin in the conch of the apse would have been visible to lay viewers in the nave (Fig. 53).[20] When the sanctuary curtains were open, the Mandylion crowned a sophisticated program of concelebrating bishops who converge on a small figure of Christ, the eucharistic sacrifice (Fig. 56). The epithet inscribed around the Virgin in the conch of the apse, "Mother of God, the *Acheiropoietos*," is unique to this church.[21] Scholars have suggested that the inscription was related to an icon that may have been housed in a nearby church, but it is equally possible that it referred to the collected symbols of the

incarnate Logos that surround the Virgin: the Mandylion, one of the most revered *acheiropoietoi,* and the bloodless sacrifice represented in the Communion of the Apostles above and the child Christ as the oblation below.

Literary evidence, though scarce, may support the connection between the Mandylion and the bloodless sacrifice visibly offered in images. An anonymous Greek text, probably written in Constantinople shortly after the translation of the relic in 944, describes a feast held in Edessa on the Sunday before the first week of Lent.[22] The account offers symbolic parallels between the procession of the Mandylion and the Great Entrance, the sacred procession in which the eucharistic offerings were carried to the main altar. During the course of the ceremony, the bishop, clergy, and laity would gather in the *skeuophylakion,* where the Mandylion was placed on the throne on which it was transported into the sanctuary, preceded by incense and candles. Arriving at the sanctuary, the image was placed on a special table set up to the east of the altar. According to the text, the table was "smaller on the one hand, but on the other hand higher" than the central altar. Here,

> while the Eucharist was taking place, and after everyone had partaken
> of the Holy Communion, the bishop alone was allowed to approach
> the holy and immaculate image, venerate it, kiss it, and after that lift
> from it the white cloth [that had covered it] and replace it with one
> of a purple color.[23]

In a second ceremony described by the anonymous author, the relic is wiped with a sponge, and the damp liquid on the sponge is sprinkled over the faithful.[24] At the end of the description of these rituals, the author explains the symbolic meaning of the ceremony:

> In this way, the coming forth of the holy and *acheiropoietos* image of Christ
> was celebrated with procession and spectacle. We do not know the reasons
> and causes. As far as we can understand, by the throne is represented the
> power of the divinity over all; by the scepters, the greatness of the power of
> the kingdom of heaven; by the *rhipidia* is symbolized the reverence of the
> seraphim and cherubim towards the divinity; by the incense and censers is
> underscored the mystical and ineffable fragrance of the myrrh which was
> emptied for us. The candles allude to the dwelling in the eternal and inac-
> cessible light. . . . And what is meant by the placement of the image inside
> the sanctuary and the secret ceremony? These elucidate his sacrifice in
> flesh on our behalf and his willingness to undergo the Passion and death.[25]

The text uses language similar to that employed by mystagogical authors to comment on the Great Entrance, and it describes actions that parallel the celebrant's for the eucharistic service. For example, in the early fifth century, the Syrian theologian Theodore of Mopsuestia described the procession of the bread and wine into the sanctuary:

We must therefore think of the deacons who (at the offertory) carry the
Eucharistic bread and bring it out for the Sacrifice as representing the
invisible hosts of ministry but with this difference: that through this min-
istry of theirs and through these memorials they do not send Christ our
Lord to his salvific Passion. When they bring up (the offering) they place it
on the altar in order to complete the representation of the Passion so that
we may think of him on the altar as if he were placed in the sepulcher after
enduring his Passion. This is why by spreading the linens on the altar the
deacons portray (to us) the figure of the linen cloths at the burial. . . . They
stand on both sides and fan all the air above the holy body with fans . . . by
this they show the greatness of the body which is lying there.[26]

Similar language was used in the widely circulated mystagogical treatise attributed to
the eighth-century Constantinopolitan patriarch Germanos, the presumed author of one
of the canons on the Mandylion:

By means of the procession of the deacons and the representation of the
fans, which are in the likeness of the seraphim, the Cherubic Hymn signi-
fies the entrance of the angelic hosts, who run invisibly in advance of the
great king, Christ, who is proceeding to the mystical sacrifice, borne aloft
by material hands. Together with them comes the Holy Spirit in the
unbloody and unreasonable sacrifice. The Spirit is seen spiritually in the
fire, incense, smoke, and fragrant air: for the fire points to his divinity, and
the fragrant smoke to his coming invisibly and filling us with good fra-
grance through the mystical, living, and bloodless service and sacrifice of
burnt-offering. In addition, the spiritual powers and the choirs of angels,
who have seen his dispensation fulfilled through the cross and death of
Christ, the victory over death which has taken place, the descent into hell
and the resurrection on the third day, with us exclaim the alleluia.[27]

The procession of the Mandylion is seen in the same symbolic manner and described
with the same rhetorical language as the entrance of the eucharist. The entrance from the
skeuophylakion may be equated with the Great Entrance, which began in the prothesis
chamber. In these three texts, both the cloth image of Christ, when placed on the sec-
ondary altar, and the blessed elements stand for the sacrificial death of Christ, re-
presented in the celebration of the eucharist. The placement of the painted Mandylion
over the altar of the church reflects its interpretation as an image of eucharistic sacrifice.

In the last centuries of Byzantium the Mandylion was placed on the east wall of
numerous churches. In several, however, the relic was included in the decoration of the
lower registers of the sanctuary. In these churches, all dated to the thirteenth century,
the Mandylion replaces or is adjacent to the *melismos*. As Tania Velmans has noted, the
replacement of one image for another suggests that both shared an equivalent mean-

ing.[28] In St. Barbara in Khé, a thirteenth-century Georgian church, the Mandylion is painted on the wall behind the altar, the position normally reserved, as we have seen, for the *melismos* (Fig. 87).[29] In the thirteenth-century domed church of the Savior in Geraki, the relic is placed in the center of the apse, not at the base of its dome (Fig. 88).[30] Here the representation is located in an intermediate register, suspended over the double window between the celebrating hierarchs, directly below the dual altar in the Communion of the Apostles and above the *melismos*. In the same century, in St. Nicholas tes Rhodias near Arta, the Mandylion is situated below the central apse window, the position generally reserved for the *melismos*.[31] In these thirteenth-century churches, the consistent positioning of the Mandylion in the lower registers of the sanctuary establishes programmatic, iconographic, and symbolic associations between the Mandylion and the other images of eucharistic import.

When the Mandylion was represented in the sanctuary program, its primary message of Incarnation was therefore supplemented by its close proximity to images directly concerned with eucharistic sacrifice. The meanings were not incompatible, since Christ assumed flesh in every eucharistic liturgy. This second interpretation of the Mandylion, as an image of Christ's sacrifice, was in accord with continuing discussions over eucharistic theology in medieval Byzantium. Such discussions were especially heated in the time when the Mandylion was first placed on the east wall of the church.[32]

The Relic as a Liturgical Cloth

The Mandylion's association with the sanctuary program, and its interchangeability with subjects of specifically eucharistic significance, enabled the viewer to amplify and refine his grasp of the Incarnation. A final association may support the eucharistic interpretation of the Mandylion. In monumental programs, such as in St. Nicholas tou Kasnitze, the painted relic appears to billow over the sanctuary opening, the effect achieved by the illusionistic rendering of the relic as a starkly white, gathered cloth set against the deep blue background of the painted wall (Fig. 23). The precise rendering of two hooks solidified the impression that the Mandylion was not a painted facsimile, but an actual cloth that was suspended over the most holy section of the church.

For the medieval Orthodox viewer, decorated textiles would have had certain associations within an ecclesiastical context.[33] A poetic connection between the communion service and a white cloth is established in a vision recounted in the *Life* of St. Elizabeth the Wonderworker. In this fourteenth-century text, the cloth is seen descending to the altar during the eucharistic liturgy:

> Once, while the divine liturgy was being celebrated in the church, she had
> a vision. An ineffable light flashed round about and the All-Holy Spirit, in
> the form of a blinding white linen cloth, descended into the sanctuary after

the Cherubic Hymn [had been sung] and circled round the priest before coming to rest before the holy altar.[34]

The veiling and unveiling of the host and other objects associated with eucharistic celebration was strictly guided by liturgical rubrics, as were the opening and closing of the curtains that obscured the sanctuary to the faithful. Each movement was understood to have symbolic value. Germanos of Constantinople, for example, associated the liturgical cloth *(aer)* that covered the eucharistic offerings with burial, sacrifice, and incarnation:

> The veil, or the *aer*, corresponds to the stone which Joseph placed against the tomb and which the guards of Pilate sealed. The apostle speaks thus about the veil: "We have confidence to enter the sanctuary by the blood of Jesus Christ, by the new and living way he opened to us through the veil, that is through his flesh, and since we have a great priest over the house of God."[35]

The veil is linked to the flesh of Christ just as the Mandylion is linked with the Incarnation and sacrifice of that flesh. For Symeon of Thessalonike, writing some centuries later, the *aer* "also represents the shroud."[36] From the twelfth century onward, the embroidered decoration of the *aer*, with such symbols as Christ as the eucharistic offering, made the visual association of cloth and sacrifice manifest.[37]

The *epitaphios*, a type of *aer* developed in the late Byzantine period, was carried through the church during the *orthros* service of Holy Saturday. Embroidered with an image of the dead Christ, the cloth was deposited in a specially constructed "tomb" in the center of the church in order to dramatize his burial for the faithful. The fourteenth-century *epitaphios* from Thessalonike is divided into three panels surrounded by a decorative border (Fig. 89).[38] In the center, angels lament the dead Christ. The two side panels depict the Communion of the Apostles. The gold-embroidered program of the Thessalonike *epitaphios* unites medium and meaning: the textile, the image of the dead Christ, and the double representation of the Communion of the Apostles associate the cloth with Christ's eucharistic sacrifice. In monumental painting, the *epitaphios* appears in the sanctuary of the late-twelfth-century church of Zoodochos Pege (Samari) in Messenia, below the Virgin and Child in the apse (Fig. 90).[39] In this unique placement, the dead Christ is laid out on a cloth fringed at either end. The inscription above the image, "He who eats my flesh and drinks my blood abides in me and I in him," recalls the liturgical invocations "Take, eat," and "Drink" before communion. As textiles, the *epitaphios* and the Mandylion have a common sacrificial connotation.

The placement of the *epitaphios* in the monumental program of the sanctuary at Zoodochos Pege, and its accompanying inscription, associates the representation with eucharistic sacrifice. As with the painted *epitaphios,* the emphasis on the fabric in monumental representations of the Mandylion, seen in the detailed rendering of fringes, woven stripes, and ornate folds, evokes the metaphoric and metonymic associations of veil and

flesh, relic and sacrifice. The eucharistic significance of both the painted Mandylion and the *epitaphios* would have been obvious to any viewer who participated in the life of the church.

In the Byzantine church, the eastern wall above the conch of the apse was reserved for a prescribed number of images that contributed to the sanctuary program. The Mandylion embodied two messages stressed by this program: Incarnation and sacrifice. In association with the Annunciation flanking the arch and with the Virgin and Child in the conch of the apse, the Mandylion forms one of the proofs of the Incarnation. From the end of the twelfth century, however, the Mandylion was given an explicitly eucharistic significance, complementary to, and expanding on, its primary meaning. The symbolism of the relic was itself transformed by its placement over the sanctuary opening, and its meaning enlarged through its depiction in place of the *melismos*. The illusionistic rendering of the cloth further associated the relic of the Mandylion with textiles used in the liturgy. While the Mandylion's initial placement on the east wall might have resulted from the absence of a dome in some churches, the consequent expansion of its visual and textual associations resulted in its long-term integration into the developing sanctuary program.

VI

Conclusion

For centuries the church building has housed rituals that are central to the life of the Orthodox Christian. Upon entering the church, the faithful see themselves reflected in the portraits of male and female saints, who are invoked for protection from enemies, healing in the place of physicians, and salvation in the afterlife. Within the church nave, narrative scenes mark the celebration of feasts and urge adherence to the Lenten fast through the example of Christ's Passion. Church decoration provides lessons for the faithful who see in the story of Christ and his saints models for their own daily struggles. Depending on the composition of the church congregation, the paintings on the nave walls vary enormously.

This study has focused on the decoration of the sanctuary in medieval Byzantium. Unlike those parts of the church that were accessible to all, it followed a relatively consistent decorative scheme, a type of painted template. The motivation for the creation of this painted program was provided by its audience. By the period under discussion, only ordained men were permitted entrance into the sanctuary; it was for them that the decoration was intended. This book has introduced a number of writings germane to an understanding of the sanctuary program; three, in particular, stand out. The decoration of the lower registers of the wall immediately surrounding the altar is best understood through the liturgy and liturgical rubrics for the priest. The words of the service, divided into prayers spoken aloud on behalf of the faithful and those spoken in a quiet tone for the spiritual benefit of the celebrant, inspired the decoration. As we have seen, the painted celebrants hold scrolls, inscribed with preparatory and consecratory prayers. The words the priest spoke before he distributed communion are inscribed over the heads of the apostles who approach Christ. Judas's betrayal of Christ has been related to the hymns read in churches during Holy Week. The priestly kiss and communion by means of a spoon represent actual practices. The knowledge of the liturgy that the faithful brought to the church gave them an intuitive understanding of its decoration.

Painters and the clergy they served read liturgical commentaries that were written by churchmen from Thessalonike, Constantinople, and elsewhere. We have seen the influence of commentary in the representation of the Ark of the Covenant over the sanctuary or the painted throne within it. These commentaries also provide a means for the modern viewer to approach the church and its spatial divisions.

In the period under discussion, not every detail can be understood by reading the liturgy or liturgical commentary. Contact with the West provoked widespread debate

over the particulars of church ceremony. Among the points of contention were the use of leavened or unleavened bread for the eucharist, the place of the kiss within the communion rite, and who should have access to the sanctuary. Numerous polemical treatises survive and were apparently well known in the Byzantine empire. Discussions within Byzantium over the nature of the eucharistic sacrifice have also been shown to be relevant to church decoration surrounding the altar.

By the thirteenth century the program presented, at a glance, a familiar appearance. A Byzantine man or woman attending services away from home would have taken comfort in the representation of the church hierarchy. The sanctuary decoration was rich enough to allow communities or individual patrons to honor local saints and to change scenes in ways that addressed their unique devotional needs. While this book has addressed the overarching framework of the program created for this space, it has also pointed out its flexibility.

Time is suspended in the Byzantine church. Decorated with saints who gesture across empty space and speak to each other by means of scrolls, the church need not be inhabited by people to be fully active. The sanctuary decoration participates in this idea of the living church by mirroring actual celebration. Momentarily joined by the priest, the painted celebrants include him in their prayers. Candles rendered in fresco flicker on the walls flanking the sanctuary. Mary of Egypt pauses before crossing the sanctuary door to take communion from Zosimas. Inside the sanctuary all is prepared. The service is about to begin.

APPENDIX

Catalogue of Decorated Sanctuaries in Macedonia

T HE CHURCHES THAT FORM THE CORE of this study represent a wide range of architectural types: cross-in-square, single-aisled chapel, and basilica.[1] Their architectural diversity is a reflection of the variety of congregations they served, from monastic to metropolitan. Churches described below in Serres, Servia, and Ohrid served as the metropolitan seats. Single-aisled churches, such as those found in Kastoria and Veroia, were built by families, whose piety was expressed through the construction and dedication of small but handsomely painted churches. Such churches may have also functioned as burial sites for the members of the founding families. St. Panteleimon at Nerezi, St. Michael the Archangel in Prilep, and Holy Apostles in Thessalonike were built for monastic communities. The quality of the church decoration varied according to painter, patron, and region. The tastes of the local inhabitants and the date of the monument also factor into its appearance. In Macedonia, the Komnenian style was much loved and persisted well into the thirteenth century, outliving the dynasty that provided its name. It is possible that an allegiance to the Komnenian style in this region had some greater significance in the period when Constantinople was held by the Latins (1204–61). In the late thirteenth century a new painting style developed and was exported to other areas of Greece.[2] This style, which appears to have originated in Macedonia, was the product of a group of theologically astute painters, several of whom were trained in Thessalonike. The painters Panselinos, Michael Astrapas and Eutychios, Kallierges, and John have been associated with the decoration of a number of churches in the area.[3] The churches are presented chronologically. Whenever possible, artistic or programmatic influences have been indicated.

1. *Panagia ton Chalkeon, Thessalonike* (Figs. 1–3)

REFERENCES: Demetrios Evangelidis, *He Panagia ton Chalkeon* (Thessalonike: Ekdose Hetaireias ton Philon tes Vyzantines Makedonias, 1954); Karoline Kreidl-Papadopoulos, *Die Wandmalereien des 11. Jahrhunderts in der Kirche Panagia ton Chalkeon in Thessaloniki* (Graz: Bohlau, 1966); Paul Speck, "Die Inschrift am Apsisbogen der Panagia Chalkeon," *Hellenika* 20 (1967): 419–21; Anna Tsitouridou, "Die Grabkonzeption des ikonographischen Programms der Kirche Panagia Chalkeon in Thessaloniki," *JÖB* 32 (1982): 435–41; Anna Tsitouridou, *He Panagia ton Chalkeon* (Thessalonike: Hidryma Meleton Chersonesou tou Haimou, 1975); Wharton, *Art of Empire*, 106–11.

The church is dated to 1028 by a carved inscription on the marble lintel over the west portal:[4]

> This once profane place is dedicated as an eminent church of the
> Mother of God by Christopher, the most illustrious royal *protospatharios*
> and *katapan* of Longobardia,[5] together with his wife Maria, and their
> children Nikephoros, Anna, and Katakale. In the month of September,
> indiction 12, in the year 6537 (= 1028).

> + Ἀφηερόθη ὁ πρὴν βέβηλος τόπος εἰς ναὸν περίβλεπτον τῆς
> Θ(εοτό)κου παρὰ Χριστωφό(ρου) τοῦ ἐνδοξοτά(του) βασιληκοῦ
> (πρωτο)σπαθαρήου κ(αὶ) κατ(ε)πάνο Λαγουβαρδίας κ(αὶ) τῆς συνβίου
> αὐτοῦ Μαρίας κ(αὶ) τῶν τέκνον αὐτῶν Νικηφό(ρου) Ἄννης κ(αὶ)
> Κατακαλῖς μηνῆ Σεπτεμβρίο ἠνδ(ικτιῶνος) ιβ' ἔτ(ους) ,ϛφλζ'+

An inscription painted on the sanctuary arch also names the founders of the church and asks for the remission of their sins.[6]

The Panagia ton Chalkeon preserves one of the earliest multi-register sanctuary programs in Macedonia (Fig. 1). An inscription painted on the face of the eastern arch prompted the viewer to contemplate the sacred iconography of the sanctuary and to respond emotionally to its powerful paintings. The twelve-syllable verse, as reconstructed, may be translated:

> Beholding the sanctuary of the Lord's altar,
> Stand trembling, O man! [. . .]
> For within, Christ is sacrificed daily.
> And the powers of incorporeal angels, celebrating,
> Circle around it [the sanctuary] in fear.

> Ὁρῶν τὸ βῆμα τῆς τραπέζης Κ(υρίο)υ
> στῆθι τρέμων, ἄν(θρωπ)ε, [. . .]ς·
> Χ(ριστὸ)ς γὰρ ἔνδον θύεται καθ᾽ ἡμέραν
> καὶ [αἱ δυνάμει]ς ἀσωμάτων ἀγγέλων
> λειτουργικῶς κυκλοῦσιν αὐτὸ ἐν φόβῳ.[7]

The words refer to the eucharistic rite celebrated within the sanctuary as well as to the representation of the apostolic communion on the north and south walls (Fig. 3).[8] An identical verse was inscribed within the apse of the tenth-century basilica of St. Achilleios on the island of Prespa.[9]

 The conch of the apse contains a representation of the orant Virgin flanked by two archangels, whose bent pose and outstretched hands signify their reverence. The angels are dressed in tunics and mantles, the hems and edges of which blow mysterious-

ly toward the Virgin. The pose of the figures and the flow of the drapery focus the view-
er's eye on the central figure. An unusual addition to the composition is the hand of
God that descends from the upper border of the apse to bless the Virgin.

The intermediate register of the apse presents four saints: Gregory of Nyssa (Fig.
2), Gregory Thaumatourgos, Gregory of Akragas (Agrigentum), and Gregory of
Armenia. Each stands in a frontal pose and holds a Gospel book in his left arm. The
unusual clustering of four saints bearing the same name, in addition to their frontal
stance and plain *phelonia,* are elements consistent with the early-eleventh-century date
of the decorative program. At this time, as discussed in chapter II, a wide variety of
saints, all rendered in frontal pose, could be summoned for the decoration of church
sanctuaries.

Four half-length *anargyroi* are depicted within medallions painted across the lower
register of the apse (from left to right): John, Kyros, Hermolaos, and Thallelaeos. Standing
physician saints continue on the north wall of the sanctuary; the south wall, however, is
decorated with two unidentifiable hermit saints and John the Baptist. It has been sug-
gested that the selection of physician saints for the decoration of the sanctuary may reflect
either the close association of their cult to the Virgin or the patron's desire to invoke
their healing powers (Tsitouridou). The latter seems more likely since the church was
initially constructed as a burial chapel. Evidence for this function is provided by a tomb
built against the north wall of the nave, by an inscription in the sanctuary asking for the
"redemption and remission" of the sins of the donors, and by the subject matter repre-
sented in the dome (the Ascension) and narthex (the Last Judgment).[10] Considering that
the church was intended eventually to serve a funerary purpose, it is likely that the promi-
nent inclusion of physician saints in the church sanctuary reflected the patron's desire
for medical protection and assistance while still alive.[11] A similar selection of medical
saints for a church with a funerary component can be seen in the Holy Anargyroi,
Kastoria (see no. 8 below).

The Communion of the Apostles in Panagia ton Chalkeon is the earliest extant
representation of the scene in the central sanctuary of a Byzantine church. The com-
munion of the bread appears on the south wall and the communion of the wine direct-
ly opposite (Fig. 3). Through their placement on the side walls, the two halves of the
representation physically surrounded the altar and drew the celebrants into the ranks
of the holy.

The painting of Panagia ton Chalkeon establishes a benchmark, for it represents
a completely decorated sanctuary before the program was transformed to depict the
eucharistic celebration in a more direct fashion. The frontal position of the four
Gregories distances them from the celebrant. The paintings are iconic and function as
portraits of holy men or heavenly intercessors rather than as painted participants in
eucharistic celebration. Their prominent position in the program indicates that at the
time when this church was decorated the sanctuary was not the exclusive realm of the
holy episcopate, but could be entered by numerous saints who fulfilled specific votive
functions.

2. *Hagia Sophia, Ohrid* (Figs. 4–6)

REFERENCES: Nikolai Okunev, "Fragments de peintures de l'église Sainte-Sophie d'Ochrida," *Mélanges Charles Diehl* (Paris: E. Leroux, 1930), 2: 117–31; Ferdinando Forlati, Cesare Brandi, and Yves Froidevaux, *Saint Sophia of Ochrida: Preservation and Restoration of the Building and Its Frescoes: Report of the UNESCO Mission of 1951* (Paris: UNESCO, 1953); Radivoje Ljubinković, "La peinture murale en Serbie et en Macédoine aux XIe et XIIe siècles," *CorsiRav* 9 (1962): 413–22; André Grabar, "Les peintures murales dans le choeur de Sainte-Sophie d'Ochrid," *CahArch* 15 (1965): 257–65; Ann Wharton Epstein, "The Political Content of the Paintings of Saint Sophia at Ohrid," *JÖB* 29 (1980): 315–29; Cvetan Grozdanov, *Saint Sophia of Ohrid* (Ohrid: Zavod za zaštita na spomenicite na kulturata i Naroden muzej, 1988); Wharton, *Art of Empire*, 105–6.

According to an entry in a list of Bulgarian archbishops, the founder of Hagia Sophia in Ohrid was "Leo, first of the Romans, *chartophylax* of the Great Church [Hagia Sophia, Constantinople], founder of the lower church in the name of the Holy Wisdom of God."[12] Leo served as Ohrid's bishop from 1037 to 1056 and played an active role in the theological disputes between the Latin and Orthodox churches.[13]

The basilican plan of the eleventh-century Hagia Sophia in Ohrid and the unusual lengthening of its sanctuary enhanced the experience of the decorative program (Fig. 4). It is a sophisticated amalgam of images derived from both the Old and New Testaments. Despite innovations in the choice of subjects, certain aspects of the sanctuary program, such as the representation of Church hierarchs in frontal pose, betray the early date of the decoration.

The enthroned Virgin in the conch of the apse holds a small mandorla containing the Christ child in front of her chest. The representation of the child forms a stark contrast to the adult Christ depicted in the scene of the Ascension in the vault above. In both portraits, Christ is dressed in a gold robe, holds a closed scroll in his left hand, and raises his right hand in a benedictional gesture. The child Christ, however, also wears a deacon's scarf over his shoulder, a reference to his role in the eucharistic liturgy. On the side walls at the level of the conch, genuflecting angels in long friezes approach the Virgin and Child. These angels play the role described by the inscription crowning the sanctuary in Panagia ton Chalkeon; they are the companions and guides of the faithful who, at discrete moments of the liturgy, join the ranks of the holy by means of specific prayers and actions.

In the central register of the apse Christ stands behind an altar and chancel barrier as nimbed apostles approach from either side (Fig. 5). Two angels holding *rhipidia* assist in the ceremony. The scene has been interpreted (Wharton Epstein) as representing both the Communion of the Apostles and the *proskomide* (the preparation of the offerings). The latter identification is supported by comparing this scene to a similar representation that serves as the headpiece for the *proskomide* prayer in the Jerusalem Roll (Cod. Stavrou 109).[14] Moreover, scholars have noted that the round offering depicted in Hagia Sophia is stamped

in the center and complete, indicating that the *amnos* has not yet been extracted.[15] It seems unlikely that Byzantine viewers would have understood the representation to signify a specific moment of the liturgy. In all other ways, the scene conforms to scenes of the Communion of the Apostles found elsewhere, where Christ is approached by two lines of apostles who extend their hands to receive communion. If the scene were intended to represent the *proskomide,* we might have expected it to be located in the prothesis chamber.

Images placed on the side walls of the sanctuary at the same level as the communion seem to be designed to supplement the meaning of the central scene, although in ways that are difficult to grasp with any certainty. On the north wall of the sanctuary, St. Basil, author of the most commonly used liturgy of this period, stands over an altar and holds an open scroll inscribed with the words of the *proskomide* prayer from the liturgy that carries his name (Fig. 6). Next to him, in extremely damaged condition, is a representation of John Chrysostom receiving Holy Wisdom. The sanctuary of Hagia Sophia also includes Old Testament scenes typologically related to the eucharistic sacrifice: Abraham greeting the angels and the subsequent scene of the Hospitality, the Three Hebrew Children in the Furnace, Jacob's Ladder, and the Sacrifice of Abraham.

Six frontal bishops are represented in the lower register of the central apse: Gregory Thaumatourgos, Gregory the Theologian (Nazianzos), John Chrysostom, Basil, Athanasios of Alexandria, and Nicholas of Myra, all figures who were associated with the patriarchate of Constantinople. Those depicted in the pastophoria represent the remaining sees of Jerusalem, Antioch, Alexandria, and Rome.

Scholars have often praised the sophistication of the sanctuary program of Hagia Sophia. Indeed, the decoration includes a number of components never again used in this region. Typological scenes from the Old Testament, for example, are not typically found in the sanctuary decoration of Macedonian churches, although they occur occasionally outside this area.[16] The careful inclusion of bishops representing the five patriarchates and the emphasis on Constantinopolitan figures is also unusual and has been linked to Ohrid's political and ecclesiastical aspirations in the period when the church was decorated (Grabar, Wharton Epstein).

As in Panagia ton Chalkeon, the episcopal figures in Hagia Sophia do not participate in the liturgy but stand immobile in iconic frontality. The same distance is maintained in the scene of apostolic communion. Here the bread is not distributed to the apostles. Christ holds the visibly leavened offering, a detail that delivers a theological and political message rather than a liturgical one.

3. *Panagia Eleousa, Veljusa* (Figs. 7–9)

REFERENCES: Vojislav J. Djurić, "Fresques du monastère de Veljusa" *Akten des XI. Internationalen Byzantinisten-Kongresses* (Munich: C. H. Beck'sche Verlagsbuchhandlung, 1958), 2: 113–21; Miodrag Jovanović, "O Vodoči i Veljusi posle konservatorskih radova," *Zbornik na Štipskiot Naroden Muzej* 1 (1958–59): 125–35; Petar Miljković-Pepek, "Les

données sur la chronologie des fresques de Veljusa entre les ans 1085 et 1094," *Actes du XVe Congrès international des Études Byzantines* (Athens: Association Internationale des Études Byzantines, 1981), 2B: 499–510; Miljković-Pepek, *Veljusa;* Babić, "Les discussions," 368–86.

An inscription over the main entrance to the church provides the name of the church and states that it "was raised from its foundations by Manuel the Monk, Bishop of Tiberioupolis [Stroumitsa], in the year 6588 [= 1080], in the third indiction."[17] Djurić, Jovanović, and Miljković-Pepek date the apse decoration to 1080. Babić attributes the painting to the first half of the twelfth century. According to Miljković-Pepek, the wall paintings present the following chronology: the earlier layer of paintings dates to the initial construction of the church between 1080 and 1094. A second phase of painting is dated circa 1166/68 through stylistic analogies with the decoration of St. Panteleimon, Nerezi.

In the eleventh-century decoration of Panagia Eleousa, the Virgin Hodegetria dominates the conch of the apse (Fig. 7). The Christ child sits on her lap, raises his right hand in blessing, and gently rests his left hand on a closed scroll. The lower register of the sanctuary presents the unusual representation of four hierarchs: two in frontal pose and two in three-quarter pose. The bishops in three-quarter pose, John Chrysostom and Basil, hold liturgical scrolls inscribed with the First Prayer of the Faithful from the Liturgy of Chrysostom and the Second Prayer of the Faithful from the Liturgy of Basil (Fig. 9). The selection of these prayers differs from those John Chrysostom and Basil customarily hold in later churches.[18] The selection of texts supports an early dating of the program, before the Christological debates that influenced later art and the choice of the inscriptions held by the bishops.[19] Between the celebrating bishops is the *hetoimasia* (Fig. 8). The image is extremely damaged; only the right half of the cushion, a part of the dove, and a section of the Gospel book remain visible.

The discovery of fragments from the head of Christ turned in three-quarter position suggests that the second decorative phase of the sanctuary included the Communion of the Apostles (Miljković-Pepek, "Les données," fig. 4).

4. *St. Leontios, Vodoča* (Figs. 10, 11)

REFERENCES: Žarko Tatić, "Deux monuments de l'architecture byzantine dans la région de Strumica," *Skopsko Naučno Društvo. Glasnik* 3 (1928): 83–96; Petar Miljković-Pepek, *Kompleksot crkvi vo Vodoča: Del od proektot za konzervacija i restavracija na vodočkiot kompleks* (Skopje: Republički zavod za zaštita na spomenicite na kulturata, 1975).

The ecclesiastical complex at Vodoča, near Stroumitsa, consists of two earlier structures rebuilt in the late eleventh or early twelfth century to form a single cross-in-square church. I will discuss only the central church, since the evidence for the earlier churches is too fragmentary to permit a plausible reconstruction of its decorative program.

Referring to fragments depicting the lower portion of a platform, Miljković-Pepek suggested that an enthroned Virgin was originally represented in the conch of the apse. Only the upper sections of two bishops, identified as Gregory the Theologian and Basil the Great, remain from the register below the conch of the apse (Fig. 10). Miljković-Pepek proposed that these figures were full-length bishops in frontal pose. Sufficient evidence remains to reconstruct a frieze of genuflecting angels on the side wall of the sanctuary. On the south wall, below this frieze, are two standing bishops who hold closed Gospel books; Miljković-Pepek has identified one as St. Spyridon (Fig. 11). The wall paintings in this church are too fragmentary to allow any conclusion about the scope of the decorative program. The inclusion of a frieze of angels on the side walls of the sanctuary may, however, indicate associations with the decoration of Hagia Sophia in Ohrid (Fig. 4).

5. *Sts. Theodoroi (Old Metropolis), Serres* (Fig. 12)

REFERENCES: Paul Perdrizet and L. Chesney, "La Métropole de Serrès," *Monuments et mémoires publiés par l'Académie des inscriptions et belles-lettres: Fondation Eugène Piot* 10 (1903): 123–44, figs. 8–17; Ernst Diez and Otto Demus, *Byzantine Mosaics in Greece: Hosios Lucas and Daphni* (Cambridge: Harvard University Press, 1931), 106–16, figs. 122, 133; Anastasios Orlandos, "He metropolis ton Serron," *ABME* 5 (1939/40): 153–66; Angeliki Strati, "To sozomeno psephidoto tou apostolou Andrea apo ten Palaia Metropole Serron," *Makedonika* 25 (1985–86): 88–104.

A date of circa 1100–1110, based on style and iconography, has been generally accepted for the mosaic decoration of this church (Orlandos, Strati).

Only the figure of the apostle Andrew survives from the Communion of the Apostles, which once adorned the sanctuary of the metropolitan church of Serres. Old photographs and descriptions of the mosaic (Strati) indicate that Christ was depicted twice under a ciborium and was approached from either side by six nimbed apostles. Peter approached from the left to receive the bread, and a chalice was extended to Paul on the right.

6. *St. Panteleimon, Nerezi* (Figs. 13–16)

REFERENCES: Gabriel Millet and Anatole Frolow, *La peinture du moyen âge en Yougoslavie* (Paris: E. de Boccard, 1954), 1: fig. 15; Hamann-Mac Lean and Hallensleben, *Die Monumentalmalerei,* 1: 32–45; 2: 261–81; Petar Miljković-Pepek, *Nerezi* (Belgrade: Jugoslavija, 1966); Babić, "Les discussions," 368–86; Ida Sinkević, "The Church of Saint Panteleimon at Nerezi: Architecture, Painting, and Sculpture," Ph.D. diss., Princeton

University, 1994; eadem, "Alexios Angelos Komnenos: A Patron without History," *Gesta* 30, no. 1 (1996): 34–42.

The date of the church is provided by an inscription on a marble slab placed over the entrance to the nave:

> The church of the holy and renowned great-martyr Panteleimon
> was made beautiful through the contribution of kyr Alexios
> Komnenos,[20] son of the purple-born kyra Theodora, in the month
> of September, indiction 13, 6673 [= 1164], during the abbacy of
> Ioannikios.

> Ἐκαλλιεργήθη ὁ ναὸς τοῦ ἁγίου καὶ ἐνδόξου μεγαλομάρτυρος
> Παντελεήμονος ἐκ συνδρομῆς κυροῦ Ἀλεξίου τοῦ Κομνηνοῦ υἱοῦ τῆς
> πορφυρογεννήτου κυρᾶς Θεοδώρας. Μηνὶ Σεπτεμβρίῳ ἰνδικτιῶνος
> ιγʹ, ἔτους ͵ϛχογʹ ἡγουμενεύοντος Ἰωαννικίου[21]

The Virgin and Child in the conch of the apse were painted in the sixteenth century. The twelfth-century sanctuary decoration begins in the central register of the apse with the Communion of the Apostles (Fig. 13). Only two pairs of apostles and Christ were actually depicted within the apse; the rest of the scene continues on the side walls of the sanctuary. In the central portion of the apostolic communion, two angels dressed as deacons flank a ciborium and hold *rhipidia* over a paten (Fig. 14). Christ is represented once on either side of these angels; two other angels hold liturgical napkins under the chins of the approaching apostles, just as deacons did during the communion of the faithful. The pair of embracing apostles on the north wall of the sanctuary form an unusual component of this scene (Fig. 16).

John Chrysostom and Basil are represented in the lower register of the apse on either side of the *hetoimasia*. The liturgical authors wear *polystavria* and hold open liturgical scrolls. As in the communion scene in the central register, the episcopal figures continue on the side walls of the sanctuary; Gregory the Theologian and Gregory Thaumatourgos are located on the north wall and Athanasios of Alexandria and Nicholas on the south. The *hetoimasia,* similar to that in Veljusa, is represented below the central window of the apse and precisely behind the altar (Fig. 15). Flanking the throne are two half-length angels dressed as deacons and holding *rhipidia*. The artist depicted candles on the narrow face of the east wall flanking the apse.[22]

The Nerezi painter's predilection for beginning subjects in the apse and continuing them on the side walls is rare. Occasionally the celebrating bishops spill out of the apse, but lateral expansion of the Communion of the Apostles is unusual. By employing the side walls, the painter may have intended to emphasize the processional nature of the celebration.

7. *St. Michael the Archangel, Prilep* (Figs. 17, 18)

REFERENCES: Dimitar Ćornakov, "Les travaux de conservation et de restauration sur l'architecture et les fresques de l'église de St. Archanges près de Prilep," *Zbornik zastite spomenika kulture* 18 (1967): 93–98; Miljković-Pepek, "Contribution," 189–96.

Fragments from the small, single-aisled church of St. Michael the Archangel have been dated by Ćornakov to the second half of the twelfth century. The proposed date is supported by archaeological investigations into the construction phases of the building. Miljković-Pepek dates the painted fragments on stylistic grounds to the late twelfth or early thirteenth century.[23]

Wall paintings discovered during excavation of the church include the upper portions of two hierarchs turned in a three-quarter stance and holding open liturgical scrolls. From their portraits and pose we can tentatively identify them as Basil and Gregory the Theologian (Fig. 17). Another fragment belongs to the apostle Andrew from the Communion of the Apostles (Fig. 18).

8. *Holy Anargyroi, Kastoria* (Figs. 19–22)

REFERENCES: Pelekanides, *Kastoria,* figs. 5–14; Tatiana Malmquist, *Byzantine 12th-Century Frescoes in Kastoria: Agioi Anargyroi and Agios Nikolaos tou Kasnitzi* (Uppsala: Almqvist & Wiksell, 1979); Ann Wharton Epstein, "Middle Byzantine Churches of Kastoria: Dates and Implications," *Art Bulletin* 62 (1980): 190–207; Svetlana Tomeković, "Les répercussions du choix du saint patron sur le programme iconographique des églises du 12e siècle en Macédoine et dans le Péloponnèse," *Zograf* 12 (1981): 25–42; Pelekanides and Chatzidakis, *Kastoria,* 22–49 (with bibliography); Moutsopoulos, *Ekklesies tes Kastorias,* 368–91; Eugenia Drakopoulou, *He Pole tes Kastorias te vyzantine kai metavyzantine epoche (12os–16os ai.): Historia, Techne, Epigraphes* (Athens: Christianike Archaiologike Hetaireia, 1997).

Holy Anargyroi (Sts. Kosmas and Damianos) is a small, three-aisled basilica preserving three layers of wall painting. Representations in the narthex belong to the first phase executed at the beginning of the eleventh century (Pelekanides and Chatzidakis). The sanctuary decoration belongs to the second layer of painting; judging by style, it was executed in the late twelfth century, most likely in the 1180s (Malmquist, Pelekanides and Chatzidakis).[24] A third, though limited painting campaign is revealed in the thirteenth- or fourteenth-century votive portrait of a Kastorian nobleman represented in the north aisle of the church.[25]

The patron of the second decorative phase, Theodore Lemniotis, is depicted with his wife, Anna Radene, and their son, John, in the north aisle of the church.[26] An inscription in verse appears on the east wall of the narthex over the nave entrance; it reads:

Time, the sower and in turn the destroyer of all things has hastened to lay waste to your glorious house, holy dyad. I, your faithful and humble servant Theodore, offspring of the Lemniotis, fighting against the ravages of time, have succeeded in bringing forth the decoration of the church from the very foundations up to the roof. But in vain I restore your columns through the desire of my tripartite soul. I raise the house of the holy dyad [Kosmas and Damianos] hoping to find there *the ever-dewey grass and a place of the meek.*[27] And now, entreating to find the recovery of my ailing flesh and the gift of bodily health, and begging for this favor along with my wife and children.

Σπορεὺς ὁ πάντ(ων) καὶ φθορεὺς πάλιν χρόνος ἔσ|πευσε καὶ σοῦ τὸν περίκλυτον δόμον δυὰς ἁγία | τῇ φθορᾷ κατακλῦσαι ἐγὼ δὲ πιστὸς εὐτελὴς ὑμῶν λάτρις, | Θεόδωρος κλὼν Λημνιωτῶν ὀσφύος ἀντιπαλαίσας | τῇ φθορᾷ τῇ τοῦ χρόνου, βάθρων ἀπ᾽ αὐτῶν μέχρι καὶ στέγης | φθάνω τὴν εὐπρέπειαν τοῦ ναοῦ παριστάνων· | πλὴν ἐπὶ ἀδίκου σοῦ προσιστῶ τοὺς στύλους | τῷ τῆς ἐμῆς δὲ τριμεροῦς ψυχῆς πόθῳ σεπτῆς | δυάδος ἐξεγείρω τὸν δόμον σκηνὴν ἐκεῖσε τὴν ἀείδροσιν χλόην, εὑρεῖν δυσωπῶν καὶ τόπον | τῶν πραέων τὰ νῦν δὲ ῥῶσιν σαρκὸς ἠσθενημένης καὶ σω|ματικῆς δωρεὰν εὐεξίας τὴν χάριν αἰτῶν σὺν συνεύνῳ καὶ τέκ[νοις].[28]

The unusual height of the church creates additional decorative space on the east and west walls. The east wall is divided into numerous registers that are interrupted by architectural setbacks as well as by painted bands (Fig. 20). The Deesis is depicted in the uppermost register, and immediately below it, over the opening into the apse, is painted the Annunciation. The archangel Gabriel approaches from the left; the Virgin, on the right side of the composition, stands in front of a highly decorated throne and holds a spindle in her right hand. Between these two figures is a half-medallion containing the Ancient of Days. In the narrow vault over the apse is the *hetoimasia* and below this, a representation of Christ Emmanuel. In combination, these three images—the Ancient of Days, the *hetoimasia,* and Christ Emmanuel—represent the Trinity.

The height of the central aisle of the church results in an oversize representation of the enthroned Virgin and Child in the conch of the apse. The seated Hodegetria finds a close parallel in the Virgin and Child depicted in the contemporary church of St. George at Kurbinovo (Fig. 25).[29] As at Kurbinovo, the Virgin sits on an elaborate throne with her feet resting on a jeweled platform and cushion. She prevents Christ, rendered as an active child, escaping her embrace by firmly gripping his left ankle.[30] The prostrating angels on either side of the Virgin and Child also resemble those at Kurbinovo, with the exception of the standards they carry here. The apse at Holy Anargyroi is much narrower than that at Kurbinovo, an architectural difference that results in the composition's vertical elongation and the displacement of the angels to the side walls of the sanctuary. Kosmas and Damianos, the titular saints of the church, flank the Virgin and Child. Though their gazes are directed toward the viewer, they clasp their hands and turn toward the Virgin.

The lower register of the apse contains the portraits of four bishops—Gregory the Theologian, Basil the Great, John Chrysostom, and Nicholas—depicted in three-quarter pose and facing a central, painted altar (Figs. 21, 22). All of the bishops wear *polystavria,* and the *omophoria* of Basil and Chrysostom are decorated with a distinctive pattern. The bishops' eyes are directed toward the viewer rather than toward the central composition. The altar, which holds a chalice and paten, has a marble base and is covered by an ornate altar cloth. Two deacons, Stephen and Euplos, appear on the east wall flanking the apsidal curve. The program was supplemented by the depiction of three bishops, Hierotheos, Gregory of Nyssa, and John Eleemon, on the south wall of the sanctuary.

9. *St. Nicholas tou Kasnitze, Kastoria* (Figs. 23, 24)

REFERENCES: Pelekanides, *Kastoria,* figs. 46–48; Tatiana Malmquist, *Byzantine 12th-Century Frescoes in Kastoria: Agioi Anargyroi and Agios Nikolaos tou Kasnitzi* (Uppsala: Almqvist & Wiksell, 1979); Ann Wharton Epstein, "Middle Byzantine Churches of Kastoria: Dates and Implications," *Art Bulletin* 62 (1980): 190–207; Pelekanides and Chatzidakis, *Kastoria,* 50–65; Wharton, *Art of Empire,* 120–24; Moutsopoulos, *Ekklesies tes Kastorias,* 401–30; Eugenia Drakopoulou, *He Pole tes Kastorias te vyzantine kai metavyzantine epoche (12os–16os ai.): Historia, Techne, Epigraphes* (Athens: Christianike Archaiologike Hetaireia, 1997).

The frescoes of this single-aisled church have been dated on the basis of their style to the last decades of the twelfth century (Malmquist, Pelekanides and Chatzidakis, Pelekanides). The patron of the church is named in a twelve-syllable metrical inscription over the west door:

> Having received your many gifts, thrice-blessed [Nicholas], from the time that I came into this place of weeping, sinful, piteous supplicant, doer of evils. And now [I] Nikephoros, called Kasnitzes, through fortune *magistros,* raise up this church from its foundations to its heights and with burning desire adorn it with holy colors and a variety of images for you, provider of all good things.

> Πολλῶν τετευχὼς δωρεῶν σῶν τρισμάκαρ ἀφ᾽ οὗπερ ἦλθον εἰς τὸ[ν] κλαυθμῶνος τόπον ἀλιτρός, οἰκτρὸς ἱκέτης, κακεργάτης τὰ νῦν ἀνιστῶ τὸν νεὼν Νικηφόρος τύχῃ μάγιστρος καὶ τοὐπίκλην Κασνίτζης βάθρων ἀπ᾽ ἄκρων· πλὴν ζέοντι τῷ πόθῳ σεπταῖς καταλάμποντα χρωματουργίαις καὶ παντοδαπα[ῖς εἰ]κόνων ποικιλίαις σοὶ τῷ δοτῆρι τῶν καλῶ[ν].[31]

Nikephoros is represented with his wife, Anna, flanking a portrait of St. Nicholas on the east wall of the church narthex. The inscription on the nave's west wall falls directly behind these portraits, suggesting that the juxtaposition was intentional.[32]

The uppermost level of the east wall, as in Holy Anargyroi, is decorated with the Deesis. The Annunciation appears directly below, framing the opening of the apse (Fig. 23). The archangel Gabriel and the Virgin Mary are separated by a representation of the Holy Mandylion. As scholars such as Hadermann-Misguich (see *Kurbinovo*) have noted, the Annunciation in St. Nicholas resembles that in Kurbinovo, a church in close geographical and chronological proximity. In both, the Virgin's body is turned away from the angel while her gaze meets his (Figs. 24, 25). There are, however, slight differences in style and in composition: in St. Nicholas, the life-sized figures are not elongated and slender, and the drapery is less turbulent. Moreover, the Virgin fails to raise her right hand but remains absorbed in her spinning.

The conch of the apse is decorated with an image of the Virgin in an orant pose. She is flanked by two venerating angels, who extend covered hands while bowing at her feet. The lower register of the apse presents six hierarchs on either side of a two-lobed window. This level, unfortunately, is poorly preserved; the six episcopal figures are in such damaged condition that only John Chrysostom (to the right of the window) and Basil (to the left) can be identified securely. Two niches are carved within the east wall flanking the opening of the apse. The south niche contains a representation of a deacon holding an incense container. The figure in the northern niche is no longer preserved.

Frontal saints holding Gospel books adorn the side walls of the sanctuary. On the south wall are Cyril of Alexandria and an unidentified saint (Fig. 23). On the north wall of the sanctuary are two frontal bishops whose damaged condition prevents secure identification. Adjacent to these saints are the markings for the icon screen; beyond this divider is an icon of the titular saint, Nicholas.

10. *St. George, Kurbinovo* (Color Plate III, Figs. 25, 26)

REFERENCE: Hadermann-Misguich, *Kurbinovo* (with bibliography).

The church of St. George in Kurbinovo is dated by an inscription on the back of the altar that proclaims: "We have begun to paint the church on the 25th of April, in the ninth indiction, in the year 6699 [= 1191]."[33]

In Kurbinovo the scene of the Ascension occupies the upper register of the east wall of the church and fills the triangular wall space under the eaves of the roof (Fig. 25). Christ, depicted in a mandorla held aloft by two angels, crowns the scene; the orant Virgin stands below and is flanked by two angels and six apostles. In the register below is the Annunciation. As is typical in this period, the composition is divided on either side of the arched opening of the apse; the archangel Gabriel, who stands at the left side of the composition, extends his right hand in a gesture of speech. The Virgin turns from the angel with her right hand protectively raised in front of her chest. She is seated on an elaborate

throne in front of an ornate facade. Adjacent to her head is a semicircular representation of the heavens from which emanate the rays of the Holy Spirit.

Set back under the arch is an inscription that refers to Mary's virginal state before and after the Nativity. Taken from the first tone of the Octoechos, a collection of liturgical hymns attributed to John of Damascus, the inscription reads: "The celestial orders flank your child in servile worship, rightfully wondering at the seedless nature of your childbirth, O, Ever-Virgin, for you were pure, both before bearing and after childbirth."[34] The inscription is directly illustrated by the apse composition, which presents angels in attendance and prominently displays the product of the "seedless" *(asporos)* childbirth on the Virgin's lap. The Virgin and Child in the conch of the apse are monumental in scale. The painter represented Mary's elaborate throne like that of the Annunciation to draw a comparison between the beginning and end of one event.

In the lowest register of the apse, eight concelebrating hierarchs converge on the representation of the sacrificed Christ (Color Plate III, Fig. 26). The bishops are identified as Gregory of Nyssa, Gregory Thaumatourgos, Gregory the Theologian, Basil, John Chrysostom, Athanasios, Achilleios, and Nicholas. The six inner bishops wear *polystavria;* as in Holy Anargyroi, Basil and John Chrysostom are differentiated by distinctive patterns on their *omophoria.* The side walls of the sanctuary are decorated with frontal bishops wearing plain *phelonia* and carrying Gospel books.

Niches containing half-length portraits of St. Stephen (?) and St. Euplos are located on the east wall of the sanctuary. In the absence of a prothesis chamber these niches would have played a role in the preparation of the offerings and are thus appropriately decorated with portraits of deacon saints.

II. *Metropolis (St. Demetrios), Servia* (Figs. 27, 28)

REFERENCE: Andreas Xyngopoulos, *Ta mnemeia ton Servion* (Athens: M. Myrtidis, 1957), 29–75.

The metropolitan church of the abandoned medieval city of Servia was probably built following the recapture of the settlement from the Bulgarians in 1001. The wall paintings represent two phases; the second phase is dated to the late twelfth or early thirteenth century on stylistic grounds.

Within the central sanctuary, paintings are preserved only on the south wall and on a narrow section of the south curve of the apse (Fig. 27). From the surviving decoration it is clear that the lower register of the apse once presented bishops turned in three-quarter stance. Scenes from the life of the Virgin are located in the intermediate register of the sanctuary's side walls. On the north wall is the birth of the Virgin and, opposite, her Presentation in the Temple. According to Xyngopoulos, the communion of the wine was depicted adjacent to the scene of the Presentation.[35] Close examination of the scene,

however, reveals a number of discrepancies from the usual iconography: there are only eight apostles, Christ stands in a frontal position on the westernmost side of the composition, and there is no visible altar. Four frontal bishops are represented in the lower register of the south wall. Three of them are identified as the popular local saints Achilleios, Oikoumenios, and Blasios; they wear plain *phelonia* and hold Gospel books in their covered hands (Fig. 28).[36] Xyngopoulos identified the scene of the Deesis on the north wall of the sanctuary, although no traces remain to verify this observation.[37]

12. *Panagia Mavriotissa, Kastoria* (Fig. 29)

REFERENCES: Nikolaos Moutsopoulos, *Kastoria Panagia he Mauriotissa* (Athens: Ekdosis Somateiou: Philoi Vyzantinon Mnemeion kai Archaioteton Nomou Kastorias, 1967); Stylianos Pelekanides, "Chronologika provlemata ton toichographion tou Katholikou tes Mones tes Panagias tes Mauriotissas Kastorias," *Archaiologike Ephemeris* (1978): 147–59; Ann Wharton Epstein, "Middle Byzantine Churches of Kastoria: Dates and Implications," *Art Bulletin* 62 (1980): 202–7; Pelekanides and Chatzidakis, *Kastoria,* 66–83; Georgios Gounares, *He Panagia Mauriotissa tes Kastorias* (Thessalonike: Ekdoseis P. Pournara, 1987).

The sanctuary decoration of Panagia Mavriotissa is divided into several distinct phases. Chatzidakis has proposed that the upper portion of the east wall, including the conch of the apse, was destroyed at an early point and its reconstruction required repainting. He dates the original decoration to the early thirteenth century; for the second phase he suggests 1259 as a *terminus ante quem;* subsequent additions to the decoration are dated 1259–64 on the basis of inscriptions mentioning Michael VIII Palaiologos and his brother, John.[38] Wharton Epstein divides the painting into two phases based on analysis of the style and plaster joins by Cormack and Pelekanides, who were able to examine the frescoes inside the sanctuary and provide her with information on their condition. For her, the upper part of the conch and the gable above the apse are dated between 1259 and 1265. The remaining frescoes belong, on stylistic grounds, to the late eleventh or early twelfth century.[39]

The east wall above the conch of the apse contains scenes common to churches of Byzantine Macedonia. The Ascension crowns the east wall, as it does in other Macedonian churches (e.g., Kurbinovo). Also common in small, single-aisled churches, the Annunciation is divided on either side of the opening of the apse. In Panagia Mavriotissa, the standing Virgin carries a spindle in her left hand and raises her right hand to her chest in a gesture of protection (Fig. 29).

In the conch of the apse, the enthroned Virgin and Child are flanked by archangels dressed in imperial costume. The Virgin sits on an ornate, lyre-backed throne. Her hands hold the child, though they do not convincingly contain him. The child, who is small in size but rendered almost as an adult, hovers in front of the Virgin, holds a

closed scroll in his left hand, and raises his right hand in blessing. A donor of the second painted layer, the monk Manuel, crouches in *proskynesis* at the Virgin's feet. The intermediate register uniquely represents the four evangelists arranged in pairs. They flank a central medallion of Christ Emmanuel, which was inserted in a later decorative phase. The series of bishops in three-quarter pose and located in the lower register of the apse, belong to the first phase. The figures have been identified as Polykarp, an unidentified bishop, Gregory the Theologian, Basil, John Chrysostom, Athanasios, John Eleemon, and Gregory Thaumatourgos.[40] On the east wall, on either side of the evangelists, are representations of deacons, stylite saints, and doctor saints, including Hermolaos.[41]

13. *Old Metropolis, Veroia* (Fig. 30)

REFERENCES: Giorgios Chionides, *Historia tes Veroias: Tes poleos kai tes perioches* (Thessalonike: [s.n.], 1970), 2: 175–76; Mouriki, "Stylistic Trends," 68; Maria Panayotidi, "Les églises de Véria, en Macédoine," *CorsiRav* 22 (1975): 303–15; Euthymios Tsigaridas, "Les peintures murales de l'Ancienne Métropole de Véria," in *Mileševa dans l'histoire du peuple Serbe,* Colloques scientifiques de l'Académie Serbe des sciences et des arts XXXVIII, Classe des sciences historiques 6 (Belgrade: Srpska akademija nauka i umetnosti, 1987), 91–100; Papazotos, *He Veroia,* 164–69, 242–49, fig. 6.

The Old Metropolis, originally dedicated to the apostles Peter and Paul, is the largest Byzantine church in Veroia. Substantial portions of the basilica were constructed around 1070–80 according to a marble inscription that names Niketas, a bishop of that city.[42] Its painting comprises at least four distinct phases.[43] The decoration of the sanctuary dates to the thirteenth and early fourteenth centuries and may be divided into two, perhaps three, phases. The paintings of the east wall and most of the internal apsidal decoration belong to an early-thirteenth-century campaign; Papazotos has suggested that the majority of the frescoes were painted between 1215/16 and 1224/25 on the basis of stylistic comparisons to monuments such as Mileševa (dated before 1228).[44] Historical circumstances support the date provided by stylistic analysis; the decoration was most likely completed during the residency of Theodore Komnenos Doukas in the city. Theodore stayed in Veroia until his liberation of Thessalonike from the Latins in 1224.[45]

The Annunciation is located on the east wall above the opening of the apse. The uppermost section of the archangel Gabriel is now destroyed. The lower section of the body represents an active figure, dressed in a red mantle and lunging toward the Virgin. Mary, on the right side of the apse, stands on a decorated platform and holds a spindle in her left hand. She bows her head to the angel. Rays emanating from the upper left corner of the composition indicate that there once existed a representation of the heavens, as at St. George, Kurbinovo, and the Panagia Mavriotissa, Kastoria (Figs. 25, 29).

The conch of the apse has been rebuilt by the Greek Archaeological Service. In the

process of excavating below the floor of the sanctuary, archaeologists discovered fragments from representations of the Virgin and archangels. No information has yet been published regarding the type of Virgin or whether the infant Christ was included with his mother.

The intermediate register of the apse is decorated with an unusual string of medallions containing half-length portraits of the twelve apostles. Ten apostles, their heads surrounded by red nimbi, are depicted in medallions against a gold background. Peter and Paul, the titular saints of the church, are differentiated; their heads are crowned by gold nimbi against a red background. The apostles carry either scrolls or Gospel books. Originally the names of the apostles were inscribed within the medallions. Today only the name of Simon, the second figure from the right, is decipherable.

An unusually large number of concelebrating bishops, ten, adorn the lower register of the apse. From left to right they are: Eleutherios (who is tonsured), Gregory (Thaumatourgos?), Cyril, Gregory the Theologian, Basil, John Chrysostom, Athanasios of Alexandria, John Eleemon, Nicholas, and Dionysios (Fig. 30). The two bishops at each end are dressed in plain *phelonia;* the other six wear *polystavria.* Cyril is distinguished by the white cloth that is draped around his neck and knotted in the front. After the Old Metropolis, the church with the largest number of painted concelebrants is Kurbinovo, which has eight (Fig. 25).

Close examination of the central section of the lower register of the apse indicates that a layer of plaster was added on top of that decorated with the concelebrating bishops, an addition that has been dated to the early fourteenth century. Located below a three-lobed window, the upper section of the image has been destroyed. It is impossible to tell from the painted remains whether the original representation was an altar table or the *melismos.* Two half-length angels dressed as deacons flank the central altar. The heads of the angels are at the same level as the top of the altar and they hold *rhipidia.* No trace of the sacrificed Christ remains, but, considering the late date of the painting, the *melismos* seems the more likely subject for representation.

14. *St. John the Theologian, Veroia* (Color Plate IV, Figs. 31, 32)

REFERENCES: Manolis Chatzidakis, "Aspects de la peinture du XIIIe siècle en Grèce," *L'art byzantin du XIIIe siècle,* Symposium de Sopoćani, 1965 (Belgrade: Faculté de Philosophie, Departement de l'Histoire de l'Art, 1967), 63, fig. 7; Myron Michailidis, "Les peintures murales de l'église de Saint-Jean le Théologien à Véria," *Actes du XVe Congrès international des Études Byzantines* (Athens: Association Internationale des Études Byzantines, 1981), 2B: 469–88; Papazotos, *He Veroia,* 171–72, 249–50, fig. 7.

The wall paintings of St. John the Theologian have been dated to the first half of the thirteenth century on stylistic grounds (Michailides, Papazotos). Significant portions of the painted program from this period are preserved only in the easternmost section of this church.

The Ascension crowns the program of the east end of the church. In St. John the Theologian the angels are dressed in unusually ornate costumes; their mantles are bordered with pearls and their tunics have jeweled hems. Below this scene is the Annunciation, separated into halves with the archangel Gabriel on the left side of the apse and the Virgin opposite. Stylistically, the angel of the Annunciation resembles the same figure in St. Nicholas tou Kasnitze in Kastoria, whereas the standing Virgin is reminiscent of her counterpart in Holy Anargyroi. A dove descends from the heavens depicted in the upper left corner of the composition.

The conch of the apse contains an austere orant Virgin, flanked by two angels in imperial costume (Fig. 31). The Communion of the Apostles is represented in the lower register of the apse, a placement that is unique in Byzantine painting. The apostolic embrace, here exchanged between the apostles Luke and Andrew, is incorporated into the scene (Color Plate IV, Fig. 32). Due to the unusual location of the Communion of the Apostles, portraits of Basil and John Chrysostom are located on the east face of the piers flanking the apse.

At some point in the history of this church, the central window of the sanctuary was filled with plaster decorated with four nimbed figures. The painting on this added fill is damaged but seems to represent at least two angels. Based on this identification, we may propose that the *melismos* was added to the sanctuary at a later date.

15. *St. Nicholas, Melnik* (Figs. 33, 34)

REFERENCES: Antoine Stransky, "Les ruines de St. Nicolas à Melnic," *Atti del V Congresso Internazionale di Studi Bizantini* (Rome: Tipografia del Senato, 1940), 422–27; Andreas Xyngopoulos, "Paratereseis eis tas toichographies tou Hag. Nikolaou Melenikou," *Epistemonike Epeteris tes Philosophikes Scholes tou Panepistemiou Thessalonikes* 6 (1950): 113–28; Liliana Mavrodinova, "Nouvelles considérations sur les peintures du chevet de l'église Saint-Nicolas à Melnic," *Actes du XVe Congrès international des Études Byzantines* (Athens: Association Internationale des Études Byzantines, 1981), 2A: 427–38; Liliana Mavrodinova, *Tsurkvata "Sveti Nikola" pri Melnik* (Sofia: Bulg. khudozhnik, 1975).

The architecture and wall paintings that remain in the ruined basilica of St. Nicholas in Melnik, in present-day Bulgaria, have been dated to the early thirteenth century on stylistic grounds by Xyngopoulos and Mavrodinova.

Although the conch of the apse contains a representation of the enthroned Virgin and Child, the central register of the sanctuary is distinguished by a unique representation found to either side of the apsidal window and above the episcopal throne. Xyngopoulos was the first to identify the subject as the consecration of James, the first bishop of Jerusalem. In this scene, James stands between the apostle Peter and Christ, who performs the ceremony (Fig. 33).[46] An unidentified bishop, in frontal pose and carrying a

closed Gospel book, stands on the extreme left.[47] On the right side of the window, Basil, John Chrysostom, Gregory the Theologian, and Athanasios respond to the ceremony by extending their hands in a gesture of entreaty (Fig. 34). At the center of the composition, above the three-lobed window, is an altar holding a Gospel book, scroll, two candlesticks, and a small, two-handled amphora, the types of ceremonial objects that would have been used in the rite of consecration.

16. *St. Constantine, Svećani* (Fig. 35)

REFERENCES: Petar Miljković-Pepek, "The Church of St. Constantine in the Village of Svećani," *Simpozium 1100-godisnina od smrtta na Kiril Solunski* (Skopje: Makedonska akademija na naukite i umetnostite, 1970), 1: 149–62; idem, "Contribution," 193–94.

St. Constantine in Svećani stands in ruined condition. Information about its decorative program derives primarily from descriptions and drawings published by Miljković-Pepek, who dated the paintings to the late thirteenth century on stylistic grounds.

The paintings in the conch of the apse were completely destroyed during the period in which the building remained roofless, but the middle and lower registers of the central sanctuary provide some information about the original program. The Communion of the Apostles, in the middle zone, is closely tied by style and iconography to the churches of St. Nicholas Manastir and St. John Kaneo in Ohrid (Figs. 37, 41). At Svećani two groups of six apostles approach a double representation of Christ (Fig. 35). In the center of the composition, two angels stand under a ciborium. The cloth that covers the altar is similar to that represented at Manastir. As in St. Panteleimon at Nerezi and St. John the Theologian in Veroia, the representation includes the apostolic embrace at the extreme left of the scene.

Portraits of four bishops surround a single, narrow window in the lower register of the apse. The painting is too damaged to identify any of the figures. It is certain, however, that they were depicted in three-quarter position. According to Miljković-Pepek, the celebrating bishops continued onto the side walls of the sanctuary.

17. *St. Nicholas, Manastir (Moriovo)* (Figs. 36–40)

REFERENCES: Dimče Koco and Petar Miljković-Pepek, "La basilique de St. Nicolas au village Manastir dans la région de Moriovo," x. *Milletlerarasi Bizans Tetkikleri Kongresi tebligleri* (Istanbul: Comité d'organisation du x. Congrès international d'Études Byzantines, 1957), 138–40; Dimče Koco and Petar Miljković-Pepek, *Manastir* (Skopje: Univerzitetska pečatnica, 1958); Miljković-Pepek, "Contribution," 190–91, fig. 12.

According to its inscription, the basilican church of St. Nicholas was built initially in 1095 by the *protostrator* Alexios:

> In the year 6603 [= 1095], during the reign of the most pious emperor and autokrator of the Romans, kyr Alexios Komnenos. The much-beloved uncle of the emperor, kyr Alexios the *Protostrator*,[48] having passed through this place and having admired the site, raised from its foundations the church of Nicholas, [blessed] among our holy fathers, the archpriest and miracle-worker.

> + ἐν ἔτ(ει) ͵ϛχγʹ ἐπὶ τ(ῆς) βασιλ(είας) τοῦ εὐσεβεστάτ(ου) βασιλ(έως) κ(αὶ) αὐτοκράτωρ(ος) Ῥωμάι(ων) κυρ(οῦ) Ἀλεξίου τοῦ Κομν(ηνοῦ). διελθ(ὼν) ἐν τό(ν)δε τόπ(ον) ὁ περιπώθητο(ς) θεῖο(ς) τ(ῆς) βασιλεί(ας) αὐτ(ῆς) κυρ(ιὸς) Ἀλεξί(ος), ὁ πρωτ(ο)στράτ(ω)ρ, κ(αὶ) ἀρεσ(άμενος) τ(ὸν) τόπ(ον), ἀνήγυρ(ε) ναὸν ἐκ βάθρ(ων) τοῦ ἐν ἁγίοις π(ατ)ρ(ὸ)ς ἡμ(ῶν) ἀρχ(ι)ερά(ρ)χου κ(αὶ) θαυματουργ(οῦ) Νικο(λάου).

The inscription, badly damaged, continues to relate how over time the church "was becoming small, unsound, and riddled with holes," a condition that resulted in its rebuilding and redecoration by the "abbot of the monastery, kyr Ioannikios, he who took the holy [monastic] habit under the name of Akakios." The deacon John was called upon to paint the church. The inscription records this second phase in the life of the church:

> [the church] was painted in the year 6779 [= 1271], indiction 14, during the reign of the most pious and great emperor and autokrator of the Romans Michael Doukas Angelos Komnenos Palaiologos,[49] the New Constantine.

> ἀνιστορίθι δὲ ἐν ἔτι ͵ϛψοθʹ ἰνδικτιῶνος ιδʹ [ἐπὶ τῆς βασιλ]είας τοῦ εὐσεβεστάτου μεγ(ά)λ(ου) βασιλ(έω)ς καὶ αὐτοκράτωρος Ῥωμαίων Δούκα Ἀγγέλου Κομνηνοῦ Μ(ι)χα(ὴλ) τοῦ Παλαιολόγ(ου) καὶ Νέου Κωνσταντίνου.[50]

The image of a monastic donor, who is introduced to Christ by St. Nicholas, is also found in the nave of the church; an inscription identifies him as the hieromonk and abbot Akakios, the donor mentioned in the church inscription.[51]

The Virgin Orant fills the conch of the apse (Fig. 36). The wide mantle and outstretched arms frame her figure and compositionally focus attention on her body, which marks the strong vertical axis of the apse. Her face has been destroyed. Two archangels, labeled in ornate script, kneel on either side of the central figure and outstretch their arms. Their eyes are directed toward the viewer. The harsh modeling of their faces and the undulat-

ing drapery of their mantles provide evidence for the survival of the Komnenian painting style well into the thirteenth century.

The Communion of the Apostles fills the central register of the apse (Figs. 37, 38). The apostles, led by Peter and Paul, flank a central depiction of Christ. The elaborate altar cloth relates decorative details in this church to those at Nerezi and Svećani. Likewise in the church of St. Nicholas, the last two apostles on the north side of the scene exchange an embrace.

Four bishops dressed in *polystavria* are located in the lower register of the apse on either side of the *melismos* (Fig. 39). The bishops, who display liturgical scrolls, are identified as (left to right): Nicholas, Basil, John Chrysostom, and Gregory the Theologian. The representation of Christ as the offering, here labeled as *melismos,* consists of an elongated child who reclines in a long paten (Fig. 40). His lower body is covered by a liturgical cloth decorated with a cross, and his right hand is raised in benediction. The large ovoid vessel intended to represent a chalice is placed above him on the same altar. On either side of the altar are two angels who are dressed in white deacons' robes and hold *rhipidia* decorated with images of cherubim.

18. *St. John the Theologian (Kaneo), Ohrid* (Fig. 41)

REFERENCES: Petar Miljković-Pepek, "The Church of St. John the Theologian-Kaneo in Ohrid," *Kulturno Nasledstvo* 3 (1967): 67–124; idem, "Contribution," 189–96.

The church of St. John the Theologian preserves most of its sanctuary decoration. The program has been dated 1270–90 on stylistic grounds (Miljković-Pepek). The decoration of the conch of the apse was painted in the sixteenth century and will be excluded from this discussion.

The Communion of the Apostles occupies the central register of the apse (Fig. 41). Christ is represented twice under a domical ciborium, and the apostles are divided into two groups of six led by Peter and John. Two of the apostles in the communion of the wine turn to one another, as if they are about to embrace. One unusual feature of this composition is the costume of the assisting angels; they wear the imperial *loros,* a garment usually reserved for angels in the conch of the apse. Scenes of the Doubting Thomas, the Appearance of Christ to the Apostles in Galilee, and the Last Supper are located on the side walls of the sanctuary.

Twelve portraits of half-length bishops are included in a register added between the Communion of the Apostles and the concelebrating bishops. This frieze continues on the side walls of the sanctuary. The half-length portraits represent: Blasios, Cyril, and Polykarp (north wall); Clement of Ohrid, Erasmos, John Eleemon, Athanasios, Nicholas, and Gregory Dekapolites (central wall); and two unidentified saints and Gregory of Nyssa (south wall). Most of the bishops depicted in this register wear *polystavria.* The addition of

this intermediary zone is characteristic of thirteenth- and fourteenth-century sanctuary programs in Macedonia and can be seen in such later churches as the nearby Virgin Peribleptos in Ohrid (Fig. 42).

The lowest register of the sanctuary presents four concelebrating figures flanking the *melismos;* they are Gregory the Theologian, Basil, John Chrysostom, and Gregory Thaumatourgos. The episcopal program extends to the north and south walls where Nicholas and Constantine Cabasilas were represented holding open liturgical scrolls. The inclusion of Clement of Ohrid and Constantine Cabasilas, the thirteenth-century archbishop of Ohrid, must have responded to the orders of the patron and congregation.

At the center of the lower register, the *melismos* is flanked by two diminutive angels dressed as deacons holding *rhipidia.* These angels do not stand on the same ground line as the rest of the figures but seem to hover next to the paten containing the small Christ.

19. *Virgin Peribleptos (church of St. Clement), Ohrid* (Fig. 42)

REFERENCES: Dimitar Ćornakov, *The Frescoes of the Church of St. Clement at Ochrid* (Belgrade: Jugoslavija, 1961); Petar Miljković-Pepek, *Deloto na zografite Mihailo i Eutihij* (Skopje: [Republički zavod za zaštita na spomenicite na kulturata], 1967).

The church of the Virgin Peribleptos is dated to 1295 by a painted inscription over the west door of the narthex:

This most holy and divine church of the our most holy lady, the Theotokos Peribleptos, was built through the contribution and expense of kyr Progonos Sgouros,[52] *megas hetaireiarches*[53] and *gambros*[54] of our reigning and holy imperial ruler and of his wife, kyra Eudokia. During the reign of the most pious emperor and autokrator of the Romans, Andronikos Palaiologos and the most pious augusta Eirene, during the tenure of Makarios of the all-holy archbishopric of Justiniana Prima and of all Bulgaria, in the year 6803 [= 1295], the 8th indiction.

Ἀνηγέρθη ὁ θεῖος καὶ πάνσεπτος ναὸς οὗτος τῆς πανυπεραγίου
δεσποινῆς ἡμῶν Θεοτόκου τῆς Περιβλέπτου διὰ συνδρομῆς κ(αὶ)
ἐξόδου κυρίου Προγόνου τοῦ Σγούρου τοῦ μεγάλου ἑταιρειάρχου κ(αὶ)
τῆς συζύγου αὐτοῦ κυρ(άς) Εὐδοκίας κ(αὶ) γαμβροῦ τοῦ κρατίστου κ(αὶ)
ἀγίου ἡμῶν αὐτοκ(ράτορος) Βασιλέως. Ἐπὶ τῆς βασιλείας τοῦ
εὐσεβεστάτου βασιλέως κ(αὶ) αὐτοκρατορος Ρωμαίων Ἀνδρονίκου
τοῦ Παλαιολόγου κ(αὶ) Εἰρήνης τῆς εὐσεβεστάτης αὐγούστης ἀρχιερ-
ατεύοντος δὲ Μακαρίον τοῦ παναγιωτάτου ἀρχιε πισκόπου τῆς πρώτης
Ἰουστινιανῆς κ(αὶ) πάσης Βουλγαρίας ἐπὶ ἔτους ͵ϛωγʼ ἰνδ(ικτιῶνος) ηʼ [55]

The names of the painters of the church, Michael Astrapas and Eutychios, are inscribed in several places in the painted program.[56]

Twenty-six medallions containing portraits of the ancestors of Christ form a chain that encircles the opening of the central apse (Fig. 42). Representations of Christ Emmanuel and two angels are represented in the upper three; the remaining medallions emphasize Christ's priestly lineage through his Old Testament forebears. In the vault above the sanctuary the painters depicted the scene of the Ascension. Narrative scenes related to the sanctuary program are located below the springing of the sanctuary vault and adjacent to the medallions. On the north wall are the scenes of the Doubting Thomas and the Appearance of Christ to the Eleven; the Last Supper is located on the south wall. The orant Virgin stands alone in the conch of the apse. Her isolation is striking, especially considering the proliferation of figures in narrative scenes represented in the church.

Below the Virgin is the Communion of the Apostles. John approaches to receive the wine and Peter to receive the bread. Two angels dressed as deacons hold *rhipidia* over the domed ciborium. As at St. John the Theologian in Ohrid, a fourth painted register, composed of seventeen bishops portrayed in half length, extends from the center of the apse to the lateral walls of the sanctuary. James, the brother of the Lord, and the presumed author of one of the Orthodox liturgies, is represented as the central portrait.

The concelebrating figures in the lower register of the sanctuary include Gregory the Theologian, Basil, John Chrysostom, and Athanasios of Alexandria. Nicholas is located on the north wall and Cyril of Alexandria opposite him on the south. The central composition of the lower register is severely damaged. Traces of a painted altar are discernible, but it is impossible to determine whether the *melismos* was originally painted in this location. In the upper portion of the central window is a plaster filling decorated with a cross; between the arms is inscribed the letter formula Φ Χ Φ Π: the abbreviation for "The Light of Christ Appears to All." The formula is appropriately positioned over the window through which the sanctuary is illuminated.

20. *Protaton, Mount Athos* (Figs. 43–45)

REFERENCES: Gabriel Millet, *Monuments de l'Athos* (Paris: E. Leroux, 1927), figs. 5, 8, 33; Andreas Xyngopoulos, *Manuel Panselinos* (Athens: Athens Editions, 1956); Mouriki, "Stylistic Trends," 64–65; Branislav Todić, "Le Protaton et la peinture Serbe des premières décennies du XIVe siècle," in *L'art de Thessalonique et des pays Balkaniques et les courants spirituels au XIVe siècle* (Belgrade: Académie Serbe des sciences et des arts, Institut des Études Balkaniques, 1987), 21–31.

The decoration of the Protaton basilica on Mount Athos is attributed to the painter Panselinos and has been dated circa 1300 on the basis of style (Mouriki).[57] The decoration of the sanctuary is not as well preserved as that in the other parts of the church.[58]

The decoration of the sanctuary begins on the east wall of the basilica above the opening of the apse (Fig. 43). At the center of the upper register is a portrait of Christ, either the Mandylion or Kerameion, flanked by David and Solomon and then by the archangel Gabriel and the Virgin Annunciate. On the left, the angel lunges toward Mary with his right arm outstretched and his left hand holding a staff for support. The painter has represented the Virgin as standing; she bows her head toward the angel as she receives his message. The portraits of David and Solomon are an unusual, though not unique, addition to the composition.[59] The Old Testament kings wear crowns, are nimbed, and are positioned behind fortifications that form the background for the two halves of the Annunciation. Their placement behind a receding wall artistically reinforces the message as representing the Old Law ceding to the New. Below the Annunciation, on either side of the apse, are two standing prophets whose placement is reminiscent of the positions occupied by Kosmas and Damianos in Kastoria's Holy Anargyroi (Fig. 20).

The intermediate zone of the apse contains a representation of the Communion of the Apostles, although in extremely damaged condition. The figures are placed between three small windows that pierce the curved wall of the sanctuary. Two groups of six apostles are on the extreme ends, and two representations of Christ fill the wall space between the windows. John leads the apostles to receive the wine as Peter takes the bread from Christ's hand.

The lower register of the apse is decorated with portraits of four bishops: Gregory the Theologian, Basil, John Chrysostom, and Athanasios. Due to their poor state of preservation, I have only been able to read the scroll held by Athanasios, which is inscribed with the opening line of the third antiphon. As in other churches of the region, the episcopal series continues onto the face of the east wall and, from there, to the north and south walls of the sanctuary. Cyril of Alexandria and John Eleemon are depicted in three-quarter pose on the south wall and opposite them Nicholas.[60] This register, dedicated to holy bishops, continues on the side walls with the representation of frontal bishops, who are separated from their concelebrating counterparts by the connecting doors to the side chapels. Gregory of Akragas and James, the brother of the Lord, are located on the north wall (Fig. 44); Dionysios the Areopagite and Ignatios Theophoros face them from the south wall (Fig. 45). The frontal bishops wear the same vestments as their concelebrants, but they hold decorated Gospel books instead of open scrolls.

Several narrative scenes are positioned on the upper registers of the side walls of the sanctuary. On the north wall is the Doubting Thomas; the Last Supper is on the south wall adjacent to the apostles approaching Christ for communion. Portraits of evangelists complete the decoration of the sanctuary. Due to the basilican shape of the church, they are placed on the side walls, facing east, as if describing the very scenes that are adjacent to them.

21. *St. Euthymios, Thessalonike* (Figs. 46–48)

REFERENCES: Georgios Soteriou and Maria Soteriou, *He vasilike tou Hagiou Demetriou Thessalonikes* (Athens: [He en Athenais Archaiologike Hetaireia], 1952), 1: 213–30, figs.

82–93; Manolis Chatzidakis, "Rapports entre la peinture de la Macédoine et de la Crète au XIVe siècle," in *Pepragmena tou 9 Diethnous Vyzantinologikou Synedriou* (Athens: Myrtidis, 1955), 1: 136–48; Thalia Gouma Peterson, "The Frescoes of the Parecclesion of St. Euthymios in Thessalonica: An Iconographic and Stylistic Analysis," PhD. diss., University of Wisconsin, 1964; eadem, "The Parecclesion of St. Euthymios in Thessalonica: Art and Monastic Policy under Andronicos II," *Art Bulletin* 58 (1976): 168–82; eadem, "Christ as Ministrant and the Priest as Ministrant of Christ in a Palaeologan Cycle of 1303," *DOP* 32 (1978): 199–216; eadem, "The Frescoes of the Parekklesion of St. Euthymios in Thessaloniki: Patrons, Workshop, and Style," in *The Twilight of Byzantium,* ed. Slobodan Ćurčić and Doula Mouriki (Princeton: Princeton University Press, 1991), 111–29.

The chapel of St. Euthymios, a small basilica attached to the southeast corner of St. Demetrios in Thessalonike, was decorated in 1303 through the sponsorship of the *proto-strator* Michael Doukas Glavas Tarchaneiotes and his wife, Maria.[61] A poetic inscription, written in twelve-syllable iambic trimeter, runs in a thin band along the west and north walls of the church:[62]

> Michael the Protostrator[63] and his wife Maria, scion of the Komnenian family, are restoring this holy house of Euthymios the wondrous pre[sbyter]. So that entirely filled with the joy of good works in this present life they will escape eternal sadness. The year 6811 [= 1303], the first indiction.

> Ἀνανεοῦσι τόδε τὸν θεῖον δόμον Εὐθυμίου θαυμαστοῦ τοῦ πρ[εσβυτέρου] ὁ Μιχαὴλ πρωτοστράτωρ σὺν [συμβίῳ Μαρί]α Κομνηνοφυεῖ τυγχανούσῃ πρὸς γένους. Ὡς εὐθυμίας ἐκ καλῶν ἐργασίας πλησθέντες ἀβρῶς τῷ παρόντι βιότῳ ἀθυμίαν φύγωσι τὴν αἰωνίαν. ἔτους ‚ϛωια᾽ ἰνδ(ικτιῶνος) α᾽

The Annunciation appears to either side of the Holy Mandylion on the east wall above the apse. From the left side, the archangel Gabriel appears to leap across the apse as he delivers his message. The Virgin is seated on a high, round-backed chair and twists her body away from the approaching messenger but turns her head toward him. The ambiguous position reflects her inner distress, and her emotional state is further revealed by the way she raises her right hand and extends it, palm outward, to ward off the strange apparition. The Mandylion serves to unite the two halves of the divided scene. The relic is depicted as a white kerchief on which the nimbed head of Christ has been superimposed. Christ's nimbus flows over its edges and on to the dark background of surrounding wall. The cloth is suspended from two painted hooks to which it is affixed by means of elaborate knots.

The half-length representations of two prophets adorn the spandrels flanking the apse. The elderly figures, usually found in the drum of the dome in cross-in-square churches, hold closed scrolls. Soteriou identified them as the prophets Isaiah and Jeremiah.[64] An additional scene has been painted on the gable above the Annunciation:

the representation of the high priests Aaron and Moses officiating before the Ark of the Covenant. This scene is often interpreted as an Old Testament prefiguration of the Virgin, but in the absence of a Marian cycle, and considering its position within the program, the tabernacle may signify the Incarnation and reflect the continuity of liturgical ceremony.[65] The addition of a narrow bay to the west of the apse provided additional space for the representation of the Pentecost (Fig. 46). Because of the width of the available space, the six apostles are grouped to sit paired in three rows flanking a medallion of the christogram. In most scenes of this period, the apostles are arranged in an inverted U shape.

In the conch of the apse, the Virgin is represented enthroned with her son on her lap (Fig. 46). This type of seated Hodegetria was popular in apse decoration of Byzantine Macedonia; twelfth-century antecedents are found in Kastoria's Holy Anargyroi and in St. George, Kurbinovo (Figs. 20, 25).[66] The representation in St. Euthymios differs slightly from these earlier depictions in presenting the Virgin turned slightly to her left and seated on a high-backed, curved throne. To cradle the child, her left arm rests on the raised side of the throne. Her raised left leg also assists in supporting his weight. The pose is strikingly similar to that in the Annunciation. Yet differences between the two figures are significant. In the Annunciation, the Virgin turns her head toward the approaching angel and raises her hand in fear. The apsidal Virgin faces the viewer with a look of serenity; her hand motions toward the child in the characteristic gesture of the Virgin "who guides." Two archangels, dressed in imperial vestments, bow before the Virgin and Child. Their eternal pose of subservience forms a striking contrast to that of the angel in the scene of the Annunciation, who is the epitome of inspired dynamism.

Portraits of four bishops are represented in half length below the Virgin and Child in a zone pierced by the windows of the apse (Fig. 46). The bishops, located between the windows, wear *polystavria* and hold closed Gospels. Due to the effacement of the inscriptions, only Cyril of Alexandria, who wears a mitre, can be identified. Adjacent to these episcopal figures on the side walls of the sanctuary is the Communion of the Apostles. Its location is not unusual and has as a precedent the early-eleventh-century decoration of the neighboring Panagia ton Chalkeon (Fig. 3). On the south wall of the sanctuary Christ gives wine to the apostle John, and in the opposing scene Peter takes the bread (Figs. 47, 48). The heavy figures are rendered in an active manner that accords with the stylistic preferences of early-fourteenth-century Macedonian painters.

Episcopal concelebrants find their place at the lowest level of the sanctuary. Six bishops are represented, four within the apse and one on each pier. Although lacking inscriptions, the bishops can be identified by portrait-type and by their location within the program. Flanking the central window are John Chrysostom and Basil; Gregory the Theologian and Nicholas of Myra stand adjacent to Basil. It is most likely that Athanasios, generally the fourth bishop in the central apse, stands next to Chrysostom. The four deacons represented on the arches connecting the pastophoria to the bema have been identified as Stephen the Protomartyr, Romanos, Euplos, and Laurentios.

An unusual feature in this sanctuary is the inclusion of an angel on the south

window splay between the concelebrating hierarchs. Due to his location, and the hypothesized presence of a corresponding angel on the north side of the window, Gouma Peterson has suggested that the *melismos* was included in the decorative program above the central arch of the window between the two busts of the hierarchs.[67] If the *melismos* were included in this location, however, this church would present a unique example. It is more likely that the *melismos* was represented in a filled-in section of the window that has since been removed (as was the case in St. John the Theologian in Veroia) or that it was not represented at all.

22. *Christos (church of the Anastasis of Christ), Veroia*
(Color Plate V, Figs. 49, 50)

REFERENCES: Stylianos Pelekanides, *Kallierges: Holes Thettalias aristos zographos* (Athens: He En Athenais Archaiologike Hetaireia, 1973); Georgios Gounares, *The Church of Christ in Veroia* (Thessalonike: Institute for Balkan Studies, 1991); Papazotos, *He Veroia*, 172–74, 253–57, fig. 39.

An inscription in twelve-syllable lines painted on the interior west wall over the church entrance states:

> Xenos Psalidas erects the church of God
> seeking the remission of his many sins.
> Giving it the name of the Anastasis of Christ.
> His wife, Euphrosyne, completes this.
> The name of the painter is Kallierges,
> among my good and decent brothers,[68]
> the best painter in all of Thessaly.
> A patriarchal hand[69] consecrates the church
> in the reign of the great emperor Andronikos
> Komnenos Palaiologos, in the year 6823 [= 1315].

> Ξένος Ψαλιδᾶς ναὸν Θεοῦ ἐγείρει
> Ἄφεσιν ζητῶν τῶν πολλῶν ἐγκλημάτων.
> Τῆς Ἀναστάσεως Χ(ριστο)ῦ ὄνομα θέμενος.
> Εὐφροσύνη σύνευνος τοῦτον ἐκπληροῖ.
> Ἱστοριογράφος ὄνομα Καλ(λ)ιέργης
> τοὺς καλοὺς καὶ κοσμίους αὐταδέλφους μου
> ὅλης Θετταλίας ἄριστος ζωγράφος.
> Πατριαρχικὴ χεὶρ καθιστᾷ τὸν ναὸν
> ἐπὶ τοῦ μεγάλου βασιλέως Ἀνδρονίκου
> Κομνηνοῦ τοῦ Παλαιολόγου ἐν ἔτει ͵ϛωκγʹ[70]

The uppermost scene on the east wall, separated from the lower registers by a painted band of corbels, represents the half-length image of Christ Emmanuel in a medallion held aloft by two archangels (Fig. 49). Flanking this central image are half-length images of David and Solomon, who carry open scrolls inscribed with verses from the Psalms. The inclusion of these prophets within the sanctuary program occurs in the Protaton, painted some fifteen years before this church (Fig. 43).

The Annunciation is divided on either side of the arch leading into the apse. The Virgin sits on a round-backed throne (Color Plate V). Her contorted position and alarmed expression contrast sharply with her self-possessed pose in the conch of the apse. The archangel Gabriel moves rapidly toward the Virgin, literally crossing the open space of the apse by extending his right foot into the composition's red border. The frontal Virgin in the conch of the apse serenely holds her son and is flanked by two angels who extend their hands in veneration.

The Holy Mandylion is represented above the central point of the apse and immediately below the image of Christ Emmanuel. The relic is represented as if suspended from two elaborate gold hooks and is labeled both with the title of the relic and the abbreviation of Christ's name. The nimbed head of Christ is placed at the center of the cloth. Within the nimbus, three inscribed arms of the cross define the contours of the head. In its position above the apse, the Mandylion defines the center of three representations of Christ ordered on a vertical axis (Emmanuel, Mandylion, Christ child).

The lower registers of the sanctuary contain episcopal portraits. Two medallions with half-length portraits of Clement and Hierotheos are placed in an intermediate register on either side of the apse below the Annunciation. Half-length episcopal portraits continue on the north and south walls with representations of Metrophanes and Polykarp. The bishops all hold closed Gospel books and, except for Polykarp, wear *polystavria*. At ground level, four concelebrating bishops converge on a central single window. There is no evidence that the decorative program ever included an image below or even above this window, even if the surrounding bishops incline their heads as if to acknowledge the existence of some central figure. It is difficult to imagine that the *melismos* was omitted from the church program. If one uses the church of St. Blasios as a guide, then this subject would have been depicted behind and below the altar. Athanasios of Alexandria, John Chrysostom, Basil, and Gregory the Theologian are all dressed in *polystavria* and carry liturgical rolls. Athanasios holds the prayer of the first antiphon, Chrysostom holds the Prothesis prayer, Basil holds the silent prayer of the Cherubikon, and Gregory holds the prayer of the third antiphon. A portrait of Cyril is located on the east wall to the south of the apse. On the south wall, the episcopal series continues with John Eleemon and Silvester of Rome.[71] The presence of two prothesis niches and a prothesis table in the northeast corner, adjacent to the apse, required the placement of the half-length portraits of Spyridon and Antipas above the openings. Within the niches are represented two deacons: Stephen and another who cannot be identified. On the north wall, adjacent to the prothesis niche, is a portrait of Nicholas, who carries a partially rolled scroll in his left hand and blesses with his right hand (Fig. 50). His eyes are direct-

ed at a downward angle toward the prothesis table and niches immediately before him. With the exception of Spyridon, the bishops are dressed in *polystavria* and hold Gospel books decorated with jewel-encrusted covers.

23. *St. Blasios, Veroia* (Fig. 51)

REFERENCES: Mouriki, "Stylistic Trends," 68; Anna Tsitouridou, "La peinture monumentale à Salonique pendant la première motié du XIVe siècle," in *L'art de Thessalonique et des pays balkaniques et les courants spirituels au XIVe siècle* (Belgrade: Académie Serbe des sciences et des arts, Institut des études Balkaniques, 1987), figs. 9–12; Papazotos, *He Veroia*, 174–75, 255–57, figs. 12, 13, 39–44.

The church of St. Blasios, originally a single-aisled structure, is located in close proximity to the church of Christ. Similarities in style and iconography suggest a date of circa 1320 for the decoration of St. Blasios and raise the possibility that the same workshop of painters was involved in the decoration of both churches (Mouriki, Papazotos).[72]

As in other small, single-aisled churches, the Ascension is painted in the gable of the east wall. Christ is held aloft in a mandorla by two angels. A local precedent for this type of representation was established by the neighboring church of St. John the Theologian. In St. Blasios two groups of apostles are positioned in the corners of the scene and are guided to the Ascension by gesturing angels. There is one difference between the depictions in the two Veroian churches: in St. John the Theologian, the Virgin stands below the ascending Christ and gestures toward him. A century later, in St. Blasios, the Virgin was depicted with outstretched arms and turned toward the faithful. This orant Virgin is placed exactly above the Virgin and Child in the conch of the apse. In St. John the Theologian, the Virgin in the apse is represented in an orant pose, and it would have been repetitive to represent her in both apse and gable in an identical stance.

The Annunciation is divided by the arched opening of the apse; the Virgin is on the right side of the opening and the archangel on the left. The Virgin sits on an ornate throne and holds her right hand across her chest. She leans slightly in the direction of the archangel who extends his right hand in a gesture of speech. There is no representation of the Holy Mandylion.

The close resemblance between the standing Virgin and Child in the churches of Christ and St. Blasios (Figs. 49, 51) has been seen as evidence for a common painter (Papazotos). The St. Blasios Virgin is extremely tall; the folds of the drapery and the position of her feet mirror those in the representation of the Virgin in the neighboring church. The pose of the archangels, who bow on either side of the Virgin and Child, is similar to that of the archangels in the church of Christ, though their garments and shoes present subtle differences.

Below the level of the Virgin and Child the two churches differ substantially. In

St. Blasios, two angels dressed as deacons carry *rhipidia* and turn away from the central window of the apse to face two hierarchs. Between the angels and behind the altar, in a position that renders the depiction nearly invisible to the viewer, is the *melismos*, a small figure of Christ placed on an elaborate altar and covered by an *asterisk*, the crossed bands of bent metal that covered the offered bread. Above the window is represented a white medallion decorated with a red cross. John Chrysostom and Basil stand on either side of the angels, carrying open liturgical scrolls. Basil's scroll was inscribed with the Cherubikon prayer, but in an unusual departure from the established convention, Chrysostom's scroll carries the prayer of the consecration over the bread. This inscription may be related to the medallion in the center of the apse, which resembles the stamp applied to the offered bread in order to differentiate the portion that would be extracted for communion.

Below the Virgin of the Annunciation, on the face of the east wall, is a single deacon. The inscription that identified him is lost. He is dressed in the same manner as the angels in the apse but carries a cross in his right hand. On the north wall adjacent to the apse is the half-length representation of Silvester, a portrait type dictated by his placement over the prothesis niche. Another deacon is painted within the northeast prothesis niche.

The sanctuary decoration continues on the south wall of the church. Karpos and Polykarp are represented, both holding open scrolls. The inclusion of Karpos, the first bishop of Veroia, reflects the special veneration of a local saint.[73] He is honored further by holding the Prothesis prayer, the text usually inscribed on Chrysostom's scroll. In an intermediate zone above these two figures are two half-length episcopal portraits enclosed in medallions. On the north wall of the church are the bishops Cyril of Alexandria and Athanasios. The figure of Cyril has unfortunately been destroyed by the insertion of a later doorway.

24. *St. Paraskeve, Veroia*

REFERENCE: Papazotos, *He Veroia*, 182–83.

The small church of St. Paraskeve is sited in close proximity to the church of Christ. Although the wall paintings are primarily post-Byzantine, the removal of seventeenth-century layers on the north wall of the church revealed an early-fourteenth-century decorative phase. The paintings are comparable to those of other churches in Veroia of this date in both style and iconography.

Fourteenth-century paintings within the sanctuary are found on the northeast wall and include three frontal episcopal portraits and five medallions containing half-length bishops. The full-length bishops wear plain *phelonia* and carry closed, ornamented Gospel books in their left hands as they bless with their right. Preserved inscriptions identify the figures as Achilleios, Spyridon, and Hermogenes. The half-length figures also wear

plain *phelonia* and hold Gospel books in their left hands. Four of the figures are identified as Antipas, Gregory of Akragas, Gregory of Armenia, and Silvester of Rome.

25. *St. Nicholas Orphanos, Thessalonike* (Color Plates I and II, Figs. 52–58)

REFERENCES: Andreas Xyngopoulos, *Hoi toichographies tou Hagiou Nikolaou Orphanou Thessalonikes* (Athens: Archaiologikon Deltion, 1964); Tania Velmans, "Les fresques de Saint-Nicolas Orphanos à Salonique," *CahArch* 16 (1966): 145–76; Chrysanthe Mavropoulou-Tsioumi, *The Church of St. Nicholas Orphanos* (Thessaloniki: Institute for Balkan Studies, 1986); Anna Tsitouridou, *Ho zographikos diakosmos tou Hagiou Nikolaou Orphanou ste Thessalonike: Symvole ste melete tes palaiologeias zographikes kata ton proimo 14° aiona* (Thessalonike: Kentro Vyzantinon Ereunon, 1986) (with bibliography).

The decoration of St. Nicholas Orphanos has been dated circa 1310–20 on stylistic grounds (Xyngopoulos, Tsitouridou).

The attenuated height of the central nave of St. Nicholas Orphanos provides additional space for decoration on the east wall of the church (Fig. 53).[74] The two upper registers of the east wall are filled with scenes of the appearance of Christ to the holy women (gable), the Annunciation, the Nativity, and the Adoration of the Magi (upper register) (Fig. 52).

The sanctuary's liturgical decoration begins with the intermediate register of the east wall, where two scenes of the Communion of the Apostles are placed above the apse, separated by a representation of the Holy Mandylion. So far as I know, this is the only example in Byzantine art where the Communion of the Apostles is placed on the east wall of a church in this manner. The upper portion of the communion of the bread is damaged (Fig. 54), but the communion of the wine is well preserved (Fig. 55). The unusual placement of the communion scene is the result of architectural exigency: the shallow and short form of the apse limited the available space for decoration.

As in a number of Macedonian churches, the Holy Mandylion is suspended directly over the apse by means of two elaborate gold hooks. The medallion containing the nimbed Christ is centered on the cloth. The three arms of the cross behind the head of Christ are decorated with a pattern that recalls the decorative pastiglio found on icons of the period.

The Virgin in the apse is depicted in an orant position against a dark, star-filled background, which suggests that the Byzantines associated the apse with the heavens (Fig. 56).[75] Archangels, dressed in imperial regalia, bow in reverence on either side of this majestic figure. The beauty of the image is enhanced by the extensive use of gold highlights. An unusual element is presented by the legend inscribed on either side of the Virgin's head, which reads: "The Mother of God Not Made by Human Hands." Scholars have linked this epithet to a devotional icon housed in the church of the Acheiropoietos, also located in Thessalonike.[76]

The lower register of the central apse contains the standard four bishops: Athanasios, John Chrysostom, Basil, and Gregory the Theologian. They carry liturgical scrolls and bow their heads in reverence toward the representation of the *melismos* at the center of the apse. A row of half-length bishops is placed above the standing figures. In order to relieve the monotony of a string of portraits, these bishops turn in various directions and hold their Gospel books in different positions (Fig. 58).

The *melismos* is placed in an unusual position over the central window of the apse at the eye level of the painted celebrants (Fig. 57). The miniature Christ child, placed on a small altar, raises his right hand in blessing. His body is covered by a liturgical veil and a small *asterisk*.

26. *St. Catherine, Thessalonike* (Fig. 59)

REFERENCE: Mouriki, "Stylistic Trends," 60–61. (The decoration of the church is unpublished.)

The paintings of St. Catherine's have been dated on the basis of style to circa 1315. Doula Mouriki has proposed that the decorative program was executed by two masters, one for the nave and one for the apse and narthex.

The extant Byzantine paintings of the sanctuary appear in the two lower registers of the apse. The intermediate register of the sanctuary was decorated with the Communion of the Apostles. The scene was positioned around a double window, with a wide pier between its two parts. Two angels were depicted back-to-back on this pier and hold *rhipidia*. Two groups of twelve apostles, each led by Peter, approach Christ from either side of the windows. In the apse's lower register are the concelebrating bishops Athanasios, John Chrysostom, Basil, and Gregory the Theologian (Fig. 59). The painter has attempted to relieve the monotony by depicting the liturgical scrolls in varying positions: the two central bishops hold their scrolls in the customary diagonal fashion, whereas the two remaining bishops support their scrolls horizontally.

27. *Holy Apostles, Thessalonike*

REFERENCES: Andreas Xyngopoulos, *He psephidote diakosmesis tou Naou ton Hagion Apostolon Thessalonikes* (Thessalonike: Hetaireia Makedonikon Spoudon, 1953); Mouriki, "Stylistic Trends," 62–63; Soterios Kissas, "La datation des fresques des Saint-Apôtres à Thessalonique," *Zograf* 7 (1977): 52–57; Christine Stephan, *Ein byzantinisches Bildensemble: Die Mosaiken und Fresken der Apostelkirche zu Thessaloniki* (Worms: Wernersche Verlagsgesellschaft, 1986) (with bibliography); Peter Kuniholm and Cecil Striker, "Dendrochronological Investigations in the Aegean and Neighboring Regions,

1977–1982," *Journal of Field Archaeology* 10, no. 4 (1983): 411–20; Nikos Nikonanos, *The Church of the Holy Apostles in Thessaloniki* (Thessalonike: Institute for Balkan Studies, 1986); Peter Kuniholm and Cecil Striker, "Dendrochronological Investigations in the Aegean and Neighboring Regions, 1983–1986," *Journal of Field Archaeology* 14, no. 4 (1987): 385–97.

The church of the Holy Apostles in Thessalonike had traditionally been dated circa 1315 on the style of its mosaics and the monograms of the patriarch Niphon located on the west facade.[77] Using historical evidence, Kissas suggested a *terminus post quem* of 1328. Kissas's date places the decoration in the reign of Andronikos III, when Niphon would have returned to imperial favor. Kissas's argument is supported by Striker and Kuniholm, whose dendrochronological investigations also suggest a later date, circa 1329.

The decoration of the church of the Holy Apostles took place in two phases, one mosaic and one painted. The change in decorative media may be attributed to the patron's having run out of funds, possibly owing to his dismissal from the patriarchate in 1314. The Virgin and Child were most likely depicted in mosaic; the lower registers of the apse were executed in paint. Only the painted portraits of celebrating bishops remain.

The six bishops in the central sanctuary of the church are Nicholas of Myra, Athanasios, John Chrysostom, Basil the Great, Gregory the Theologian, and Cyril of Alexandria. The bishops are dressed in *polystavria* and carry liturgical scrolls. There is no indication that the *melismos* was included in the decoration of the central sanctuary, but the subject was represented in two other locations in Holy Apostles: the conch of the prothesis chamber and the prothesis niche for the chapel of John the Baptist in the northeast corner of the church.

Frequently Cited Sources

ABME: Archeion ton Byzantinon Mnemeion tes Hellados
BZ: Byzantinische Zeitschrift
CahArch: Cahiers archéologiques
Corsi Rav: Corsi di cultura sull'arte ravennate e bizantina
DChAE: Deltion tes Christianikes Archaiologikes Hetaireias
DOP: Dumbarton Oaks Papers
JÖB: Jahrbuch der Österreichischen Byzantinistik (before 1969,
* Jahrbuch der Österreichischen byzantinischen Gesellschaft)*
REB: Revue des études byzantines
ZRVI: Zbornik radova Vizantološkog Instituta

Babić, Gordana, "Les discussions christologiques et le décor
 des églises byzantines au XIIe siècle: Les évêques
 officiant devant l'Hétimasie et devant l'Amnos,"
 Frühmittelalterliche Studien 2 (1986): 368–86.

Dmitrievskij, Aleksej, *Opisanie liturgičeskich rukopisej,* 3 vols.
 (Kiev: Universiteta sv.Vladimira, 1895–1917).

Drandakes, Nikolaos V., *Vyzantines toichographies tes Mesa
 Manes* (Athens: Athenais Archaiologike Hetaireia,
 1995).

Hadermann-Misguich, Lydie, *Kurbinovo: Les fresques de
 Saint-Georges et la peinture byzantine du XIIe siècle*
 (Brussels: Éditions de Byzantion, 1975).

Hamann-Mac Lean, Richard, and Horst Hallensleben, *Die
 Monumentalmalerei in Serbien und Makedonien vom 11.
 bis zum frühen 14. Jahrhundert,* 3 vols. (Giessen: Schmitz,
 1963–76).

Miljković-Pepek, Petar, "Contribution aux recherches
 sur l'évolution de la peinture en Macédoine au XIIIe
 siècle," in *L'art byzantin du XIIIe siècle,* Symposium de

Sopoćani, 1965 (Belgrade: Faculté de philosophie,
 Departement de l'histoire de l'art, 1967), 189–96.

———, *Veljusa: Manastir Sv. Bogorodica Milostiva vo seloto
 Veljusa kraj Strumica* (Skopje: Fakultet za filozofsko-
 istoriski nauki na univerzitetot Kiril i Metodij, 1981).

Mouriki, Doula, "Stylistic Trends in Monumental Painting
 of Greece at the Beginning of the Fourteenth
 Century," in *L'art byzantin au début du XIVe siècle,*
 Symposium of Gračanica, 1973 (Belgrade: Filozofski
 fakultet, Odeljenje za istoriju umetnosti, 1978), 55–83.

Moutsopoulos, Nikolaos K., *Ekklesies tes Kastorias, 9.–11.
 aionas* (Thessalonike: Parateretes, 1992).

Moutsopoulos, Nikolaos K., and Georgios Demetrokalles,
 Geraki: Hoi ekklesies tou oikismou (Thessalonike:
 Kentron Vyzantinon Ereunon, 1981).

Papazotos, Thanases, *He Veroia kai hoi naoi tes (11os–18os ai.):
 Historike kai archaiologike spoude ton mnemeion tes poles*
 (Athens: Ekdose tou Tameiou Archaiologikon Poron
 kai Apallotrioseon, 1994).

Pelekanides, Stylianos, *Kastoria* (Thessalonike: Makedonike
 Vivliotheke, 1953).

Pelekanides, Stylianos, and Manolis Chatzidakis, *Kastoria*
 (Athens: Melissa, 1985).

Taft, Robert F., "The Pontifical Liturgy of the Great
 Church According to a Twelfth-Century Diataxis in
 Codex *British Museum Add. 34060,*" *Orientalia christiana
 periodica* 45 (1979): 279–307.

Wharton, Annabel Jane, *Art of Empire: Painting and
 Architecture of the Byzantine Periphery: A Comparative
 Study of Four Provinces* (University Park: Pennsylvania
 State University Press, 1988).

Notes

Preface

1. Georgios Vizyenos, *My Mother's Sin and Other Stories,* trans. William F. Wyatt (Hanover and London: University Press of New England, 1988), 7.

2. Gennadi G. Litavrin, *Sovety i rasskazy Kekavmena* (Moscow: Nauka, 1972), 212.

3. For sanctuary programs dating before Iconoclasm, see Christa Belting-Ihm, *Die Programme der christlichen Apsismalerei vom vierten Jahrhundert bis zur Mitte des achten Jahrhunderts* (Wiesbaden: Steiner, 1960).

4. For a complementary study on the medieval sanctuary, see Jean-Michel Spieser, "Le décor peint," in Anthony Cutler and Jean-Michel Spieser, *Byzance médiévale, 700–1204* (Paris: Gallimard, 1996), 257–313.

5. As an exception, see the analysis of Cappadocian churches in Catherine Jolivet-Lévy, *Les églises byzantines de Cappadoce: Le programme iconographique de l'abside et de ses abords* (Paris: Éditions du Centre National de la Recherche Scientifique, 1991).

I
The Creation of Sacred Space

1. René Bornert, *Les commentaires byzantins de la Divine Liturgie du VIIe au XVe siècle,* Archives de l'Orient chrétien 9 (Paris: Institut français d'études byzantines, 1966); F. E. Brightman, "The *Historia Mystagogica* and Other Greek Commentaries on the Byzantine Liturgy," *Journal of Theological Studies* 9 (1908): 248–67, 387–97.

2. Maximus the Confessor, *The Church, the Liturgy, and the Soul of Man: The Mystagogia of St. Maximus the Confessor,* trans. Julian Stead (Still River, Mass.: St. Bede's Publications, 1982), 71.

3. Ibid.

4. Sophronios, patriarch of Jerusalem, *Commentarius liturgicus: PG* 87ter, 3984C.

5. Symeon of Thessalonike, *De sacro liturgia: PG* 155, 292A.

6. Georgios Soteriou, "Ho en Thevais naos Gregoriou tou Theologou," *Archaiologike Ephemeris* (1924): 2. The date of the church is given as 872.

7. F. E. Brightman, *Liturgies Eastern and Western,* 1, *Eastern Liturgies* (Oxford: Clarendon Press, 1896), 318, 377.

8. Symeon of Thessalonike, *De sacro templo: PG* 155, 344.

9. For a preliminary study of the use of lights in the church, see George Galavaris, "Some Aspects of Symbolic Use of Lights in the Eastern Church: Candles, Lamps and Ostrich Eggs," *Byzantine and Modern Greek Studies* 4 (1978): 69–78.

10. Symeon of Thessalonike, *Treatise on Prayer: An Explanation of the Services Conducted in the Orthodox Church,* trans. H. L. N. Simmons (Brookline, Mass.: Hellenic College Press, 1984), 26.

11. Paul Speck, "Die Inschrift am Apsisbogen der Panagia Chalkeon," *Hellenika* 20 (1967): 419–21; Ninoslava Radošević-Maksimović, "A Byzantine Epigram from St. Achilius's Basilica at Mala Prespa," *ZRVI* 12 (1970): 9–13.

12. Stephen G. Xydis, "The Chancel Barrier, Solea, and Ambo of Hagia Sophia," *Art Bulletin* 29 (1947): 1–24; Thomas F. Mathews, *The Early Churches of Constantinople: Architecture and Liturgy* (University Park and London: Pennsylvania State University Press, 1971), 109–11.

13. Pericles-Pierre Joannou, *Disciplina generale antiqua,* 1, *Les canons des conciles oecuméniques* (Rome: Tipografia Italo-Orientale S. Nilo, 1962), 207.

14. Germanos of Constantinople, *On the Divine Liturgy,* trans. Paul Meyendorff (Crestwood, N.Y.: St. Vladimir's Seminary Press, 1984), 63. See also Sophronios (as in n. 4), 3984D–3985A.

15. Nicos Zias, "Panagia Protothrone at Chalki," in *Naxos,* ed. Manolis Chatzidakis (Athens: Melissa, 1989), 30.

16. Niketas Stethatos, *Opuscules et lettres,* ed. Jean Darrouzès (Paris: Éditions du Cerf, 1961), 232–34.

17. The bibliography on decorated epistyles is extensive. For the decorated screen before Iconoclasm, see Cyril Mango, "On the History of the *Templon* and the Martyrion of St. Artemios at Constantinople," *Zograf* 10 (1979): 40–43; Lawrence Nees, "The Iconographic Program of Decorated Chancel Barriers in the pre-Iconoclastic Period," *Zeitschrift für Kunstgeschichte* 46 (1983): 15–26; R. Martin Harrison, *Excavations at Saraçhane in Istanbul* (Princeton: Princeton University Press, 1986), 1: 156–57. For stone screens, see, among other articles, Arthur H. S. Megaw, "The Skripou Screen," *Annual of the British School at Athens* 61 (1966): 1–32; Nezih Fıratlı, "Découverte d'une église byzantine à Sébaste de Phrygie," *CahArch* 19 (1969): 151–66. For icons painted on wooden beams, see Viktor Lazareff, "Trois fragments d'épistyles peintes et le templon byzantin," *DChAE,* ser. 4, 4 (1964–65): 117–43; Manolis Chatzidakis, "Eikones

epistyliou apo to Hagion Oros," *DChAE,* ser. 4, 4 (1964–65): 377–400; idem, "Ikonostas," *Reallexikon zur byzantinischen Kunst* (Stuttgart: A. Hiersemann, 1973), cols. 326–54; idem, "L'évolution de l'icône aux 11e–13e siècles et la transformation du templon," *XV Congrès international des Études Byzantines* (Athens: Vivliotheke tes en Athenais Archaiologikes Hetaireias, 1976), 3: 159–91; Kurt Weitzmann, "Icon Programs of the 12th and 13th Centuries at Sinai," *DChAE,* ser. 4, 12 (1984): 86–94. For ceramic icons, see Jannic Durand and Christine Vogt, "Plaques de céramique décorative byzantine d'époque macédonienne," *Revue du Louvre* 42, no. 4 (1992): 38–44. For metallic decoration, see Xydis (as in n. 12), 1–11; Ann W. Epstein, "The Middle Byzantine Sanctuary Barrier: Templon or Iconostasis?" *Journal of the British Archaeological Association* 134 (1981): 6; Cyril Mango, *The Art of the Byzantine Empire, 312–1453* (Toronto: Medieval Academy of America, 1986), 194. For ivory, see Kurt Weitzmann, "Diptikh slonovoi kosti iz Ermitazha, otnosyashchiisya k krugu Imperatora Roman," *Vyzantijskij vremennik* 32 (1971): 142–55 (reprinted as "An Ivory Diptych of the Romanos Group in the Hermitage," in *Byzantine Book Illumination and Ivories* [London: Variorum Reprints, 1980], no. VIII); idem, "An Ivory Plaque with Two of the Forty Martyrs of Sebaste in the Glencairn Museum, Bryn Athyn, Pa.," in *Euphrosynon: Aphieroma ston Manole Chatzedake* (Athens: Ekdose tou Tameiou Archaiologikon Poron kai Apallotrioseon, 1992), 2: 704–12. For enamel, see Hans R. Hahnloser et al., *Il Tesoro de San Marco,* 1, *La Pala d'Oro* (Florence: Sansoni, 1965), pls. xliii–xlviii, lxix–lxx.

18. André Grabar, "Deux notes sur l'histoire de l'iconostase d'après des monuments de Yougoslavie" *ZRVI* 7 (1961): 13–22; Christopher Walter, "The Origins of the Iconostasis," *Eastern Churches Review* 3 (1971): 251–67; idem, "A New Look at the Byzantine Sanctuary Barrier," *REB* 51 (1993): 203–28.

19. Pelekanides and Chatzidakis, *Kastoria,* 32; Epstein (as in n. 17), 1–28. For a thorough study of *proskynetaria* icons, see Gordana Babić, "La décoration en fresques de clôtures de choeur," *Zbornik za likovne umetnosti* 11 (1975): 3–47.

20. Epstein (as in n. 17), 1–28.

21. Tia Kolbaba, "Meletios Homologetes *On the Customs of the Italians,*" *REB* 55 (1997): 158.

22. Stethatos (as in n. 16), 232–34.

23. Ibid., 284–85.

24. Nicholas of Andida, *Protheoria: PG* 140, 445C.

25. Paul Gautier, "La diataxis de Michel Attaliate," *REB* 39 (1981): 97.

26. Dmitrievskij, *Opisanie,* 2: 170–71.

27. Philotheos Kokkinos, *Diataxis: PG* 154, 748A.

28. Epstein (as in n. 17), 16–22. Masonry screens are common in Cappadocia and in the south of Greece.

29. Eleni Counoupiotou, "Geraki: Synteresis toichographion," *Archaiologika Analekta ex Athenon* 4, no. 1 (1971): fig. 8; Moutsopoulos and Demetrokalles, *Geraki,* 134–35. Although Ann Epstein dismisses the screen as "a crude masonry affair" (Epstein [as in n. 17], 20), the painting in this church is of the highest quality.

30. Moutsopoulos and Demetrokalles, *Geraki,* 10. The authors note that the interior of the templon is painted with "plain, aniconic decoration."

31. See Doula Mouriki in *Sinai: Treasures of the Monastery of Saint Catherine,* ed. Konstantinos Manafis (Athens: Ekdotike Athenon, 1990), 105, n. 25; Chatzidakis, "L'évolution de l'icône" (as in n. 17), 3: 168.

32. For a recent analysis of the devotional experience of the Byzantine viewer, see Robin Cormack, *Painting the Soul: Icons, Death Masks and Shrouds* (London: Reaktion Books, 1997), 24–31.

33. Jeffrey C. Anderson, "A Note on the Sanctuary Mosaics of St. Demetrios, Thessalonike" (forthcoming).

34. See chapter IV, 53–54.

35. Pelekanides and Chatzidakis, *Kastoria,* 30. The titular saints are also represented on the exterior, west facade, of the church, which has been dated to the late 12th century.

36. See the appendix, Catalogue of Decorated Sanctuaries in Macedonia, no. 8.

37. See ibid., no. 9.

38. Anna Tsitouridou, *Ho zographikos diakosmos tou Hagiou Nikolaou Orphanou ste Thessalonike: Symvole ste melete tes palaiologeias zographikes kata ton proimo 14⁰ aiona* (Thessalonike: Kentro Vyzantinon Ereunon, 1986), pl. 14.

39. Christopher Walter suggests that ex-votos were regularly placed in the sanctuary. According to Walter ([as in n. 18], 260): "In the monastery of the Eleousa at Veljusa in Macedonia there were in the sanctuary alone some ninety icons, according to an inventory made in 1449. The explanation for their presence seems simple. The sanctuary was the holiest part of the church since there the Eucharist was offered. The donor therefore wished that the icon of the saint to whom he had a devotion should be by his image as close as possible to Christ who was really present in the consecrated species."

40. On the practice of naming children after specific saints, see Angeliki E. Laiou, "Peasant Names in Fourteenth-Century Macedonia," *Byzantine and Modern Greek Studies* 1 (1975): 72. On painted evidence for the relationship of women and their name saints, see Sharon Gerstel, "Painted Sources for Female Piety in Medieval Byzantium," *DOP* 52 (1998).

41. See, for example, the portrait of St. Kyriake in the church of St. Panteleimon, Upper Boularioi, Mani. Adjacent to the saint is an inscription from a woman named Kyriake. Drandakes, *Vyzantines toichographies,* 390–91.

42. Myrto Georgopoulou-Verra, "Toichographies tou telous tou 13⁰ᵘ aiona sten Euvoia," *Archaiologikon Deltion* 32 (1977): 10, 14–15, pl. 14b.

43. Agape Vasilake-Karakatsane, *Hoi toichographies tes Omorphes Ekklesias sten Athena* (Athens: Christianike Archaiologike Hetaireia, 1971), 15, pl. 18b.

44. The location of these churches in areas that were under Latin rule may account for a misunderstanding in the

polemical texts. For the accusations of Constantine Stilbes regarding the West's alleged practice of permitting women to enter the sanctuary, see Jean Darrouzès, "Le mémoire de Constantin Stilbès contre les Latins," *REB* 21 (1963): 51–100. For an analysis of the portion of this text concerning women in the sanctuary, see Henry Maguire, "*Abaton and Oikonomia*: St. Neophytos and the Iconography of the Presentation of the Virgin," in *Medieval Cyprus: Studies in Art, Architecture and History in Memory of Doula Mouriki* (Princeton: Princeton University Press, 1999), 95–115.

45. *Vita Stephani Diaconi: PG* 100, 1123C. For the monastery of Trichinarea, see Raymond Janin, *Les églises et les monastères des grands centres byzantins: Bithynie, Hellespont, Latros, Galesios, Trebizonde, Athènes, Thessalonique* (Paris: Institut français d'études byzantines, 1975), 45. I thank Alice-Mary Talbot for this reference.

46. Andreas Stylianou and Judith A. Stylianou, "Donors and Dedicatory Inscriptions, Supplicants and Supplications in the Painted Churches of Cyprus," *JÖB* 9 (1960): 102–3.

47. Sophia Kalopissi in "Ereuna ste Mane," *Praktika tes en Athenais Archaiologikes Hetaireias* (1979): 204–5, pl. 131.

48. Nikolaos Drandakes, "Panagia at Yallou," in *Naxos*, ed. Manolis Chatzidakis (Athens: Melissa, 1989), 100; Sophia Kalopissi-Verti, *Dedicatory Inscriptions and Donor Portraits in Thirteenth-Century Churches of Greece* (Vienna: Verlag der Österreichischen Akademie der Wissenschaften, 1992), 89.

49. Among the many churches containing such inscriptions are Archangel Michael, Polemitas, Mani (1278); St. George, Distomo, Naxos (1286/87); St. Panteleimon, Bizariano, Crete (2nd quarter of 13th century) (Kalopissi-Verti [as in n. 48], 74, 88, 92); St. Nicholas in Platsa (1343/44) (Anna Philippidis-Braat, "Inscriptions du Péloponnèse," *Travaux et mémoires* 9 [1985]: 333).

50. Philippidis-Braat (as in n. 49), 45–46, pl. IX, 1. The inscription also notes the name of the marble worker, Niketas, from the village of Maina.

51. Kalopissi-Verti (as in n. 48), 109.

52. See, for example, Ihor Ševčenko, "The Sion Treasure: The Evidence of the Inscriptions," in Susan Boyd and Marlia Mundell Mango, *Ecclesiastical Silver Plate in Sixth-Century Byzantium* (Washington, D.C.: Dumbarton Oaks Research Library and Collection, 1992), 39–56.

53. Alice-Mary Talbot, "Women and Mt. Athos," in *Mount Athos and Byzantine Monasticism*, Papers from the Twenty-eighth Spring Symposium of Byzantine Studies, Birmingham, March 1994, ed. Anthony Bryer and Mary Cunningham (Aldershot, Great Britain: Variorum, 1996), 76–79.

54. Meletius Michael Solovey, *The Byzantine Divine Liturgy: History and Commentary*, trans. D. Wysochansky (Washington, D.C.: Catholic University of America Press, 1970), 127.

55. Linos Polites, "Katalogos leitourgikon eiletarion tes Hieras Mones Vatopediou," *Makedonika* 4 (1955–60): 407.

56. Gary Vikan, *Gifts from the Byzantine Court* (Washington, D.C.: Dumbarton Oaks Center for Byzantine Studies, 1980), 4.

57. Sharon Gerstel, "Ritual Swimming and the Feast of Epiphany," *Byzantine Studies Conference Abstracts* 21 (1995): 78.

II
Assembling the Company of Bishops

1. Otto Demus, *Byzantine Mosaic Decoration: Aspects of Monumental Art in Byzantium* (London: Routledge, 1948; reprint, New Rochelle, N.Y.: Caratzas Brothers, 1976), 9.

2. For the symbolic value ascribed to colors, including blue, see Liz James, *Light and Colour in Byzantine Art* (Oxford: Clarendon Press, 1996), 121.

3. For the decoration of the early Byzantine sanctuary, see Christa Ihm, *Die Programme der christlichen Apsismalerei vom vierten Jahrhundert bis zur Mitte des achten Jahrhunderts* (Wiesbaden: Franz Steiner Verlag, 1960).

4. Otto G. von Simson, *Sacred Fortress: Byzantine Art and Statecraft in Ravenna* (Princeton: Princeton University Press, 1987), 58–60, pl. 21.

5. Nicos Zias, "Panagia Protothrone at Chalki," in *Naxos*, ed. Manolis Chatzidakis (Athens: Melissa, 1989), 35, fig. 7.

6. At Bawit, for example, frontal figures holding books are found in Chapels VII, VIII, XVII, and XXVIII. These figures seem mostly to represent local church dignitaries. See Jean Clédat, *Le monastère et la nécropole de Baouît* (Cairo: Imprimerie de l'Institut français d'archéologie orientale, 1904), pls. XXVII, XXX, XLV, XCVII.

7. Cyril Mango and Ernest J. W. Hawkins, "The Mosaics of St. Sophia at Istanbul: The Church Fathers in the North Tympanum," *DOP* 26 (1972): 23–24.

8. Nano Chatzidakis, *Hosios Loukas* (Athens: Melissa, 1997), figs. 43, 44; Robert Weir Schultz and Sidney Howard Barnsley, *The Monastery of Saint Luke of Stiris, in Phocis, and the Dependent Monastery of Saint Nicolas in the Fields, near Skripou, in Boeotia* (London: Macmillan and Company, 1901), 59–60, pls. 43, 44; Ernst Diez and Otto Demus, *Byzantine Mosaics in Greece: Hosios Lucas and Daphni* (Cambridge: Harvard University Press, 1931), plan of Hosios Loukas.

9. Marcell Restle, *Byzantine Wall Painting in Asia Minor* (Greenwich, Conn.: New York Graphic Society, 1967), 2: figs. 4, 13, 18. Restle identifies the figures as evangelists, but they clearly wear episcopal costume.

10. Panagiotes Vocotopoulos, "Fresques du XIe siècle à Corfou," *CahArch* 21 (1971): 177; idem, "Peri ten chronologesin tou en Kerkyra naou ton Hagion Iasonos kai Sosipatrou," *DChAE*, ser. 4, 5 (1966–69): 170.

11. Germaine Da Costa-Louillet, "Saints de Grèce aux VIIIe, IXe et Xe siècles," *Byzantion* 31 (1961): 326–30.

12. Moutsopoulos, *Ekklesies tes Kastorias*, 388–92, with bibliography.

13. Mango and Hawkins (as in n. 7), 37–41.

14. Manolis Chatzidakis, "Vyzantines toichographies ston Oropo," *DChAE*, ser. 4, 1 (1959): 87–107.

15. Paris, Bibliothèque Nationale, gr. 510, fol. 71v. Henri Omont, *Miniatures des plus anciens manuscrits grecs de la Bibliothèque nationale du VIe au XIVe siècle,* 2d ed. (Paris: H. Champion, 1929), pl. XXVII.

16. *Il Menologio di Basilio II (Cod. Vaticano greco 1613)* (Turin: Fratelli Bocca, 1907), 2: 54, 74, 88, 116, 123, 160, 177, 188, 226, 233, 239, 254, 263, 265, 276, 288, 291, 303, 305, 307, 322, 332, 340, 349, 377, 378, 381, 388, 397, 398, 409, 410, 411, 412, 415, 416, 417, 424. The vast majority of the figures thus depicted are labeled as bishops. Priests, popes, and archbishops are also numbered among their ranks.

17. Drandakes, *Vyzantines toichographies,* 365–91. See also Anthony Cutler and Jean-Michel Spieser, *Byzance médiévale, 700–1204* (Paris: Gallimard, 1996), 135–36.

18. In addition to the churches discussed, 11th-century churches within Byzantine territory that contain frontal bishops in their apsidal programs include the church of the Metamorphosis near Koropi in Attika; Sakli kilise (Göreme, Chapel 2a); Elmale kilise (Göreme, Chapel 19); Çarikli kilise (Göreme, Chapel 22); Karanlik kilise (Göreme, Chapel 23) (Karin Skawran, *The Development of Middle Byzantine Fresco Painting in Greece* [Pretoria: University of South Africa, 1982], 154–55, fig. 47; Catherine Jolivet-Lévy, *Les églises byzantines de Cappadoce: Le programme iconographique de l'abside et de ses abords* [Paris: Éditions du Centre National de la Recherche Scientifique, 1991], pls. 60.3, 75.1, 80, 84).

19. Local bishops like Kornoutos of Ikonion and Athenogenios appear among the episcopal figures represented in the central apses of several 11th-century churches in Cappadocia, including Eski Gümüs and St. Barbara in Soğanli. See Jolivet-Lévy (as in n. 18), 261, 280.

20. Karoline Papadopoulos, *Die Wandmalereien des XI. Jahrhunderts in der Kirche Panagia ton Chalkeon in Thessaloniki* (Graz-Cologne: Hermann Böhlaus, 1966), pls. 5–7.

21. Nikolaos Drandakes, "Hai toichographiai tou Hagiou Eutychiou Rethymnes," *Kretika Chronika* 10 (1956): 215–36.

22. André Grabar, "Deux témoignages archéologiques sur l'autocéphalie d'une église," *ZRVI* 8 (1964): 163–68.

23. André Grabar, "Les peintures murales dans le choeur de Sainte-Sophie d'Ochrid," *CahArch* 15 (1965): 257–65; Ann Wharton Epstein, "The Political Content of the Paintings of Saint Sophia at Ohrid," *JÖB* 29 (1980): 321–25; Christopher Walter, "Portraits of Local Bishops: A Note on Their Significance," *ZRVI* 21 (1982): 15–16.

24. Anna Tsitouridou, "Les fresques du XIIIe siècle dans l'église de la Porta-Panaghia en Thessalie," *XV Congrès international des Études Byzantines* (Athens: Vivliotheke tes en Athenais Archaiologikes Heteraireias, 1981), 2B: 863–78. The same stylistic observation holds true for the early-13th-century decoration of St. George at Oropos and St. George in Belisirma (Cappadocia), dated 1282–95. See Chatzidakis (as in n. 14), 88–90, pls. 34, 35; Jolivet-Lévy (as in n. 18), 318–19, fig. 176.

25. Drandakes, *Vyzantines toichographies,* 398.

26. Ibid., 162.

27. Aimilia Bakourou, "Toichographies apo dyo asketaria tes Lakonias," in *Praktika tou A' Topikou Synedriou Lakonikon Meleton* (Athens: Hetaireia Peloponnesiakon Spoudon, 1983), 408, fig. 2.

28. H. Grigoriadou-Cabagnols, "Le décor peint de l'église de Samari en Messénie," *CahArch* 20 (1970): 185.

29. The church of St. Peter near Gardenitsa, in the Mani, is doubled-apsed like St. Panteleimon, which was painted several centuries earlier. At St. Peter's, four frontal hierarchs are placed in each of the two apses below orant representations of St. Paraskeve and the archangel Michael. The small cave chapel of St. John the Baptist in Lakonia, dated on stylistic grounds to 1275–1300, contains frontal bishops carrying Gospel books in their left hands. From the same period, frontal bishops are found in the sanctuaries of St. Theodore near Tsopaka and St. Niketas in Karavas, both located in the central Mani. See Drandakes, *Vyzantines toichographies,* 34, 268; Bakourou (as in n. 27), 404–40; Nikolaos Gkioles, "Ho naos tou Hag. Niketa ston Karava Mesa Manes," *Lakonikai spoudai* 7 (1983): 170.

30. There are two examples in the region surrounding the Gulf of Corinth: the church of the Savior at Alepochori (ca. 1260–80) and St. Nicholas at Klenia, near Corinth (dated by an inscription to 1287). Frontal hierarchs also appear in the churches of Panagia at Yallou (1288/89) and St. Constantine Vourvourias (1310), both on the island of Naxos. For these churches, see Doula Mouriki, *Hoi toichographies tou Sotera konta sto Alepochori Megaridos* (Athens: Demosieumata tou Archaiologikou Deltiou, 1978), 17–18; Maria Vardavake, "Hoi toichographies tou Hagiou Nikolaou sten Klenia tes Korinthias," *Diptycha* 4 (1986–87): 106–7, pl. 4; Nikolaos Drandakes, "Hai toichographiai tou naou tes Naxou 'Panagia stes Giallous' (1288/9)," *Epeteris Hetaireias Vyzantinon Spoudon* 33 (1964): 258–69; Georgios Demetrokallis, "Ho Hagios Konstantinos Vourvourias Naxou," *Epeteris Hetaireias Kykladikon Meleton* 3 (1963): 533–52.

31. Anastasios Orlandos, "Ho Hagios Demetrios Katsoure," *ABME* 2 (1936): 66–68.

32. Sirarpie Der Nersessian, "Program and Iconography of the Frescoes of the Parecclesion," in *The Kariye Djami,* ed. Paul Underwood (Princeton: Princeton University Press, 1975), 4: 318–19.

33. Hans Belting, Cyril Mango, and Doula Mouriki, *The Mosaics and Frescoes of St. Mary Pammakaristos (Fethiye Çamii) at Istanbul* (Washington, D.C.: Dumbarton Oaks Center for Byzantine Studies, 1978), 46 and plan B.

34. Ibid., 71.

35. Kalliope Diamante, "Ho naos tou Hagiou Ioanne tou Prodromou sto Vasilaki tes Lakonias," *Archaiologikon Deltion* 36 (1981): 171–74, pls. 73, 76.

36. Ibid., 172, no. 16.

37. Symeon of Thessalonike, *De ordine sepulturae: PG* 155, 676B, as quoted in James Kyriakakis, "Byzantine Burial Customs: Care of the Deceased from Death to the

Prothesis," *Greek Orthodox Theological Review* 19 (1974): 57.

38. Jacobus Goar, *Euchologion sive rituale graecorum* (Venice: Bartholomaei Javarina, 1730; reprint, Graz: Akademische Druck- und Verlagsanstalt, 1960), 6.

39. Chatzidakis (as in n. 14), 96–99; Ioan D. Stefanescu, *L'illustration des liturgies dans l'art de Byzance et de l'Orient* (Brussels: Université Libre de Bruxelles, Institut de Philologie et d'Histoire Orientales, 1936), 129.

40. Milan, Bibliotheca Ambrosiana, cod. 49–50. André Grabar, *Les miniatures du Grégoire de Nazianze de l'Ambrosiènne (Ambrosianus 49–50)* (Paris: Vanoest, 1943).

41. Vocotopoulos (as in n. 10), figs. 4–6.

42. Miljković-Pepek, *Veljusa,* 156, drawing 1; Vojislav J. Djurić, "Fresques du monastère de Veljusa," in *Akten des XI. Internationalen Byzantinisten-Kongresses* (Munich: C. H. Beck'sche Verlagsbuchhandlung, 1958), 2: 113–15; Babić, "Les discussions," 382.

43. Cyril Mango, Ernest J. W. Hawkins, and Susan Boyd, "The Monastery of St. Chrysostomos at Koutsovendis (Cyprus) and Its Wall Paintings," *DOP* 44 (1990): 77, pls. 71, 75. The church is dated ca. 1100.

44. Four other bishops are depicted at Nerezi. Two, Epiphanios of Cyprus and Gregory of Nyssa, are painted in the arches leading from the bema to the side chambers. The remaining two, Gregory Thaumatourgos and Nicholas of Myra, are depicted on the western ends of the sanctuary walls.

45. See n. 42 above.

46. Hadermann-Misguich, *Kurbinovo,* 67–93, pl. 34.

47. Among other churches, one may cite the Protaton on Mount Athos, the churches of Christ and St. Blasios in Veroia, and St. Nicholas Orphanos in Thessalonike.

48. Georgios Gounares, *The Church of Christ in Veria* (Thessalonike: Institute for Balkan Studies, 1991), pl. 4; Stylianos Pelekanides, *Kallierges: Holes Thettalias aristos zographos* (Athens: Vivliotheke tes en Athenais Archaiologikes Hetaireias, 1973), 87, pl. 71.

49. Ellen Schwartz, "Painted Pictures of Pictures: The Imitation of Icons in Fresco," *Byzantine Studies Conference Abstracts* 4 (1978): 31–32; Jeffrey C. Anderson, "The Byzantine Panel Portrait before and after Iconoclasm," in *The Sacred Image East and West,* ed. Robert Ousterhout and Leslie Brubaker (Urbana: University of Illinois Press, 1995), 35–36.

50. See, for example, St. Athanasios in Geraki and the Virgin Chrysaphitissa in Chrysapha, both in Lakonia. Moutsopoulos and Demetrokalles, *Geraki,* 152–53; Nikolaos Drandakes, "Panagia He Chrysaphitissa (1290)," in *Praktika tou A' Topikou Synedriou Lakonikon Meleton* (Athens: Hetaireia Peloponnesiakon Spoudon, 1983), 337–403, fig. 12.

51. Pelekanides (as in n. 48), pls. 5, 66. The same technique is employed in the 14th-century Veroian churches of St. Blasios and St. Paraskeve, the result of a workshop or related workshops active within a single city. See Papazotos, *He Veroia,* 175, 183, pls. 44, 57.

52. Pelekanides, *Kastoria,* pl. 136 a, b.

53. The feast of the Three Hierarchs was established during the reign of Constantine IX Monomachos. See Constantine G. Bonis, "Worship and Dogma: John Mavropous, Metropolitan of Euchaita (11th Century): His Canon on the Three Hierarchs and Its Dogmatic Significance," *Byzantinische Forschungen* 1 (1966): 1.

54. Anthony Cutler, "Liturgical Strata in the Marginal Psalters," *DOP* 34/35 (1980–81): 30.

55. Nancy Ševčenko, *The Life of Saint Nicholas in Byzantine Art* (Turin: Bottega D'Erasmo, 1983), 22.

56. Christopher Walter, *Art and Ritual of the Byzantine Church* (London: Variorum Publications, 1982), 232–38.

57. Vitalien Laurent, "Le rituel de la proscomidie et le métropolite de Crète Élie," *REB* 16 (1958): 129–30, ll. 74–97.

58. Dmitrievskij, *Opisanie,* 2: 84.

59. Ibid., 172. Averkios was a bishop of Hierapolis in Phrygia.

60. Walter (as in n. 56), 236–37.

61. Robert Taft, "Mount Athos: A Late Chapter in the History of the Byzantine Rite," *DOP* 42 (1988): 193.

62. Panagiotes Trempelas, *Hai treis leitourgiai: Kata tous en Athenais Kodikas* (Athens: Ekdidetai hypo tes M. Patriarchikes Epistemonikes Epitropes pros Anatheoresin kai Ekdosin ton Leitourgikon Vivlion, 1935), 235.

63. For a recent study of the representation of local bishops, see Chara Konstantinidi, "Le message idéologique des évêques locaux officiants," *Zograf* 25 (1996): 39–50.

64. For this church, see Nikolaos Moutsopoulos, *He vasilike tou Hagiou Achilleiou sten Prespa: Symvole ste melete ton Vyzantinon mnemeion tes perioches* (Thessalonike: Aristoteleio Panepistemio Thessalonikes, Kentro Vyzantinon Ereunon, 1989).

65. Hadermann-Misguich, *Kurbinovo,* 83–84.

66. Andreas Xyngopoulos, *Ta mnemeia ton Servion* (Athens: Typographeion M. Myrtidou, 1957), 41; Ida Sinkević, "The Church of Saint Panteleimon at Nerezi: Architecture, Painting, and Sculpture," Ph.D. diss., Princeton University, 1994, 127 (the author does not identify the saint); Papazotos, *He Veroia,* 183.

67. Papazotos, *He Veroia,* 175.

68. Petar Miljković-Pepek, "The Church of St. John the Theologian-Kaneo in Ohrid," *Kulturno Nasledstvo* 3 (1967): pl. x.

69. For individual components of the episcopal costume, see Tano Papas, *Studien zur Geschichte der Messgewänder im byzantinischen Ritus* (Munich: Institut für Byzantinistik und neugriechische Philologie der Universität, 1965); Walter (as in n. 56), 7–34; P. Bernardakis, "Les ornements liturgiques chez les Grecs," *Échos d'Orient* 5 (1901–2): 129–39; Nicole Thierry, "Le costume épiscopal byzantin du IXe au XIIIe siècle d'après les peintures datées," *REB* 24 (1966): 308–15.

70. Meletius Michael Solovey, *The Byzantine Divine Liturgy: History and Commentary,* trans. D. Wysochansky (Washington, D.C.: Catholic University of America Press, 1970), 116–18.

71. Trempelas (as in n. 62), 1–2.

72. Symeon of Thessalonike, *De sacra liturgia: PG* 155, 256B.

73. This garment is strictly reserved for Christ depicted as patriarch and occurs occasionally in late Byzantine scenes of the apostolic communion. See Titos Papamastorakes, "He morphe tou Christou-Megalou Archierea," *DChAE*, ser. 4, 17 (1993–94): 67–78; Walter (as in n. 56), 215–17.

74. Theodore Balsamon, *Meditata: PG* 138, 1021C–D; Symeon of Thessalonike (as in n. 72), 256–60.

75. Germanos of Constantinople, *On the Divine Liturgy*, trans. P. Meyendorff (Crestwood, N.Y.: St. Vladimir's Seminary Press, 1984), 66–67.

76. Taft, "Pontifical Liturgy," 290–91, 306–7.

77. Symeon of Thessalonike (as in n. 72), 293C.

78. Djurić (as in n. 42), 118.

79. Theodore Balsamon, *Commentarius: PG* 137, 456A.

80. Symeon of Thessalonike, *Responsa ad Gabrielem Pentapolitanum: PG* 155, 872B.

81. On preparatory incising in Byzantine monumental painting, see David C. Winfield, "Middle and Later Byzantine Wall Painting Methods: A Comparative Study," *DOP* 22 (1968): 96–99, fig. 11.

82. Bernardakis (as in n. 69), 130, n. 1; A. Quacquarelli, "La gammadia pietra angolare: L," *Vetera Christianorum* 21 (1984): 5–25.

83. Pelekanides (as in n. 48), color pl. 15; Anna Tsitouridou, *Ho zographikos diakosmos tou Hagiou Nikolaou Orphanou ste Thessalonike: Symvole ste melete tes palaiologeias zographikes kata ton proimo 14° aiona* (Thessalonike: Kentro Vyzantinon Ereunon, 1986), pl. 3.

84. Hadermann-Misguich, *Kurbinovo*, pls. 22, 23.

85. Papazotos, *He Veroia*, pl. 6.

86. Unpublished.

87. Walter (as in n. 56), 19–22.

88. Germanos (as in n. 75), 66–67.

89. Symeon of Thessalonike (as in n. 80), 868D–869A.

90. Papas (as in n. 69), 81–105, refers to a letter written in 1054 from Peter of Antioch to the patriarch Michael Keroularios.

91. Franz Miklosich and Joseph Müller, *Acta et diplomata graeca medii aevi sacra et profana* (Vienna: C. Gerold, 1862), 2: 568.

92. *Actes de Lavra*, ed. Paul Lemerle, André Guillou, and Nicolas Svoronos (Paris: P. Lethielleux, 1979), 3: 105–7.

93. Sophronios Eustratiadou, "He en Philadelpheia Mone tes hyperagias Theotokou tes Koteines," *Hellenika* 3 (1930): 331–32; Manuel I. Gedeon, "Diatheke Maximou monachou ktitoros tes en Lydia mones Kotines," *Mikrasiatika Chronika* 2 (1939): 281. The two editions differ in the number of white vestments. Considering the small size of the monastery, I have translated the text naming the more appropriate number of robes.

94. Sharon E. J. Gerstel, "Liturgical Scrolls in the Byzantine Sanctuary," *Greek, Roman and Byzantine Studies* 35 (1994): 195–204.

95. Taft, "Pontifical Liturgy," 279–307.

96. Charles Astruc, "L'inventaire—dressé en septembre 1200—du Trésor et de la Bibliothèque de Patmos: Édition diplomatique," *Travaux et mémoires* 8 (1981): 15–30.

97. Eustratiadou (as in n. 93), 331; Gedeon (as in n. 93), 281.

98. Miklosich and Müller (as in n. 91), 2: 568.

99. For the collections of the Great Lavra and the Vatopedi monastery, see Chrysostomos Lavriotos, "Katalogos leitourgikon eiletarion tes Hieras Mones Megistes Lauras," *Makedonika* 4 (1955–60): 391–402; Linos Polites, "Katalogos leitourgikon eileetarion tes Hieras Mones Vatopediou," *Makedonika* 4 (1955–60): 403–9.

100. Andreas Xyngopoulos, "He prometopis ton kodikon Vatikanou 1162 kai Parisinou 1208," *Epeteris Hetaireias Vyzantinon Spoudon* 13 (1937): 170; Victoria Kepetzi, "Les rouleaux liturgiques byzantins illustrés du XIe au XIVe siècle," Ph.D. diss., Université de Paris IV, 1979, 50–54.

101. *The Glory of Byzantium*, ed. Helen C. Evans and William D. Wixom (New York: Metropolitan Museum of Art, 1997), 110–11.

102. Taft, "Pontifical Liturgy," 286–87, 292–94.

103. Thalia Gouma Peterson, "Christ as Ministrant and the Priest as Ministrant of Christ in a Palaeologan Program of 1303," *DOP* 32 (1978): 215–16.

104. André Grabar, "Un rouleau liturgique constantinopolitain et ses peintures," *DOP* 8 (1954): 165–66, figs. 1, 5, 9.

105. Gordana Babić and Christopher Walter, "The Inscriptions upon Liturgical Rolls in Byzantine Apse Decoration," *REB* 34 (1976): 269–80. Basil holds this prayer in the following Macedonian churches: St. Panteleimon, Nerezi; Holy Anargyroi, Kastoria; St. George, Kurbinovo; Old Metropolis, Veroia; St. John the Theologian, Veroia; St. Nicholas, Manastir; St. John the Theologian, Ohrid; St. Nicholas, Prilep; Virgin Peribleptos, Ohrid; church of Christ, Veroia; St. Blasios, Veroia; Holy Apostles, Thessalonike; St. Catherine, Thessalonike; and St. Nicholas Orphanos, Thessalonike.

106. Isaac Habert, *Archieratikon: Liber Pontificalis Ecclesiae Graecae* (Paris, 1643; reprint, Westmead, England: Gregg International, 1970), 52–53.

107. In Panagia Eleousa in Prespa, dated by an inscription to 1409/10, John Chrysostom and Basil hold rolled scrolls with the prayers of consecration and flank a painted altar. Their right hands are extended in blessing toward the central image of Christ as the offering. Stylianos Pelekanides, *Vyzantina kai metavyzantina mnemeia tes Prespas* (Thessalonike: Hetaireia Makedonikon Spoudon, 1960), pl. XLVI.

108. Taft, "Pontifical Liturgy," 298.

109. A number of scrolls on Mount Athos contain only communion prayers: Vatopedi 10 (13th century), Vatopedi 13 (14th century), Vatopedi 14 (14th century), Vatopedi 15 (13th century), Lavra 44 (15th century), Lavra 45 (14th century), Dionysiou 110 (12th century), Pantokrator 64 (14th

century), Iviron 4131 (11th century), and Iviron 4133 (11th century). See Polites (as in n. 99), 404; Lavriotos (as in n. 99), 402; Spyridon Lampros, *Catalogue of the Greek Manuscripts on Mount Athos* (Cambridge: University Press, 1900), 1: 99, 334; 2: 2.

110. Lampros (as in n. 109); Viktor Gardthausen, *Catalogus codicum graecorum sinaiticorum* (Oxford: Clarendon, 1886); Nikos Bees, *Ta cheirographa ton Meteoron: Katalogos perigraphikos ton cheirographon kodikon ton apokeimenon eis tas monas ton Meteoron* (Athens: [s.n.], 1967), vol. 1; Nikos Bees, *Katalogos ton hellenikon cheirographon kodikon tes en Peloponneso mones tou Megalou Spelaiou* (Athens: Hestias, 1915), vol. 1; A. Komines, *Facsimiles of Dated Patmian Codices* (Athens: Royal Hellenic Research Foundation, Center of Byzantine Studies, 1970).

111. Cyril Mango, *The Art of the Byzantine Empire, 312–1453: Sources and Documents* (Englewood Cliffs, N.J.: Prentice-Hall, 1972), 186.

112. Babić and Walter (as in n. 105), 269–80.

113. On the authorship of this prayer, see Robert Taft, *The Great Entrance: A History of the Transfer of Gifts and Other Preanaphoral Rites of the Liturgy of St. John Chrysostom* (Rome: Pont. Institutum Studiorum Orientalium, 1975), 134.

114. Following the system established by Babić and Walter, the order of the prayers in Kurbinovo is: 8, 9, 10, 11 . . . 1, 2, 3, 4. In Holy Anargyroi the order is: 8, 11 . . . 1, 2.

115. The order of the prayers is: Christos, Veroia: 2, 1 . . . 11, 4; St. Nicholas Orphanos, Thessalonike: 4, 1 . . . 11, 12; St. Katherine, Thessalonike: 2, (1?) . . . 11, 12; Holy Apostles, Thessalonike: 4, 1 . . . 11, 6.

116. Cyril Mango and Ernest J. W. Hawkins, "The Hermitage of St. Neophytos and Its Wall Paintings," *DOP* 20 (1966): 167, figs. 69, 70. This system is also used in the church of the Trinity, Sopoćani, and in the crypt of St. Nicholas in Kambia. For the latter, see Maria Panayotidi, "Hoi toichographies tes kryptes tou Hagiou Nikolaou sta Kambia tes Voiotias," *XV Congrès international des Études Byzantines* (Athens: Vivliotheke tes en Athenais Archaiologikes Hetaireias, 1976), 2B: 597–622.

117. A similar pattern is followed in St. Nikita in Čučer, St. George near Sagri on Naxos, the south chapel of the Cave of Penteli, Attika, the church of the Virgin, Studenica, and the Taxiarchs in Markopoulo, Attika. See Mary Aspra-Vardavaki, "Hoi vyzantines toichographies tou Taxiarche sto Markopoulo Attikes," *DChAE,* ser. 4, 8 (1975–76): 199–229, with bibliography.

118. Nicholas Cabasilas, *A Commentary on the Divine Liturgy,* trans. J. M. Hussey and P. A. McNulty (London: S.P.C.K., 1960), 26.

119. John Chrysostom, *De sacerdotio*, 6: 4; cited in Casimir A. Kucharek, *The Byzantine-Slav Liturgy of St. John Chrysostom: Its Origin and Evolution* (Allendale, N.J.: Alleluia Press, 1971), 226.

120. Alphonse Raes, "Le concélébration eucharistique dans les rites orientaux," *La Maison-Dieu* 35 (1953): 24–47; Robert Taft, *Beyond East and West: Problems in Liturgical*

Understanding (Washington, D.C.: Pastoral Press, 1984), 81–99, with bibliography.

121. Taft (as in n. 113), 308.

122. John Meyendorff, *The Byzantine Legacy in the Orthodox Church* (Crestwood, N.Y.: St. Vladimir's Seminary Press, 1982), 119. On the development of the Byzantine rite, see Taft (as in n. 61), 179–94.

123. Thomas F. Mathews, " 'Private' Liturgy in Byzantine Architecture: Toward a Re-appraisal," *CahArch* 30 (1982): 125–38.

III
The Sacrificial Offering

1. At certain times of the year, the deacon proclaimed the same words during the lighting of the lamps for vespers. Miguel Arranz, "L'office de l'Asmatikos Hesperinos ('vêpres chantées') de l'ancien Euchologe byzantin," *Orientalia christiana periodica* 44 (1978): 404.

2. In addition to the three motifs under discussion, a number of churches contain unique representations. The sanctuary decoration of St. George Diasoritis on Naxos, dated to the 11th century, contains frontal portraits of Gregory the Theologian, Basil, John Chrysostom, and Nicholas in the intermediate level of the sanctuary. Three figures are represented in the register below: George, the titular saint of the church, depicted in half-length and surrounded by an ornate frame in imitation of painted icons; Polychronia, his mother; and Gerontios. See Myrtali Acheimastou-Potamianou, "Hagios Georgios Diasoritis," in *Naxos,* ed. Manolis Chatzidakis (Athens: Melissa, 1989), 70. In the hermitage of St. Neophytos in Cyprus (1183), for example, four bishops converge on an image of the orant Virgin (Fig. 68).

3. Representations of the altar table and *melismos* throughout the Byzantine world have been collected in a comprehensive dissertation by Chara Konstantinide, "Ho Melismos," Ph.D. diss., University of Athens, 1991. For a study of the development of this imagery within the context of a Cypriot church, see Susan Hatfield Young, "The Iconography and Date of the Wall Paintings at Ayia Solomoni, Paphos, Cyprus," *Byzantion* 48 (1978): 91–111.

4. Germanos of Constantinople, *On the Divine Liturgy,* trans. Paul Meyendorff (Crestwood, N.Y.: St. Vladimir's Seminary Press, 1984), 60–61.

5. See, for example, the discussion relating the *hetoimasia* to the bishop's cathedra in Tilmann Buddensieg, "Le coffret en ivoire de Pola: Saint-Pierre et le Latran," *CahArch* 10 (1959): 157–200.

6. Paul Durand, *Étude sur l'Etimacia symbole du Jugement Dernier dans l'iconographie grecque chrétienne* (Chartres and Paris: Garnier, 1867); T. von Bogyaz, "Zur Geschichte der Hetoimasia," *Akten des XI. Internationalen Byzantinisten-kongresses* (Munich: C. H. Beck'sche Verlagsbuchhandlung, 1960), 58–61.

7. Among other examples, the *hetoimasia* as part of the Last Judgment is found in monumental decoration in Sta. Maria Assunta at Torcello (Irina Andreescu, "Torcello," *DOP* 26 [1972]: pl. 15); in miniature painting in Paris, Bibliothèque Nationale, gr. 74, fol. 93v (Bogyaz [as in n. 6], pl. III.1); and in icons at Mount Sinai (Georgios Soteriou and Maria Soteriou, *Eikones tes Mones Sina* [Athens: Institut français d'Athènes, 1958], 1: pls. 150, 151).

8. Annemarie Weyl Carr, "Hetoimasia," in *Oxford Dictionary of Byzantium* (New York and Oxford: Oxford University Press, 1991), 2: 926.

9. Miljković-Pepek, *Veljusa,* 158.

10. Ida Sinkević, "The Church of St. Panteleimon at Nerezi: Architecture, Painting, and Sculpture," Ph.D. diss., Princeton University, 1994, 119.

11. The instruments of the Passion were regularly included from the 11th century in representations of the *hetoimasia.* The church of the Koimesis at Nicaea, decorated after 843, contains the *hetoimasia,* but without the flanking lance and sponge. Theodor Schmit, *Die Koimesis-Kirche von Nikaia* (Berlin and Leipzig: W. de Gruyter, 1927), pl. XII.

12. Nicholas of Andida, *Protheoria:* PG 140, 448B.

13. Meletius Michael Solovey, *The Byzantine Divine Liturgy: History and Commentary,* trans. D. Wysochansky (Washington, D.C.: Catholic University of America Press, 1970), 272–73.

14. The *hetoimasia* is included in a liturgical scroll in Athens as an illustration at the end of the First Prayer of the Faithful. The image is unpublished. For the roll, see Victoria Kepetzi, "A propos du rouleau liturgique 2759 de la Bibliothèque Nationale d'Athènes," in *XV Congrès international des Études Byzantines* (Athens: Vivliotheke tes en Athenais Archaiologikes Hetaireias, 1981), 2: 253–72.

15. Scholars have often identified the image as the *melismos* (Suzy Dufrenne, "L'enrichissement du programme iconographique dans les églises byzantines du XIIIème siècle," in *L'art byzantin du XIIIe siècle,* Symposium du Sopoćani, 1965 [Belgrade: Faculté de Philosophie, 1967], 36), but from personal observation it is clear that an altar and liturgical implements are represented. For a reconstruction, see Hadermann-Misguich, *Kurbinovo,* pl. 28.

16. Chrysostom holds the Prothesis prayer. Basil holds the opening verses of the Cherubikon.

17. The first antiphon is held by Nicholas. Gregory the Theologian holds the Prayer of the Catechumens. Considering the lack of catechumens at this time, this prayer should be understood as an entreaty on behalf of the faithful for the remission of sins.

18. For example, the church of the Virgin in Myriokephalon, Crete (third layer of painting, ca. 1200) (Manfred Bissinger, *Kreta: Byzantinische Wandmalerei* [Munich: Maris, 1995], 59; *Archaiologikon Deltion* 28 [1973]: 604, pl. 575). For other examples and bibliography, see Konstantinide (as in n. 3), 109–13.

19. Jacqueline Lafontaine-Dosogne, "Une église inédite

de la fin du XIIe siècle en Cappadoce: La Bezirana kilisesi dans la vallée de Belisirma," *BZ* 61 (1968): 291–301; Catherine Jolivet-Lévy, *Les églises byzantines de Cappadoce: Le programme iconographique de l'abside et de ses abords* (Paris: Éditions du Centre National de la Recherche Scientifique, 1991), 315–17, pl. 173, with a discussion of the date.

20. Lafontaine-Dosogne (as in n. 19), 296.

21. Hadermann-Misguich, *Kurbinovo,* 74–78, pls. 5, 21, 29.

22. For an example of an earlier *asterisk,* see Susan A. Boyd, "A 'Metropolitan' Treasure from a Church in the Provinces: An Introduction to the Study of the Sion Treasure," in *Ecclesiastical Silver Plate in Sixth-Century Byzantium,* ed. Susan A. Boyd and Marlia Mundell Mango (Washington, D.C.: Dumbarton Oaks Research Library and Collection, 1992), fig. S7.1.

23. Moutsopoulos and Demetrokalles, *Geraki,* pls. 2–4.

24. See, for example, Panagia Mavriotissa at Kastoria (Pelekanides, *Kastoria,* pl. 71); Palaiomonastero at Vrontamas (Nikolaos Drandakes, "To Palaiomonastero tou Vrontama," *Archaiologikon Deltion* 43, 1 [1988]: pls. 70, 72a); Hagios Strategos, Upper Boularioi, Mani (Drandakes, *Vyzantines toichographies,* 419). For additional representations, see Bianca Kühnel, "The Personifications of Church and Synagogue in Byzantine Art: Towards a History of the Motif," *Journal of Jewish Art* 19/20 (1993–94): 113–23.

25. Solovey (as in n. 13), 317–20.

26. Nicholas Cabasilas, *A Commentary on the Divine Liturgy,* trans. J. M. Hussy and P. A. McNulty (London: S.P.C.K., 1960), 37–38.

27. On the representation of "realism" in the eucharistic sacrifice, primarily in post-Byzantine painting, see Miltos Garidis, "Approche 'réaliste' dans le représentation du Mélismos," *JÖB* 32 (*Akten des XVI. Internationaler Byzantinistenkongress* II.5) (1982): 495–502.

28. Cabasilas (as in n. 26), 41.

29. Germanos of Constantinople (as in n. 4), 58–59.

30. A. V. Rystenko, *Materialien zur Geschichte der byzantinisch-slavischen Literatur und Sprache* (Odessa, 1928; reprint, Leipzig: Zentralantiquariat, 1982), 136, ll. 30–34.

31. Turin, University Library, cod. C.1.6.199, fol. 88v. George Galavaris, *The Illustrations of the Liturgical Homilies of Gregory Nazianzenus* (Princeton: Princeton University Press, 1969), fig. 58.

32. Solovey (as in n. 13), 231.

33. Ibid., 132.

34. This date reflects the analysis of extant monuments. The *melismos* is also preserved in St. Blasios in Veroia (Fig. 51) and in St. Nicholas Orphanos in Thessalonike (Fig. 57).

35. The term *"melismos,"* from the Greek μελισμός (dismembering, dividing), refers to the ritual fraction of the *amnos* (lamb). For the liturgical performance of this rite, see Robert Taft, "Melismos and Comminution: The Fraction and Its Symbolism in the Byzantine Tradition," *Studia Anselmiana* 95 (1988): 531–52.

36. Panagiotes Trempelas, *Hai treis leitourgiai: Kata tous en Athenais Kodikas* (Athens: M. Patriarchike Epistemonike

Epitrope pros Anatheoresin kai Ekdosin ton Leitourgikon Vivlion, 1935), 11.

37. For example, the south church (St. George) at Apeiranthos, Naxos (1253/54) (Karin Skawran, *The Development of Middle Byzantine Fresco Painting in Greece* [Pretoria: University of South Africa, 1982], fig. 416); St. John, Kaphione, Mani (ca. 1300) (Nikolaos Drandakes, "Hoi toichographies tou Hagiou Ioannou Kaphionas," in *Byzantium: Tribute to Andreas N. Stratos,* ed. Nia A. Stratos [Athens: N. A. Stratos, 1986], 1: 242).

38. Christopher Walter, *Art and Ritual of the Byzantine Church* (London: Variorum Publications, 1982), 232–38.

39. Vitalien Laurent, "Le rituel de la proscomidie et le métropolite de Crète Élie," *REB* 16 (1958): 129–30.

40. Babić, "Les discussions," 368–86; Ashton L. Townsley, "Eucharistic Doctrine and the Liturgy in Late Byzantine Painting," *Oriens Christianus* 58 (1974): 138–53; Walter (as in n. 38), 207–12.

41. "Le Synodikon de l'Orthodoxie: Édition et commentaire," ed. and trans. Jean Gouillard, *Travaux et mémoires* 2 (1967): 60; Lowell Clucas, *The Trial of John Italos and the Crisis of Intellectual Values in Byzantium in the Eleventh Century* (Munich: Institut fur Byzantinistik, Neugriechische Philologie und Byzantinische Kunstgeschichte der Universitat, 1981).

42. "Synodikon" (as in n. 41), 72–73.

43. John Kinnamos, *Deeds of John and Manuel Comnenus,* trans. Charles Brand (New York: Columbia University Press, 1976), 135–36.

44. This prayer was used as one of the proof texts in the synod held against Michael of Thessalonike. See Niketas Choniates, *Thesaurus Orthodoxae Fidei: PG* 140, 165C: "From the prayer of Basil the Great that begins 'No man is worthy. . . .'"

45. In addition to other members of Alexios's extended family, his brothers John, Andronikos, and Isaakios also attended. Ibid., 253B; Konstantinos Varzos, *He genealogia ton Komnenon* (Thessalonike: Kentron Vyzantinon Ereunon, 1984), 1: 654–55. The imperial edict that resulted from the proceedings was carved in marble and set up in Hagia Sophia; see Cyril Mango, "The Conciliar Edict of 1166," *DOP* 17 (1963): 317–29.

46. Babić, "Les discussions," 381.

47. Choniates (as in n. 44), 261–68.

48. Alexios I Komnenos had visited Veljusa during his campaigns against the Serbs. Two of his successors, John II Komnenos and Manuel I Komnenos, issued decrees on behalf of the monastery. In 1152 Manuel I appointed a cousin by marriage, John (Roger) Dalassenos (husband of Maria Komnene), *doux* of Stroumitsa. See Varzos (as in n. 45), 355; Lucien Stiernon, "Trois membres de la famille Rogerios," *REB* 22 (1964): 190, n. 38. In May 1160, four years before the foundation of Nerezi by Alexios Angelos Komnenos, Alexios's older cousin, the emperor Manuel I had awarded the monastery at Veljusa a yearly income of 30 *nomismata* from local tax revenues. Miljković-Pepek, *Veljusa,* 282–83. The continuing interest of the Komnenoi

in this region may have influenced Alexios in his decision to establish a monastery near Skopje.

49. *Apophthegmata patrum: PG* 65, 156–60; cited in Taft (as in n. 35), 545–46.

50. François Nau, "Jean Rufus: Évêque de Maiouma," *Patrologia orientalis* 8 (1912): 175, ll. 18–23.

51. Choniates (as in n. 44), 140, 157B.

52. "Synodikon" (as in n. 41), 68–69, ll. 366–67.

53. Nicholas of Andida (as in n. 12), 428B.

54. Cabasilas (as in n. 26), 80.

55. Ibid., 81.

56. Michael Keroularios, *Epistolae: PG* 120, 751–820, esp. 763; Anton Michel, *Humbert und Kerullarios* (Paderborn, Prussia: F. Schoningh, 1924–30).

IV
The Sacred Communion

1. Babić, "Les discussions," 368–86; Aleksei Lidov, "The Schism and Byzantine Church Decoration," in *The Eastern Christian Church: Liturgy and Art,* ed. Aleksei Lidov (St. Petersburg: Dmitri Bulanin, 1994), 17–35.

2. The scene is found in the Rossano Gospels (Guglielmo Cavallo, Jean Gribomont, and William Loerke, *Codex purpureus Rossanensis: Museo dell'Arcivescovado, Rossano calabro: Commentarium* [Rome: Salerno Editrice, 1987], fols. 3v–4r); the Rabbula Gospels, fol. 11 (Carlo Cecchelli, *The Rabbula Gospels* [Olten, Switzerland: Urs Graf-Verlag, 1959]); the Stuma Paten in the Istanbul Archaeological Museum (Erica Cruikshank Dodd, *Byzantine Silver Stamps* [Washington, D.C.: Dumbarton Oaks Research Library and Collection, 1961], 95, 108); and the Riha Paten in the Dumbarton Oaks Collection (Marvin C. Ross, *Catalogue of the Byzantine and Early Medieval Antiquities in the Dumbarton Oaks Collection, 1, Metalwork, Ceramics, Glass, Glyptics, Painting* [Washington, D.C.: Dumbarton Oaks Research Library and Collection, 1962], pl. XI).

3. The scene appears in three well-known psalters of the ninth century: Mount Athos, Pantokrator monastery, cod. 61 (fol. 37r); the Chludov Psalter (Moscow, State Historical Museum, gr. 129, fol. 25r); and Paris, Bibliothèque Nationale, gr. 20 (fol. 25). See Suzy Dufrenne, *L'illustration des psautiers grecs du moyen âge* (Paris: C. Klincksieck, 1966), 1: 24, 46, 50, pls. 5, 50. In the mid–10th century, the representation appears in the Homilies of John Chrysostom (Athens, National Library, cod. 211, fol. 110v) (Anna Marava-Chatzinicolaou and Christina Toufexi-Paschou, *Catalogue of the Illuminated Byzantine Manuscripts of the National Library of Greece* [Athens: Academy of Athens, Centre of Byzantine and Post-Byzantine Art, 1997], 3: fig. 23). In the 11th and 12th centuries, the composition illustrates psalm 109 in the Theodore Psalter (London, British Museum, Add. ms. 19352, fol. 152r) (Sirarpie Der Nersessian, *L'illustration des psautiers grecs du moyen âge, 2, Londres Add. 19.352* [Paris: C. Klinckseick, 1970], 52, fig. 244), and the Barberini Psalter (Rome, Biblioteca Apostolica

Vaticana, cod. Barb. gr. 372, fol. 194) (Jeffrey Anderson, Paul Canart, and Christopher Walter, *The Barberini Psalter: Codex Vaticanus Barberinianus Graecus 372* [Zurich: Belser, 1989], 131–32). The scene is also contained in the liturgical scroll Jerusalem, Greek Patriarchate, cod. Stavrou 109 (André Grabar, "Un rouleau liturgique constantinopolitain et ses peintures," *DOP* 8 [1954]: fig. 13), and the Gospel book Paris, Bibliothèque Nationale, cod. gr. 74, fol. 156v (Henri Omont, *Evangiles avec peintures byzantines du XIe siècle* [Paris: Berthaud frères, 1908], pl. 133).

4. William Loerke has argued that the compositions in the Rabbula Gospels and the Rossano Gospels derive from lost Palestinian church decoration. William Loerke, "The Monumental Miniature," in *The Place of Book Illumination in Byzantine Art* (Princeton: Princeton University Press, 1975), 78–97.

5. Maria Panayotidi, "L'église rupestre de la Nativité dans l'île de Naxos: Ses peintures primitives," *CahArch* 23 (1974): 112, fig. 6; eadem, "La peinture monumentale en Grèce de la fin de l'Iconoclasme jusqu'à l'avenement des Comnènes (843–1081)," *CahArch* 34 (1986): 75–108.

6. Catherine Jolivet-Lévy, *Les églises byzantines de Cappadoce: Le programme iconographique de l'abside et de ses abords* (Paris: Éditions du Centre National de la Recherche Scientifique, 1991), 140, pl. 88, fig. 1.

7. Jürgen Borchhardt, ed., *Myra: Eine lykische Metropole in antiker und byzantinischer Zeit* (Berlin: Gebruder Mann, 1975), 385–87, pls. III, 123, 124.

8. There are very few churches where the communion scene is placed outside of the central register of the sanctuary. These exceptions include: St. John the Theologian in Veroia, where the scene occupies the lower register of the apse (Fig. 31); St. Nicholas Orphanos, Thessalonike, where the scene is placed on the east wall flanking the conch of the apse (Fig. 52); and the early-14th-century painting of St. Nicholas in Pyrgi, Euboia, where the scene is located on the north wall at the east end of the barrel vault (Melita Emmanuel, "Hoi toichographies tou Hag. Nikolaou ston Pyrgo," *Archeion Euboikon Meleton* 26 [1984–85]: 396, fig. 16).

9. Panagia ton Chalkeon in Thessalonike, ca. 1028 (Fig. 3); Hagia Sophia in Kiev, 1043–46 (Hryhorii Logvin, *Kiev's Hagia Sophia* [Kiev: Mistetstvo Publishers, 1971], pl. 52); Hagia Sophia in Ohrid, mid–11th century (Fig. 5); Karabaş kilise, Soğanli, Cappadocia, 1060–61 (Marcell Restle, *Byzantine Wall Painting in Asia Minor* [Greenwich, Conn.: New York Graphic Society, 1967], 3: fig. 457); Panagia Phorbiotissa, Asinou, 1106 (Fig. 77); St. Michael the Archangel in Kiev, 1108 (Viktor Lazarev, *Old Russian Murals and Mosaics from the XI to the XVI Century* [London: Phaidon, 1966], figs. 51–53).

10. F. E. Brightman, *Liturgies Eastern and Western,* 1, *Eastern Liturgies* (Oxford: Clarendon, 1896), 385–86, 405. The invocation combines words used in the synoptic Gospels (Mt 26:26–28, Mk 14:22–24, Lk 22:17–19) with the account of the Last Supper by Paul in I Cor (11:23–26).

11. Unpublished. This pattern is also followed at St. Nikita at Čučer and at Gračanica (Hamann-Mac Lean and Čučer Hallensleben, *Die Monumentalmalerei,* 1: 224–27; Branislav Todić, *Gračanica-slikarstvo* [Belgrade: Prosveta, 1988], pl. II).

12. In Macedonia, see: Virgin Peribleptos, Ohrid (Fig. 42); St. John the Theologian, Ohrid (Fig. 41); Protaton, Mount Athos (unpublished); St. Euthymios, Thessalonike (Fig. 48); St. Catherine, Thessalonike (unpublished); St. Nicholas Orphanos, Thessalonike (Fig. 55). In Serbia this pattern appears in the church of the Kral at Studenica and at George, Staro Nagoričino, both painted by the Astrapas workshop (Hamann-Mac Lean and Hallensleben, *Die Monumentalmalerei,* 1: pls. 252, 279).

13. Laskarina Bouras, "The Epitaphios of Thessaloniki: Byzantine Museum of Athens No. 685," in *L'art de Thessalonique et des pays Balkaniques et les courants spirituels au XIVe siècle* (Belgrade: Academie Serbe des sciences et des arts, Institut des Études Balkaniques, 1987), 211–31.

14. Arthur H. S. Megaw and Ernest J. W. Hawkins, "The Church of the Holy Apostles at Perachorio, Cyprus, and Its Frescoes," *DOP* 16 (1962): fig. 22; Arthur H. S. Megaw, "Twelfth-Century Frescoes in Cyprus," *Actes du XIIe Congrès international d'Études Byzantines* (Belgrade: Comité Yougoslave des Études Byzantines, 1964), 3: 262.

15. Otto Demus, *The Mosaics of Norman Sicily* (London: Routledge & Paul, 1949), 318; Thalia Gouma Peterson, "The Frescoes of the Parecclesion of St. Euthymios in Thessalonica: An Iconographic and Stylistic Analysis," Ph.D. diss., University of Wisconsin, 1964, 52.

16. Gabriel Millet, *Recherches sur l'iconographie de l'évangile aux XIVe, XVe et XVIe siècles, d'après les monuments de Mistra, de la Macédoine et du Mont-Athos* (Paris: Boccard, 1916; reprint, Paris: Boccard, 1960), 286–309.

17. Anastasios Orlandos, *He architektonike kai hai vyzantinai toichographiai tes Mones tou Theologou Patmou* (Athens: Grapheion Demosieumaton tes Akademias Athenon, 1970), 200–204, pls. 18–19.

18. See, for example, representations in the church of St. Michael the Archangel in Kiev and on an 11th-century Sinai icon. Lazarev (as in n. 9), figs. 51–53; Georgios Soteriou and Maria Soteriou, *Eikones tes Mones Sina* (Athens: Institut français d'Athènes, 1956–58), 66–68, pl. 49.

19. Ioli Kalavrezou-Maxeiner, "The Byzantine Knotted Column," in *Byzantina kai Metabyzantina,* ed. Spiros Vryonis, Jr. (Malibu, Calif.: Undena Publications, 1985), 4: 95–103, esp. 96–98.

20. Orlandos (as in n. 17), 201. For actual doors, see Katia Loverdou-Tsigarida, "Bema Door," in *Treasures of Mount Athos,* exh. cat. (Thessalonike: Museum of Byzantine Culture, 1997), 304. The doors, from the Protaton church, have been dated to the second half of the 10th century and are comprised of ivory and bone plaques both inlaid and pegged to a wooden core. For bibliography and a brief mention of these doors, see Ihor Ševčenko, "The Lost Panels of the North Door to the Chapel of the Burning

Bush at Sinai," in *AETOS: Studies in Honour of Cyril Mango,* ed. Ihor Ševčenko and Irmgard Hutter (Stuttgart and Leipzig: Teubner, 1998), 296–97. For wooden ecclesiastical doors, with extensive bibliography, see Evangelias Papatheophanous-Tsoure, "Xyloglypte porta tou Katholikou tes Mones Koimeseos Theotokou ste Molyvdoskepaste Ioanninon," *Archaiologike Ephemeris* 132 (1993): 83–106.

21. Nafsika Coumbaraki-Panselinou, *Saint-Pierre de Kalyvia-Kouvara et la Chapelle de la Vierge de Mérenta: Deux monuments du XIIIe siècle en Attique* (Thessalonike: Kentron Vyzantinon Ereunon, 1976), 128–29, pl. 62.

22. Germanos of Constantinople, *On the Divine Liturgy,* trans. Paul Meyendorff (Crestwood, N.Y.: St. Vladimir's Seminary Press, 1984), 59.

23. Nicholas of Andida, *Protheoria: PG* 140, 441–44.

24. Gouma Peterson (as in n. 15), 45.

25. Logvin (as in n. 9), pl. 52; Karin Skawran, *The Development of Middle Byzantine Fresco Painting in Greece* (Pretoria: University of South Africa, 1982), 167; Agape Vasilake-Karakatsane, *Hoi toichographies tes Omorphes Ekklesias sten Athena* (Athens: Christianike Archaiologike Hetaireia, 1971), pl. 30.

26. Cyril Mango, *The Art of the Byzantine Empire, 312–1453: Sources and Documents* (Englewood Cliffs, N.J.: Prentice-Hall, 1972), 88.

27. Glanville Downey, "Nikolaos Mesarites: Description of the Church of the Holy Apostles at Constantinople," *Transactions of the American Philosophical Society,* n.s., 47 (1957): 891.

28. The glazed chalice in Komotini bears an inscription asking for the forgiveness of the sins of the donor. These chalices have been associated with a burial context by Eric Ivison, "A Moment of East-West Cultural Exchange: Byzantine Funerary Chalices," *Byzantine Studies Conference: Abstracts of Papers* 22 (1996): 40.

29. Brightman (as in n. 10), 385–86, 405.

30. Paul Gautier, "La diataxis de Michel Attaliate," *REB* 39 (1981): 91.

31. For clay vessels of these shapes, see Charalampos Bakirtzes, *Vyzantina tsoukalolagena* (Athens: Ekdose tou Tameiou Archaiologikon Poron kai Apallotrioseon, 1989), 70–88, 95–99.

32. Jerusalem, Patriarchal Library, cod. Taphou 14. See Athanasios Papadapoulos-Kerameus, *Hierosolymitike Vivliotheke, etoi Katalogos ton en tais vivliothekais tou hagiotatou apostolikou te kai katholikou orthodoxou patriarchikou thronou ton Hierosolymon kai pases Palaistines apokeimenon Hellenikon Kodikon* (St. Petersburg: V. Kirspaoum, 1891; reprint, Brussels: Culture et Civilisation, 1963), 1: 46.

33. Pietro Luigi M. Leone, "L' 'Encomium in patriarcham Antonium II Cauleam' del filosofo e retore Niceforo," *Orpheus,* n.s., 10 (1989): 421.

34. Symeon of Thessalonike, *De sacra liturgia: PG* 155, 301–4.

35. Nicholas Cabasilas, *A Commentary on the Divine Liturgy,* trans. J. M. Hussy and P. McNulty (London: S.P.C.K., 1960), 119–20.

36. Cyril of Jerusalem, *Catechesis mystagogica: PG* 33, 1123–26.

37. Robert Taft, *Beyond East and West: Problems in Liturgical Understanding* (Washington, D.C.: Pastoral Press, 1984), 103.

38. Dodd (as in n. 2), 95, 108.

39. The same ritual of Peter kissing Christ's hand is seen in St. Constantine, Svećani, St. Nicholas Manastir, St. John the Theologian in Ohrid, and the Virgin Peribleptos in Ohrid.

40. Cyril of Jerusalem (as in n. 36), 1123–26.

41. The event is described in the synoptic Gospels: "And as they were eating, Jesus took bread, and blessed it, and broke it, and gave it to the disciples, and said, Take, eat; this is my body. And he took the cup, and gave thanks, and gave it to them, saying, Drink ye all of it; For this is my blood of the new testament, which is shed for many for the remission of sins." Mt 26:26–28, Mk 14:22–24, Lk 22:19–20.

42. St. John the Theologian, Ohrid; Virgin Peribleptos, Ohrid; Protaton, Mount Athos; St. George, Staro Nagoričino (Hamann-Mac Lean and Hallensleben, *Die Monumentalmalerei,* 1: pls. 252, 279).

43. See, for example, Nicholas Cabasilas, *De vita in Christo: PG* 150, 585C, where the author writes that "the Eucharist alone of the mysteries brings perfection to the other sacraments."

44. Thomas F. Mathews, *The Early Churches of Constantinople: Architecture and Liturgy* (University Park: Pennsylvania State University Press, 1977), 173; for a discussion of the decrease in communion in monastic contexts, see Emil Herman, "Die häufige und tägliche Kommunion in den byzantinischen Klöstern," in *Mémorial Louis Petit: Mélanges d'histoire et d'archéologie byzantines* (Bucharest: Institut français d'études byzantines, 1948), 203–17.

45. Robert Taft, "Byzantine Communion Spoons: A Review of the Evidence," *DOP* 50 (1996): 225. In a Constantinopolitan psalter of the same period (Rome, Biblioteca Apostolica Vaticana, gr. 752, fol. 193v), St. Silvester is shown administering communion to a group of penitents by means of a liturgical spoon. See Ernest T. De Wald, *The Illustrations in the Manuscripts of the Septuagint* (Princeton: Princeton University Press, 1942), 3/2: pl. XXXV.

46. Symeon of Thessalonike, *Expositio de divino templo: PG* 155, 744D–745B.

47. André Jacob, "La traduction de la Liturgie de saint Jean Chrysostome par Léon Toscan," *Orientalia christiana periodica* 32 (1966): 160.

48. Gabriel Millet and Tania Velmans, *La peinture du moyen âge en Yougoslavie* (Paris: E. de Boccard, 1969), 4: pl. 15.

49. Andreas Stylianou, "The Communion of St. Mary of Egypt and Her Death in the Painted Churches of Cyprus," *Actes du XIVe Congrès international des Études Byzantines* (Bucharest: Editura Academiei Republicii

Socialist Romania, 1976), 3: 435–41. For bibliography on representations in Greece, see Moutsopoulos and Demetrokalles, *Geraki,* 64–70. In manuscript illumination, see Paris, Bibliothèque Nationale, Suppl. gr. 1276, fol. 95 (Henri Omont, "Miniature du XIIe siècle représentant sainte Marie l'Égyptienne et saint Sozime," *Bulletin de la Société des Antiquaires de France* (1898): 332.

50. Andreas Stylianou and Judith Stylianou, *The Painted Churches of Cyprus* (Stourbridge: Mark and Moody, 1964), 55–57.

51. Helena Grigoriadou-Cabagnols, "Le décor de l'église de Samari en Messénie," *CahArch* 20 (1970): 188.

52. Moutsopoulos and Demetrokalles, *Geraki,* 61–70.

53. John H. Erickson, "Leavened and Unleavened: Some Theological Implications of the Schism of 1054," *St. Vladimir's Theological Quarterly* 14 (1970): 165; John Meyendorff, *Byzantine Theology: Historical Trends and Doctrinal Themes* (New York: Fordham University Press, 1974), 95–96, 204–6. See also Tia Kolbaba, "Heresy and Culture: Lists of the Errors of the Latins in Byzantium," Ph.D. diss., University of Toronto, 1992, 57–61.

54. Treatises against *azymes* were written by Leo of Ohrid, Niketas Stethatos, Peter of Antioch, Leo of Preslav, John of Kiev, Theophylact of Bulgaria, John of Antioch, Simeon of Jerusalem, Nicholas of Andida, and Niketas Seides, among others. For writings on this issue, see Jean Darrouzès, "Nicholas Andida et les azymes," *REB* 32 (1974): 199–210.

55. John IV Oxita, *De azymis.* See Bernard Leib, "Deux inédits byzantins sur les azymes au début du XIIe siècle," *Orientalia Christiana* 2 (1924): 113; Erickson (as in n. 53), 157.

56. Joseph Hergenröther, ed., *Photius, Patriarch von Constantinopel: Sein Leben, seine Schriften und das griechische Schisma* (Regensburg: G. J. Manz, 1869), 3: 155.

57. Erickson (as in n. 53), 160.

58. Stilbes had been a teacher at the patriarchal school in Constantinople.

59. Jean Darrouzès, "Le mémoire de Constantin Stilbès contre les Latins," *REB* 21 (1963): 63.

60. Ibid., 88.

61. Vitalien Laurent, *Les regestes des actes du patriarcat de Constantinople,* 4, *Les regestes de 1208 à 1309* (Paris: Institut français d'études byzantines, 1971), 244, no. 1453.

62. Symeon of Thessalonike, *Dialogus contra haereses: PG* 155, 101A; idem, *De sacra liturgia,* 265D–273D.

63. Deno Geanakoplos, "A Greek Libellus against Religious Union with Rome after the Council of Lyons (1274)," in *Interaction of the "Sibling" Byzantine and Western Cultures in the Middle Ages and Italian Renaissance* (New Haven: Yale University Press, 1976), 159; Donald Nicol, "Popular Religious Roots of the Byzantine Reaction to the Second Council of Lyons," in *The Religious Roles of the Papacy: Ideals and Realities, 1150–1300,* Papers in Medieval Studies 8, ed. Christopher Ryan (Toronto: Pontifical Institute of Mediaeval Studies, 1989), 327–28.

64. Most recently, see Aristeides Papadakis, *The Christian East and the Rise of the Papacy: The Church, 1071–1453 A.D.* (Crestwood, N.Y.: St. Vladimir's Seminary Press, 1994), 152.

65. André Grabar, "Les peintures murales dans le choeur de Sainte-Sophie d'Ochrid," *CahArch* 15 (1965): 257–65; Ann Wharton Epstein, "The Political Content of the Paintings of Saint Sophia at Ohrid," *JÖB* 29 (1980): 320.

66. Leo's objections to the use of *azymes* are mostly on the grounds of Judaizing. On Leo's role in the controversy over *azymes,* see Erickson (as in n. 53), 155–76.

67. See chapter III, 40–47.

68. Sharon Gerstel, "Apostolic Embraces in Communion Scenes of Byzantine Macedonia," *CahArch* 44 (1996): 141–48.

69. For Nerezi, see Hamann-Mac Lean and Hallensleben, *Die Monumentalmalerei,* 1: 33. For St. John the Theologian, see Myron Michailidis, "Les peintures murales de l'église de Saint-Jean le Théologien à Véria," *Actes du XVe Congrès international des Études Byzantines* (Athens: Association Internationale des Études Byzantines, 1981), 2B: 487, figs. 19, 20, 22. The author dates the frescoes to the first half of the thirteenth century. See also Manolis Chatzidakis, "Aspects de la peinture du XIIIe siècle en Grèce," *L'art byzantin du XIIIe siècle* (Belgrade: Faculté de philosophie, Departement de l'histoire de l'art, 1967), 63, fig. 7, where the author suggests an early-thirteenth-century date for the sanctuary frescoes. For St. Constantine, see Petar Miljković-Pepek, "The Church of St. Constantine in the Village of Svećani," *Simposium 1100—godisnina od smrtta na Kiril Solunski* (Skopje: Makedonska akademija na naukite i umetnostite, 1970), 1: 149–62. The church of St. John the Theologian (Kaneo) might be added to this list. In the scene of the communion of the wine, as Miljković-Pepek has observed, the fourth and fifth apostles face each other in a manner suggesting that they are about to embrace or have just embraced. For Manastir, see Dimče Koco and Petar Miljković-Pepek, *Manastir* (Skopje: Univerzitetska pečatnica, 1958), 47–51.

70. Miljković-Pepek (as in n. 69), 159.

71. Francis Dvornik, *The Idea of Apostolicity in Byzantium and the Legend of the Apostle Andrew* (Cambridge: Harvard University Press, 1958).

72. See, for example, the discussion of antithesis in Henry Maguire, *Art and Eloquence in Byzantium* (Princeton: Princeton University Press, 1981), 53–83.

73. Herbert Kessler, "The Meeting of Peter and Paul in Rome: An Emblematic Narrative of Spiritual Brotherhood," *DOP* 41 (1987): 265–75. The embrace of these two apostles in icon painting is discussed by Maria Vassilaki, "A Cretan Icon in the Ashmolean: The Embrace of Peter and Paul," *JÖB* 40 (1990): 405–22.

74. Euthymios Tsigaridas has dated the figures to 1170–80. See *Treasures of Mount Athos,* exh. cat. (Thessalonike: Museum of Byzantine Culture, 1997), 40–41.

75. National Library, cod. 7, fol. 2. Anthony Cutler, *The Aristocratic Psalters in Byzantium* (Paris: Picard, 1984), fig. 3.

76. Robert Taft, *The Great Entrance: A History of the Transfer of Gifts and Other Pre-Anaphoral Rites* (Rome:

Pontificium Institutum Studiorum Orientalium, 1978), 374–96.

77. For the connection between the embracing apostles and the kiss of peace Miljković-Pepek ([as in n. 69], 158, n. 31) cites a letter from André Grabar: "Malheureusement, je ne connais ni d'autres exemples de cette iconographie particulière ni d'explications autres que celle-ci: ce serait le 'baiser de paix' que la liturgie connaît jusqu'à nos jours. Personellement, je crois qu'il s'agit de ce 'Baiser de paix,' l'iconographie ayant eu l'idée d'en faire remonter l'origine au jour de la fondation de l'Eucharistie, c'est-à-dire au dernier repas du Christ avec ses disciples."

78. Taft, "Pontifical Liturgy," 298–99.

79. Robert Taft, "How Liturgies Grow: The Evolution of the Byzantine Divine Liturgy," *Orientalia christiana periodica* 43 (1977): 374.

80. Taft (as in n. 37), 104.

81. Taft, "Pontifical Liturgy," 300–303.

82. Taft (as in n. 76), 388.

83. See chapter II, 34–36.

84. Michael Keroularios, *Michaelis sanctissimi archiepiscopi Constantinopolis novae Romae, et oecumenici patriarchae, Cerularii, ad Petrum santissimum patriarchum Theopolis magnae Antiochiae: PG* 120, 793–94.

85. Darrouzès (as in n. 59), 63–64.

86. Tia Kolbaba, "Meletios Homologetes *On the Customs of the Italians,*" *REB* 55 (1997): 163.

87. Pelekanides, *Kastoria,* pl. 144b.

88. Klaus Wessel ("Apostelkommunion," *Reallexikon zur byzantinischen Kunst,* 1: col. 242) cites the detail of Judas betraying the blessed bread as a possible Western iconographic influence.

89. Megaw (as in n. 14), 262–63, fig. 1; Megaw and Hawkins (as in n. 14), 304–5, fig. 22.

90. Megaw (as in n. 14), 263–64, fig. 6.

91. Jenny Albani, "Byzantinische Freskomalerei in der Kirche Panagia Chrysaphitissa: Retrospektive Tendenzen eines lakonischen Monuments," *JÖB* 38 (1988): 372, n. 26; Nikolaos Drandakes, "Panagia He Chrysaphitissa (1290)," in *Peloponnesiaka,* Praktika tou Protou Topikou Synedriou Lakonikon Meleton (Athens: Hetaireia Peloponnesiakon Spoudon, 1982–83), 353, n. 3.

92. For example, the church of the Virgin in Patso, Amari. The detached frescoes are displayed in the church of St. Catherine, Heraklion, Crete. See *Byzantine Murals and Icons,* exh. cat., National Gallery (Athens: Archaeological Service, 1976), pl. 38.

93. A photograph of the five apostles in the scene of the communion of the bread is published in Manolis Chatzidakis, "Rapports entre la peinture de la Macédoine et de la Crète au XIVe siècle," *Actes du IX Congrès international des Études Byzantines* (Athens: Myrtide, 1955), 142, pl. 12a.

94. For a wide variety of examples, see Gertrud Schiller, *Ikonographie der christlichen Kunst* (Gütersloh: Gütersloher Verlagshaus G. Mohn, 1968), 2: pls. 81–91.

95. Demus (as in n. 15), 284, fig. 68.

96. Wessel (as in n. 88), 61.

97. *The Lenten Triodion,* trans. Mother Mary and Kallistos Ware (London: Faber and Faber, 1978), 551–52.

98. Ibid., 556.

99. Ibid., 558.

100. Nicholas of Andida (as in n. 23), 449D.

101. Casimir Kucharek, *The Byzantine-Slav Liturgy of St. John Chrysostom: Its Origin and Evolution* (Allendale, N.J.: Alleluia Press, 1971), 702.

V
Reviewing the Mandylion

1. Material in this chapter was presented at the 19th Byzantine Studies Conference (Princeton University, 1993). See Sharon Gerstel, "The Transformation of the Miraculous Mandylion" (in Russian), in *Chudotvornaia ikona v Vizantii i drevnei Rusi,* ed. Aleksei Lidov (Moscow: Martis, 1996), 76–87. I thank Nicholas Constas, Dale Kinney, and Nancy Ševčenko for their assistance in further refining this material.

2. Otto Demus, *Byzantine Mosaic Decoration: Aspects of Monumental Art in Byzantium* (London: Routledge, 1948; reprint, New Rochelle, N.Y.: Caratzas Brothers, 1976), 17–19.

3. André Grabar, *La Sainte Face de Laon: Le Mandylion dans l'art orthodoxe* (Prague: Seminarium Kondakovianum, 1931), 28.

4. Ernst von Dobschütz, *Christusbilder. Untersuchungen zur christlichen Legende,* Texte und Untersuchungen zur Geschichte der altchristlichen Literatur, 3 (Leipzig: J. C. Hinrichs, 1899), 102–96, 158*–249*. For more recent analyses of the relic's history, see Averil Cameron, "The History of the Image of Edessa: The Telling of a Story," in *Okeanos: Essays Presented to Ihor Ševčenko on His Sixtieth Birthday,* Harvard Ukrainian Studies 7, ed. Cyril Mango and Omeljan Pritsak (Cambridge: Ukrainian Research Institute, Harvard University, 1984), 80–94; Hans Belting, *Likeness and Presence: A History of the Image before the Era of Art* (Chicago: University of Chicago Press, 1994), 208–15.

5. Eusebios of Caesarea, *Historia ecclesiastica: PG* 20, 120–29.

6. *Chronique de Michel le Syrien, patriarche Jacobite d'Antioche (1166–1199),* trans. Jean Baptiste Chabot (Paris: E. Leroux, 1901), 2: 476–77.

7. *Narratio de imagine edessena: PG* CXIII, 423–54.

8. Theodor Wiegand, *Der Latmos* (Berlin: G. Reimer, 1913), 127, ll. 4–7.

9. Kurt Weitzmann, "The Mandylion and Constantine Porphyrogennetos," *CahArch* 11 (1960): 164–84; reprinted in idem, *Studies in Classical and Byzantine Manuscript Illumination,* ed. Herbert Kessler (Chicago: University of Chicago Press, 1971). See also Belting (as in n. 4), 210, fig. 125.

10. The Mandylion appears in two 11th-century menologia: Paris, Bibliothèque Nationale, gr. 1528, and Moscow, State Historical Museum, cod. 382; see Weitzmann

(as in n. 9), 170–71. The image also appears in the *Heavenly Ladder* of John Klimakos (Rome, Biblioteca Apostolica Vaticana, Ross. 251, fol. 12) and in a Georgian Gospel book dated to 1054 (Tiflis, Sion, no. 484, fol. 320); for these two manuscripts, see André Grabar, *L'iconoclasme byzantin: Le dossier archéologique,* 2d ed. (Paris: Flammarion, 1984), 52–53, figs. 67–68, and John Rupert Martin, *The Illustration of the Heavenly Ladder of John Climacus* (Princeton: Princeton University Press, 1954), 110–11, fig. 231. The fullest illustration of the legend of the Mandylion is found in an illuminated 14th-century scroll, New York, Pierpont Morgan Library, cod. M. 499; see Sirarpie Der Nersessian, "La légende d'Abgar d'après un rouleau illustré de la Bibliothèque Pierpont Morgan à New York," *Bulletin de l'Institut archéologique bulgare* 10 (1936) (Actes du IVe Congrès international des Études Byzantines): 98–106; reprinted in eadem, *Études byzantines et arméniennes* (Louvain: Imprimerie orientaliste, 1973), 1: 175–81. For the illustrated homily, see Weitzmann (as in n. 9), 170; Theodoros Moschonas, *Katalogoi tes Patriarches Vivliothekes* (Alexandria: Anatole, 1945), 1: 53. For a late monumental cycle of the Abgar legend, see Christopher Walter, "The Abgar Cycle at Mateić," in *Studien zur byzantinischen Kunstgeschichte: Festschrift für Horst Hallensleben zum 65. Geburtstag* (Amsterdam: Adolf M. Hakkert, 1995), 221–31.

11. Nicole Thierry, "Deux notes à propos du Mandylion," *Zograf* 11 (1980): 16–19.

12. See chapter IV, 49.

13. Grabar (as in n. 3), 24–25.

14. Numerous churches in Byzantine Macedonia contain this programmatic cluster, for example: St. Nicholas tou Kasnitze in Kastoria (Fig. 23); St. Euthymios in Thessalonike; and Christ in Veroia (Fig. 49). These churches are in close proximity to one another. Outside Macedonia, the Mandylion is placed with the Annunciation in the early-13th-century church of St. John the Baptist in Megale Kastania in the Mani, the church of the Taxiarchs in Desphina in central Greece (1332), the 14th-century church of St. Peter, Berende in Bulgaria, and St. Nicholas in Platsa, Mani (ca. 1343/44). The painted programs of a number of Cretan churches, from the beginning of the 13th century to the middle of the 14th century, also group the Mandylion and the Annunciation on the eastern wall above the sanctuary opening. These churches include: St. George Kavousiotis in Kritsa (late 13th/early 14th century), St. Michael the Archangel in Astratego (1300–1350), Panagia Kera in Kardiotissa (ca. 1310), St. Michael the Archangel near Archanes (1315/16), St. George near Cheliana (1319), St. Nicholas in Maza (1325/26), and St. Paraskeve in Siwa (early 14th century). For individual churches, see Klaus Gallas, Klaus Wessel, and Manolis Borboudakis, *Byzantinisches Kreta* (Munich: Hirmer, 1983). In several Cretan churches the Mandylion is flanked by medallions containing portraits of Joachim and Anna. For this cluster of images, see Stella Papadake-Oekland, "The Holy Mandylion as the New Symbol in an Ancient Iconographic Scheme," *DChAE,* ser. 4, 14 (1987–88): 283–94.

15. Dobschütz (as in n. 4), 120**–126**; Venance Grumel, "Léon de Chalcédoine et le canon de la fête du Saint Mandilion," *Analecta Bollandiana* 2 (1950): 135–52. The iconophiles used the relic as proof of Christ's endorsement of pictorial representations through the creation of a likeness of his own face. See, for example, Robin Cormack, *Writing in Gold: Byzantine Society and Its Icons* (London: George Philip, 1985), 122–25, for a discussion of the letters of the patriarchs of Alexandria, Antioch, and Jerusalem to the emperor Theophilos in the year 836. Both the Mandylion and the eucharistic offerings were cited as "licit" images of the incarnate Christ during the iconoclastic debates. See, for example, John of Damascus, "Expositio fidei," in Bonifatius Kotter, *Die Schriften des Johannes von Damaskos* (Berlin: de Gruyter, 1973), 2: 208, ll. 51–56; John of Damascus, *On the Divine Images: Three Apologies against Those Who Attack the Holy Images,* trans. David Anderson (Crestwood, N.Y.: St. Vladimir's Seminary Press, 1980), 35. The image was discussed already in the 7th century by Vrt'anes K'ert'ogh, an Armenian monk, in defense of icons; see Sirarpie Der Nersessian, "Une apologie des images du septième siècle," *Byzantion* 17 (1944–45): 58–87; reprinted in *Études byzantines et arméniennes* (Louvain: Imprimerie orientaliste, 1973), 1: 379–403.

16. Tatiana Malmquist, *Byzantine 12th-Century Frescoes in Kastoria: Agioi Anargyroi and Agios Nikolaos tou Kasnitzi* (Uppsala: Almqvist & Wiksell, 1979), 26, 35.

17. When Grabar completed his work, he stated: "Les très nombreuses décorations des petites églises tardives dans tous les pays balkaniques n'ayant pas encore fait l'objet d'une description, ni d'une étude, il est très vraisemblable que beaucoup de monuments, où le Mandylion surmonte la niche de l'abside, nous échappent actuellement" (Grabar [as in n. 3], 25). Indeed, since 1931 a number of monuments in the Balkans have been published.

18. Grabar (as in n. 3), 16–17.

19. Thalia Gouma Peterson, in her analysis of the decorative program at St. Euthymios, Thessalonike, suggested that since the Mandylion that was knotted at both ends and suspended from hooks "first appeared in Byzantine painting in 1265, and was in use from then on, it seems that its origin is not Latin and that, as has been the case in other instances, it should be re-attributed to Byzantine iconography." Thalia Gouma Peterson, "The Frescoes of the Parecclesion of St. Euthymios in Thessalonica: An Iconographic and Stylistic Analysis," Ph.D. diss., University of Wisconsin, 1964, 38.

20. Anna Tsitouridou, *Ho zographikos diakosmos tou Hagiou Nikolaou Orphanou ste Thessalonike: Symvole ste melete tes palaiologeias zographikes kata ton proimo 14° aiona* (Thessalonike: Kentro Vyzantinon Ereunon, 1986), 72, 73, 75.

21. Andreas Xyngopoulos, "Hai peri tou naou tes Acheiropoietou eideseis tou Konstantinou Harmenopoulou," *Epistemonike epeterida tou Tmematos Nomikes tes Scholes Nomikon kai Oikonomikon Epistemon tou Aristoteleiou Panepistemiou Thessalonikes* 6 (1952): 1–26.

22. For the text's date and attribution to Constantinople, see Dobschütz (as in n. 4), 108★★–110★★.

23. Ibid., 111★★.

24. Ibid., 112★★.

25. Ibid., 112★★–113★★; Grabar (as in n. 3), 29.

26. Quoted in Casimir Kucharek, *The Byzantine-Slav Liturgy of St. John Chrysostom* (Allendale, N.J.: Alleluia Press, 1971), 494.

27. Germanos of Constantinople, *On the Divine Liturgy,* trans. P. Meyendorff (Crestwood, N.Y.: St. Vladimir's Seminary Press, 1984), 87.

28. Tania Velmans, "Interférences sémantiques entre l'Amnos et d'autres images apparentées dans la peinture murale byzantine," in *Harmos: Timetikos tomos ston kathegete N. K. Moutsopoulo gia ta 25 chronia pneumatikes tou prosphoras sto panepistemio* (Thessalonike: Aristoteleio Panepistemio Thessalonikes, Polytechnike Schole, Tmema Architektonon, 1990–91), 3: 1905–1928; eadem, "Valeurs sémantiques du Mandylion selon son emplacement ou son association avec d'autres images," in *Studien zur byzantinischen Kunstgeschichte: Festschrift für Horst Hallensleben zum 65. Geburtstag* (Amsterdam: Adolf M. Hakkert, 1995), 173–84.

29. Tania Velmans, "L'église de Khé en Georgie," *Zograf* 10 (1979): 71–82. Several other Georgian churches display the image in the lower register of the apse: St. George at Cvirmi (12th century), the church of Christ at Caldasi (12th century), and Holy Archangels "Tanghil" (13th century). See Tania Velmans, "Les peintures de l'église dite 'Tanghil' en Georgie," *Byzantion* 52 (1982): 389–412.

30. See Aimilia Giaoure (Bakourou), "Geraki: Hagios Sozon," *Archaiologika analekta ex Athenon* 10 (1977): 87, fig. 4; Moutsopoulos and Demetrokalles, *Geraki,* 214–15, figs. 292, 338, 339.

31. Miljković-Pepek, *Veljusa,* 171.

32. Babić, "Les discussions," 368–86.

33. For a discussion of cloth and Christology in the sermons of Proclus of Constantinople, see Nicholas P. Constas, "Weaving the Body of God: Proclus of Constantinople, the Theotokos, and the Loom of the Flesh," *Journal of Early Christian Studies* 3, no. 2 (1995): 169–94; H. Papastavrou, "Le Veile, symbole de l'Incarnation: Contribution à une étude sémantique," *CahArch* 41 (1993): 141–68. The association of cloth and flesh appears also in secular literature, an indication of the widespread acceptance of this metaphor, for example, in a 12th-century poem attributed to Theodore Prodromos: "These tents which are now pitched, whenever I see them / lying collapsed on the ground and repositioned / I think of the temporary sojourn of human life / and the mutability of the tent of the earthly body" (Jeffrey C. Anderson and Michael Jeffreys, "The Decoration of the Sevastokratorissa's Tent," *Byzantion* 64 [1994]: 13). For an earlier mention of a tent as flesh, see also Anthony Cutler and Nicolas Oikonomides, "An Imperial Byzantine Casket and Its Fate at a Humanist's Hands," *Art Bulletin* 70 (1988): 82.

34. "The Life of the Blessed Elisabeth the Wonderworker," trans. Valerie Karras, in *Holy Women of Byzantium,* ed. Alice-Mary Talbot (Washington, D.C.: Dumbarton Oaks Research Library and Collection, 1996), 131.

35. Germanos of Constantinople (as in n. 27), 88–89.

36. Symeon of Thessalonike, *De sacra liturgia: PG* 155, 288A.

37. Hans Belting, "An Image and Its Function in the Liturgy: The Man of Sorrows in Byzantium," *DOP* 34/35 (1980–81): 1–16.

38. Laskarina Bouras, "The Epitaphios of Thessaloniki: Byzantine Museum of Athens No. 685," in *L'art de Thessalonique et des pays balkaniques et les courants spirituels au XIVe siècle* (Belgrade: Academie Serbe des sciences et des arts, Institut des Études Balkaniques, 1987), 211–31. The *epitaphios* is now in the collection of the Museum of Byzantine Culture, Thessalonike.

39. H. Grigoriadou-Cabagnols, "Le décor peint de l'église de Samari en Messénie," *CahArch* 20 (1970): 182–83.

Appendix
Catalogue of Decorated Sanctuaries in Macedonia

1. Medieval basilicas in the region include St. Achilleios at Lake Prespa; Hagia Sophia in Ohrid; Sts. Theodoroi, the metropolitan church of Serres; St. Demetrios, the metropolitan church of Servia; the Old Metropolis in Veroia; St. Nicholas in Manastir; and the Protaton on Mount Athos. See Georgios Soteriou, "Vyzantina vasilikai Makedonias kai Palaias Hellados," *BZ* 30 (1929/30): 568–76; Panagiotes Vocotopoulos, *He ekklesiastike architektonike eis ten dytiken sterean Hellada kai ten Epeiron: Apo tou telous tou 7ou mechri tou telous tou 10ou aionos* (Thessalonike: Kentron Vyzantinon Ereunon, 1975), 95–105.

2. See, for example, Agape Vasilake-Karakatsane, *Hoi toichographies tes Omorphes Ekklesias sten Athena* (Athens: Christianike Archaiologike Hetaireia, 1971), 113–15; Manolis Chatzidakis, "Rapports entre la peinture de la Macédoine et de la Crète au XIVe siècle," in *Pepragmena tou 9 Diethnous Vyzantinologikou Synedriou* (Athens: M. Myrtidis, 1955), 1: 136–48.

3. See, for example, Andreas Xyngopoulos, *Thessalonique et la peinture macédonienne* (Athens: M. Myrtidis, 1955), 26–44; G. Theocharides, "Ho vyzantinos zographos Kallierges," *Makedonika* 4 (1955–60): 541–43; Petar Miljković-Pepek, *Deloto na zografite Mihailo i Eutihij* (Skopje: [Republički zavod za zaštita na spomenicite na kulturata], 1967), 17–24, 203–34; Soterios Kissas, "La famille des artistes Thessaloniciens Astrapa," *Zograf* 5 (1974): 35–37.

4. For the inscription, see Jean-Michel Spieser, "Inventaires en vue d'un recueil des inscriptions historiques de Byzance: I, Les inscriptions de Thessalonique," *Travaux et mémoires* 5 (1973): 163.

5. For Christopher's tentative identification as Christophoros Burgaris, see Vera von Falkenhausen, *Untersuchungen über die byzantinische Herrschaft in Süditalien*

vom 9. bis ins 11. Jahrhundert (Wiesbaden: O. Harrassowitz, 1967), 87–88.

6. Spieser (as in n. 4), 164.

7. Paul Speck, "Die Inschrift am Apsisbogen der Panagia Chalkeon," *Hellenika* 20 (1967): 419–21.

8. Related to this inscription, see Sophronios, patriarch of Jerusalem, *Commentarius liturgicus: PG* 87ter, 3984c. A similar description involving angels, though not as deacons, is found in a dream in the *Life* of St. Stephen Sabaites. In the *Life,* dated 794–804, the holy man faints and sees "two angels dressed in white coming out of the sanctuary." *Vita S. Stephani Sabaitae Thaumaturgi Monachi: Acta Sanctorum,* July III (Paris and Rome: V. Goupy, 1867), 570 BC.

9. Ninoslava Radošević-Maksimović, "A Byzantine Epigram from the St. Achilius's Basilica at Mala Prespa," *ZRVI* 12 (1970): 9–13; Nikolaos Moutsopoulos, *He vasilike tou Hagiou Achilleiou sten Prespa: Symvole ste melete ton vyzantinon mnemeion tes periaches* (Thessalonike: Kentron Vyzantinon Ereunon, 1989), 1: 142–57.

10. See Anna Tsitouridou, *The Church of the Panagia Chalkeon* (Thessalonike: Hidryma Meleton Chersonesou tou Haimou, 1985), 26–27, 47; eadem, "Die Grabkonzeption des ikonographischen Programms der Kirche Panagia Chalkeon in Thessalonike," *JÖB* 32, 5 (1982): 435–41.

11. A similar motivation has been postulated for a late-10th- or early-11th-century copper votive plaque depicting St. Hermolaos. The plaque, in the Dumbarton Oaks Collection, is inscribed: "For the health and salvation and forgiveness of the sins [of]. . . ." See Susan Boyd, "Ex-voto Therapy: A Note on a Copper Plaque with Saint Hermolaos," in *Aetos: Studies in Honour of Cyril Mango,* ed. Irmgard Hutter (Stuttgart and Leipzig: Teubner, 1998), 1–13.

12. Heinrich Gelzer, *Der Patriarchat von Achrida: Geschichte und Urkunden* (Leipzig: Teubner, 1902), 6.

13. Louis Bréhier, *Le schisme oriental du XIe siècle* (Paris: E. Leroux, 1899), 93–102, 151–53.

14. André Grabar, "Un rouleau liturgique constantinopolitain et ses peintures," *DOP* 8 (1954): fig. 10.

15. André Grabar, "Les peintures murales dans le choeur de Sainte-Sophie d'Ochrid," *CahArch* 15 (1965): 259; George Galavaris, *Bread and the Liturgy: The Symbolism of Early Christian and Byzantine Bread Stamps* (Madison: University of Wisconsin Press, 1970), 176–77.

16. For example, the sanctuary program of the Virgin Peribleptos in Mystra (mid–14th century) depicts the Sacrifice of Abraham and the Three Hebrew Children in the Furnace on the side walls. Suzy Dufrenne, *Les programmes iconogaphiques des églises byzantines de Mystra* (Paris: Klincksieck, 1970), 52.

17. Miljković-Pepek, *Veljusa,* 32; Louis Petit, "Monastère de Notre-Dame de Pitié en Macédoine," *Izvestija Russkogo Arheologičeskogo Instituta v Konstantinopole* 6 (1900): 6.

18. Basil generally holds the silent prayer of the Cherubikon and Chrysostom the Prothesis prayer.

19. The decoration of the church before the Christological discussions of the 12th century meant that the Cherubikon prayer had not yet found a permanent place on Basil's scroll.

20. For Alexios, see Konstantinos Varzos, *He genealogia ton Komnenon* (Thessalonike: Kentron Vyzantinon Ereunon, 1984), 1: 654–55.

21. George Zacos and Alexander Veglery, *Byzantine Lead Seals* (Basel and Berne: J. J. Augustin, 1972), 1/3: 1527.

22. Mystagogical texts relate the use of candles in the church to the eternal light, which is assured by the continuous burning of the lights represented flanking the altar. See, for example, Sophronios (as in n. 8), 3985c.

23. Insufficient information exists for the painted program of two other churches in Prilep, St. Nicholas and St. Demetrios. For preliminary information, see F. Mesesnel, "Crkva sv. Nikole u Markovj varosi kod Prilepa," *Glasnik Skopskog Naučnog Društva* 19 (1938): 37–52; and Hamann-Mac Lean and Hallensleben, *Die Monumentalmalerie,* plan 10a–b.

24. Regarding the date of the building's initial construction, see Moutsopoulos, *Ekklesies tes Kastorias,* 391–9

25. Pelekanides and Chatzidakis, *Kastoria,* 40.

26. For Theodore Lemniotes, see E. Kyriakoudes, "Ho ktitoras tou naou ton Hag. Anargyron Kastorias Theodoros (Theophilos) Lemniotes," *Valkanika Symmeikta* 1 (1981): 3–23.

27. Allusion to Psalm 22:2.

28. Eugenia Drakopoulou, *He Pole tes Kastorias te vyzantine kai metavyzantine epoche (12os–16os ai.): Historia, Techne, Epigraphes* (Athens: Christianike Archaiologike Hetaireia, 1997), 48–50. For an earlier reading of the inscription, see Anastasios Orlandos, "Ta vyzantina mnemeia tes Kastorias," *ABME* 4 (1938): 35.

29. Of the two painters who have been distinguished in the decoration of the Holy Anargyroi, Painter A has been associated with the style of Kurbinovo. See Hadermann-Misguich, *Kurbinovo,* 542–51, 566–84, pls. 9–11; Tatiana Malmquist, *Byzantine 12th-Century Frescoes in Kastoria: Agioi Anargyroi and Agios Nikolaos tou Kasnitzi* (Uppsala: Almqvist & Wiksell, 1979), 36; Pelekanides and Chatzidakis, *Kastoria,* 43–44.

30. For examples of the restless child, see Annemarie Weyl Carr, "The Presentation of an Icon at Mount Sinai," *DChAE* 17 (1993–94), 242.

31. Drakopoulou (as in n. 28), 42–43; Orlandos (as in n. 28), 145; Nino Lavermicocca, "Sull'iscrizione di fondazione della chiesa di S. Nicola di 'Kasnitzi' a Kastorià (Macedonia)," *Nicolaus* 4 (1976): 210.

32. See Nancy Ševčenko, "The Evergetis *Synaxarion* and the Celebration of a Saint in Twelfth-Century Art and Liturgy," in *Work and Worship at the Theotokos Evergetis,* ed. Margaret Mullett and Anthony Kirby (Belfast: Belfast Byzantine Texts and Translations, 1997), 395.

33. Hadermann-Misguich, *Kurbinovo,* 17.

34. Ibid., 55.

35. Andreas Xyngopoulos, *Ta mnemeia ton Servion* (Athens: M. Myrtidis, 1957), 40–41.

36. The face of the westernmost bishop has been destroyed. Achilleios was originally from Larissa and Oikoumenios was from nearby Trikkala.

37. Unfortunately, as in the case of the "Communion of the Apostles," Xyngopoulos did not publish a photograph or complete description of the Deesis. Because the north wall of the sanctuary no longer exists, it is impossible to postulate what representation was originally placed there.

38. Pelekanides and Chatzidakis, *Kastoria,* 78–81.

39. Ann Wharton Epstein, "Middle Byzantine Churches of Kastoria: Dates and Implications," *Art Bulletin* 62 (1980): 203–6.

40. The second and third saints from the left are often mistakingly identified as Gregory the Theologian and an unknown (see, for example, Georgios Gounares, *He Panagia Mauriotissa tes Kastorias* [Thessalonike: Ekdoseis P. Pournara, 1987], 19). The saint adjacent to Basil, based on his facial features and position, is most certainly Gregory.

41. This saint is also represented in the sanctuary of Panagia ton Chalkeon.

42. Thanasis Papazotos, "He ktetorike epigraphe tes Palias Metropoles tes Veroias," *Historikogeographika* 1 (1986): 200; Papazotos, *He Veroia,* 90.

43. Tsigaridas, in a preliminary publication, suggested that the church had four distinct phases of painting dating from the early 12th through the early 14th century. Euthymios Tsigaridas, "Hoi toichographies tes Palias Metropoleos Veroias," *Deutero Symposio Vyzantines kai Metavyzantines Archaiologias kai Technes: Abstracts* (Athens: [s.n.], 1982), 98–99. For a refinement of the phases of decoration, see Papazotos, *He Veroia,* 167–69.

44. See also Maria Panayotidi, "Les églises de Véria, en Macédoine," *CorsiRav* 22 (1975): 303–15. Panayotidi dates the episcopal figures to 1100–1150. Tsigaridas dates the composition to 1225–60. Stylistically, the decoration must follow Kurbinovo (1191). I follow Papazotos's dating of the frescoes to the early 13th century (Papazotos, *He Veroia,* 247).

45. For Theodore's campaigns, see Donald Nicol, *The Despotate of Epiros* (Oxford: Blackwell, 1957), 1: 47–112.

46. Andreas Xyngopoulos, "Paratereseis eis tas toichographies tou Hag. Nikolaou Melenikou," *Epistemonike Epeteris tes Philosophikes Scholes tou Panepistemiou Thessalonikes* 6 (1950): 119; Liliana Mavrodinova, "Nouvelles considérations sur les peintures du chevet de l'église Saint-Nicolas à Melnic," *Actes du XVe Congrès international des Études Byzantines* (Athens: Association Internationale des Études Byzantines, 1981), 2A: 434.

47. Mavrodinova identifies this figure as Dionysios the Areopagite. Mavrodinova (as in n. 46), 434.

48. This figure is not attested in the sources. A nephew of Alexios I, also named Alexios (b. 1077), who was active in this region, may be the person named in the inscription. See Varzos (as in n. 20), 147–54. The wording of the church inscription is similar to the terms used to describe the nephew Alexios in a chrysobull issued on behalf of the nearby monastery of Panagia Eleousa in Veljusa by Alexios

I in 1106. See Petit (as in n. 17), 28. Against this identification is the use of the rank *protostrator* in the inscription.

49. Michael VIII Palaiologos, emperor 1259–1282.

50. Franjo Barišić, "Deux inscriptions grecques de Manastir et de Strouga," *ZRVI* 8, 2 (1964): 15–16; Dimče Koco and Petar Miljković-Pepek, *Manastir* (Skopje: Univerzitetska pečatnica, 1958), figs. 7, 7a. The inscription needs to be re-edited.

51. Ibid., 8–11, pl. 33.

52. *Prosopographisches Lexikon der Palaiologenzeit* (Vienna: Verlag der Österreichischen Akademie der Wissenschaften, 1990), 10: 203, no. 25060.

53. For the rank of *megas hetaireiarches,* see Patricia Karlin-Hayter, "L'hétériarque," *JÖB* 23 (1974): 101–43.

54. By the late 13th century, *gambros* was used as an honorific title as well as a term for in-laws of the emperor. For the use of this term, see Lucien Stiernon, "Notes de titulature et de prosopographie byzantines: Sébaste et gambros," *REB* 23 (1965): 222–32.

55. Miljković-Pepek (as in n. 3), 44.

56. For the work of these painters, see Xyngopoulos (as in n. 3), 36, fig. 4; Miljković-Pepek (as in n. 3); R. Hamann-Mac Lean, "Zu den Malerinschriften der 'Milutin-Schule,'" *BZ* 53 (1960): 112–17.

57. Mouriki, "Stylistic Trends," 65.

58. The decoration of this church is being studied by D. Kalomoirakes.

59. This detail is also included in the church of Christ, Veroia.

60. The damaged state of the bishop on the north face of the east wall prohibits identification.

61. For their role also in the decoration of St. Mary Pammakaristos in Constantinople, see Hans Belting, Cyril Mango, and Doula Mouriki, *The Mosaics and Frescoes of St. Mary Pammakaristos (Fethiye Camii) at Istanbul* (Washington, D.C.: Dumbarton Oaks Center for Byzantine Studies, 1978), 11–22.

62. For the Greek text, see Spieser (as in n. 4), 168.

63. G. I. Theocharides, "Michael Doukas Glavas Tarchaneiotes," *Epistemonike Epeteris tes Philosophikes Scholes tou Panepistemiou Thessalonikes* 7 (1957): 183–206.

64. Georgios Soteriou and Maria Soteriou, *He vasilike tou Hagiou Demetriou Thessalonikes* (Athens: [He en Athenais Archaiologike Hetaireia], 1952), 1: 213.

65. Thalia Gouma Peterson, "The Frescoes of the Parecclesion of St. Euthymios in Thessalonica: An Iconographic and Stylistic Analysis," Ph.D. diss., University of Wisconsin, 1964, 45. The association of the tabernacle and the Incarnation derives from Paul's Epistle to the Hebrews, 9:1–22.

66. Victor Lasareff, "Studies in the Iconography of the Virgin," *Art Bulletin* 20 (1938): 60–61; Hadermann-Misguich, *Kurbinovo,* 53–67, pls. 9, 11; Gouma Peterson (as in n. 65), 26–27; eadem, "The Frescoes of the Parekklesion of St. Euthymios in Thessaloniki: Patrons, Workshop, and Style," in *The Twilight of Byzantium,* ed. Slobodan Ćurčić and Doula

Mouriki (Princeton: Princeton University Press, 1991), 121.

67. Gouma Peterson (as in n. 65), 59–61.

68. The syntax of line six is problemmatical. The painter may be comparing himself to his colleagues (good and decent brothers) in Veroia and greater Macedonia.

69. Considering the date of the church, the patriarch mentioned is probably Niphon I (1310–14), who was also associated with the construction of the church of the Holy Apostles in Thessalonike. See *Oxford Dictionary of Byzantium* (New York and Oxford: Oxford University Press, 1991), 3: 1487.

70. Stylianos Pelekanides, *Kallierges: Holes Thettalias aristos zographos* (Athens: He En Athenais Archaiologike Hetaireia, 1973), 7–11.

71. The inclusion of Silvester in Byzantine wall painting reflects the widespread belief that he, as pope of Rome, baptized Constantine the Great. On the sources and circulation of the Silvester legend, see Alexander Kazhdan, " 'Constantine Imaginaire': Byzantine Legends of the Ninth Century about Constantine the Great," *Byzantion* 57 (1987): 196–250. Portraits of Silvester are also found in the churches of St. Blasios and St. Paraskeve in Veroia. For the significance of the Silvester legend from the 11th century, see Ioli Kalavrezou, Nicolette Trahoulia, and Shalom Sabar, "Critique of the Emperor in the Vatican Psalter Gr. 752," *DOP* 47 (1993): 212–15.

72. The wall paintings of St. Blasios are being studied by C. Tsioumi.

73. Georgios Chionides, *Historia tes Veroias: Tes poleos kai tes perioches* (Thessalonike: [s.n.], 1970), 1: 171–72. The inclusion of this saint reflects the belief that Karpos was the first bishop of Veroia and was a disciple of the apostle Paul. It is more likely, however, that he served as bishop of Thracian Veroia.

74. The effect of additional height on monumental decoration may also be seen in Holy Anargyroi, Kastoria.

75. For Maximos the Confessor, for example, the sanctuary reminds one of the sky. See *The Church, the Liturgy, and the Soul of Man: The Mystagogia of St. Maximus the Confessor,* trans. Dom Julian Stead (Still River, Mass.: St. Bede's Publications, 1982), 71.

76. The Virgin in the apse of the later church of St. Nicholas tou Kiritze in Kastoria has the same inscription. For a discussion of the Virgin and the surrounding inscription, see Andreas Xyngopoulos, "Hai peri tou naou tes Acheiropoietou eideseis tou Konstantinou Harmenopoulou," *Epistemonike epeteris tes scholes nomikon kai oikonomikon epistemon* 6 (1952): 1–26; Tania Velmans, "Les fresques de Saint-Nicolas Orphanos à Salonique," *CahArch* 16 (1966): 157–58; Anna Tsitouridou, *Ho zographikos diakosmos tou Hagiou Nikolaou Orphanou ste Thessalonike: Symvole ste melete tes palaiologeias zographikes kata ton proimo 14° aiona* (Thessalonike: Kentro Vyzantinon Ereunon, 1986), 63–65.

77. Spieser (as in n.4), 168–70.

Glossary

acheiropoietos Word applied to objects that appeared miraculously or replicated themselves miraculously. Lit., "not made by human hands."

aer Liturgical veil carried in the Great Entrance and placed over the eucharistic elements on the altar.

amnos The central portion of the principal offered bread, signifying Christ's body. It is marked with a stamp and extracted during the Prothesis rite and consecrated at the eucharist. Lit., "lamb."

anaphora Offering. By the sixth century, the prayer accompanying the offering.

anargyroi Epithet of healing saints who, unlike secular physicians, performed cures without taking payment. Lit., "not accepting money."

antidoron The remains of the *prosphora* distributed to the faithful at the conclusion of the liturgy. Lit., "in place of the gift."

asterisk A raised metal star-shaped utensil that stands on the paten and supports a protective veil over the sacrament.

azyme Unleavened bread used by the Armenian and Latin churches in the eucharistic sacrifice. Lit., "without yeast, leaven."

bema The area of the church containing the altar. Also referred to as *hierateion* (sanctuary).

Cherubikon The cherubic hymn; a troparion that accompanies the transfer of the gifts in the Great Entrance.

diakonikon By the medieval period, the chamber located on the south side of a tripartite sanctuary that was used for storage and for the vesting of the clergy.

diataxis A book of instructions for the bishop or priest presiding at the eucharist or, less frequently, at vespers, matins *(orthros),* and ordination.

epiklesis Invocation for the coming of the Holy Spirit. The *epiklesis* in the *anaphora* asks the Father to send his Spirit or invokes the Spirit to come upon the bread and wine to change them into the body and blood of Christ.

epitaphios The large textile used in the Burial of Christ procession at the Holy Saturday *orthros,* symbolically represented as the funerary bier of Christ.

euchologion Prayer book used by the principal liturgical celebrants for all services of the Byzantine rite.

filioque Latin word meaning "and from the Son," which in the West was added to the Creed of Nicaea-Constantinople at a Spanish council in Toledo in 589.

Great Entrance Ritual procession in which the deacon carries the paten with the eucharistic bread and the priest the chalice with the wine from the prothesis chamber into the nave of the church, then through the *templon* to the altar.

iconostasion *Templon* screen in which icons are placed in the intercolumnar spaces.

katholikon The main church in a monastic complex.

melismos Ritual breaking of the consecrated bread before communion.

metanoia Term for repentance or penance.

metropolitan Head of the episcopate in an ecclesiastical territory.

omophorion A long scarf that denotes episcopal status.

Glossary

orthros — The office of daybreak. The service began in the church narthex and terminated at the sanctuary.

pastophoria — Two auxiliary chambers within the church (in the medieval period they flank the sanctuary) used as sacristies; the *diakonikon* and the prothesis.

phelonion — A vestment worn primarily by priests and bishops, the Eastern equivalent of the Latin chasuble.

polystavrion — A *phelonion* or liturgical cape decorated all over with a pattern of little crosses.

proskynesis — The gesture of supplication or reverence.

proskynetarion — The stand holding a venerated icon, or the large icons of Christ, the Virgin, or the titular saint that flank the sanctuary entrance.

Prothesis — The preparation of the bread and chalice in a separate liturgical rite before the beginning of the eucharistic liturgy; also, the chamber to the north of the central sanctuary.

protostrator — One of the ranks of officials of the Byzantine court.

rhipidion — A liturgical fan (Latin, *flabellum*). Liturgical texts indicate that the fan was waved by the deacon over the sacramental elements to protect them from insects.

sakkos — An ornamented tunic worn by the patriarch. By the thirteenth century this vestment was also worn by clerics of metropolitan and episcopal rank.

stamnos — Ceramic container used for storing and transporting wine.

templon — The screen that separates the sanctuary from the nave.

thyomenos — Term occasionally applied to the representation of Christ as the sacrifice.

Trisagion — Byzantine name for the biblical *sanctus* chanted from the fourth century on in the *anaphora*. Lit., "thrice-holy."

troparion — In medieval usage, a stanza of a hymn.

zeon — The custom, unique to the Byzantine rite, of adding hot water to the chalice at the eucharist.

Index

Aaron, brother of Moses, 25, 104

Abgar, king of Edessa, 69, 70

acheiropoietos, 69, 72, 73

Achilleios of Larissa, saint, 24, 25, 31, 92, 93, 108

Adoration of the Magi, 109

aer, see textiles, liturgical

Alepochori (near Megara), Church of the Savior, 20 n. 30

Alexandria, patriarchate of, 84

Alexios I Komnenos, emperor, 45, 45 n. 48

Alexios Angelos Komnenos, 45, 87

Alexios the *protostrator,* 98

altar, 34

 inscriptions on, 13, 91

 proximity of icons to, 12 n. 39

 proximity of name saints to, 12

 representation of, 37, 39–40, 90, 97, 101

 symbolic associations of, 5, 8, 34, 42, 73

 votive inscriptions and, 13

altar cloth, *see* textiles, liturgical

amnos (lamb), 43 n. 35, 44, 84

Amphilochios of Ikonion, saint, 24

anaphora, 8, 61

anargyroi, 7, 11, 82, 89

Anastasis, 29, 105

ancestors of Christ, 101

Ancient of Days, 89

Andrew, apostle and saint, 60, 86, 88, 96

Andronikos II Palaiologos, emperor, 100, 105

Andronikos III Palaiologos, emperor, 111

angel, 5, 29, 34, 38, 39, 40, 41, 42, 43, 46, 48, 51, 56, 74, 76,
 81, 83, 86, 87, 89, 91, 95, 96, 97, 99, 101, 104, 108,
 110

Annunciation, 11, 29, 49, 57, 70, 71, 77, 89, 91, 92, 93, 94,
 96, 102, 103, 104, 106, 107, 109

antidoron, 11, 53–54

Antioch, patriarchate of, 84

Antipas, saint, 106, 109

antiphon, 31, 33, 40 n. 17, 102, 106

Antony II Kauleas, patriarch of Constantinople and saint,
 53

Apollinaris, theologian, 58

Apophthegmata patrum ("Sayings of the Fathers"), 45

apostles

 "historical" and "liturgical" series, 50

 representation of, 3, 7, 16, 50, 78, 83, 95

apostolic communion, *see* Communion of the Apostles

apostolic embrace, 59–63, 87, 96, 97, 99

Appearance of Christ, 99, 101

archangel, 71, 81, 89, 91, 93, 94, 96, 98, 103, 106, 107, 109

Arianism, 24

Arilje (Serbia), monastery, 26

Ark of the Covenant, 51, 52, 78, 104

Arsenios, saint, 17

Arta (Epiros)

 St. Demetrios tou Katsoure, 20, 52

 St. Nicholas tes Rhodias, 75

Ascension, 3, 82, 83, 91, 93, 96, 101, 107

Asinou, Panagia Phorbiotissa, *see* Cyprus

aspasmos

 of the clergy, 21, 61–63

 of the Gospels, 21

asterisk, 15, 37, 39, 40, 41, 42, 43, 108, 110

Athanasios of Alexandria, archbishop and saint, 22, 23, 24,
 31, 33, 84, 87, 92, 94, 95, 97, 99, 101, 102, 104, 106,
 108, 110, 111

Athenogenios, bishop, 18 n. 19

Athens, National Library (Ethnike Bibliotheke)

 cod. 7 (psalter), 61 n. 75

 cod. 211 (Homilies of John Chrysostom), 49 n. 3

 cod. 662 *(diataxis),* 25

 cod. 2759 (liturgical scroll), 30

Athens, Omorphe Ekklesia, 12, 52

Attaleiates, Michael, 9, 53, *see also* church inventories,
 Christ tou Panoiktirmonos

Attika, *see* Athens, Koropi, Markopoulou, Merenta,
 Penteli Cave

Averkios, saint, 24

azymes (unleavened bread), 47, 58, 58 n. 54, 59, 63

Babić, Gordana, 32, 44

Balsamon, Theodore, canonist, 25, 26

Bartholomew, apostle and saint, 60

Basil, bishop and saint, 16, 17, 18, 19, 20, 22, 23, 24, 26, 27,
 30, 31, 31 n. 107, 33, 36, 37 n. 2, 40, 40 n. 16, 42, 43,
 45, 53, 84, 85, 86, 87, 88, 90, 91, 92, 94, 95, 96, 97,
 99, 100, 101, 102, 105, 106, 108, 110, 111

basilicas

 Early Christian, 35

 medieval, 80, 80 n. 1, 81, 88, 101, 103

Bawit

 Chapel VII, 16 n. 6

 Chapel VIII, 16 n. 6

 Chapel XVII, 16 n. 6

 Chapel XXVIII, 16 n. 6

Belisirma (Cappadocia), St. George, 19 n. 24

belt, *see* vestments

bema, *see* sanctuary

Berende (Bulgaria), St. Peter, 70 n. 14, 72

Bethlehem, 42

Bezirana kilisesi (Cappadocia), 40
Biblical references, New Testament
 John 13:21–30, 51, 64
 John 19:34, 41
 Luke 22:8, 51
Biblical references, Old Testament
 II Kings 2:9–10, 22
bishops,
 "archaizing," 17, 19, 21
 costumes, *see* vestments
 frontal portraits of, 16–21, 23, 28, 37, 71, 81, 82, 83, 84,
 86, 92, 93, 102
 half-length portraits of, 12, 23, 99, 104, 106, 110
 heretical, 26
 local, 16, 17, 18, 24, 93, 108
 number of, 23, 24
 of Caesarea, 26
 of Corinth, 26
 of Ephesos, 26
 of Thessalonike, 26
 three-quarter stance (celebrating), 16, 17, 19, 21–23,
 28, 29, 30, 37, 40, 62, 71, 75, 78, 85, 87, 88, 90, 92,
 94, 100, 102, 104, 110, 111
 typology of, 17, 29
 withdrawal from faithful, 10, 22
Blasios, saint, 20, 24, 93, 99
blood, 40, 41, 42, 46, 55, 57, 76
bread, offered, 11, 37, 39, 40, 41, 42, 44, 45, 47, 49, 83, 108
Bulgaria, 3, 40, 96, 100
burial, 20, 80, 82

Caldasi (Georgia), Church of Christ, 75 n. 29
candles and lighting, 1, 5, 6, 16, 21, 22, 37, 37 n. 1, 39, 73,
 79, 87, 87 n. 22, 97, 101
Cappadocia, *see* Belisirma, Bezirana kilisesi, Eski Gümüs,
 Göreme, Soganli
catechumens, 40 n. 17
catharsis, 11, 33, 34
celebrant, *see* priest
Chalcedon, council of, 26
chalice, *see* vessels
chancel barrier, *see* screen, sanctuary
chanters, 13
Chatzidakis, Manolis, 17, 18
Cherubikon, 5, 30, 31, 33, 34, 40 n. 16, 42, 44, 45, 74, 76, 85
 n. 18, 106, 108
cherubim, 29, 52, 73, 99
Christ
 Arrest of, 28
 as high priest, 25, 56
 as sacrifice, 39, 40–44, 45, 74
 Betrayal of, 8
 Crucifixion of, 41, 51, 52, 74
 Emmanuel, 89, 94, 101, 106
 Pantokrator, 10, 68, 70
 Passion of, 73, 74, 78

Resurrection, 5, 52, 65, 74
 Second Coming, 38, 39
 Transfiguration, 3
Chrysapha (Lakonia), Virgin Chrysaphitissa, 23 n. 50, 64
church
 architectural divisions, 5–8, 10, 35
 dome, 68, 71, 75, 77, 82
 furnishings, 8, 10, 22, 41, 51
 symbolic interpretation of, 5, 6
Church, corporate, 3, 17, 35, 40
church inventories
 Christ tou Panoiktirmonos, 9, 53
 Hagia Sophia, Constantinople, 29
 Mother of God of Koteine (near Philadelphia), 29
 St. John the Theologian, Patmos, 29
 Virgin Gavaliotissa at Vodena (Edessa), 29
ciborium, 41, 48, 51, 52, 56, 87, 97, 99, 101
Classe, Sant'Apollinare, 16
Clement of Alexandria, saint, 23, 106
Clement of Ohrid, saint, 25, 99
clergy
 addressed by inscriptions, 1, 13, 81
 communion of, 55–57, 61–63, 66–67
 experience in church, 2, 56, 57, 61
 isolation of, 1
color
 of vestments, 26, 27
 of wall paintings, 16, 71
commemoration
 of the living and the dead, 13, 24, 44
 of the Virgin and saints, 24, 44
communion
 frequency, 56, 67
 of St. Mary of Egypt, 57, 67, 79
 rite, 11, 31, 39, 46, 48, 49, 50, 54, 55, 56
 prayers, 30, 31
 Western, 58, 59
Communion of the Apostles, 33, 48–67, 70, 72, 73, 75, 76,
 81, 82, 83, 84, 85, 86, 87, 88, 92, 96, 97, 98, 99, 101,
 102, 104, 109, 110
concelebration, 23, 35, 37, 42, 62
consecration, prayers of, 31, 31 n. 107, 33, 97, 108
consecration of James, 96–97
Constantine V, emperor, 12
Constantine VII Porphyrogennetos, emperor, 70
Constantine IX Monomachos, emperor, 24 n. 53
Constantine Cabasilas, bishop, 100
Constantinople, 84
 Great Palace, 69
 Hagia Sophia, 8, 16, 17, 29, 45 n. 45, 52, 61
 Holy Apostles, 52
 Kariye Çamii, 20
 Nea Ekklesia, 32
 St. Euphemia, 7
 St. Mary Pammakaristos, 20, 103 n. 61
 Stoudios monastery, 8
costume, *see* vestments

Crete
 Panagia Gouverniotissa, Potamies, 64, 66
 Panagia Kera, Kardiotissa, 70 n. 14
 St. Eutychios near Rethymnon, 18
 St. George near Cheliana, 70 n. 14
 St. George Kavousiotis, Kritsa, 70 n. 14
 St. Michael the Archangel, Archanes, 70 n. 14
 St. Michael the Archangel, Astrategos, 70 n. 14
 St. Nicholas, Maza, 70 n. 14
 St. Panteleimon, Bizariano, 13 n. 49
 St. Paraskeve, Siwa, 70 n. 14
 Virgin, Myriokephalon, 40 n. 18
 Virgin, Patso, 64 n. 92
crown of thorns, 38
Čučer, St. Niketa, monastery, 33 n. 117, 50 n. 11
curtains, 8, 9, 15, 66, 72, 76
Cutler, Anthony, 24
Cvirmi (Georgia), St. George, 75 n. 29
Cyprus, 40
 Holy Apostles, Perachorio, 50, 64
 Panagia Phorbiotissa, Asinou, 49 n. 9, 50, 57, 63, 64
 Panagia tou Moutoullas, 12
 St. John Chrysostom, Koutsouvendis, 22
 St. Neophytos (near Paphos), 26, 33, 37 n. 2
Cyril of Alexandria, saint, 23, 24, 91, 95, 99, 101, 102, 104, 108, 111
Cyril of Jerusalem, 55

dado, 15
Dalassenos, John (Roger), 45 n. 48
Damianos, saint, *see* Anargyroi
David, Old Testament king, 102, 106
deacons, 1, 8, 9, 35, 38, 39, 41, 43, 56, 74, 83, 87, 91, 92, 94, 99, 108
debate, theological, 44–47, 48, 58–59, 79, 83
Deesis, 20, 71, 89, 91, 93
Der Nersessian, Sirarpie, 20
Desphina, church of the Taxiarchs, 70 n. 14
devil, 65
diakonikon, 12, 70
Diamante, Kalliope, 20
diataxis, 9, 30, 43, 55, 61
 of Philotheos, patriarch of Constantinople, 9, 21, 24, 62
Dionysios, saint, 28, 95, 102
Djurić, Vojislav, 26
dogma, 3, 43
donors and patrons
 Christopher, *protospatharios* and *katapan* of
 Longobardia, 81, 81 n. 5
 John Moutoullas and his wife, Eirene, 12
 Kale Meledone, 12
 lay, 13
 Leo, bishop, 6
 Manuel the Monk, 94
 Manuel the Monk, Bishop of Tiberioupolis, 38, 85
 Michael Doukas Glavas Tarchaneiotes and his wife,
 Maria, 20, 103, 103 n. 61
 Nikephoros Kasnitzes and his wife, Anna, 71, 90
 Niketas, *protospatharios* and *tourmarches* of Naxia, 6
 Pachomios, abbot, 29
 Progonos Sgouros, *megas hetaireiarches* and *gambros,* 100
 Stephanos, Count and *Kamelares,* 6
 Theodore Lemniotis and his wife, Anna Radene, 88, 89
 Xenos Psalidas and his wife, Euphrosyne, 105
doors, 6, 8, 9, 51
Doubting Thomas, 99, 101, 102
dove, 38, 39, 40, 85, 96

earth, 5, 6
Easter, 66
Edessa (modern Urfa in Turkey), 69, 73
Edessa (Vodena), Virgin Gavaliotissa, 29
Ekklesia, 41
Ektene, 31
Eleutherios, saint, 28, 95
Elijah, prophet, 22
Elisha, prophet, 22
Elizabeth the Wonderworker, saint, 75
embrace of Peter and Paul, 60, 61
embroidery, 28, 29, 50, 76
epiklesis, 31, 33, 39, 66
Epiphanios of Cyprus, bishop and saint, 22 n. 44, 24, 26
Epiros, 20, *see also* Arta
epigonation, see vestments
epimanikia, see vestments
epistyle, *see* screen, sanctuary
epitaphios, 19, 50, 76
epitrachelion, see vestments
Erasmos, saint, 99
Eski Gümüş (Cappadocia), 18 n. 19
eucharistic miracles, 46
euchologion, 24
Euplos, saint, 90, 92, 104
Eusebios of Caesarea, 69
Eustathios, patriarch of Constantinople, 8
Eustratios of Nicaea, theologian, 44
Euthymios, saint, 30, 103
Eutychios, patriarch and saint, 12
evangelists, representation of, 3, 94, 102

fasting, 11
filioque, 59
First Entrance, *see* liturgy
Florence, Biblioteca Laurenziana, Plut. 1.56 (Rabbula
 Gospels), 48 n. 2
Fourth Crusade, 58, 69
funerary churches, 20, 21

Galesiotes, Meletios, 8, 63
gambros, 100, 100 n. 54
gammata, 27

George, saint, 10, 37 n. 2
Geraki (Lakonia)
 Church of the Savior, 75
 Evangelistria Church, 10
 St. Athanasios, 23 n. 50
 St. John Chrysostom, 10, 26, 27, 30, 41
 St. Nicholas, 57
Germanos, patriarch of Constantinople, *see* liturgical
 commentary
gesture
 of benediction, 17, 18, 37, 40, 43, 83
 of speech, 15, 91, 107
Glykeria, saint, 12
Göreme
 Chapel 1 (El Nazar), 16
 Chapel 2a (Saklı kilise), 18 n. 18, 70
 Chapel 19 (Elmalı kilise), 18 n. 18
 Chapel 21, 70
 Chapel 22 (Çarıklı kilise), 18 n. 18
 Chapel 23 (Karanlık kilise), 18 n. 18, 70
 Chapel 29 (Kılıçlar kilise), 49
Gospel books
 representation of, 18, 32, 38, 71, 85, 97, 107
 veneration of *(aspasmos),* 9, 21
Gouma Peterson, Thalia, 105
Grabar, André, 31, 68, 71
Gračanica (Serbia), monastery, 50 n. 11
Great Entrance, *see* liturgy
Gregory of Akragas (Agrigentum), bishop and saint, 18,
 24, 82, 102, 109
Gregory of Armenia (the Illuminator), bishop and saint,
 18, 24, 82, 109
Gregory of Dekapolis, 24, 99
Gregory of Nazianzos (the Theologian), bishop and saint,
 18, 22, 23, 24, 31, 33, 36, 37 n. 2, 40, 40 n. 17, 84, 86,
 87, 88, 90, 92, 94, 95, 97, 99, 100, 101, 102, 104, 106,
 110, 111
Gregory of Nyssa, theologian and saint, 18, 22 n. 44, 24,
 27, 82, 90, 92, 99
Gregory Thaumatourgos, saint, 16, 18, 22 n. 44, 24, 28, 82,
 84, 87, 92, 94, 95, 100

Hadermann-Misguich, Lydie, 91
Hawkins, Ernest, 16
healing, 14, 18, 69, 82, 82 n. 11, 89
heaven, 5, 39, 73
heresy, 44, 45, 47, 58, 59
Hermogenes, saint, 108
Hermolaos, *anargyros,* 82, 82 n. 11, 94
hetoimasia, 22, 23, 37, 38, 39, 40, 45, 47, 85, 87, 89
Hierotheos, saint, 23, 90, 106
Holy Apostles, Perachorio, *see* Cyprus
Holy of Holies, 5, 6, 52
Holy Saturday, 76
Holy Spirit, 31, 34, 39, 42, 74, 75, 92
Holy Thursday, 65, 66, 67

Holy Wednesday, 65
Holy Week, 65, 66, 78
Holy Wisdom, 84
Hospitality of Abraham, 84
hours, liturgical, 6, 17, 28, 37 n. 1, 65, 76
Humbert, cardinal of Silva Candida, 56

Iconoclasm, 17, 24, 32, 46, 71 n. 15
iconostasis, see screen, sanctuary
icons, 1, 9, 10, 14, 35
 decoration of reverse side, 10
 fictive, 18, 23, 37 n. 2
 Mount Sinai, 10, 38 n. 7, 70
 proskynetaria, 7
 of Christ, 7, 9, 10
 of the Virgin, 7, 9, 10, 72, 109
 of titular saint, 7, 10, 11, 89, 91
Ignatios Theophoros, saint, 102
inaudible (silent, mystical) prayers, 31–35, 40, 42
Incarnation, 3, 49, 68, 70, 71, 75, 76, 77, 104
incense, 5, 73, 74
inscriptions
 in churches, 6, 11, 12, 72, 81, 87, 89, 90, 91, 94, 98, 100,
 103, 105
 in manuscripts, 13, 14
 on liturgical vessels, 53
 votive, 12, 13, 98
intercessor
 saint as, 2, 10, 11, 18, 35, 78
 Virgin as, 10, 11, 22
intinction, 56, 67
Ioannikios, abbot, 87
Ioannikios (Akakios), abbot, 98
Isaiah, prophet, 103
Italos, John, 44, 46
Iznik, Archaeological Museum, 53

Jacob's Ladder, 84
James, the Brother of the Lord, 23, 24, 101, 102
James the Less, apostle, 50
Jeremiah, prophet, 103
Jerusalem, Greek Patriarchate, cod. Stavrou 109
 (liturgical scroll), 31 n. 104, 83
Joachim and Anna, 70 n. 14
John, *see* painters
John, *anargyros,* 82
John, apostle and saint, 49, 50, 51, 64, 99, 101, 102, 104
John II Komnenos, emperor, 45 n. 48
John Chrysostom, saint
 holds cross, 19
 representation of, 16, 18, 19, 20, 22, 23, 26, 30, 31, 31 n.
 107, 33, 36, 37 n. 2, 40, 40 n. 16, 42, 43, 84, 85, 87,
 90, 91, 92, 94, 95, 96, 97, 99, 100, 101, 102, 104, 106,
 108, 110, 111
 writings, 34

John Eleemon, saint, 23, 24, 28, 90, 94, 95, 99, 102, 106
John Komnenos Doukas, 20
John Rufus, 46
John of Antioch, 58
John of Damascus, 46, 71 n. 15, 91
John the Baptist, 13, 82, 111
Joseph I Galesiotis, patriarch, 58
Judas, 63–66, 78
judgment, 38, 39
Justiniana Prima, 100

Kallierges, *see* painters
Kalliope, saint, 12
Kambia (Boeotia), St. Nicholas, 33 n. 116
Karpos, saint, 25, 28, 108, 108 n. 73
Kastoria, 80
 Holy Anargyroi (Sts. Kosmas and Damianos), 7, 11, 17,
 22, 23, 26, 27, 28, 30, 31 n. 105, 33, 33 n. 114, 37, 39,
 82, 88–90, 91, 96, 102, 104
 Panagia Mavriotissa, 41 n. 24, 93–94
 St. Athanasios tou Mouzake, 63
 St. Nicholas tou Kasnitze, 10, 11, 23, 28, 70 n. 14, 71,
 72, 75, 90–91, 96
 St. Nicholas tou Kiritze, 109 n. 76
 Taxiarchs, 23, 27, 31, 33
Kerameion, 102
Kerkyra (Corfu)
 St. Merkourios, 22
 Sts. Jason and Sosipater, 17
Khé (Georgia), St. Barbara, 75
Kiev
 Hagia Sophia, 49 n. 9, 52
 St. Michael the Archangel, 49 n. 9, 51 n. 18
Kinnamos, John, historian, 44
kiss, *see* apostolic embrace
kiss of peace *(pax)*, 61–63, *see also* apostolic embrace
Klenia (near Corinth), St. Nicholas, 20 n. 30
Komnenian style, 80
Komnenoi (ruling family), 37, 45, 45 n. 45, 45 n. 48
Komotini (Thrace), Archaeological Museum, 53
Kornoutos of Ikonion, bishop, 18 n. 19
Koropi (Attika), church of the Metamorphosis, 18 n. 18
Kosmas, saint, *see* Anargyroi
Koteine (near Philadelphia), Mother of God, 29
Kourkouas, John, general, 69
Koutsovendis, St. John Chrysostom, *see* Cyprus
Kucharek, Casimir, 66
Kurbinovo, St. George, 23, 25, 26, 27, 31, 31 n. 105, 33, 33
 n. 114, 37, 38, 40, 41, 89, 91–92, 93, 94, 95, 104
Kyriake, saint, 12 n. 41
Kyros, *anargyros,* 82

laity
 communion of, 56, 57, 58, 59, 65
 devotional practices, 10–14, 17, 18, 22, 35, 47, 66, 71,
 72, 79

 place in church, 8, 35
 prohibited entrance into sanctuary, 2, 6, 11, 12, 35, 78
 viewing the mysteries, 7, 8, 11, 56, 66, 76
Lakonia, 19, *see also* Geraki, Chrysapha, Mani, Mystra,
 Vasilaki, Vassaras, Vrontamas
Last Judgment, 38, 38 n. 7, 82
Last Supper, 49, 50, 52, 53, 56, 58, 64, 65, 99, 101, 102
Latins
 artistic influence of, 64–65
 compared to Armenians, 58
 compared to heretics, 58
 compared to Jews, 58, 59
 grievances against, 8, 12 n. 44, 47, 58, 59, 63
 interaction with, 65
Laurentios, saint, 104
Lectionary of Catherine Komnene, 14
Lent, 46, 73, 78
Leo of Chalcedon, prelate, 70
Leo of Ohrid, archbishop and polemicist, 58, 59, 63, 83
Leo Tuscus, translator, 57
Lesnovo (Macedonia), Church of the Archangels, 57
liturgical (mystagogical) commentary, 2, 5, 41, 73, 76
 Germanos, patriarch of Constantinople, 6, 25, 28, 38,
 42, 51, 70, 74, 76
 Maximus the Confessor, 5, 109 n. 75
 Nicholas Cabasilas, 33, 34, 41, 46
 Nicholas of Andida, 8, 46, 52, 66
 Sophronios, patriarch of Jerusalem, 5, 81 n. 8, 87 n. 22
 Symeon, archbishop of Thessalonike, 5, 21, 25, 26, 28,
 29, 53, 56, 76
liturgical scrolls, 13, 14, 21, 29–32, 33, 42, 45, 71
liturgical spoon, 56, 57, 78
liturgical vessels, *see* vessels
liturgical vestments, *see* vestments
liturgy
 First Prayer of the Faithful, 39 n. 14, 85
 First (Little) Entrance, 1
 Great (Second) Entrance, 1, 42, 73, 74
 instructions for celebrant *(diataxis),* 2, 21, 29, 30
 patriarchal, 30, 31, 35, 55, 61
 Prayer of the Catechumens, 40 n. 17
 Presanctified, 24, 30
 Second Prayer of the Faithful, 85
 of Basil, 13, 29, 30, 33, 84, 85
 of James, 30
 of John Chrysostom, 29, 30, 33, 57, 85
 of the Faithful, 34
Loerke, William, 49 n. 4
London, British Library
 Add. MS 19352 (Theodore Psalter), 49 n. 3
 Add. MS 34060 *(diataxis),* 30, 61, 62
Luke, evangelist, 50, 60, 96

Macedonia, region, 3, 40, 43
Manastir, St. Nicholas, 31 n. 105, 43, 55 n. 39, 60, 97–99
Mandylion, 68–77, 91, 102, 103, 106, 107, 109
Mango, Cyril, 16

Mani, 18
 Archangel Michael, Polemitas, 13 n. 49
 Episkopi, 19
 Hagios Strategos, Upper Boularioi, 19, 41 n. 24
 St. John, Kaphione, 43 n. 37
 St. John the Baptist, Megale Kastania, 70 n. 14
 St. Kyriake, Marathos, 13
 St. Nicholas in Platsa, 13 n. 49, 70 n. 14
 St. Niketas, Karavas, 20 n. 29
 St. Panteleimon, Upper Boularioi, 12 n. 41, 18, 19
 St. Peter, Gardenitsa, 20 n. 29
 St. Theodore near Tsopaka, 20 n. 29
Manuel I Komnenos, 45 n. 48
Mark, evangelist, 50
Markopoulou (Attika), Taxiarchs church, 33 n. 117
martyrs, 2, 3, 16, 32
Mary of Egypt, saint, *see* communion
Matthias, apostle, 50
Maximos the Confessor, *see* liturgical commentary
Mega Spelaion (Kalavryta), monastery, 32
Megaw, Arthur H. S., 50
melismos, 38, 40–48, 59, 71, 72, 74, 75, 77, 95, 96, 99, 100, 101, 105, 106, 108, 110, 111
Melnik (Bulgaria), St. Nicholas, 26, 96–97
Merenta (Attika), Panagia, 51
Merkourios, saint, 22
Messenia, Zoodochos Pege (Samari), 19, 57, 76
metadosis (the distribution), 49, 52
metalepsis (the partaking), 49, 52
Meteora, monasteries, 32
Metrophanes, saint, 23, 106
metropolitan churches, 18, 80, 86, 92, 94
Michael I Keroularios, patriarch, 28 n. 90, 47, 63
Michael VIII Palaiologos, 58, 93, 98
Michael (Astrapas) and Eutychios, *see* painters
Michael Doukas Glavas Tarchaneiotes, 20, 103, 103 n. 61
Michael (Rhetor) of Thessalonike, 44
Michael the Confessor, saint, 12
Michael the Syrian, 69
midnight office, *see* hours, liturgical
Milan, Biblioteca Ambrosiana, cod. 49–50 (Homilies of Gregory of Nazianzos), 21
Mileševa (Serbia), church, 26
Miljković-Pepek, Petar, 60, 97
Modestos, saint, 20, 24
monks and monastic practices, 2, 6, 8, 17, 29, 35, 61, 80
Monreale (Sicily), Cathedral, 65
Moscow, State Historical Museum (Gosudarstvennij Istoričeskij Muzej)
 gr. 129 (Chludov Psalter), 49 n. 3
 gr. 382 (menologion), 70 n. 10
Moses, prophet, 58, 104
Mount Athos, 30, 32, 50
 Dionysiou monastery, cod. 110 (liturgical scroll), 31 n. 109
 Esphigmenou monastery, cod. 34 (euchologion), 24
 Great Lavra, 30 n. 99

 Great Lavra, cod. 44 (liturgical scroll), 31 n. 109
 Great Lavra, cod. 45 (liturgical scroll), 31 n. 109
 Iviron monastery, cod. 4131 (liturgical scroll), 31 n. 109
 Iviron monastery, cod. 4133 (liturgical scroll), 31 n. 109
 Pantokrator monastery, cod. 61 (psalter), 49 n. 3
 Pantokrator monastery, cod. 64 (liturgical scroll), 31 n. 109
 Protaton church, 23, 23 n. 47, 27, 28, 50 n. 12, 51, 55 n. 42, 101–2, 106
 Vatopedi monastery, 30 n. 99, 60
 Vatopedi monastery, cod. 10 (liturgical scroll), 31 n. 109
 Vatopedi monastery, cod. 13 (liturgical scroll), 31 n. 109
 Vatopedi monastery, cod. 14 (liturgical scroll), 31 n. 109
 Vatopedi monastery, cod. 15 (liturgical scroll), 31 n. 109
 Vatopedi monastery, cod. 20 (liturgical scroll), 13
Mount Auxentios, 12
Mount Sinai, 32
Mouriki, Doula, 20
Myra, St. Nicholas, 49
Mystra (Mistra)
 Virgin Hodegetria, 29
 Virgin Peribleptos, 84 n. 16

name saints, 12, 13
narthex
 decoration of, 17, 27, 82, 88, 90
 inscriptions in, 12, 88, 89
 symbolic interpretation of, 5, 6
Nativity, 92, 109
nave
 decoration of, 2
 inscriptions in, 12
 symbolic interpretation of, 5, 6
Naxos, 43
 Nativity, near Sagri, 49
 Panagia at Yallou, 13, 20 n. 30
 Panagia Protothrone, Chalke, 6, 16
 St. Constantine Vourvourias, 20 n. 30
 St. George (south church), Apeiranthos, 43 n. 37
 St. George Diasoritis, 37 n. 2
 St. George, Distomo, 13 n. 49
 St. George near Sagri, 33 n. 117
Nerezi, St. Panteleimon, 6, 7, 22, 25, 31 n. 105, 37, 38, 39, 45, 45 n. 48, 52, 60, 61, 80, 85, 86–87, 97, 99
New Law, 22, 102
New York, Pierpont Morgan Library, cod. M. 499 (Abgar scroll), 70 n. 10
Nicaea, church of the Koimesis, 39 n. 11
Nicholas, saint, representation of, 10, 11, 16, 17, 18, 20, 22, 22 n. 44, 24, 27, 28, 31, 33, 37 n. 2, 40, 84, 87, 90, 92, 95, 99, 100, 101, 102, 104, 106, 111
Nicholas III Grammatikos, patriarch, 44
Nicholas of Andida, *see* liturgical commentary
Nikephoros Kasnitzes, 71
Niketas, bishop of Veroia, 94
Niketas, marble worker from Maina, 13 n. 50

Niphon, bishop of Konstantiane, 42

Niphon, patriarch, 111

Octoechos, 92

Ohrid, 23, 50, 83

 Hagia Sophia, 18, 31, 49 n. 9, 51, 52, 53, 58, 59, 63, 80, 83–84, 86

 St. John the Theologian (Kaneo), 25, 31 n. 105, 43, 50 n. 12, 52, 55 n. 39, 55 n. 42, 60 n. 69, 97, 99–100, 101

 Virgin Peribleptos (St. Clement), 6, 12, 26, 28, 31 n. 105, 37, 50 n. 12, 52, 53, 55, 55 n. 39, 55 n. 42, 100–101

Oikoumenios, saint, 24, 93

Old Law, 22, 25, 102

Old Testament, 84

omophorion, see vestments

Oropos (Attika), St. George, 19 n. 24

Pachomios, abbot, 29

paganism, 44

painters, 15, 50

 John, 80, 98

 Kallierges, 80, 105

 Michael (Astrapas) and Eutychios, 12, 50, 80, 101

 Panselinos, 80, 101

painting techniques, 27, 91, 110

Panagia tou Moutoullas, *see* Cyprus

Panselinos, *see* painters

Panteleimon, saint, 7, 10, 87

Panteugenos, Soterichos, theologian, 44

Paphos, St. Neophytos, *see* Cyprus

paradise, 5, 6

Paris, Bibliothèque Nationale

 gr. 20 (psalter), 49 n. 3

 gr. 74 (Gospels), 38 n. 7, 49 n. 3

 gr. 510 (Homilies of Gregory of Nazianzos), 18

 gr. 1528 (menologion), 70 n. 10

 Suppl. gr. 1276, 57 n. 49

parish churches, 2, 35, 48, 71

Passion, instruments of, 38, 39

Passover, 51, 58

pastiglio, 109

paten, *see* vessels

Patmos, Monastery of St. John the Theologian, 32, 51

 cod. 707 (liturgical scroll), 14, 30

 cod. 719 *(diataxis),* 9, 24

Paul, apostle and saint, 48, 49, 50, 55, 60, 86, 95, 98

Paul of Latros, saint, 70

Paul the Silentiary, 52

Peloponnesos, 43, *see also* Lakonia, Messenia

penance *(metanoia),* 9, 59

Pentecost, 104

Penteli Cave (Attika), south church, 33 n. 117

Peter, apostle and saint, 48, 49, 50, 51, 55, 57, 60, 86, 95, 96, 98, 99, 101, 102, 104, 110

Peter of Antioch, 28 n. 90

phelonion, see vestments

Philotheos Kokkinos, patriarch of Constantinople, *see diataxis*

Phokis, Hosios Loukas, 16, 17

Photios, patriarch of Constantinople, 17, 32

polemical literature, 2, 8, 47, 58, 59, 63, 83

Polychronia, saint, 37 n. 2

Polykarp, saint, 20, 23, 24, 28, 94, 99, 106, 108

polystavrion, see vestments

Pontius Pilate, 8, 76

Prespa

 Panagia Eleousa, 31 n. 107

 St. Achilleios, 6, 18, 25, 81

priest

 actions of, 1, 9, 25, 26, 29, 30, 32, 33, 34, 35, 41, 47, 55, 61

 and sanctuary decoration, 15, 28, 32, 33, 40, 55, 56, 57, 62, 72

 and vigil over the deceased, 20, 21

 entrance into sanctuary, 1, 25, 57, 72

 instructions for celebration, *see diataxis*

 place of, 6, 8, 32

 vesting of, *see* vestments

Prilep

 St. Michael the Archangel, 80, 88

 St. Nicholas, 31 n. 105, 88 n. 23

processions, liturgical, 1, 56, 73

Proclus of Constantinople, 75 n. 33

property, donation of, 13

prophets, 22, 103

proskomide, 83, 84

proskynesis, 7, 55, 94

proskynetaria icons, *see* icons

proskynetarion, 11

prothesis

 chamber, 42, 54, 74, 84, 92, 111

 niche, 49, 70, 92, 106, 111

Prothesis

 prayer, 33, 40 n. 16, 42, 85 n. 18, 106

 rite, 24

psalter, 49, 49 n. 3

Pyli (Thessaly), Porta Panagia, 19, 20

Pyrgi (Euboia)

 Church of the Transfiguration, 12

 St. Nicholas, 49 n. 8

regional patterns, 10, 19, 20, 23, 43, 50, 104

rhipidion (liturgical fan), 38, 39, 40, 41, 43, 56, 73, 83, 87, 95, 99, 100, 101, 108, 110

Riha Paten, 49, 55

Romanos, saint, 104

Romanos I Lekapenos, emperor, 69

Rome, Biblioteca Apostolica Vaticana
 Barb. gr. 372 (Barberini Psalter), 49 n. 3
 gr. 752 (psalter), 56 n. 45
 gr. 1613 (Menologion of Basil II), 18
 Ross. 251 (Heavenly Ladder of John Klimakos), 70 n. 10
Rossano, Cathedral Treasury, Gospels, 48 n. 2
Rule of St. Sabas, 35

sacrifice
 bloodless, 39, 72, 73, 74
 of Abraham, 84, 84 n. 16
St. Neophytos (near Paphos), *see* Cyprus
saints
 female, 12
 intercessory role of, 2, 10, 11, 18, 35, 78
 movement of, 1, 16, 37
 portraits of, 7, 13
sakkos, see vestments
sanctuary
 admission into, 6, 11, 12, 14
 representation of, 30
 seeking refuge in, 12
 symbolism of, 5, 6
 window, 37, 39, 40, 43, 75, 87, 97, 101, 105, 110
screen, sanctuary *(templon)*, 1, 9, 71, 72
 attachment of, 11
 chancel barrier, 6, 7, 51, 52, 83
 epistyle, 6, 7
 icons and, 8, 9
 masonry, 10, 57
 reverse side, 10
Serbia, *see* Arilje, Gračanica, Mileševa, Sopoćani, Studenica
Serres, Sts. Theodoroi (Old Metropolis), 49, 80, 86
Servia, Metropolis (St. Demetrios), 23, 25, 80, 92
silentiarios, 21
Silvester (Pope), saint, 23, 28, 106, 106 n. 71, 108, 109
Simon, apostle, 60, 95
skeuophylakion, 73, 74
Skopje, 45 n. 48
Soğanli (Cappadocia)
 Karabaş kilise, 49 n. 9
 St. Barbara, 18 n. 19
solea, 51
Solomon, Old Testament king, 102, 106
Sophronios, patriarch of Jerusalem, *see* liturgical commentary
Sopoćani (Serbia), Church of the Trinity, 33 n. 116
sponge, 38, 73
Spyridon, saint, 24, 86, 106, 108
Staro Nagoričino (Macedonia), St. George, 50 n. 12, 55 n. 42
Stephen Sabaites, saint, 81 n. 8
Stephen the Protomartyr, saint, 90, 92, 106
Stephen the Younger, saint, 12
Stethatos, Niketas, monk, 8, 9, 58
sticharion, see vestments

Stilbes, Constantine, metropolitan of Kyzikos, 12 n. 44, 58, 63
Studenica (Serbia)
 Church of the Kral, 50 n. 12
 Church of the Virgin, 33 n. 117
Stuma Paten, 48 n. 2, 55
stylite saints, 94
Svećani (Macedonia), St. Constantine, 55 n. 39, 60, 97, 99
Symeon, archbishop of Thessalonike, *see* liturgical commentary

Taft, Robert, 62
Tanghil (Georgia), Holy Archangels, 75 n. 29
templon, see screen, sanctuary
textiles, liturgical, 9, 71, 75–76
 aer, 8, 76
 altar cloth, 9, 12, 39, 41, 43, 50, 90, 97, 99
 eiliton, 62
Thaddeus, apostle, 50
Thallelaeos, *anargyros,* 82
Thebes, St. Gregory the Theologian, 5
Theodore Komnenos Doukas, ruler of Epiros, 94
Theodore (Manganeios) Prodromos, poet, 75 n. 33
Theodore of Mopsuestia, bishop, 73
Thessalonike, 23, 26, 50, 58
 Acheiropoietos Church, 109
 epitaphios, 76
 Holy Apostles, 31 n. 105, 33 n. 115, 80, 110–11
 Panagia ton Chalkeon, 6, 18, 28, 49 n. 9, 67, 80–82, 83, 84, 104
 St. Catherine, 27, 28, 31 n. 105, 33 n. 115, 50, 50 n. 12, 110
 St. Demetrios, 10, 11, 103
 St. Euthymios, 28, 30, 52, 53, 55, 70 n. 14, 72 n. 19, 102–5
 St. Nicholas Orphanos, 11, 15, 23 n. 47, 26, 27, 31 n. 105, 33 n. 115, 43, 43 n. 34, 49 n. 8, 50 n. 12, 52, 53, 72, 109–10
 St. Panteleimon, 27
Thessaly, 105
Thierry, Nicole, 70
Three Hebrew Children in Furnace, 84, 84 n. 16
Three Hierarchs, feast of, 24 n. 53
throne, 38, 38 n. 5, 40, 73, 89, 93, 104, 106
thyomenos, 43
Tiflis, Sion, no. 484 (Gospels), 70 n. 10
Titos, saint, 18
Torcello, Sta. Maria Assunta, 38 n. 7
Transfiguration, 3
Trinity, 27, 38, 45, 89
Trisagion, 30, 31, 33, 34
troparia, penitential, 9
Trullo, council in, 6
Turin, Biblioteca Nazionale e Universitaria, cod. C.1.6.199 (Homilies of Gregory of Nazianzos), 42 n. 31.

Vasilaki (Lakonia), St. John the Baptist, 20

Vassaras (Lakonia), St. John the Baptist, 20 n. 29

Vassilakes, Nikephoros, 44

Veljusa (near Stroumitsa), Panagia Eleousa, 12 n. 39, 22, 26, 37, 38, 39, 45 n. 48, 84–85, 87, 98 n. 48

Velmans, Tania, 74

Veroia, 80

 Christos (church of the Anastasis of Christ), 23, 23 n. 47, 26, 27, 28, 31 n. 105, 33 n. 115, 68, 70 n. 14, 105–7, 108

 Old Metropolis (Sts. Peter and Paul), 28, 31 n. 105, 94–95

 St. Blasios, 23 n. 47, 23 n. 51, 25, 27, 28, 31 n. 105, 33, 43 n. 34, 106, 107–8

 St. John the Theologian, 31 n. 105, 48, 49 n. 8, 53, 55, 60, 95–96, 97, 105, 107

 St. Paraskeve, 23 n. 51, 25, 108–9

vessels, 39, 40, 50, 52–54

 amphora, 53, 97

 chalice, 37, 39, 41, 42, 46, 49, 52, 53, 53 n. 28, 55, 56, 57, 61, 90, 99

 cup, 48, 50, 52

 Early Christian, 52

 goblet, 53

 krater, 53

 paten, 37, 39, 40, 41, 42, 43, 44, 48, 52, 53, 87, 90, 99, 100

 stamnos, 53

vestments, 17, 25–29, 35

 belt, 25, 28

 decoration of, 26, 27, 28, 29, 90

 encheirion, 28

 epigonation, 25, 28, 29

 epimanikia (cuffs), 25, 28, 29

 epitrachelion (stole), 25, 28, 29

 omophorion (pallium), 18, 25, 26, 27, 90, 92

 phelonion (chasuble), 21, 25, 26, 27, 28, 61, 82, 92, 93, 95, 108, 109

 polystavrion, 25, 26, 27, 28, 30, 87, 90, 92, 95, 99, 104, 106, 107, 111

 prayers associated with, 25

 rituals associated with, 25

 sakkos (dalmatic), 25, 56

 sticharion (alb), 25

 symbolic associations of, 25

Virgin, 11

 Hodegetria, 10, 85, 89, 104

 Life of, 92, 104

 Orant, 11, 37 n. 2, 71, 81, 91, 96, 98, 101, 107, 109

 Paraklesis, 10, 11, 22

 addressed in inscriptions, 6, 100

 and Child, 13, 83

 enthroned, 86, 89, 93, 96

Vizyenos, Georgios, 1

Vocotopoulos, Panagiotes, 17

Vodena (Edessa), Virgin Gavaliotissa, 29

Vodoča (near Stroumitsa), St. Leontios, 26, 85–86

Vrontamas (Lakonia), Palaiomonastero, 41 n. 24

Walter, Christopher, 24, 32

Washington, D.C., Dumbarton Oaks Collection, acc. no. 79.31 (lectionary fragment), 14

water, 14, 41

Weitzmann, Kurt, 70

Wessel, Klaus, 65

Western medieval art, 64, 54, 72

women, Byzantine

 prohibited entrance into sanctuary, 2, 11, 12, 12 n. 44

 seek refuge in sanctuary, 12

workshops, 23 n. 51

Xyngopoulos, Andreas, 92, 93, 96

zeon, 41

Zosimas, abbot, *see* communion

PHOTOGRAPH CREDITS

Illustrations

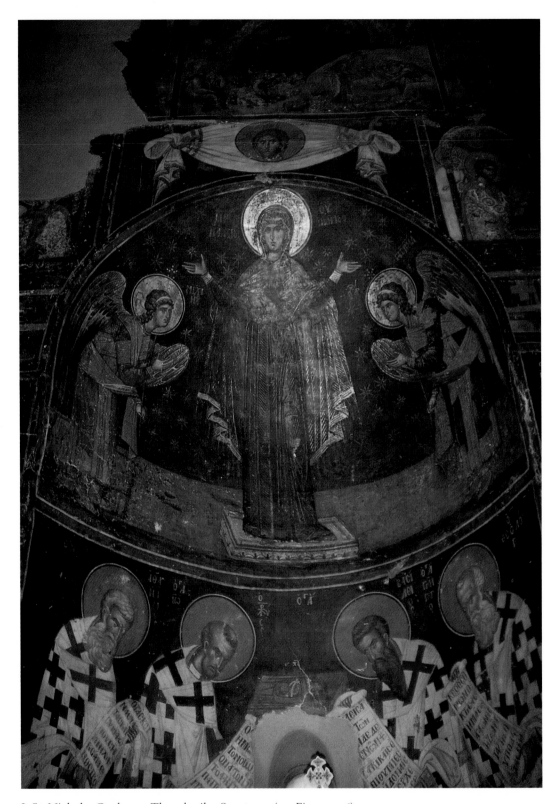

I St. Nicholas Orphanos, Thessalonike, Sanctuary (see Figs. 53, 56)

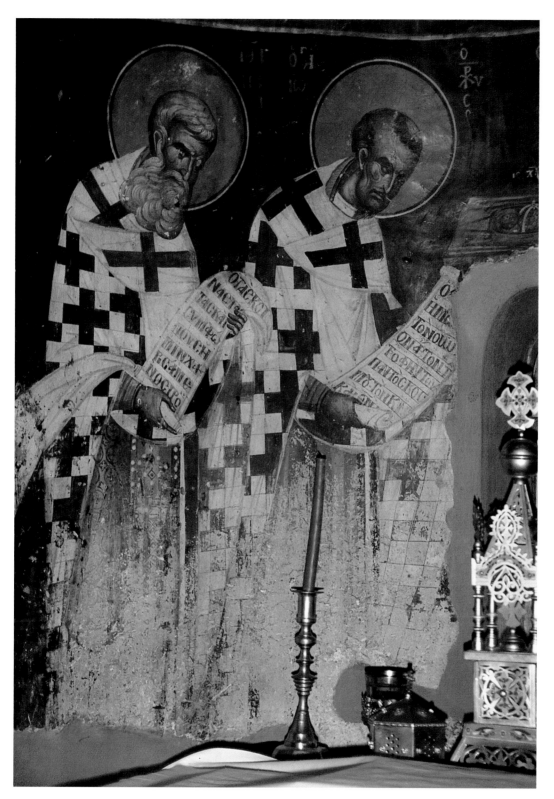

II St. Nicholas Orphanos, Thessalonike, Sts. Athanasios and John Chrysostom (see Fig. 56)

III St. George, Kurbinovo, Christ as the sacrifice (see Fig. 26)

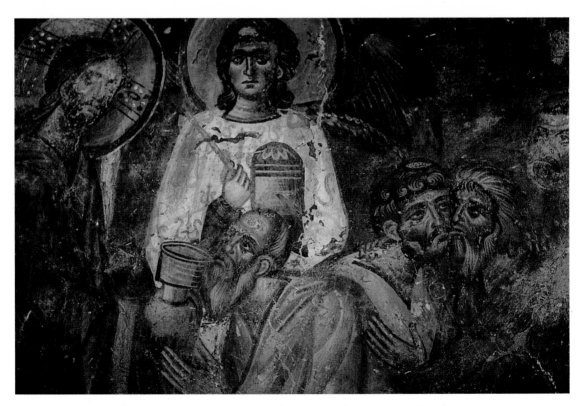

IV St. John the Theologian, Veroia, Communion of the Apostles (see Figs. 31, 32)

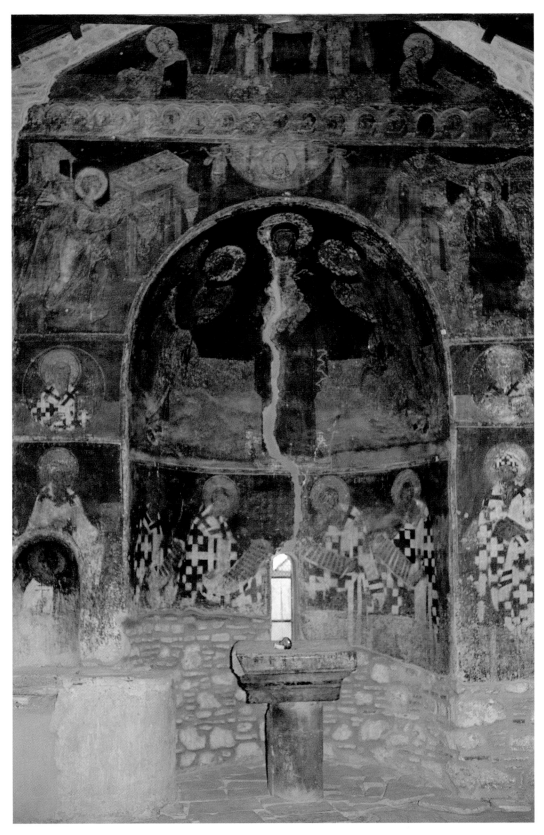

V Christos, Veroia, Sanctuary (see Fig. 49)

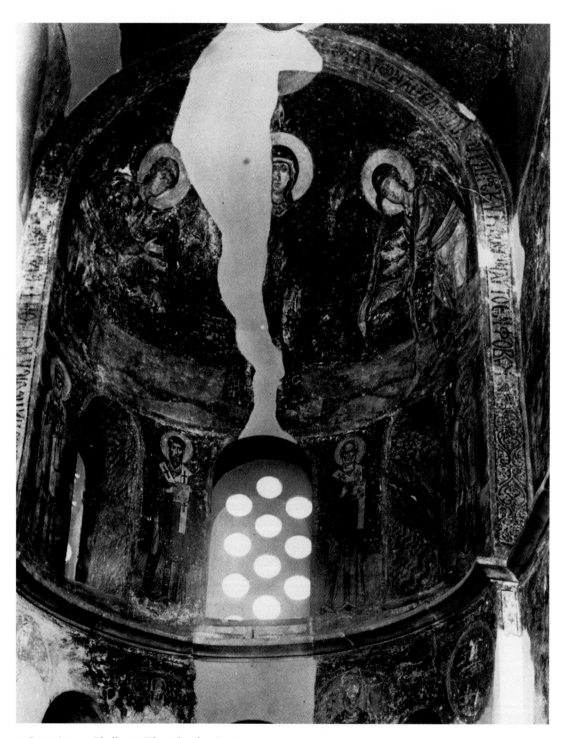

1 Panagia ton Chalkeon, Thessalonike, Sanctuary

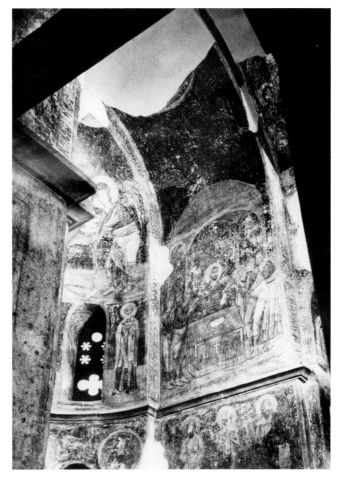

2 Panagia ton Chalkeon, Thessalonike, St. Gregory of Nyssa

3 Panagia ton Chalkeon, Thessalonike, South wall of sanctuary

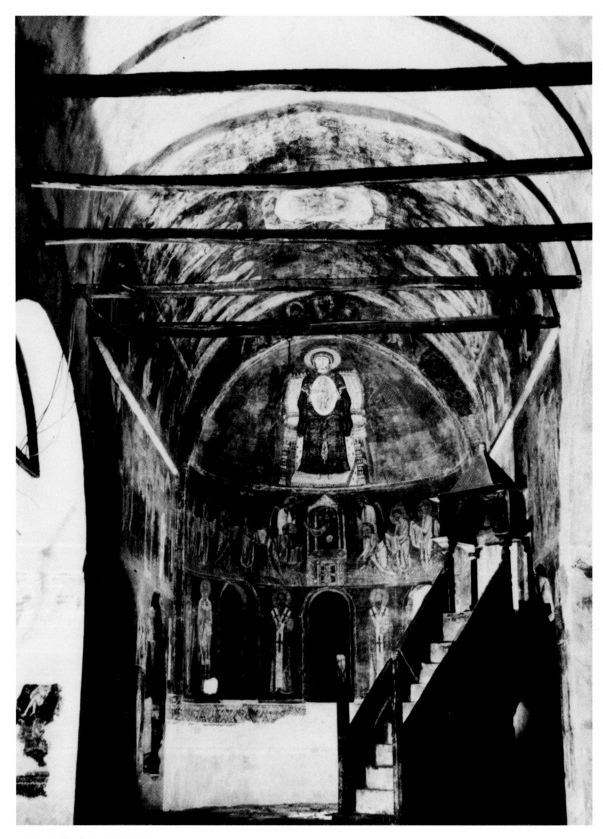

4 Hagia Sophia, Ohrid, Sanctuary

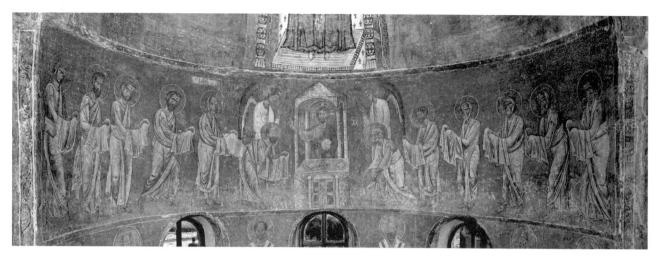

5 Hagia Sophia, Ohrid, Communion of the Apostles

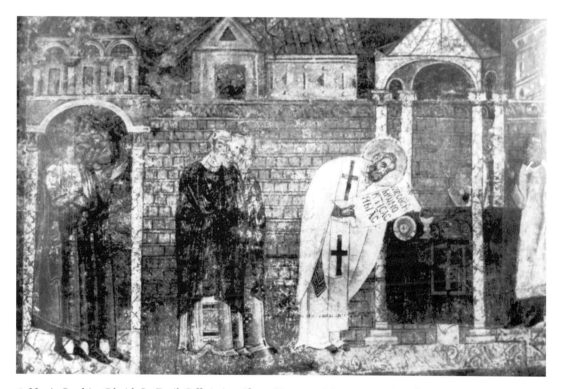

6 Hagia Sophia, Ohrid, St. Basil Officiating (from Hamann-Mac Lean and Hallensleben, *Die Monumentmalerei*, 1: fig. 25)

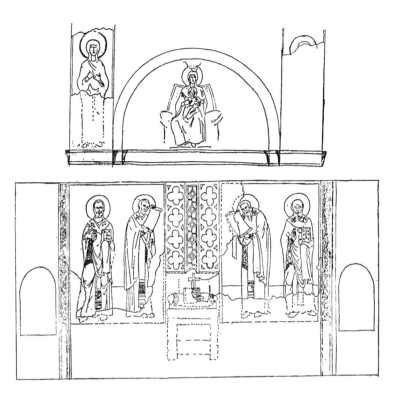

7 Panagia Eleousa, Veljusa, Drawing of sanctuary decoration (from Miljković-Pepek, *Veljusa*, fig. 1)

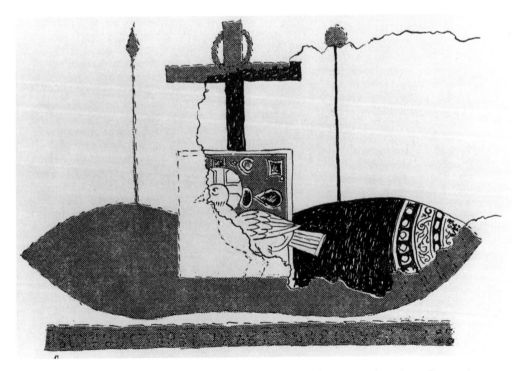

8 Panagia Eleousa, Veljusa, Drawing of *hetoimasia* (from Miljković-Pepek, *Veljusa*, fig. 26.1)

9 Panagia Eleousa, Veljusa, St. John Chrysostom (from Miljković-Pepek, *Veljusa*, fig. 45)

10 St. Leontios, Vodoča, St. Basil (from Petar
Miljković-Pepek, *Le complexe des églises de
Vodoča* [Skopje: Republički zavod za zaštita na
spomenicite na kulturata, 1975], pl. XXII)

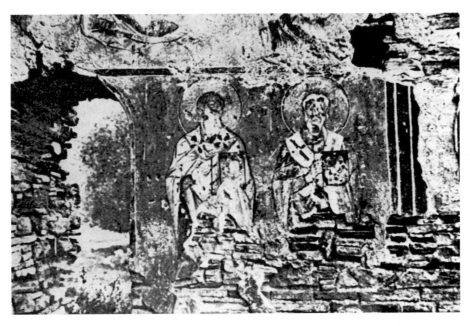

11 St. Leontios, Vodoča, South wall of sanctuary (from Petar Miljković-Pepek, *Le
complexe des églises de Vodoča* [Skopje: Republički zavod za zaštita na spomenicite na
kulturata, 1975], pl. XXII)

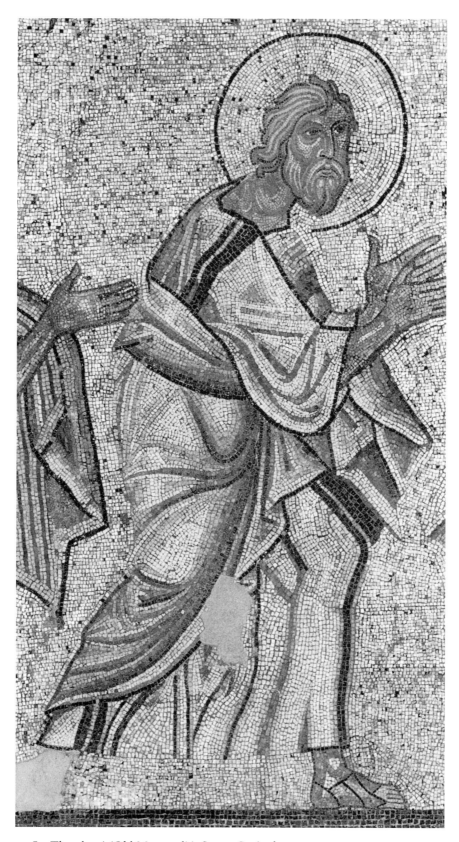

12 Sts. Theodoroi (Old Metropolis), Serres, St. Andrew

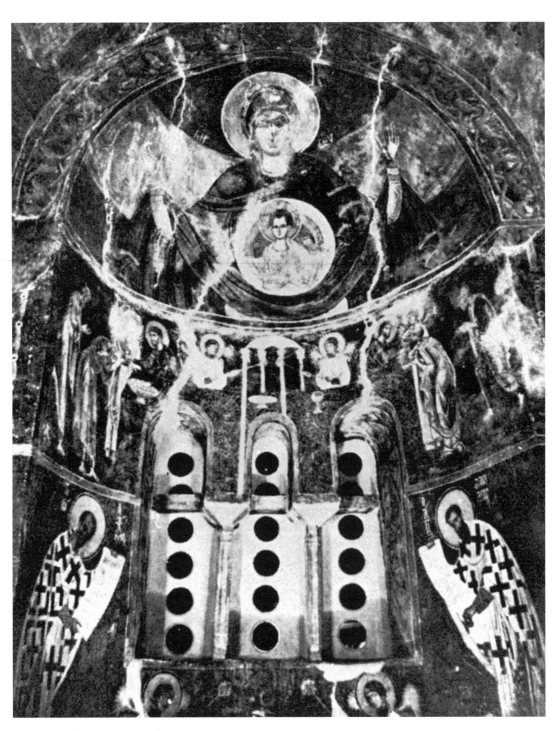

13 St. Panteleimon, Nerezi, Sanctuary

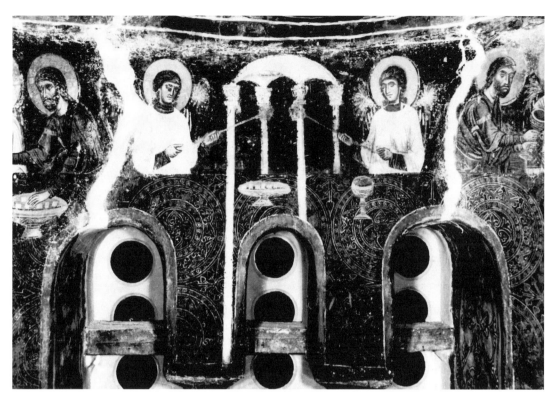

14 St. Panteleimon, Nerezi, Communion of the Apostles

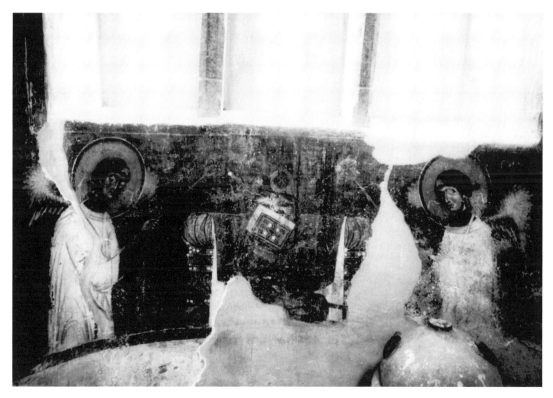

15 St. Panteleimon, Nerezi, *Hetoimasia*

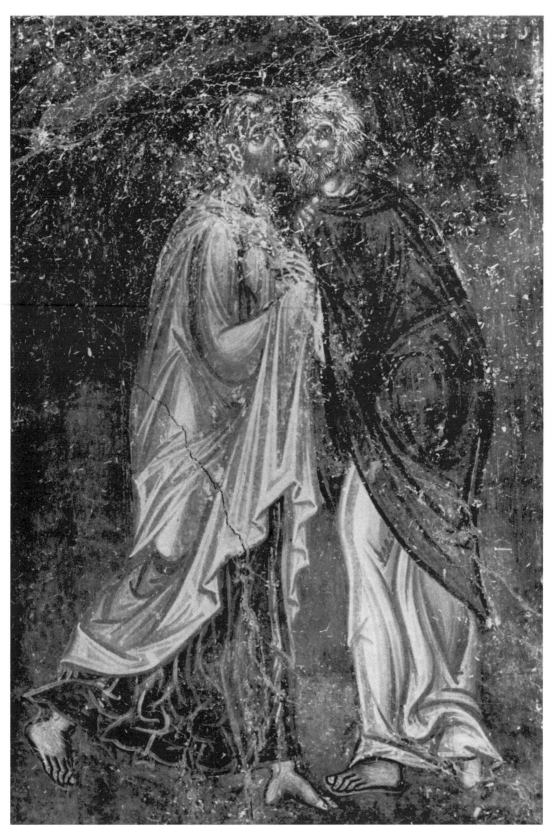

16 St. Panteleimon, Nerezi, Embracing apostles

17 St. Michael the Archangel, Prilep, St. Gregory the Theologian (from Miljković-Pepek, "Contribution," fig. 4)

18 St. Michael the Archangel, Prilep, St. Andrew (from Miljković-Pepek, "Contribution," fig. 2)

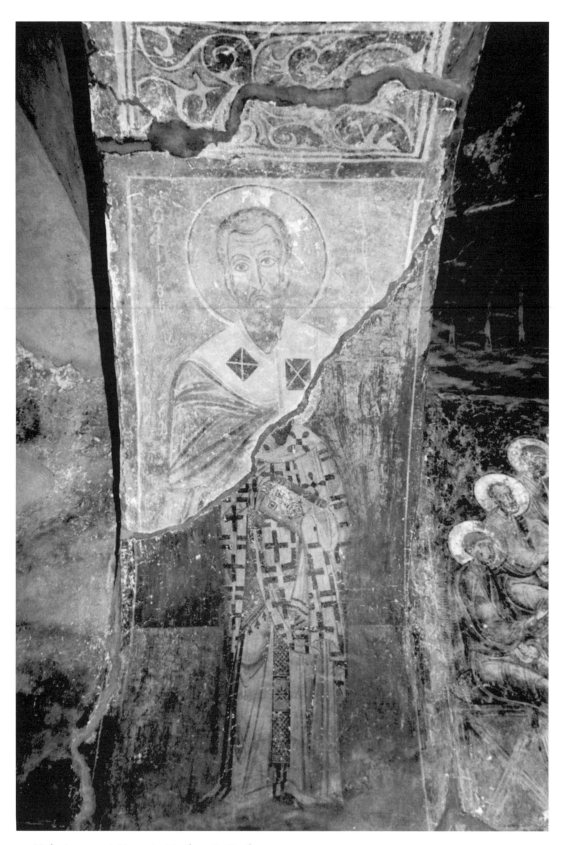

19 Holy Anargyroi, Kastoria, Narthex, St. Basil

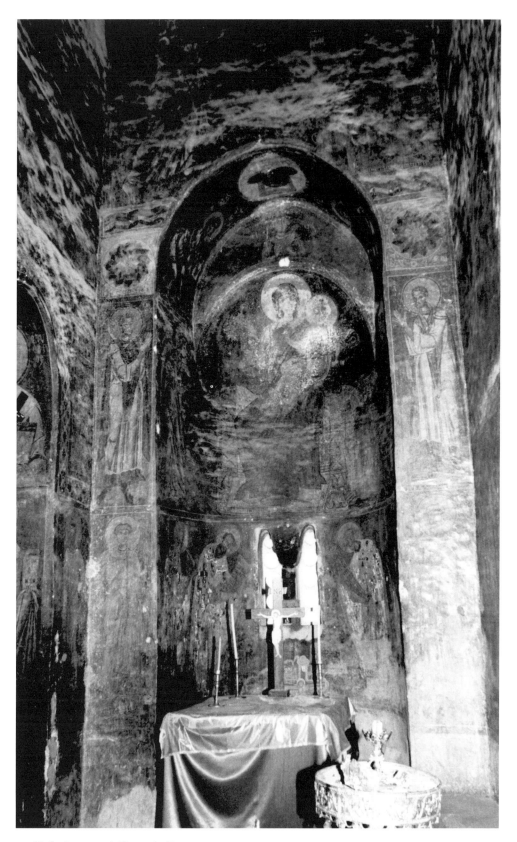

20 Holy Anargyroi, Kastoria, Sanctuary

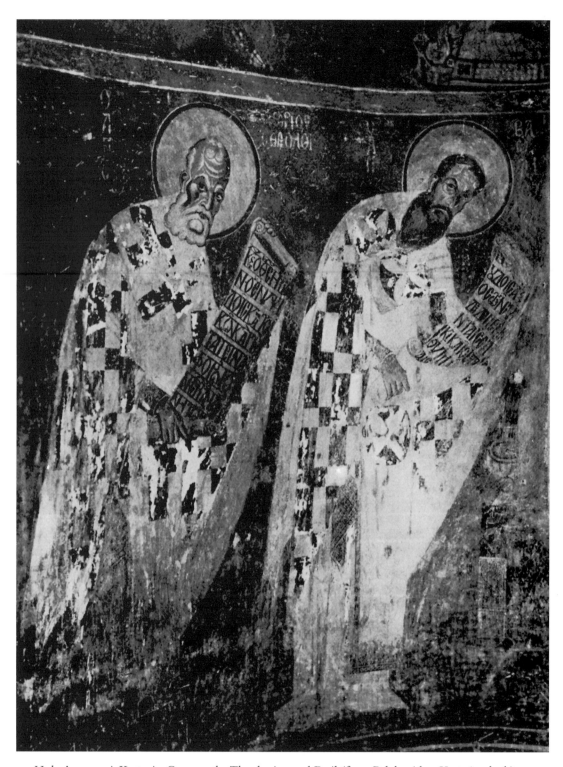

21 Holy Anargyroi, Kastoria, Gregory the Theologian and Basil (from Pelekanides, *Kastoria*, pl. 9b)

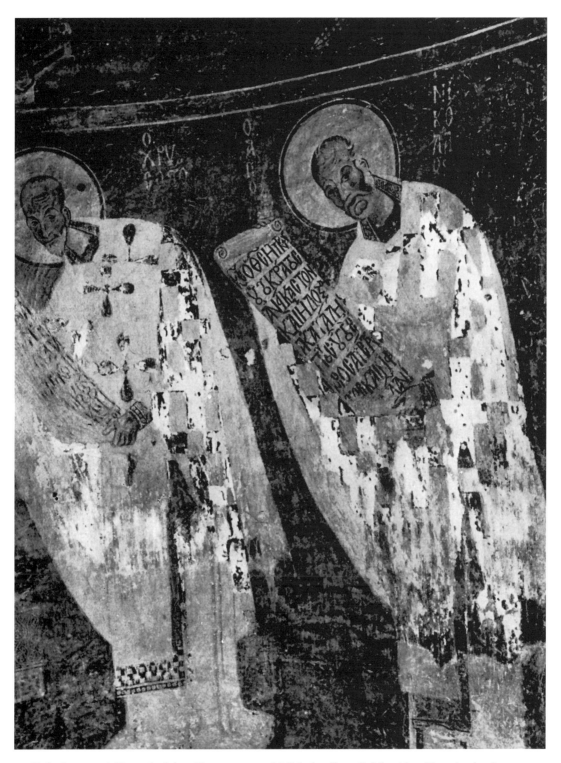

22 Holy Anargyroi, Kastoria, John Chrysostom and Nicholas (from Pelekanides, *Kastoria*, pl. 9a)

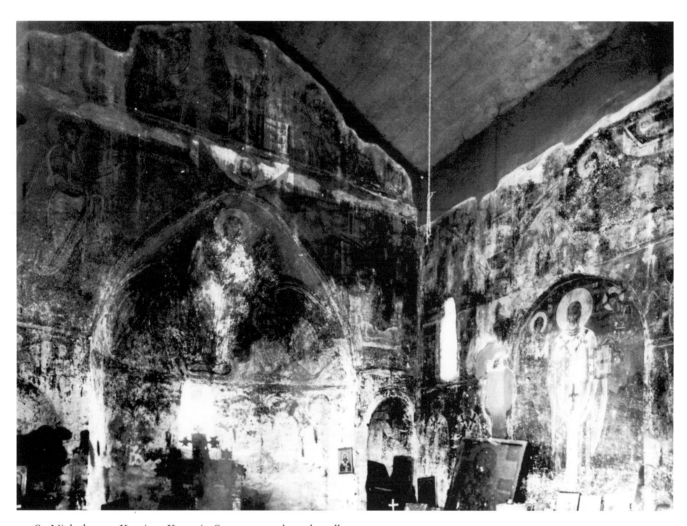

23 St. Nicholas tou Kasnitze, Kastoria, Sanctuary and south wall

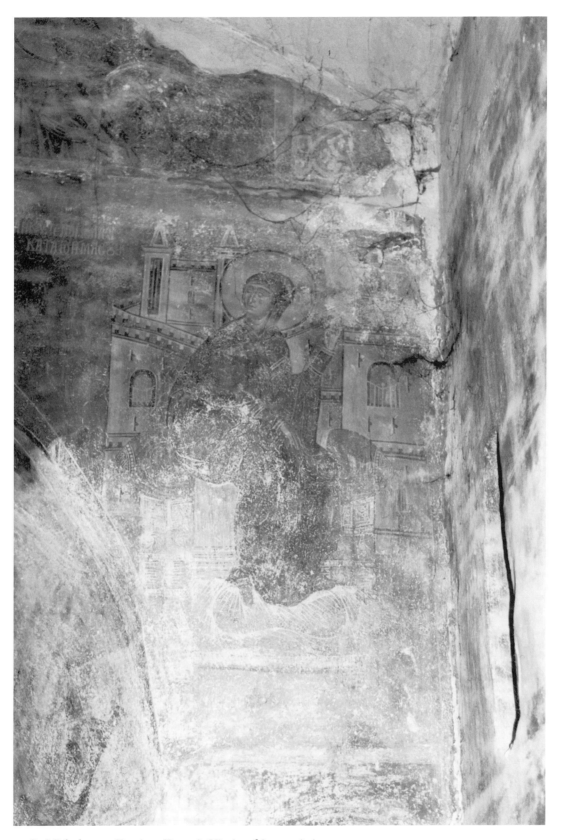

24 St. Nicholas tou Kasnitze, Kastoria, Virgin of Annunciation

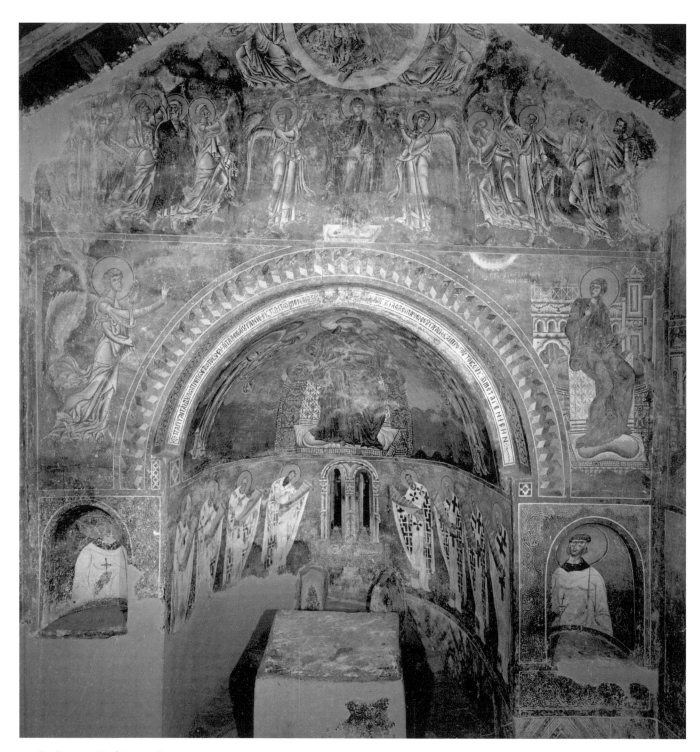

25 St. George, Kurbinovo, Sanctuary

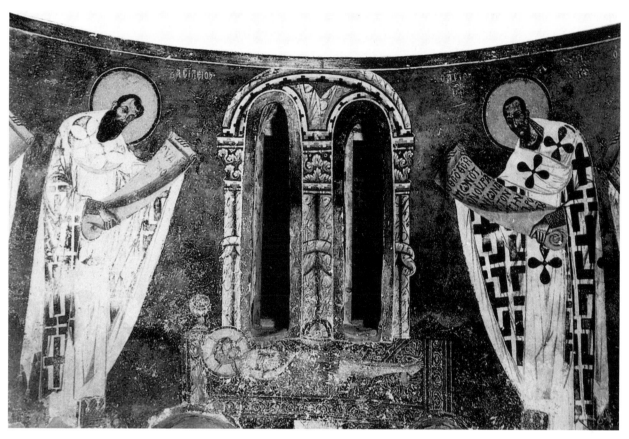

26 St. George, Kurbinovo, Christ as the sacrifice (from Cvetan Grozdanov and Lydie Hadermann-Misguich, *Kurbinovo* [Skopje: Makedonska kniga: Republički zavod za zaštita na spomenicite na kulturata, 1992], pl. 10)

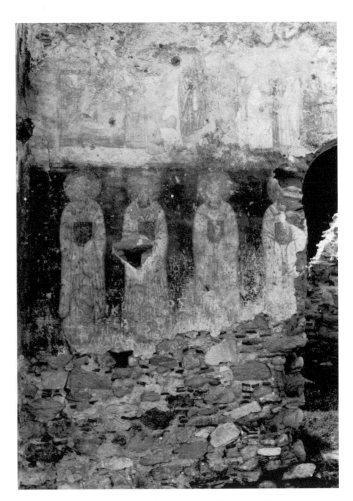

27 Metropolis (St. Demetrios), Servia, Sanctuary and south wall

28 Metropolis (St. Demetrios), Servia, South wall

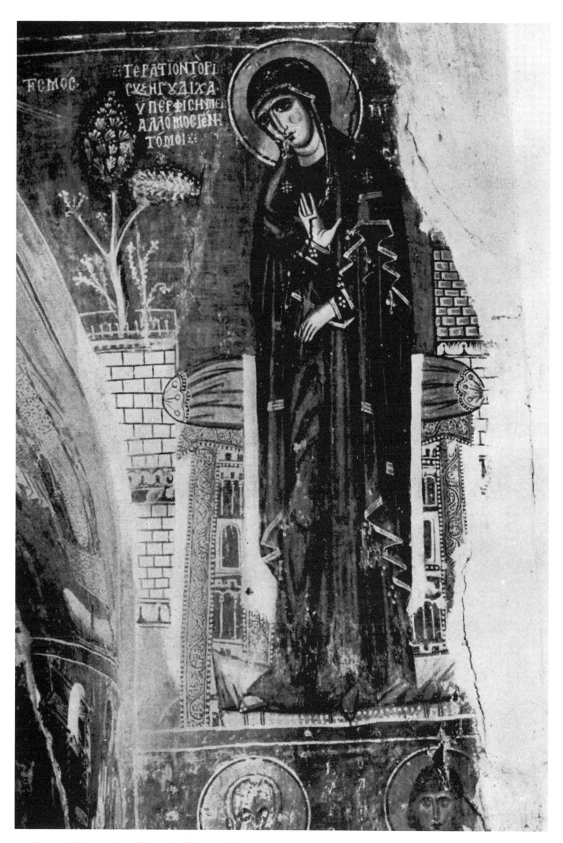

29 Panagia Mavriotissa, Kastoria, Virgin of Annunciation (from Pelekanides, *Kastoria*, pl. 68b)

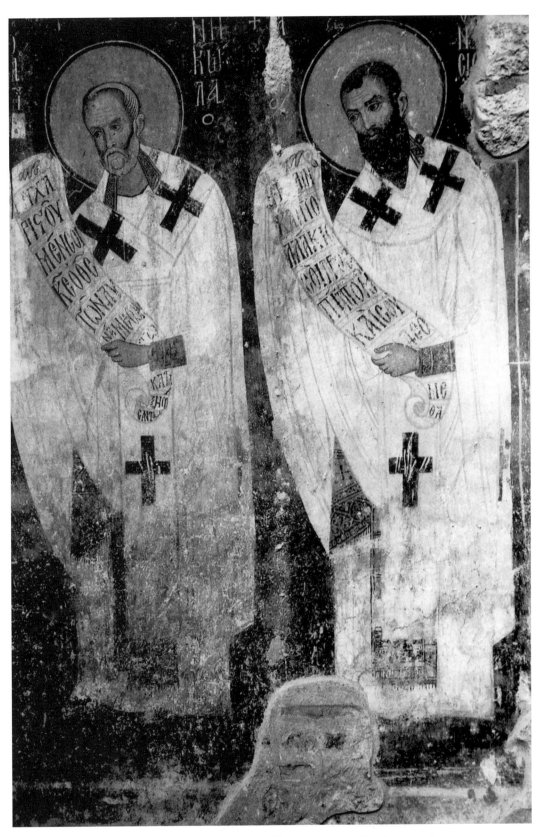

30 Old Metropolis, Veroia, Nicholas and Dionysios (from Papazotos, *He Veroia*, pl. 6)

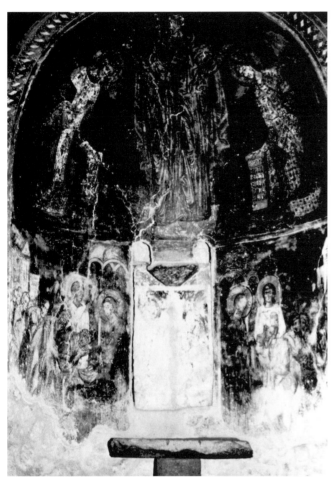

31 St. John the Theologian, Veroia, Sanctuary

32 St. John the Theologian, Veroia, Embracing apostles

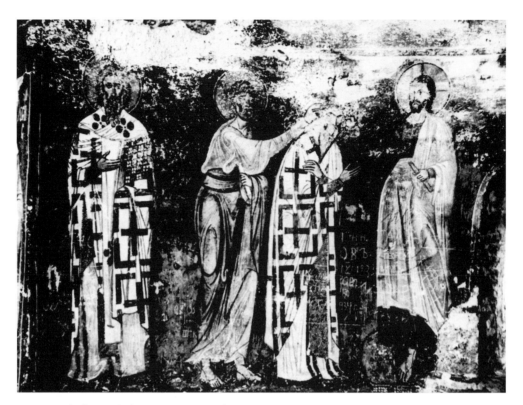

33 St. Nicholas, Melnik, Consecration of St. James

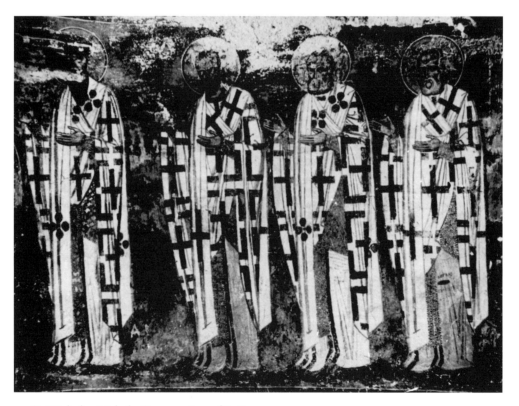

34 St. Nicholas, Melnik, Consecration of St. James

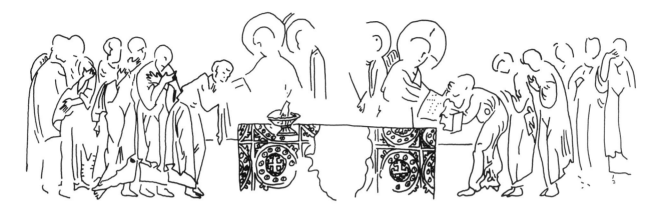

35 St. Constantine, Svećani, Drawing of the Communion of the Apostles (from Miljković-Pepek, "Contribution," fig. 10)

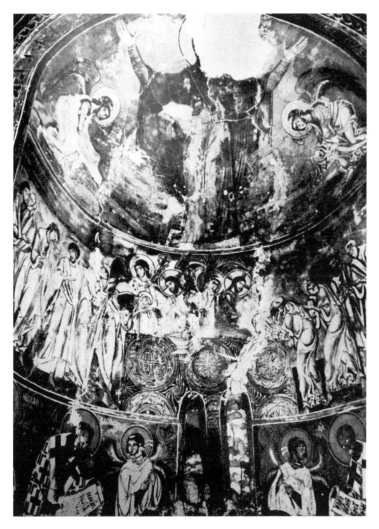

36 St. Nicholas, Manastir (Moriovo), Sanctuary (from Miljković-
Pepek, "Contribution," fig. 12)

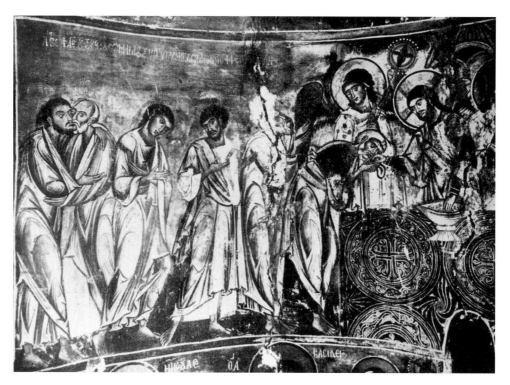

37 St. Nicholas, Manastir (Moriovo), Communion of the bread (from Dimče Koco and Petar Miljković-Pepek, *Manastir* [Skopje: Univerzitetska pečatnica, 1958], pl. 13)

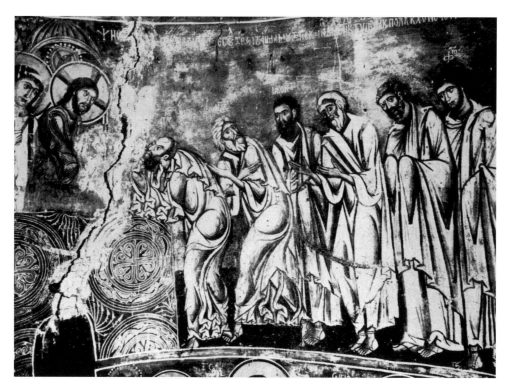

38 St. Nicholas, Manastir (Moriovo), Communion of the wine (from Dimče Koco and Petar Miljković-Pepek, *Manastir* [Skopje: Univerzitetska pečatnica, 1958], pl. 12)

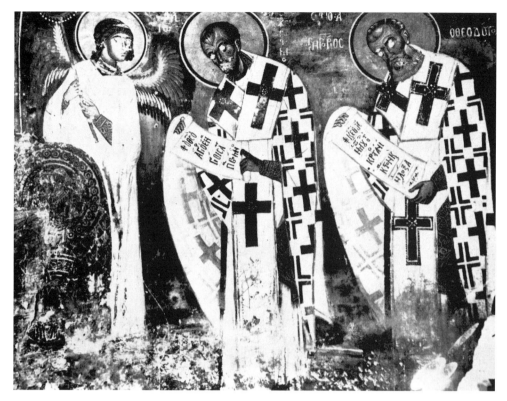

39 St. Nicholas, Manastir (Moriovo), John Chrysostom and Gregory the Theologian (from Dimče Koco and Petar Miljković–Pepek, *Manastir* [Skopje: Univerzitetska pečatnica, 1958], pl. 19)

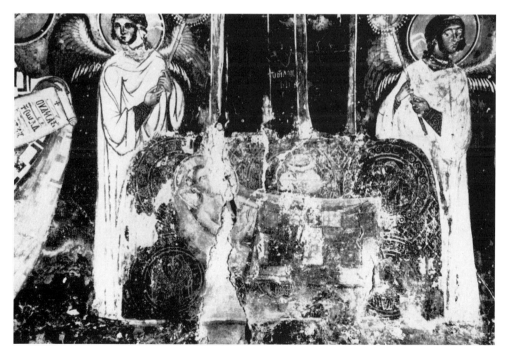

40 St. Nicholas, Manastir (Moriovo), *Melismos* (from Dimče Koco and Petar Miljković–Pepek, *Manastir* [Skopje: Univerzitetska pečatnica, 1958], pl. 10)

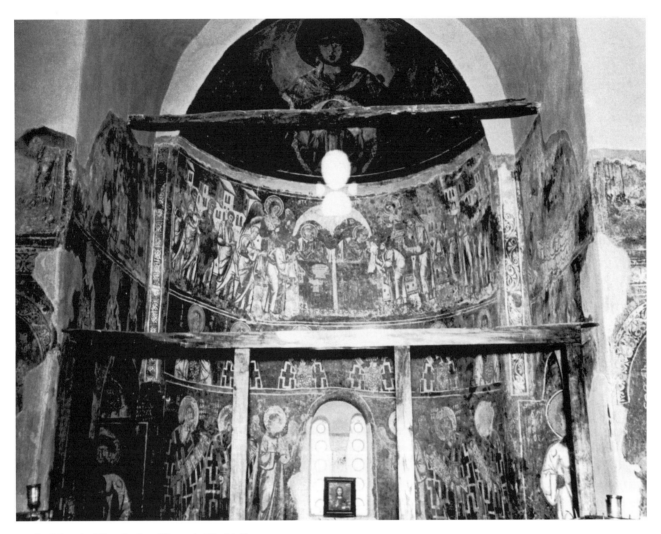

41 St. John the Theologian (Kaneo), Ohrid, Sanctuary

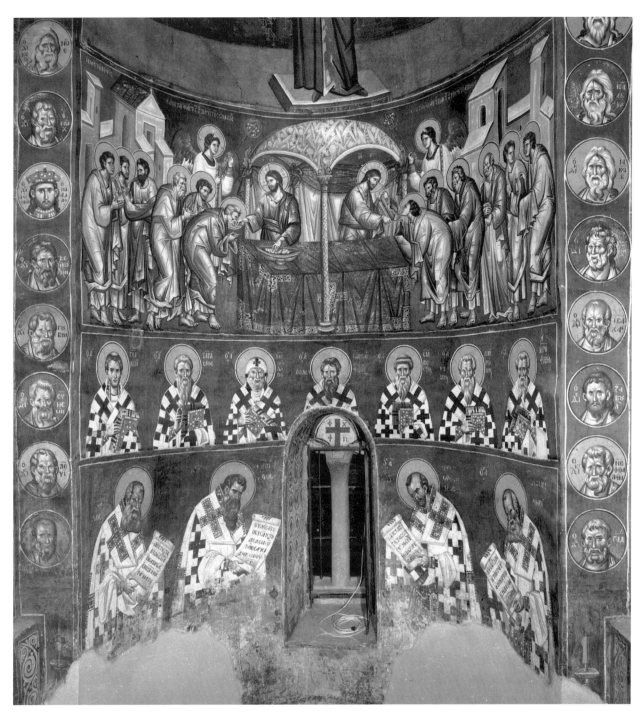

42 Virgin Peribleptos (church of St. Clement), Ohrid, Sanctuary

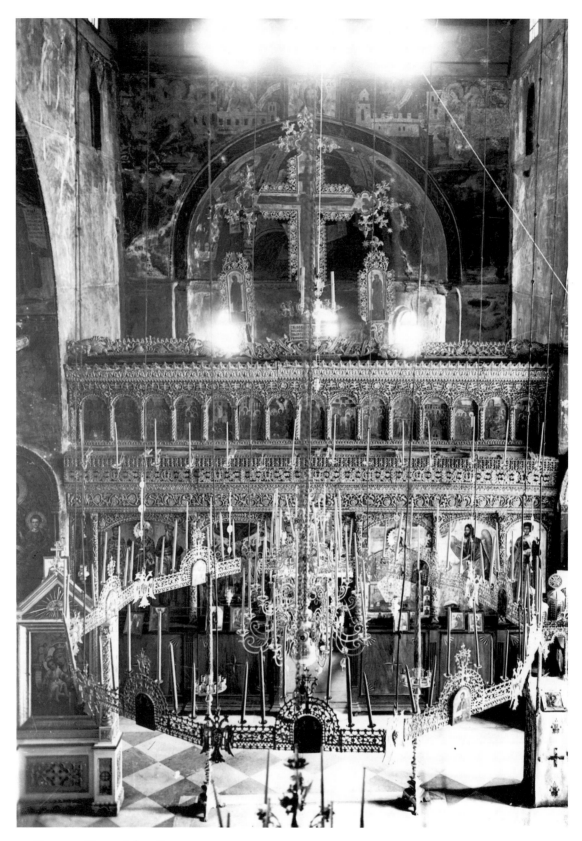

43 Protaton, Mount Athos, Sanctuary screen

44 Protaton, Mount Athos, North wall of sanctuary

45 Protaton, Mount Athos, South wall of sanctuary

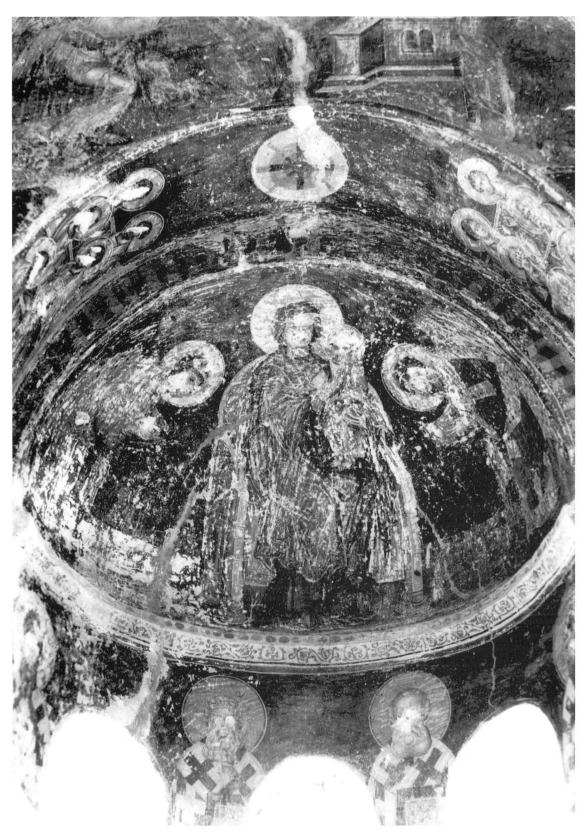

46 St. Euthymios, Thessalonike, Conch of apse

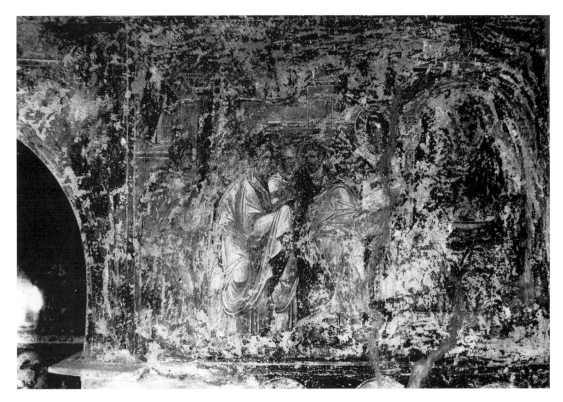

47 St. Euthymios, Thessalonike, Communion of the bread

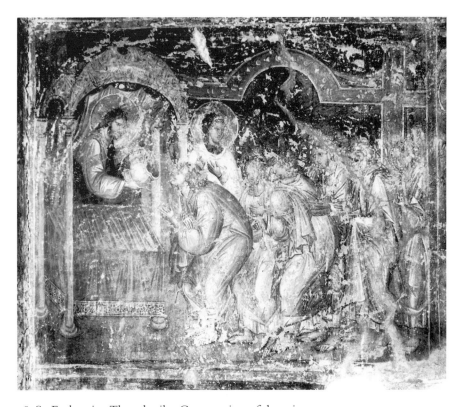

48 St. Euthymios, Thessalonike, Communion of the wine

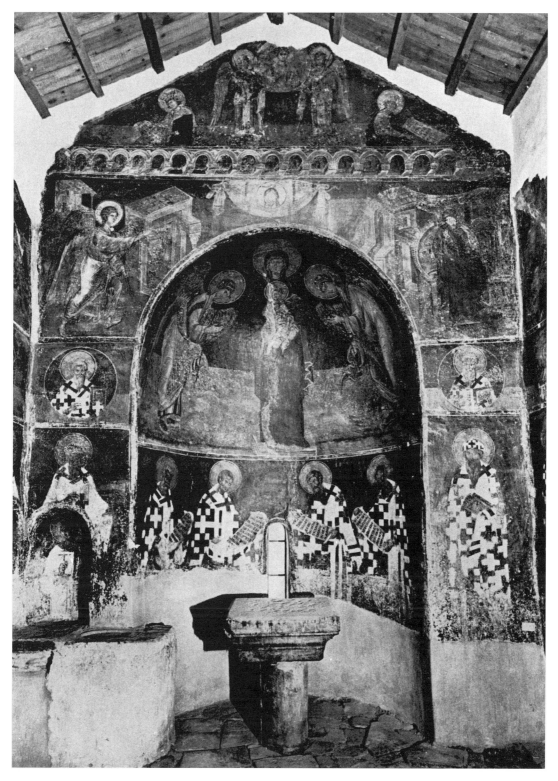

49 Christos, Veroia, Sanctuary

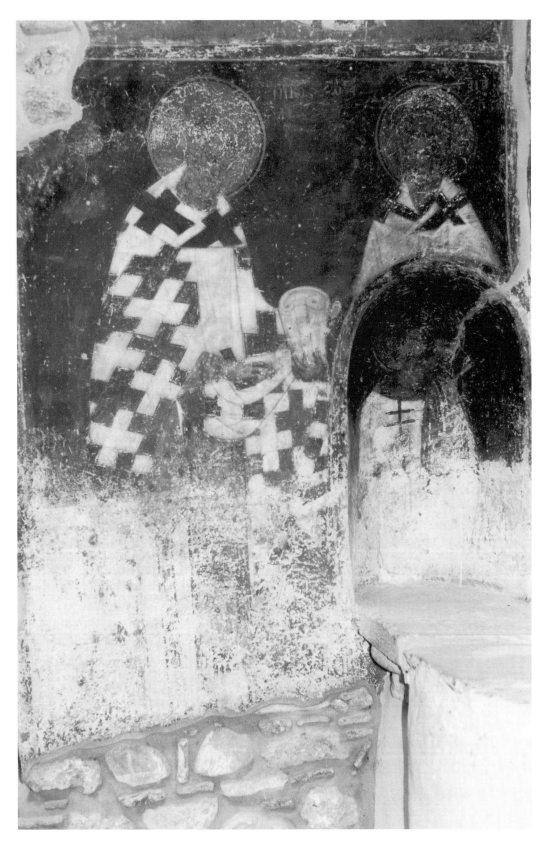

50 Christos, Veroia, North wall of sanctuary

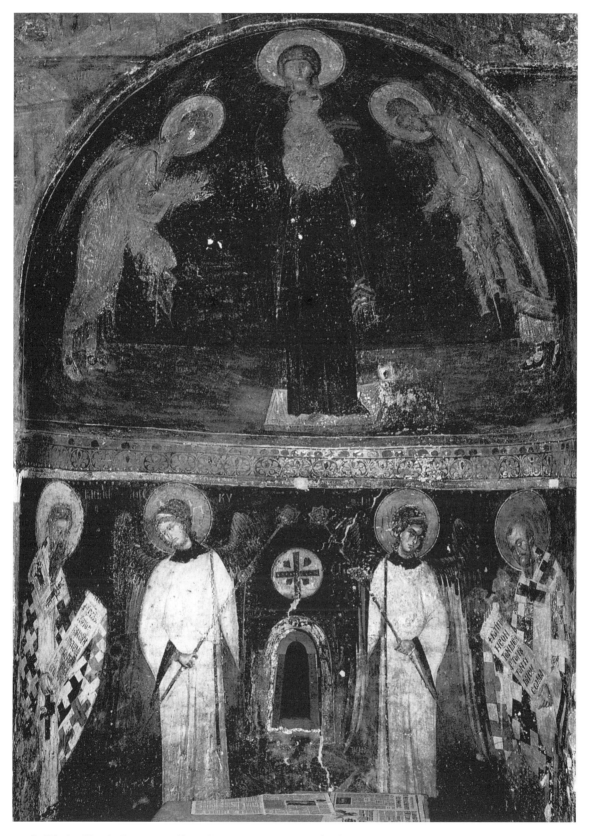

51 St. Blasios, Veroia, Sanctuary (from Papazotos, *He Veroia*, pl. 12)

52 St. Nicholas Orphanos, Thessalonike, East wall

53 St. Nicholas Orphanos, Thessalonike, Sanctuary screen

54 St. Nicholas Orphanos, Thessalonike, Communion of the bread

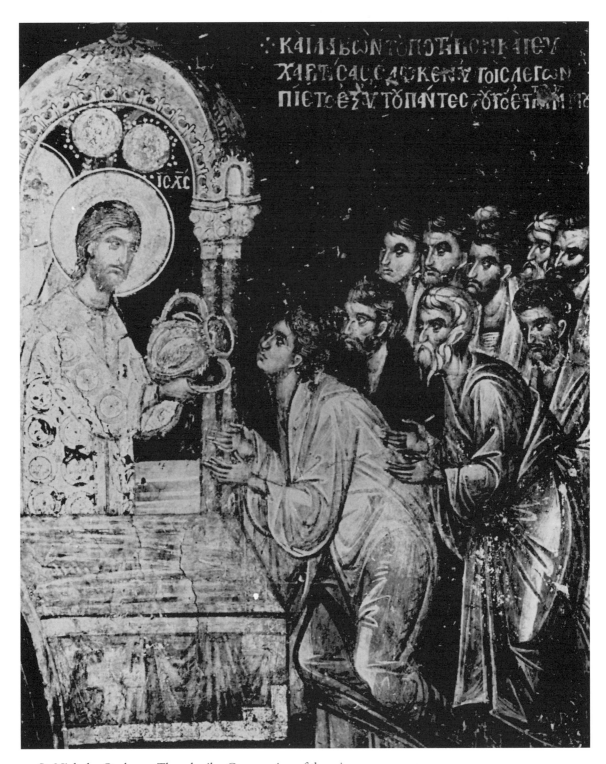

55 St. Nicholas Orphanos, Thessalonike, Communion of the wine

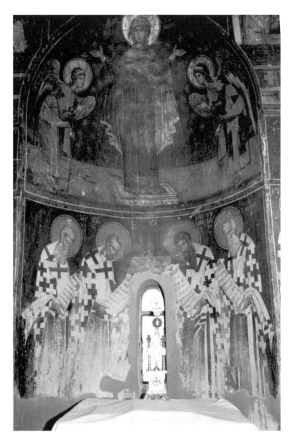

56 St. Nicholas Orphanos, Thessalonike, Sanctuary

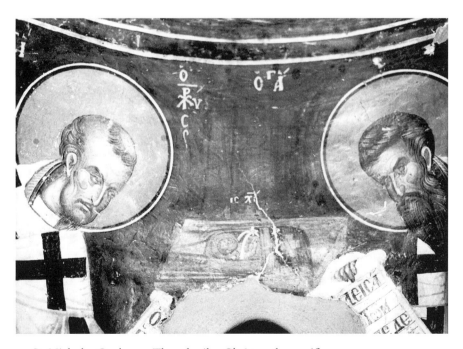

57 St. Nicholas Orphanos, Thessalonike, Christ as the sacrifice

58 St. Nicholas Orphanos, Thessalonike, South wall of sanctuary

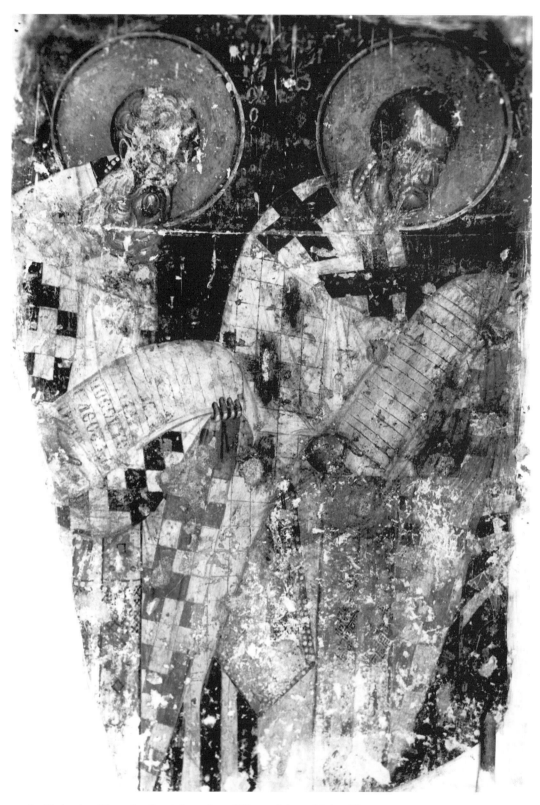

59 St. Catherine, Thessalonike, Athanasios of Alexandria and John Chrysostom

60 Panagia Protothrone, Naxos, Sanctuary (from *Naxos,* ed. Manolis Chatzidakis [Athens: Melissa, 1989], 35)

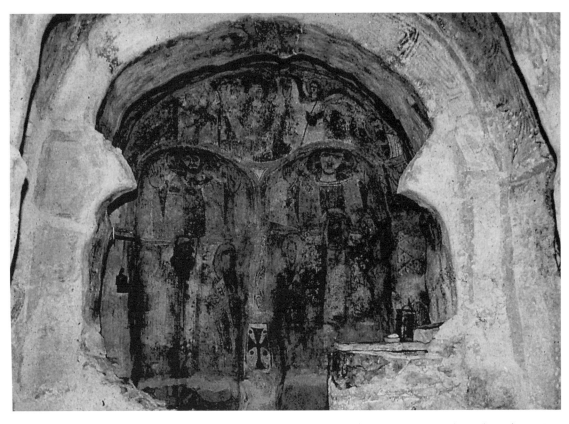

61 St. Panteleimon, Upper Boularioi, Mani, Sanctuary (from Drandakes, *Vyzantines toichographies*, pl. XVIII)

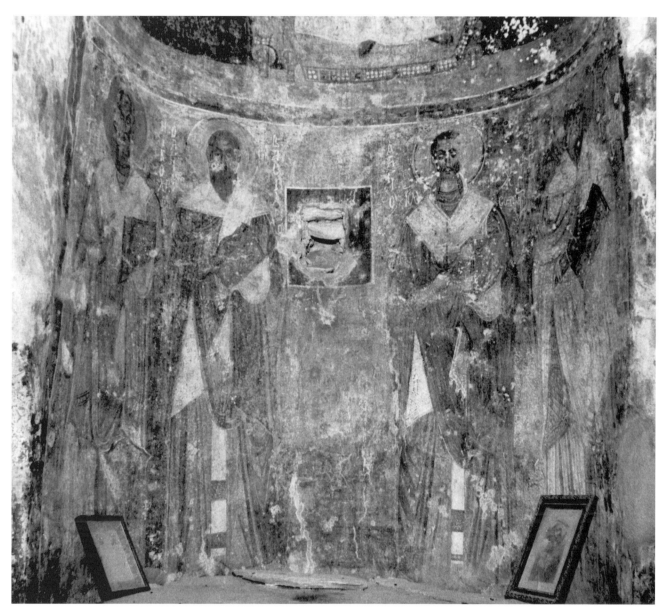

62 Hagios Strategos, Upper Boularioi, Mani, Sanctuary

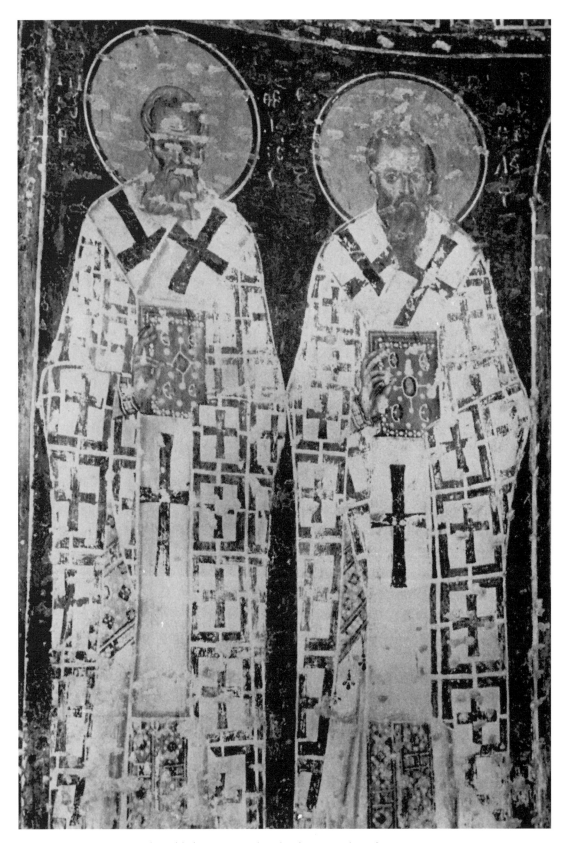

63 Porta Panagia, near Pyli, Trikkala, Gregory the Theologian and Basil

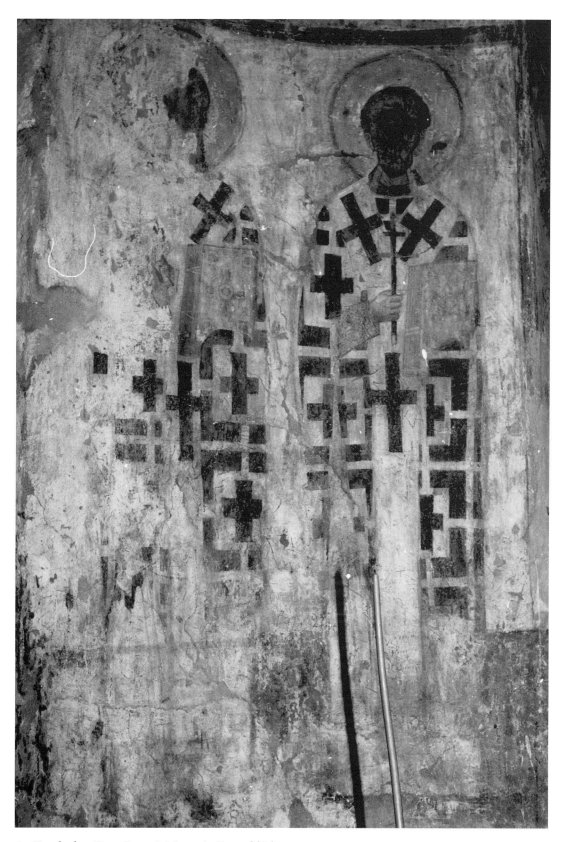

64 Zoodochos Pege, Samari, Messenia, Frontal bishops

65 St. Merkourios, Corfu, Sanctuary (from Panagiotes Voctotopoulos, "Fresques du XIe siècle à Corfou," *CahArch* 21 [1971]: 155, fig. 4)

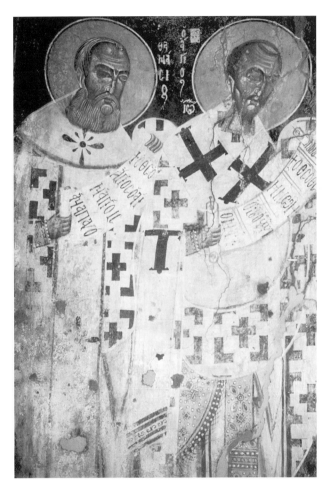

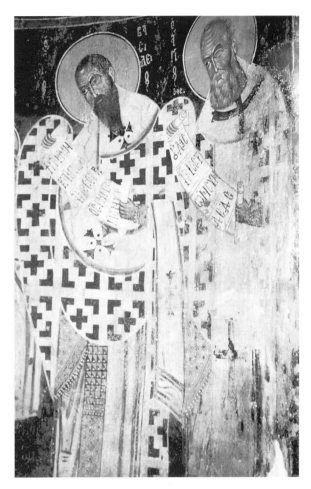

66 St. John Chrysostom, Geraki, Athanasios and John Chrysostom

67 St. John Chrysostom, Geraki, Basil and Gregory the Theologian

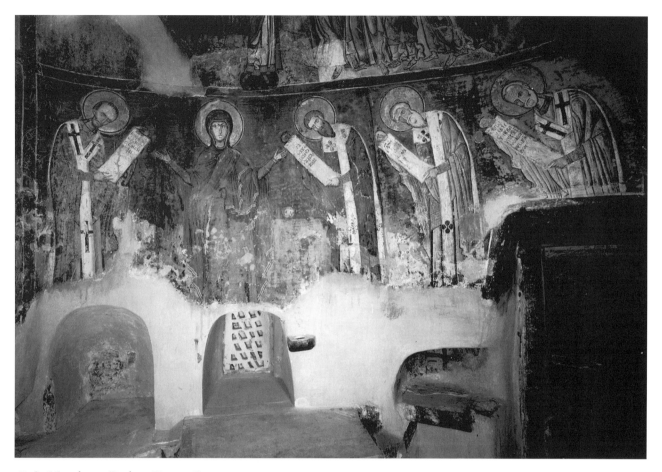

68 St. Neophytos, Paphos, Cyprus, Sanctuary

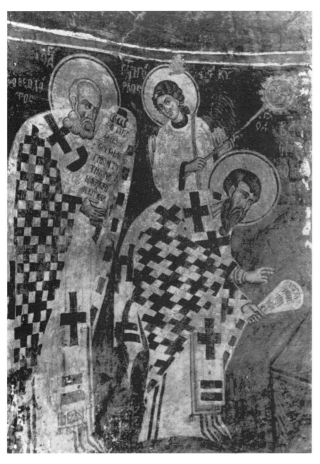

69 Taxiarchs of the Metropolis, Kastoria, Gregory the
Theologian and Basil (from Pelekanides, *Kastoria*, pl. 121b)

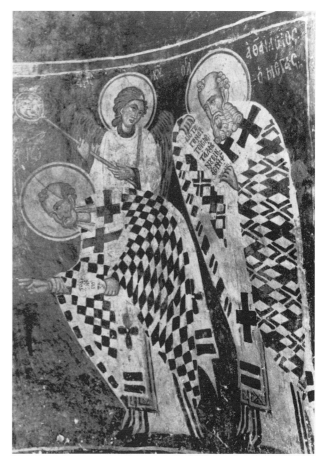

70 Taxiarchs of the Metropolis, Kastoria, John Chrysostom
and Athanasios of Alexandria (from *Pelekanides*, Kastoria, pl.

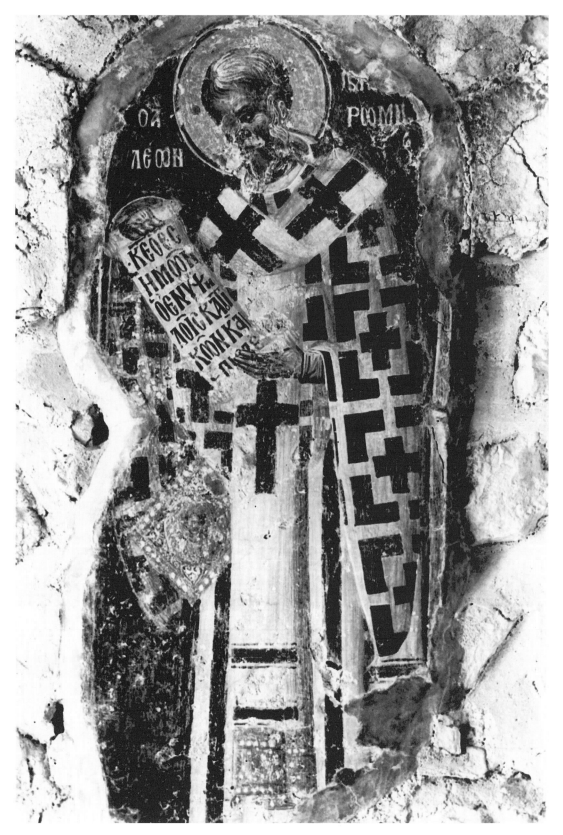

71 Hodegetria, Mystra, Leo of Rome

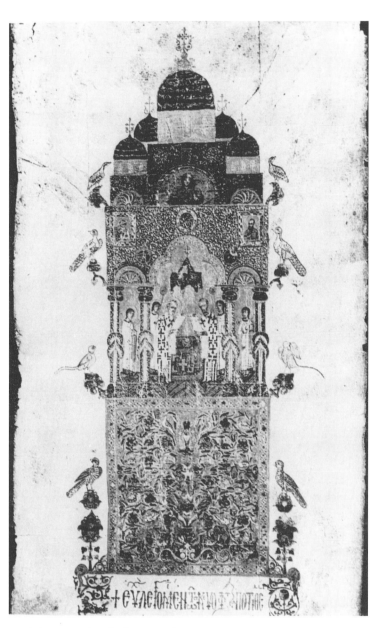

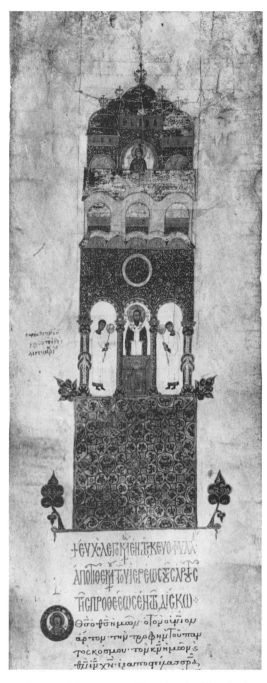

72 Athens, National Library, cod. 2559

73 Patmos, Monastery of St. John the Theologian, cod. 707

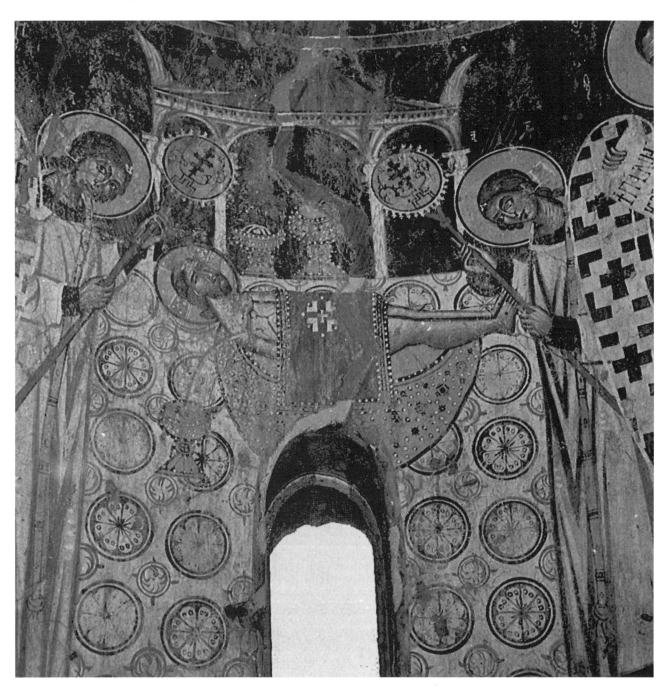

74 St. John Chrysostom, Geraki, Christ as the sacrifice

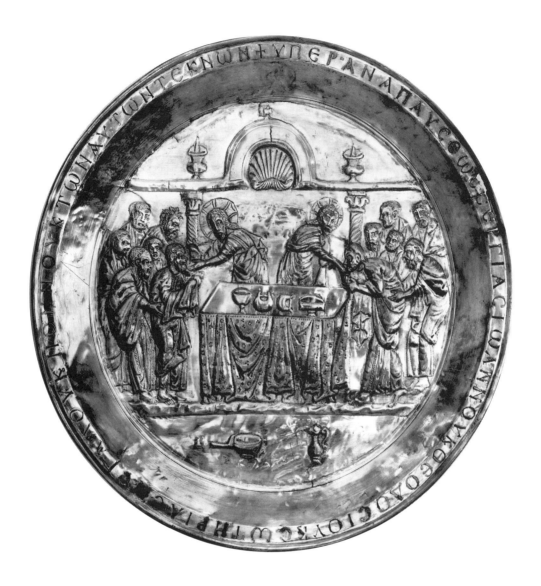

75 Dumbarton Oaks, Washington, D.C., Riha Paten (acc. no. 54.89.21)

76 St. Nicholas, Myra, Communion of the Apostles

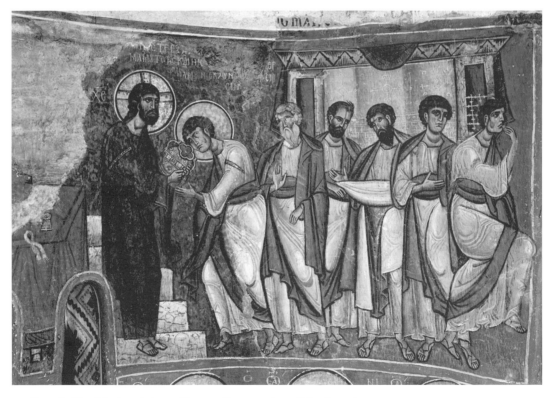

77 Panagia Phorbiotissa, Asinou, Cyprus, Communion of the Apostles

204

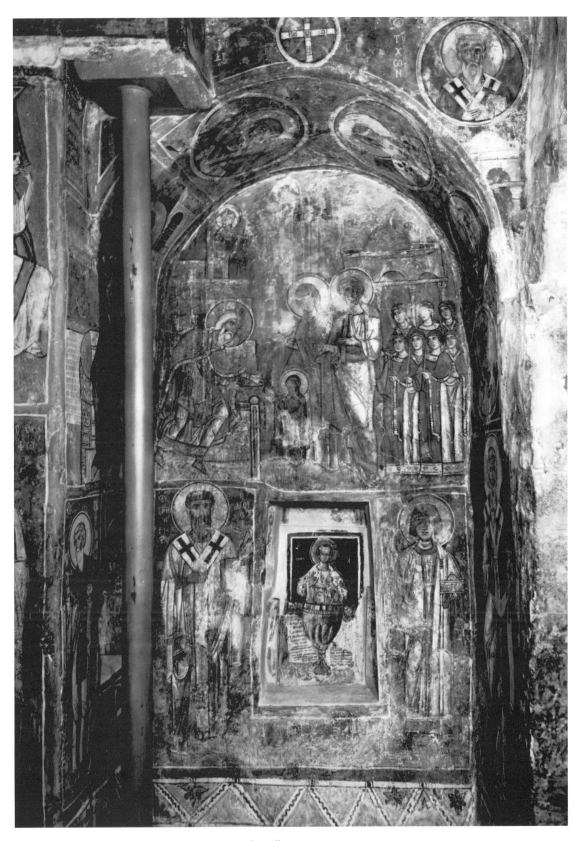

78 Panagia Phorbiotissa, Asinou, Cyprus, South wall

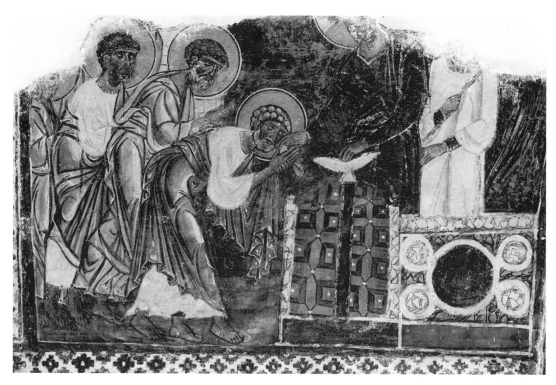

79 St. John the Theologian, Patmos, Communion of the bread

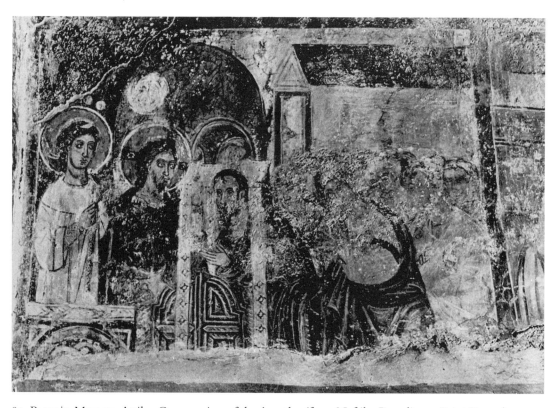

80 Panagia, Merenta, Attika, Communion of the Apostles (from Nafsika Panselinou, *Saint-Pierre de Kalyvia-Kouvara et la Chapelle de la Vierge de Mérenta* [Thessalonike: Kentron Vyzantinon Ereunon, 1976], pl. 62)

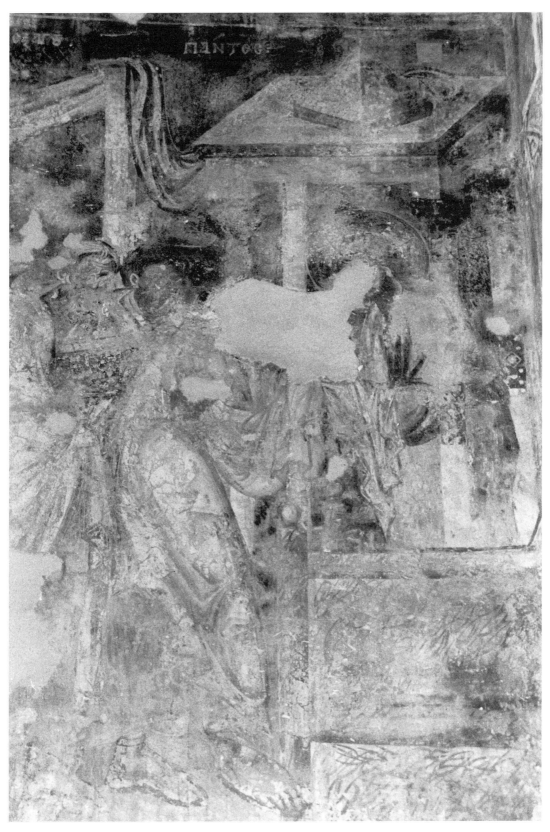

81 Omorphe Ekklesia, Athens, Communion of the bread

82 Iznik Archaeological Museum, Chalice

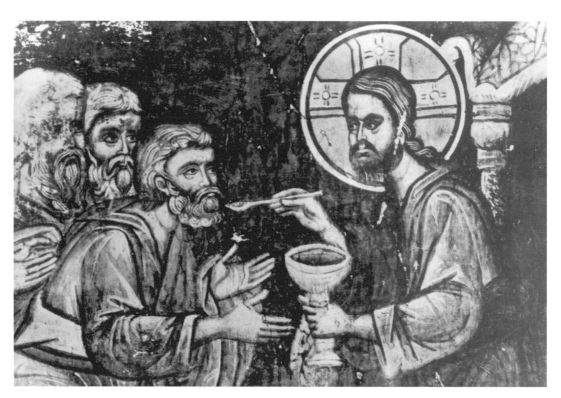

83 Holy Archangels, Lesnovo, Communion of the wine (from Gabriel Millet and Tania Velmans, *La peinture du moyen âge en Yougoslavie* [Paris: E. de Boccard, 1969], 4: pl. 7)

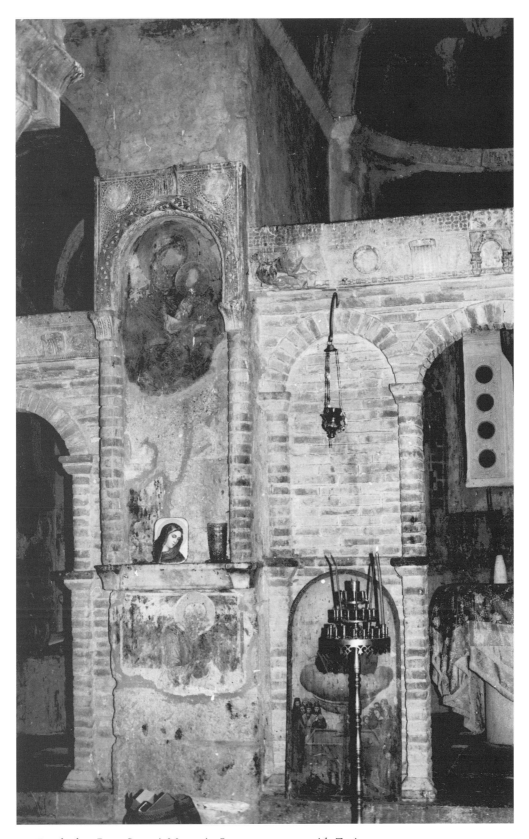

84 Zoodochos Pege, Samari, Messenia, Sanctuary screen with Zosimas

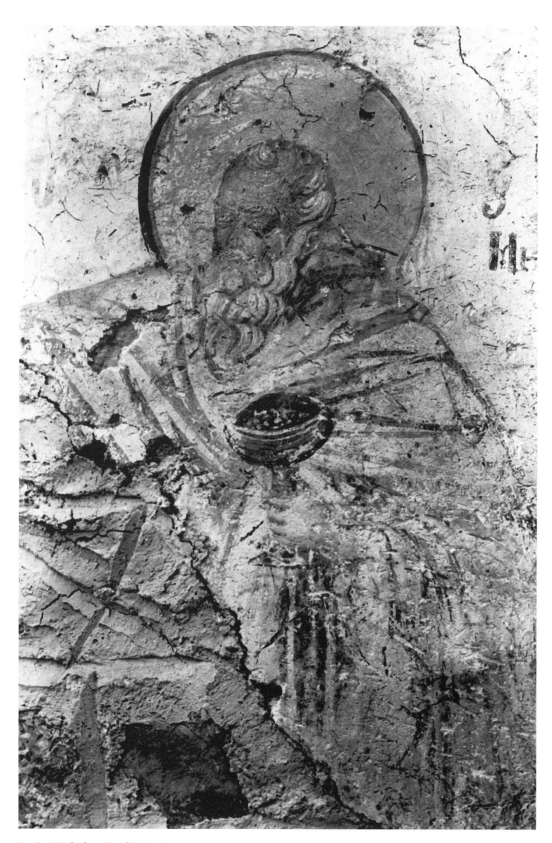

85 St. Nicholas, Geraki, Zosimas

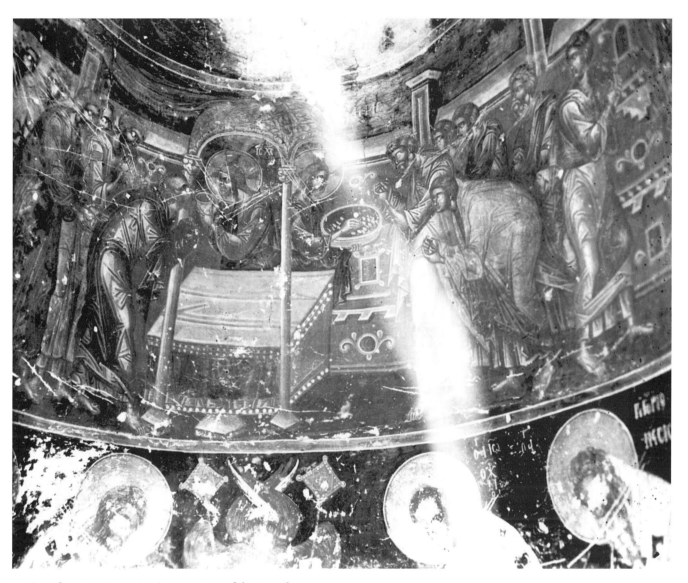

86 St. Athanasios, Kastoria, Communion of the Apostles

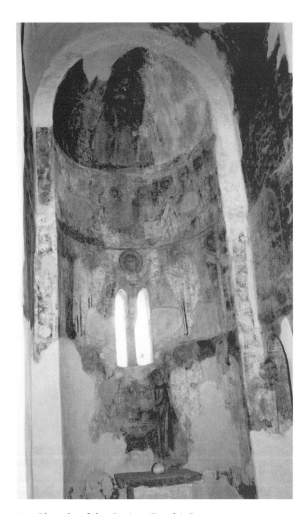

87 St. Barbara, Khé, Georgia, Mandylion (from Tania Velmans, "L'église de Khé en Georgie," *Zograf* 10 [1979]: 74, fig. 6)

88 Church of the Savior, Geraki, Sanctuary

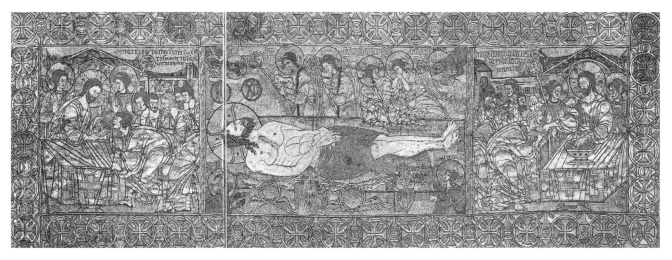

89 Thessalonike *epitaphios*

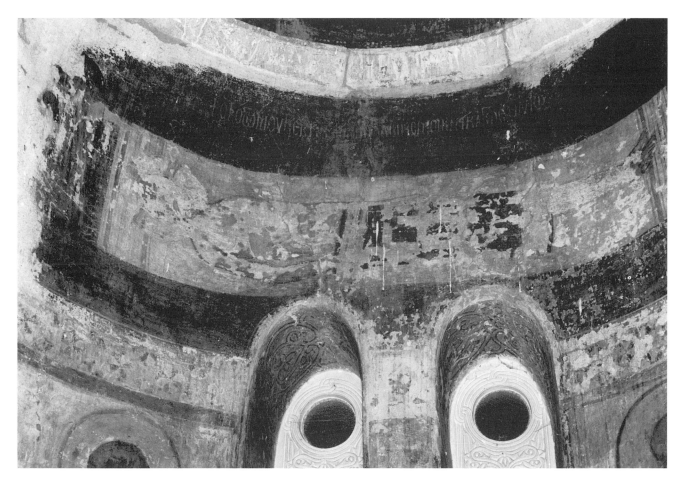

90 Zoodochos Pege, Samari, Messenia, *Epitaphios*

CAA Monographs on the Fine Arts

Order the following from University of Washington Press, P.O. Box 50096, Seattle, Washington 98145-5096, 800/441-4115. For CAA members' discount, cite membership number with your order.

DIANA GISOLFI and STAALE SINDIG-LARSEN, *The Rule, the Bible, and the Council: The Library of the Benedictine Abbey at Praglia.* 1998. CAA Monograph LV. ISBN 0-295-97661-6. $55.00 (members $41.25)

JOAN A. HOLLADAY, *Illuminating the Epic: The Kassel* Willehalm *Codex and the Landgraves of Hesse in the Early Fourteenth Century.* 1997. CAA Monograph LIV. ISBN 0-295-97591-1. $50.00 (members $37.50)

BRIGITTE BUETTNER, *Boccaccio's* Des cleres et nobles femmes: *Systems of Signification in an Illuminated Manuscript,* 1996. CAA Monograph LIII. ISBN 0-295-97520-2. $45.00 (members $33.75)

CLIFFORD M. BROWN and GUY DELMARCEL, with the collaboration of Anna Maria Lorenzoni, *Tapestries for the Courts of Federico II, Ercole, and Ferrante Gonzaga, 1522–63.* 1996. CAA Monograph LII. ISBN 0-295-97513-X. $50.00 (members $37.50)

BACKLIST

The following monographs are available from Penn State Press, Suite C, Barbara Building, 820 North University Drive, University Park, Pennsylvania 16802, 814/865-1327. For CAA members' discount, cite membership number with your order.

MARILYN R. BROWN, *Degas and the Business of Art: "A Cotton Office in New Orleans."* 1994. CAA Monograph LI. $57.50 (members $43.25)

ANITA FIDERER MOSKOWITZ, *Nicola Pisano's Arca di San Domenico and Its Legacy.* 1994. CAA Monograph L. $55.00 (members $41.25)

CAROL RADCLIFFE BOLON, *Forms of the Goddess Lajja Gauri in Indian Art.* 1992. CAA Monograph XLIX. $47.50 (members $35.75)

JEFFREY C. ANDERSON, *The New York Cruciform Lectionary.* 1992. CAA Monograph XLVIII. $42.50 (members $31.75)

MEREDITH PARSONS LILLICH, *Rainbow Like an Emerald: Stained Glass in Lorraine in the Thirteenth and Early Fourteenth Centuries.* 1991. CAA Monograph XLVII. $49.50 (members $37.25)

EDITH W. KIRSCH, *Five Illuminated Manuscripts of Giangaleazzo Visconti.* 1991. CAA Monograph XLVI. $39.50 (members $26.50)

ALEX SCOBIE, *Hitler's State Architecture: The Impact of Classical Antiquity.* 1990. CAA Monograph XLV. $35.00 (members $26.25)

JAROSLAV FOLDA, *The Nazareth Capitals and the Crusader Shrine of the Anunciation.* 1986. CAA Monograph XLII. $35.00 (members $26.25)

LIONEL BIER, *Sarvistan: A Study in Early Iranian Architecture.* 1986. CAA Monograph XLI. $35.00 (members $26.25)

BERNICE F. DAVIDSON, *Raphael's Bible: A Study of the Vatican Logge.* 1985. CAA Monograph XXXIX. $35.00 (members $26.25)

ROBERT S. NELSON, *The Iconography of Preface and Miniature in the Byzantine Gospel Book.* 1980. CAA Monograph XXXVI. $35.00 (members $26.25)

JOHN R. CLARKE, *Roman Black-and-White Figural Mosaics.* 1979. CAA Monograph XXXV. $35.00 (members $26.25)

HENRY-RUSSELL HITCHCOCK, *Netherlandish Scrolled Gables of the Sixteenth and Early Seventeenth Centuries.* 1978. CAA Monograph XXXIV. $35.00 (members $26.25)

MILLARD MEISS and ELIZABETH H. BEATSON, *La Vie de Nostre Benoit Sauveur Ihesuscrits and La Saincte Vie de Nostre Dame.* 1977. CAA Monograph XXXII. $35.00 (members $26.25)

WALTER CAHN, *Romanesque Wooden Doors of Auvergne.* 1975. CAA Monograph XXX. $35.00 (members $26.25)

CLAIRE RICHTER SHERMAN, *The Portraits of Charles V of France.* 1969. CAA Monograph XX. $35.00 (members $26.25)

HOWARD SAALMAN, *The Bigallo: The Oratory and Residence of the Compagnia del Bigallo e della Misericordia in Florence.* 1969. CAA Monograph XIX. $35.00 (members $26.25)

JACK J. SPECTOR, *The Murals of Eugène Delacroix at Saint-Sulpice.* 1968. CAA Monograph XVI. $35.00 (members $26.25)